Chromatic Cinema

Chromatic Cinema

A History of Screen Color

Richard Misek

A John Wiley & Sons, Ltd., Publication

This edition first published 2010
© 2010 Richard Misek

Blackwell Publishing was acquired by John Wiley & Sons in February 2007. Blackwell's publishing program has been merged with Wiley's global Scientific, Technical, and Medical business to form Wiley-Blackwell.

Registered Office
John Wiley & Sons Ltd, The Atrium, Southern Gate, Chichester, West Sussex, PO19 8SQ, United Kingdom

Editorial Offices
350 Main Street, Malden, MA 02148-5020, USA
9600 Garsington Road, Oxford, OX4 2DQ, UK
The Atrium, Southern Gate, Chichester, West Sussex, PO19 8SQ, UK

For details of our global editorial offices, for customer services, and for information about how to apply for permission to reuse the copyright material in this book please see our website at www.wiley.com/wiley-blackwell.

The right of Richard Misek to be identified as the author of this work has been asserted in accordance with the UK Copyright, Designs and Patents Act 1988.

Wiley also publishes its books in a variety of electronic formats. Some content that appears in print may not be available in electronic books.

Designations used by companies to distinguish their products are often claimed as trademarks. All brand names and product names used in this book are trade names, service marks, trademarks or registered trademarks of their respective owners. The publisher is not associated with any product or vendor mentioned in this book. This publication is designed to provide accurate and authoritative information in regard to the subject matter covered. It is sold on the understanding that the publisher is not engaged in rendering professional services. If professional advice or other expert assistance is required, the services of a competent professional should be sought.

Library of Congress Cataloging-in-Publication Data

Misek, Richard, 1971–
 Chromatic cinema : a history of screen color / by Richard Misek.
 p. cm.
 Includes bibliographical references and index.
 ISBN 978-1-4443-3239-1 (hardcover : alk. paper)
 1. Color cinematography–History. 2. Colors in motion pictures. I. Title.
 TR853.M57 2010
 778.5′342–dc22

 2009037084

A catalogue record for this book is available from the British Library.

Set in 10.5/13pt Minion by SPi Publisher Services, Pondicherry, India
Printed and bound in Singapore by Fabulous Printers Pte Ltd

01 2010

To Marcus, for the motivation
To mum, for everything else

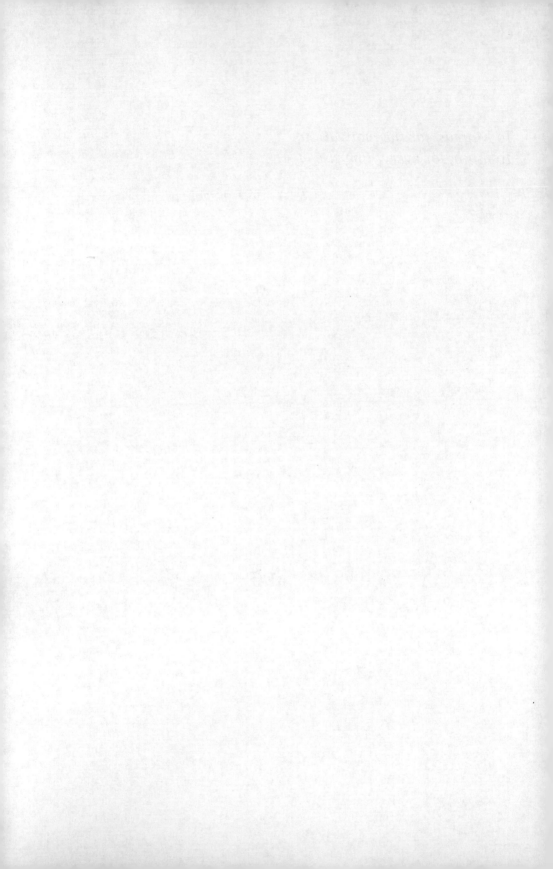

Contents

Plates

Acknowledgments

I would like briefly to express my gratitude to those who have aided me with the completion of this work.

Influential contributors to this project have included the various colleagues with whom I have worked over the last eight years, first at the University of Warwick, then at the University of Melbourne. Notable among these are my MA supervisor Charlotte Brunsdon, my PhD supervisor Angela Ndalianis, and my de facto mentor Sean Cubitt (sir, you are a scholar and a gentleman). Victor Perkins and Jon Burrows also provided me with support and advice at a crucial early point in the project, which was beyond the call of duty. Thanks also to Brian Price, my reader at Wiley-Blackwell, for his perceptive and supportive feedback. Particular thanks are due to Allan Cameron, who for four-and-a-half years was my most scrupulous critic and my favourite drinking companion; his ideas pervade this book.

Various friends whose contributions, direct and indirect, have helped enrich my work also deserve thanks. These include the following: Ben Murphy, Magnus Aronson, Natasha Soobramanien, Luke Williams, Ian Edwards, Asa Sandzén, and especially Eszter Szabo, whose help with my research on light added a new dimension to the book, and whose understanding and support helped me finish it.

Introduction

"A common greyness silvers everything."

Robert Browning (1991: 99)

Aristotle observed that it is impossible to see color without light (*On the Soul* ¶419a). This is true, but it *is* possible to see light without color, in the form of monochrome photographic images. By means of the camera, two visually inseparable but theoretically distinct phenomena have been transformed into two visually distinct but symbiotic modes of communication: color and black-and-white. In this book, I explore the changing uses and meanings of color and black-and-white in moving images, from hand painting in early serpentine dance films to the latest trends in digital color manipulation.

Color permeates film and its history, but study of its contribution to film has so far been fragmentary. Over the last few decades, there have appeared numerous historical accounts of color in film, but they have tended to focus on individual aspects of color. These microhistories include technological histories, aesthetic histories, anecdotal histories that privilege the role of individuals, didactic histories that privilege the role of ideology, period-specific histories, country-specific histories, process-specific histories, and histories that variously explore technological, aesthetic, economic, and ideological factors in combination.[1] Most of these histories have taken the form of articles or essays rather than books. The result is that the study of color in film has become the domain of the anthology, as if bringing together multiple voices were the only way to address color's visual diversity.[2] Individual essays by different writers each examine localized aspects of color. Sometimes they overlap, often they do not.

Chromatic Cinema complements this approach by providing both a condensed history of color in film and a theoretical framework within

which to understand it. My theory, in short, is that the history of screen color is in fact a history of color *and its absence*. There is a beautiful moment in *Go West* (Buster Keaton, 1925), when Keaton accidentally dons a devil costume, and a herd of cattle starts to chase after him. Unlike the bulls, we can only see the costume's horns and pitchfork tail, not its color. Yet though the devil suit appears on screen as dark gray, we comprehend that it is red and sense the allure of color. In this specific sequence, black-and-white and color exist in cognitive symbiosis. Across cinema as a whole, they also exist in historical, technological, aesthetic, and theoretical symbiosis. Yet each is routinely perceived as autonomous, and discussed without reference to the other.[3] Black-and-white is typically perceived in one of two ways: in its presence prior to the mid-1960s as an aesthetic default, and in its presence since the mid-1960s as an occasional idiosyncrasy. In the former case, it tends to be overlooked in favor of color, less common and so more prominent. In the latter case, discourse on black-and-white is dominated by the brief media interest that follows the release of occasional mainstream black-and-white films. In my view, however, black-and-white and color have permeated and referenced each other throughout the history of cinema. Cinematic color emerged from black-and-white, defined itself in response to it, and has evolved in symbiosis with it. Accordingly, in this book, I focus not on color cinema but on what I refer to as *chromatic cinema*, which comprises the full ebb and flow of color through film history.

Over the course of this book, I highlight some of the most significant historical developments in how film-makers have exploited color and black-and-white. I focus on how they have done so within individual films, as well as across genres, industries, and cultures. As a result, though my main interest is color aesthetics, I also engage with the cultural, economic, artistic, and – above all – technological forces that have shaped how color appears on screen. Read almost any historical account of color in film by a practitioner or journalist, and you will probably find a variant of the same master narrative – namely, that a series of technological advances (new cameras, new film stocks, etc.) have propelled cinema ever closer toward chromatic "realism." Of course, the assumption that technology motivates all cultural change is easily contradicted. The history of screen color, as I shall demonstrate, is full of discontinuities. These include moves away from as well as toward common notions of realism, meanings morphing and inverting, technologies appearing too early to become established, ideas pre-dating the technologies needed to implement them, and occasional appearances of

the radically new, followed by the absorption of innovation into dominant culture. Within this context, cinema's move toward chromatic "realism" is just one narrative among many.

At the same time, though I reject technological determinism, I also reject the opposite view that technology merely embodies cultural change. Color is a technology through which cultural products can be created (e.g. colored paint) as well as a constituent of these products (the color of a painting). Inevitably, then, color films are dependent on color technology – for example, hand-painted films look completely different from Technicolor films in part because they involve different processes. A key question, unavoidable in any history of screen color, is – how precisely does the color that we see on screen interact with the technologies used to create it? By paying close attention to film-makers' uses of color, *Chromatic Cinema* suggests possible answers to this question. At the same time, it is impossible to investigate changing uses of black-and-white and color without also investigating the changing ways in which they have been understood to function. Uses and perceptions feed into each other in a potentially infinite causal loop, each influencing and modifying the other. Accordingly, a secondary aim of this book is to uncover some of the ideologies and cultural meanings which have informed uses of black-and-white and color, and which have in turn been influenced by these uses.

Though *Chromatic Cinema* aims to provide a general overview of cinema's chromatic history, this overview is inevitably incomplete. To touch on all aspects of black-and-white and color individually is a task beyond the scope of one book; to explore both exhaustively would involve a lifetime of work. My omissions therefore exceed my inclusions. For example, I do not provide an exhaustive list of the dozens of early color technologies that appeared and disappeared in the first decades of cinema; I focus only on technologies that had a sustained influence on screen aesthetics. I also make no claim to address the specificities of every national cinema's responses to color. I have tried to achieve as global a reach as possible, especially when exploring the various cultural and economic factors underlying different countries' adoption of color in the post-war decades. However, it has again proven impossible to explore all periods in all countries' chromatic histories. At different points in the history, I therefore privilege specific countries, specific genres, or specific modes of production, depending on their historical significance and their relevance to my argument. In particular, I have found it impossible to travel any great historical distance without eventually returning to Hollywood.

My final and most notable exclusion is animation. Many of the most startling uses of color in film history have occurred through animation. The works of Oskar Fischinger, Len Lye, and above all Walt Disney belong at the center of any truly inclusive study of color. Animation has also made an important contribution to the historical spread of color within cinema. For example, were it not for Disney's decision to use color in its *Silly Symphonies* from 1932 onward, Technicolor might not have survived beyond the early 1930s, when producers of live-action films remained reluctant to take the financial risk of using color. Nonetheless, despite the many overlaps between animation and cinematography, the two have distinct genealogies. Color in live-action has historically been harnessed to the amorphous concepts of "realism" and "spectacle." By contrast, animation has immersed itself in color, responding more directly to color's impact on the retina. When looking for ways to prevent this book from becoming too unwieldy, I therefore made the reluctant decision to exclude animation's genealogy. I hope others will fill this gap.

It is also worth emphasizing that my focus is primarily on films and on the institution of cinema. Of course, cinema is not an autonomous entity. Recent hybridities between music, movies, telephony, television, computer gaming, and so on, reminds us that "film" is just one of many forms of mediation. In acknowledgment of the recent explosion of moving imagery beyond the confines of cinema and television, my analysis of color's recent history includes reference to music videos, television commercials, and motion graphics. However, with the exception of some essential discussions about the influence on cinema of art history, I restrict my attention to time-based media. I do not explore other strata of the media landscape, for example newspapers, billboard advertising, photography, fashion, graphic design, and web design. Some of my conclusions apply across all visual culture, some do not. I leave it to the reader to make connections between moving images and other modes of communication.

"Color" is both a noun and an adjective. Color (adjective) refers to all phenomena that have color (noun). In this sense, color (adjective) is – at least on the surface – a fairly unambiguous term. We all know intuitively what "color" refers to, though we each perceive it in different ways. "Black-and-white," on the other hand, is not an intuitive term. It is only an adjective, not a noun. The term was invented, probably in the nineteenth century, to describe a specific mode of representation that was itself an invention. As the technology behind monochrome cinematography has changed, "black-and-white"

has found itself not quite up to the task of describing what it is meant to describe. On this subject, Ludwig Wittgenstein commented:

> If I say a piece of paper is pure white, and if snow were placed next to it and it then appeared grey, in its normal surroundings I would still be right in calling it white and not light grey. It could be that I use a more refined concept of white in, say, a laboratory.... (1977: 2)

For most people, in most cases, it is enough to regard black-and-white films simply as films without color. However, in the laboratory conditions of this book, the imprecision of "black-and-white" cannot be ignored. The term has historically been used to describe not just films comprising only pure blacks and pure whites (for example, the white on black line animations of Émile Cohl) but also most monochrome films, in which there is a range of tonality from black to white via gray. Furthermore, monochrome films need not even be grayscale. Often films that appear to lack any perceptible color can be seen, when juxtaposed with other monochrome films, to include a variety of tones depending on the film stocks and laboratory processes used during their production (see, for example, the surprising chromatic diversity of Plates 2.9 to 3.6). To complicate matters even further, tinted films are also definable as monochrome: shot in black-and-white, with a single, uniform color cast added in the laboratory, color mono-chrome films are also typically classified as "black-and-white." "Black-and-white," of course, also references an era in cinema history that lasted until about the 1960s.

What, then, does "black-and-white" refer to? Is a hand-painted Georges Méliès film black-and-white? What about a tinted D. W. Griffith film? Or *Sin City* (Robert Rodriguez & Frank Miller, 2005), whose graphic blacks and whites are overlaid by patches of digital color: red lips, blue eyes, a yellow face ...? Can a film be black-and-white *and* color? This ambiguity complicates the already fluid relationship between black, white, and color. Over the course of this book, I highlight many chromatic ambiguities. However, there is one that can be eradicated immediately, namely the ambiguity between "black-and-white" and "black and white." For the purposes of this book, I use the term "black-and-white" as broadly as possible. I use it to describe all grayscale monochrome films, most sepia-toned films, and some color mono-chrome films. I also use the term to describe the imprecise historical era of "black-and-white" cinema. By contrast, when I use the term "black and white," I refer specifically to the on-screen presence of black and of white.

The ambiguity over what "black-and-white" refers to interlaces with an ambiguity over how black and white should be classified. A recurrent question dating at least as far back as Aristotle has been: are black and white colors? The answer is yes and no. A report delivered at the 1935 convention of the Society of Motion Picture Engineers (SMPE) provides the following elaboration:

> We may imagine that, at the present moment, one of the lady guests of the Convention is asking a friend, "Are you wearing a colored gown to the banquet tonight?" The friend, thinking of her black dress or white dress, answers, "No." But had she been asked, "What color dress are you wearing tonight?" the answer would have been "black" or "white" without hesitation. (Anon. 1935: 29)

This reference to conversations that male SMPE experts imagined (or hoped) their wives might be having pinpoints perfectly the imprecision of black, white, and color. Whether the lady guest's friend refers to the whiteness of her dress as a color or an absence of color depends on the way in which the lady guest asks her about it. The first question is premised on the assumption that there exist not-colors, and demands an answer that shares this assumption. The second question is premised on the assumption that all is color, again demanding an answer that shares this assumption. In color theory, as in everyday conversation, black and white can also be conceptualized as color or not-color. To demonstrate how this can be the case, I need first to summarize the basic principles of color mixture. This is not the most exciting part of the book, so I shall try to keep it brief. Please bear with me, as it informs much of what comes later.

When we talk about color, we are usually referring to one of two forms of color: optical color (color as light) and surface color (color as pigments). Each involves different relations between individual colors. Optical color involves what is typically referred to as additive color mixture, and surface color involves subtractive color mixture. Each makes a distinct contribution to screen color.

Additive color. All color depends on light. When only some wavelengths of light act on our optic nerves, we perceive color. What we refer to as "red" is a perception associated with a particular range of wavelengths, "violet" is the perception associated with a different range of wavelengths, and so on. When all wavelengths of light act on our optic nerves in roughly equal measure, we perceive white light.[4] Though white light comprises all

visible color wavelengths, it can be achieved by combining only red, green, and blue light. Red, green, and blue light each comprise a wide enough range of wavelengths to ensure that together they encompass almost all wavelengths of light. When red, green, and blue light sources mix with the same intensity, they create white light. When they mix with different intensities, they create different colors of the spectrum. Because optical colors are created by the addition of light to light, this form of color mixture is often described as *additive*. Red, green, and blue are the additive primary colors, the three colors of light that can mix in various proportions to form any other color.[5]

Additive color mixture formed the basis of early Technicolor and numerous other early twentieth-century color technologies. The earliest additive color systems involved three cameras, each with a different primary colored filter placed in front of the lens (red, green, blue), recording the same scene. The three resulting black-and-white negatives each captured different wavelengths of colors: one captured reds, one captured greens, one captured blues. The three black-and-white film prints made from these three negatives could then be projected onto a white screen, each through the same color filter originally used to create the negative. When superimposed onto each other, the red-filtered, green-filtered, and blue-filtered black-and-white film prints combined to create a full color image. Though ingenious, additive color cinematography proved to be a complicated process, and was incrementally replaced by subtractive technologies. Additive color mixture survives, however, in the RGB of the cathode ray tube, where red, green, and blue phosphors combine to create color images. It also survives in LCD screens, in which each pixel comprises red, green, and blue sub-pixels. The relative brightness of each sub-pixel dictates the overall color value of the pixel.

Subtractive color. Subtractive color mixture pertains to mixtures of colored pigments – particles of color suspended in oil or water to create paints, inks, dyes, etc. The objects around us are visible to us by virtue of the fact that they reflect light. When white light shines on a pigment, the pigment absorbs or subtracts certain colors (certain wavelengths) of the spectrum and reflects the rest. For example, we perceive a blue object as blue because it absorbs (subtracts) all wavelengths of white light apart from blue, reflecting blue back at our retinas. A mixture of two pigments absorbs a wider range of wavelengths than one pigment, resulting in a third color: for example, blue and yellow pigments mix to create green. The more pigments one combines, the more light they subtract, resulting in progressively darker colors. Pigmentary color mixture is therefore referred to as *subtractive* color mixture.

There are three subtractive primaries: cyan, magenta, and yellow. A mixture of these three colors absorbs all the wavelengths of light falling onto them – cyan absorbs red, yellow absorbs blue, and magenta absorbs green – resulting in the perception of black. Cyan and magenta do not exist as natural pigments, so until the invention of synthetic color in the nineteenth century, subtractive color combinations typically involved blue, red, and yellow pigments.[6] The combination of red, yellow, and blue is enough to provide a high quality "full color" image, as demonstrated by the experimental mezzotint prints made by painter and inventor Jakob Christof le Blon during the 1720s (Kemp 1990: 282). Using three printing plates – one inked with red, one with yellow, and one with blue – le Blon created color images with a chromatic range that even now takes one's breath away. With the invention of coal-based aniline pigments in the nineteenth century, which enabled far more precise color mixtures, color theorists soon pinpointed the subtractive primaries more precisely.[7] Taking advantage of these discoveries, printers improved on their previous techniques by combining cyan, magenta, and yellow inks with black ink (added because it improved the density of the final image). CMYK printing remains the foundation of print color to the present day. The color plates in this book are printed in CMYK, translated for print from RGB digital files, as are most "full color" print images. Similarly, all color film stocks developed since the 1950s have included layers with cyan, magenta, and yellow color dyes.

It is also worth briefly mentioning another way of combining colors subtractively. This involves following a model commonly referred to either as HSL (hue saturation lightness), HSB (hue saturation brightness), or HSV (hue saturation value). This model classifies colors according to three clearly distinguishable properties. Hue references a wavelength of light, and manifests itself as a type of color: for example, red, green, or violet. Saturation is the intensity of the hue. Lightness/brightness/value is the amount of light reflected by a color: the more reflective a color is, the lighter it appears. HSL is a useful model for understanding color because it describes it in an intuitive way: the sun at noon, for example, is yellow in hue, desaturated, and bright (Williamson & Cummins 1983: 16). A black-and-white image has various degrees of lightness, but no hue or saturation. HSL is also a useful frame of reference because it corresponds to how painters commonly mix pigments. Hue is the equivalent of a pigment of pure color. If a painter regards a color as too intense, she can desaturate it by adding white pigment. If the color is too light, she can darken it by adding black

pigment. In this model, color, white, and black are three separate, constituent elements of the painter's final color; black and white can therefore be regarded as an absence of color. By contrast, in RGB and CMYK color modes, black and white can be regarded as colors, inasmuch as they derive from the combination of additive or subtractive primaries. Hence, black and white are both not-color and color.

The question of how black, white, and color can be conceptualized in relation to each other has provided color theory with one of its enduring themes. The first significant attempt to address this question was made, hesitantly, by Aristotle. Aristotle asserted that black and white are the two primary colors (*De sensu et sensibili* ¶439a). He explained this strange claim by hypothesizing the presence in all physical elements of what he referred to as "the transparent." According to Aristotle, the transparent is "some sort of constitution and potency which they have in common, and which, not being an independent reality, finds its existence in these bodies …" (*De sensu* ¶439a). In air, the absence of the transparent causes shadow and its presence causes light; in solids, its absence causes blackness and its presence causes whiteness. Just as our color perception results from the interaction of light and shadow, the presence of color in solids results from the interaction of black and white. At the same time, though Aristotle privileged black and white, he still classified them as colors. Inspired by the seven notes of the diatonic musical scale, he suggested a scale of seven colors, arranged according to brightness: black, blue, green, violet, red, yellow, and white (Shapiro 1994: 602).[8] Though the science behind Aristotle's classification is nonexistent, his assertion that – of all the colors – black and white are first among equals provides this book with one of its main themes.

Aristotle's chromatic hypotheses form part of a broader investigation into sensation. Unsurprisingly, much of his brief discussion of color is devoted to surfaces, as it is on surfaces that objects' colors reveal themselves to our perception (*On the Soul* ¶418a). Like Aristotle, Renaissance art theorists also took a keen interest in surfaces. However, they did so as much for practical as for philosophical reasons – many of them were painters, and so had a professional interest in how colored pigments mix (Kemp 1990: 266). This shift in focus from theory to practice is emphasized by Leon Battista Alberti in his groundbreaking work *De Pictura* (1435–6), when he states, "Let us leave aside the disputes of philosophers regarding the origins of colors …" (I, 9). Alberti's pragmatism is particularly pronounced in his discussion of black and white. In painting, their roles are far less ambiguous than they are in the natural world. The addition of white decreases the saturation of a

colored pigment, and the addition of black darkens it. Neither white nor black has the ability to change a color, so both function in a manner that allows them to be perceived as separate from color. Accordingly, Alberti challenged the Aristotelian view that black and white are colors, asserting instead that "white and black are not true colors, but, one might say, moderators of colors, for the painter will find nothing but white to represent the brightest glow of light, and only black for the darkest shadows" (I, 10).

Alberti divided the process of painting into three elements: circumscription, composition, and reception of light ("*reception luminum*") (II, 30). He incorporated color into the latter category because it was a function of light: "colors vary according to light … as the light disappears, so also do all the colors, and when it returns, the colors come back along with the strength of the light" (I, 9). These categories became codified in the mid-sixteenth century, notably by Paolo Pino in his 1548 treatise *Dialogo di pittura*, into a division between *disegno, invenzione,* and *colorire* (2000: 106). *Disegno* described the element of line in a painting, in particular the delineation of the nude human body; it also described the conception and drafting of a painting, the mental process by which the painting was planned, and the draughtsmanship of the artist. *Invenzione* was the subject matter of the painting and the manner in which this was represented. *Colorire,* or *colore,* referred to the process of rendering in color, which included the use of paint to work up the effect of light and shadow, and its results (Poirier 1976: 28).

Following the publication of Giorgio Vasari's *Lives of the Painters, Sculptors and Architects* in 1550, *disegno* and *colore* became polarized and incorporated into a turf war between Florentine and Venetian art theorists. Vasari (a Florentine) celebrated Michelangelo (also a Florentine) as the greatest ever painter, praising his *disegno* and intimating that he might even be divine (1996: 642). As Carl Goldstein observes, the *Lives* was thus as much rhetoric as biography, bullishly asserting the pre-eminence of Florentine artists (1991: 648). An early Venetian response to Vasari's provocation came in 1557, in the form of Lodovico Dolce's dialogue *L'Aretino.* Dolce opposed Vasari's celebration of *disegno* in the work of Michelangelo by celebrating the *colore* of his fellow Venetian and friend Titian (1970: 71). Of course, *disegno* and *colore* were only rhetorically opposed. The work of many Renaissance painters was far less easily classifiable than Michelangelo's precisely inscribed nudes and Titian's protean expanses of color. The *chiaroscuro* of Leonardo da Vinci, for example, is guided by line. At the same time, instead of following Dürer and Cranach by delineating clear boundaries for his figures, Leonardo lingered on the interplay of light and shadow,

smudging the borders between the two. The great art historian Heinrich Wölfflin suggested that this in turn creates "the semblance of a movement ceaselessly emanating, never ending" (1950: 19). Nonetheless, despite plentiful visual evidence to contradict the rhetorical opposition between *disegno* and *colore*, the terms became paradigmatic. Over the course of a century, the technological distinctions between black/white and color highlighted by Alberti developed into a rhetorical opposition that was both arbitrary and universally accepted.

Chromatic Cinema's narrative proceeds from an analogous development, whereby the material distinction between two film technologies was expanded into a rhetorical opposition between "black-and-white" and "color." Chapter 1 focuses on the incremental codification of black-and-white and color as opposites. In early cinema, black-and-white and color mixed in the form of hand-painted, stencilled, tinted, and toned images that comprised colored dyes applied onto the surface of black-and-white film prints. Color was not an alternative to black-and-white but an addition to it. Following the rise of "natural" cinematographic color in the 1920s, black-and-white and color became separated. In about two-thirds of Technicolor feature films released between 1920 and 1930, color is restricted to individual sequences within otherwise black-and-white films (Limbacher 1969: 206). In the 1930s, separation polarized into opposition, culminating in *The Wizard of Oz* (Victor Fleming, 1939), which used black-and-white to signify the real world of Kansas and color to signify the dream world of Oz.

Taking inspiration from Wölfflin, I suggest that this rhetoric of opposition belies the dynamic relationship between black-and-white and color. Accordingly, in subsequent chapters, I demonstrate how chromatic opposition has been adapted, challenged, discarded, inverted, and reasserted in various ways throughout screen history. In Chapter 2, I demonstrate how post-war European and Japanese art film-makers stripped black-and-white and color of their associations, and allowed them to mix in previously prohibited ways. In Chapter 3, I explore the consequences of cinema's historical transition from black-and-white to color, and identify how this technological transition interacted with contemporaneous cultural transitions, notably the transition from modernity to postmodernity. In Chapter 4, I spatialize black-and-white, transforming it into shadow and light. Screen color emerged from black-and-white and superseded it, but continues to exist within the limits set by black's absorptiveness and white's reflectivity. So too, monochrome cinematography has continued to cast a shadow over color, from New Hollywood to "*neo-noir*" and beyond. In Chapter 5, I explore how

digital technologies and production processes have undermined black-and-white and color's opposition, and made possible chromatic manipulations that previous generations of film-makers could only dream of. Yet though the realization of film-makers' chromatic dreams is now easier than ever, the dreams themselves are still constrained by a lingering assumption that color is a surface phenomenon. Though scientists have been scrutinizing the ambiguities of color as light and perception for over 300 years, film-makers have historically tended to take their lead from art theory in treating color as a surface phenomenon. Film theorists and historians have also, when focusing on color aesthetics, tended to discuss color as though it had the same properties as color on canvas (e.g. consistency, stillness, stability, and above all materiality).[9] A further goal of this book is to break through the superficial view that screen color is a surface phenomenon.

Screen color *can* appear as a surface phenomenon, but it also takes various other forms. To highlight the diverse ways in which screen color has manifested itself, I divide my history into five sections. Each describes a different mode of production roughly corresponding to a distinct period in Film history. *Film color* is color applied onto film prints. In early cinema, color took the form of pigments or dyes added to the surface of black-and-white prints by methods including hand painting, stencilling, tinting, and toning. *Surface color* is color reflected off surfaces in front of the camera. In classical Hollywood, color was "naturalized"; it became incorporated into the cinematographic process, no longer occupying the surface of the film but surfaces *within* the film. From the 1930s to the 1960s and beyond, film-makers typically explored color by placing colored surfaces in front of the camera, in the form of colored sets, costumes, make-up, and props. Consequently, as Jacques Aumont notes, color became the domain of the art department (1994: 184). *Absent color* is black-and-white. Though its presence extends across screen history, black-and-white has ironically become especially noticeable since (and because of) its marginalization by color; it is now prominent as an absence of color. *Optical color* is color as light. It involves the decomposition of white light into colored light by means of filtration, and is the domain of the cinematographer. Optical color developed parallel to, and in tension with, surface color; it never quite displaced surface color, but it did emerge as a significant tendency in post-classical cinema, especially between the 1970s and the 1990s. *Digital color* is color as code. Closely associated with post-production, digital color variously augments and transforms the other color modes. More than any other mode, it exemplifies screen color's variability and actualizes its instability.

These five color modes are not intended to be definitive. I do not in any way wish to suggest that they constitute the entirety of screen color. Their purpose is simply to clarify some of the most significant tendencies in its history. My goal in using them is not to taxonomize color but to draw attention to its diversity, and to provide a variety of perspectives on it. Through them, I hope to make the complexity of color comprehensible without excessive simplification. Though I hope they may prove useful in this respect, these five conceptual categories exist to be overcome. The ultimate excitement of color is that it resists all categories and constraints, including my own.

1

Film Color

"Last night I was in the kingdom of shadows. If you only knew how strange it is to be there.... Everything there – the earth, the trees, the people, the water and the air – is dipped in monotonous grey. Grey rays of the sun across the grey sky, grey eyes in grey faces, and the leaves of the trees are ashen grey. It is not life, but its shadow...."

Maxim Gorky (Leyda 1960: 407)

Coloration in Early Cinema, 1895–1927

It was the sheer *grayness* of the first films by the Lumière brothers that most startled Maxim Gorky. Black-and-white photography had been an element of everyday life for over a generation, but as soon as monochrome images began to move, they became ashen. Movement brought still images to life, but it was a deathly life without its essential color. In his famous review of an 1896 screening of the Lumières' early films in St Petersburg, Gorky expressed the awareness widespread among early cinemagoers that behind each black-and-white image there existed a color reality that had not survived the transition to film. In an article entitled "A Montreal, des sujets hauts en couleur, dès 1897 ...," a reviewer for Montreal newspaper *La Presse* (June 29, 1896) noted cinema's audio-visual lack equally emphatically: "On peut dire que le résolution obtenu est vraiment étonnant. Pour rendre l'illusion complète, il ne manquait que les couleurs et le phonographe reproduisant les sons." Like sound, color was an absence immediately felt and a need immediately addressed. Even before these reviews, early film practitioners were already adding color to black-and-white prints. In this chapter, I explore color as an addition in early cinema and classical Hollywood. Between the 1890s and 1920s, this

addition took place through techniques including hand painting, spray painting through stencils, and the immersion of film prints in baths of colored dye. With the rise of Technicolor in the 1930s, screen color became the result of a process that reproduced the color frequencies of light cinematographically onto a film print.[1] Nonetheless, as I discuss later, even the "natural" color of Technicolor films involved the application of colored pigments to black-and-white film prints. Throughout this chapter, I refer to the color achieved by applying pigments directly to black-and-white film prints as "film color."[2] My use of the term is inspired by, but distinct from, psychologist David Katz's use of the term to describe color that one is able to look through, as distinct from color that exists on a surface and forms a barrier to vision (1935: 8). Between the 1890s and 1940s, almost all screen color was film color.

The earliest film color involved hand painting. A startling example of hand painting can be seen in a print of a "serpentine dance" film by the Edison Manufacturing Company held at the British Film Institute (BFI), probably dating from 1895 (Yumibe 2005). Made fashionable by Loïe Fuller in the early 1890s, serpentine dances involved a female performer dancing in a flowing white dress under varyingly colored stage lighting. In the BFI's copy of *Annabelle Serpentine Dance*, hypnotic swirls of hand-painted color move through different hues and saturations, mimicking the changing colors of stage light reflected by the dress (Plate 1.1). Despite its artistic potential, hand-painted film died in its infancy. By the mid-1900s, the average length of films had increased and the number of exhibition venues demanding prints had multiplied, so coloring entire films frame by frame with a paintbrush became economically unfeasible (Neale 1985: 115).[3] In order to reconcile film color with cinema's rapid industrialization, French production giant Pathé pioneered a partially mechanized stenciling process in 1905/6 and began to use it commercially in 1908 (Musser 2002). Stencils for Pathécolor prints were created by using a pantograph connected to a needle, which cut out pieces of each frame of a film print. Like needlework, the process was considered (by men) to be too delicate for men, and so was carried out by an exclusively female workforce – a rare example of patriarchal stereotypes benefitting women in the workplace.[4] The resulting stencil was placed in front of a second print of the film and the two prints were run together under a roller saturated with colored ink or put in front of an airbrush.[5] Each extra color required a different stencil, but stencils could be re-used many times, so the process was far more efficient than hand painting.

Early films were alive with color, but color fades. Over the last century, most of early cinema's colors have melted away to the point where – to appropriate Gorky's metaphor – they too have become shadows. The instability of film color compounds the already considerable difficulty of writing about an era of cinema over half of whose products are lost to us.[6] Nonetheless, even from the imperfect evidence available, some visual characteristics typical of early color processes are immediately apparent. Hand painting resulted in amorphous, oscillating colors that varied from moment to moment, according to the amount of pigment applied on the brush strokes, as seen in *Annabelle Serpentine Dance*. Stenciling resulted in blocks of color whose outlines were more clearly defined and whose density was more consistent, but which often did not quite register with the cinematographic image they overlaid, creating a slight visual mismatch between the outlines of objects and their colors. In addition, both hand-painted and stenciled colors were translucent. The combined result of these visual properties is that early film color appeared clearly separate both from the objects filmed and from the monochrome film itself. The fact that it resulted from the addition of dyes to black-and-white film was so obvious that newspapers routinely referred to color films as *colored* films.[7]

Color and black-and-white coexisted not only materially, one applied onto the other, but also visibly next to each other within the frame. Economic constraints frequently prevented entire frames from being hand-painted or stenciled, as each added color was also an added expense. The Pathé workshop had the capability to stencil up to six separate colors onto a black-and-white negative but typically added only one or two (Nowotny 1983: 12). As a result, much of the frame often remained black-and-white, with color restricted to specific details. The features most consistently colorized were items of clothing, though colorists often also painted prominent props and elements of the production design. Naturally colored phenomena – trees, rivers, rocks, sky, etc. – typically remained uncolored. As Philippe Dubois notes, the tendency for color to be added to costumes and sets was commensurate with the general perception of the period that cinematic color was a surface characteristic (1995: 77). The addition of pigments to the surface of the film mimicked the addition of pigments to objects within the film: what was painted in front of the camera was painted onto the print. For example, in the cave scenes of a hand-painted 1905 re-release of *Ali Baba et les quarante voleurs* (Segundo de Chomón, 1902), the thieves' costumes appear in assorted colors but the natural rock walls of the cave remain gray (Plate 1.2). The amount of film color varies from shot to shot according to the amount of surface color

present in front of the camera. As a result, black-and-white and color exist in a dynamic visual relationship: color variously surges into and drains out of the image. For example, when the 40 thieves evacuate the cave, leaving Ali Baba alone with their riches, chromatic chaos gives way to monochrome calm. In later scenes set in opulent domestic interiors, the presence of gray is largely restricted to people's skin, a surface whose essential color not even the most enthusiastic colorist dared mimic.

The most meticulously colored films of the 1900s came from the Pathé workshop: for example, in *Le Scarabée d'or* (Segundo de Chomón, 1907) multiple layers of stenciled color mimic the chromatic cacophony of a fire-work display (Plate 1.3).[8] Similar, if less spectacular, uses of color also occurred in early American films. For example, a print of Edwin Porter's *The Great Train Robbery* (1903) held at the BFI features selective hand coloring. Explosions and gunshots are painted red, and a few clothes are painted purple and yellow. In the film's famous gunshot-to-camera shot, which exhibitors were able to splice in at the start or end of the film according to their preference, the shootist is adorned with green and purple (Plate 1.4). As in *Ali Baba*, the colors do not perform any obvious narrative or thematic function: they do not help establish continuity, draw attention to significant narrative details, or emphasize visual leitmotifs. Indeed, as Tom Gunning has persuasively argued in a seminal article on early film color, "meaning" is not a concept that we can usefully apply to early cinematic color (1995). For example, though the colors in *Ali Baba* are primarily those of surfaces, in one shot set in a loggia looking out over a cityscape, the sky is painted blue. Why is the optical blue of the sky, a result of white sunlight refracted through atmospheric gases, represented with pigmentary color? It is probably because the even expanse of gray sky in the film print was amenable to rapid coloring. Unconcerned with the nuances of atmospheric optics, the film's colorists painted the sky blue because it allowed them to achieve maximal color with minimal effort.

Gunning observes that in early cinema color appeared far more often in films that sold themselves as spectacles than in documentaries. Many prints of early fantasies by George Méliès, for example, were hand-painted; Méliès's later films, including *Le Voyage à travers l'impossible* (1904), were typically stenciled. Color here again fulfils no clear narrative or thematic function – what matters most is simply its presence. If one accepts Gunning's description of early color as "more or less arbitrarily applied," rather than something to which meaning can be affixed, then one must also accept that this arbitrariness precluded color and black-and-white from signifying opposition.

The fact that color was a material addition to black-and-white further militated against opposition. Opposition requires mutual exclusivity. It is difficult to imagine how black-and-white and color could be perceived as mutually exclusive in the above examples, in which black-and-white underlies the added color and variously surrounds and is surrounded by it. In early cinema, color was not a negation of black-and-white but something "superadded" to the film print, providing audiences with what Gunning refers to in his article as "an extra sensual intensity which draws its significance at least in part from its difference from black and white."

It is therefore surprising that Gunning follows the above sentence with a *non sequitur*: "We do not need a historian or critic to point out the significance of this paradigmatic opposition between color and black and white images." He refers to "this" paradigmatic opposition as though he has just demonstrated it, when in my view he has demonstrated the contrary. In fact, Gunning's assertion that there existed an opposition between black-and-white and color is dependent not on his exploration of the material nature of early cinematic color but on his observation of the existence in the late nineteenth century of a culturally constructed opposition between black-and-white and color print media. "Quality" newspapers were black-and-white, while penny novels had color covers. It is far from clear, however, how – if at all – the chromatic oppositions evident in print media migrated to cinema. It is telling that to demonstrate black-and-white and color's cinematic opposition Gunning cites *The Wizard of Oz*, a film made long after the era of early cinema.

Underpinning the contradictions in Gunning's article is his use of the word "paradigmatic." When used of a set of linguistic terms, it describes grammatical choices that are mutually exclusive. To refer to black-and-white and color as paradigmatic in this sense is to suggest that each is what the other is not; when one changes, the other changes inversely. The word can also be used to identify the various manifestations of a hegemonic worldview – the belief that the Sun revolved around the Earth was once a paradigm, as is now the belief that the Earth revolves around the Sun. These two uses of the word are themselves mutually exclusive. It is my view, and I suspect Gunning's too, that black-and-white and color are not paradigmatic opposites in the sense that they are intrinsically opposed. They have, however, often been *perceived* as opposites. In other words, there has at various points in history developed a culturally constructed paradigm of opposition between black-and-white and color. In early cinema, there was no such cultural construct.

The boundaries between black-and-white and color were already unclear in hand-painted and stenciled films, but they became even less clear following the invention of color tinting. Producer Sigmund Lubin first offered "mono-tinted" films in 1904, and by the following year tinting was already widespread (Musser 1990: 398). Stenciling and tinting coexisted until the late 1910s, at which point the final stage of the film industry's move from artisanal to industrial production caused producers to regard the labor-intensive process of stenciling – like hand painting before it – as unacceptably expensive (Neale 1985: 117). The ease with which tinting, and the less popular alternative of toning, could be carried out resulted in color permeating cinema more widely in the 1910s. By the early 1920s, between 80 percent and 90 percent of films were colored.[9] In comparison to the attention given to the troubled progress of early cinematographic color processes of the 1900s and 1910s (for example, Kinemacolor and the earliest Technicolor), journalism of the period rarely referred to tinting. Color monochromes were not the next big thing: they were already an aesthetic norm, and accepted as a given. Joshua Yumibe observes that tinting was so common by the late 1910s that the Biograph Company's tendency *not* to tint their films was often singled out for mention (2005).

In tinting, a film print is immersed in a colored dye. The dye is absorbed by the film's emulsion, resulting in an evenly – and often intensely – colored image in which the white highlights are replaced by color (Plate 1.5). In toning, only the opaque areas of the film positive absorb color; the clear portions remain unaltered, resulting in an image in which the highlights are colorless while the midtones and shadows adopt the color of the dye. Philippe Dubois succinctly summarizes the difference between the two when he refers to tinting as "black-and-color" and toning as "color-and-white" (1995: 75). Through tinting and toning, early cinema reached a new level of chromatic mixture. Black-and-white and color chemically combined to create images in which the hue was the product of a colored dye but the tone was that of a monochrome photographic image. As Dubois's transchromatic labels imply, tinting and toning often led to an aesthetic cleavage of black-and-white into black and white. Black, white, and color were able, through tinting and toning, to interact in any combination.

An example of black and color can be seen in Lotte Reiniger's *Die Abenteuer des Prinzen Achmed* (1926). A mythical fantasy based on *The Arabian Nights*, Reiniger's tinted animation was achieved through the manipulation of hand-cut silhouettes, and takes the form of filmed shadow theater. Pure black figures move across evenly colored backgrounds (Plate 1.6). From scene

to scene, the film moves between black and blue, black and yellow, black and green, black and orange, and black and red. When all is reduced to solid blocks of black and color, the result is a visual binary. But this binary is not between black-and-white and color; rather, it is between black and color. Each appears as an absence of the other: the outlines of the black shapes visually define and are defined by the outlines of the colored shapes.

Reiniger's shadow puppetry is an extreme example of black and color, but equally extreme examples occurred in live-action cinema. Early black-and-white film stocks were not panchromatic – they were not sensitive to the full spectrum of color frequencies. Insensitive to red frequencies, they registered them not as shades of gray but as black. In addition, film prints due to be tinted were routinely processed at higher than normal contrast to ensure firm blacks (Usai 1996: 25). So all tinting tended toward black and color, because the stock that was to be tinted tended toward black and white. The appearance of "low-key" lighting in the mid-1910s exacerbated this tendency. As Janet Staiger notes, the introduction of directional arc lamps in the mid-1910s led to a decrease in the use of diffused lighting in favor of spotlighting, resulting in shots with selective areas of brightness surrounded by pools of shadow and relatively little by way of midtones (Bordwell et al. 1985: 223). The opportunities provided by arc lamps to use light creatively were quickly exploited throughout the film industry. In the United States, low-key lighting became closely associated with the work of Cecil B. DeMille. In Germany, it became the visual mainstay of Expressionist cinema. When low-key lighting combined with tinting, as in Paul Wegener's *Der Golem* (1920), the result was startlingly similar to Reiniger's animation (see Plates 1.5 and 1.6). The influence of German Expressionism on international cinema, and on Hollywood in particular, contributed to the continued prominence of black and color throughout the 1920s, even though the black-and-white film stocks of the period were becoming progressively more responsive to the full spectrum of colors.

Philippe Dubois further distinguishes between two forms of chromatic interpenetration (1995: 74). He refers to the co-presence of monochrome and color within shots as "métissage" (mixture), and refers the coexistence within a film of monochrome shots and color shots as "hybridation" (hybridity). Throughout this book, I return to the distinction between chromatic mixture *within* shots and chromatic hybridity *between* shots. However, when discussing the first three decades of cinema, this distinction is of limited use. The concurrent availability of hand painting,

stenciling, tinting, and toning made possible a diversity of chromatic combinations that defy Dubois's categories. For example, early films often included tinted and untinted sequences. In these films, black is a constant, but white is an intermittent presence; white is only one of a range of colors used as a visual counterpoint to black. In addition, many early films are the product of more than one color process. Paolo Cherchi Usai has uncovered footage from as early as 1908 that combines tinted and stenciled scenes (1996: 25). Films could also be tinted *and* toned, resulting in color duochromes. For example, prints of Frank Lloyd's *A Tale of Two Worlds* (1922) were tinted in amber and toned in green (Parker 1972: 21). The result was not "black-and-white," not even "black-and-color," but "color-and-color." Prints of D. W. Griffith's *Way Down East* (1920) were tinted and toned and may also have included some hand painting (Limbacher 1969: 3). Augusto Genina's *Cyrano de Bergerac* (1922) was toned and then stenciled with up to four colors (Gili 1992: 125). The rise of Technicolor allowed for further chromatic variety in the tentative form of brief cinematographic color sequences. For example, Cecil B. DeMille's *The Ten Commandments* (1922) and *King of Kings* (1927) combined tinted footage and material shot in Technicolor. King Vidor's *The Big Parade* (1925) and Rupert Julian's *The Phantom of the Opera* (1925) included black-and-white footage, a Technicolor sequence, and a more sophisticated version of stenciling known as Handschiegl coloring (Nowotny 1983: 297).[10] Erich von Stroheim's *The Merry Widow* (1925) combined black-and-white sequences, tinted sequences, a Handschiegl insert, and a Technicolor sequence (Koszarski 2000: 341).

Chromatic variations also occurred from print to print of the *same* film. Tom Gunning draws attention to the fact that in the first decade of cinema a film could often be bought in black-and-white or color versions (1995). For a higher price, an exhibitor could buy a color print and charge higher ticket prices. At the same time, Usai suggests that hand-painted color was so expensive that "the cost of producing colored prints was only partially justified by the demands of the exhibition market" (1996: 23). This may be true for hand painting, but with the development of stenciling and tinting, the economics of coloration became more persuasive. For Pathé, color itself, regardless of the film, could generate profit. After 1908, the company began to re-release films from its back catalogue in the form of new stenciled prints, the addition of color to these prints giving them new economic life (Musser 2002). Richard Abel further suggests that distributors unwilling to pay Pathé's premium for

color may have added their own colors (1994: 95). If this did indeed happen, then there could have existed at any point in time countless different color versions of the same film.

Little is known about the economic factors that decided why color was added in some cases and not others. Little is also known about why some prints have more color than others. And why, as Nicola Mazzanti notes, different colors were typically added to film prints depending on which countries they were being exported to (2009: 70). Yet though the details of the decision-making behind early film color remain elusive to contemporary researchers, this much is clear – economically, as well as materially and aesthetically, color was an addition to black-and-white. For distributors and exhibitors, coloration was a means of increasing marginal revenue; like special edition DVDs, it redirected products toward consumers with surplus disposable income. For consumers, it was a means of gaining more pleasure for more money.

Over the course of the 1910s and 1920s, directors found various ways for color to play a less arbitrary role within their films' structures of meaning. Tinted color could provide rudimentary narrative information, in particular indicating if a scene was set in moonlight (blue) or artificial light (yellow). It could also provide rudimentary thematic information: red, for example, might signify a character's anger. At the same time, then – as now – no definitive meaning could be attributed to a color. In a different context, red could just as easily suggest heat.

In a minority of films, color fulfils more subtle functions. Though rare and not necessarily influential, such films constituted a form of "best practice," and so it is worth looking at a few examples. For example, D. W. Griffith's *The White Rose* (1923) features a brief red blush. To achieve this effect, Griffith used Handschiegl printing; by doing so, he cleverly subverted the cliché that applied color was for surfaces only. Though printed onto the skin of the film, the red appears to emanate from underneath it. The same trick is used by the aging nymph Celia in Jonathan Swift's poem *The Progress of Beauty*, but with less success; every morning Celia tries to "teach her cheeks again to blush," but colored pigments cannot bring back the essential reds of a youthful face (Swift 1983: 193). In certain prints of *Greed* (1924), Eric von Stroheim also used Handschiegl color, integrating it into the film's narrative. According to Jay Leyda, not only was the protagonist's fateful stash of gold yellow, so too were "gold teeth, brass beds, gilt frames and canary" (Koszarski 1999: 14). The yellow in *Greed* marked a further development in color's ability to signify. Von Stroheim imbued the color

with thematic meaning, turning it into a leitmotif, a recurrent chromatic expression of the insatiable avarice of *nouveau riche* dentist McTeague and his mercenary wife Trina. Leyda's comment also suggests that chromatic variations continued from print to print into the 1920s. This fact is confirmed by Richard Koszarski, who observes that though hand coloring became less common in the 1920s, it still existed in certain prints of certain films shown in certain theaters (2000: 341).[11] However, in contrast to the chromatic vagaries of the films cited above, the absence of yellow in certain prints of *Greed* is not an example of arbitrary coloring. It is instead an example of economic limitations preventing a director's specific chromatic intentions from being implemented on all prints of his film.

A more complex use of color occurs in Sergei Eisenstein's *The Battleship Potemkin* (1925). Following a successful mutiny aboard the Potemkin, we see a hand-painted shot of a Soviet flag hoisted up the ship's mast (Plate 1.7). It is difficult to imagine a more symbolically direct use of color: the flag is both red and Red. Eisenstein harnesses the sensual power of the flag's redness to glorify and elicit a sense of pleasure in the rise of Communism. Yet even in this inspired example of symbolic color, the sensual immediacy of the red overwhelms its intended meaning. We feel the flag's redness more intensely than its Redness. The intensity with which red asserts its redness was famously summarized by Jean-Luc Godard, in his response to an interviewer's comment on the profusion of blood in *Pierrot le fou* (1965): "Not blood, red" (Godard 1972: 217). It is no coincidence that Gilles Deleuze picked out this line as evidence that color tends to absorb the referential into the affective, overwhelming meaning through its sensual directness (1986: 118). Nor is it a coincidence that C. S. Peirce, who had such an immense influence on Deleuze, used red as an example of his category of "firstness" (Hanssen 2006: 104). Red's singularity was even intuited by the colorists at the Pathé studios, who never allowed it to mix with other colors in their stenciled prints: "Le rouge n'était que du rouge" (Dana 1992: 127). In *Potemkin*, red is not quite "only red," but it is primarily red.

It was left to Abel Gance, in a startling *coup de cinéma* at the end of *Napoléon* (1927), to tap the affective power of primary color and simultaneously give it meaning. Gance shot the film's climactic battle sequence with three synchronized cameras, so that it could be projected in cinemas on three screens. The multi-screen climax begins with the three shots combining to create ultra wide screen panoramas of epic battle scenes. Gance's use of three screens soon becomes even more experimental. His experiment culminates in a moment of overwhelming chromatic nationalism: the left-hand

image is tinted blue, the right-hand image is tinted red, while the central image is left untinted so that its highlights remain white. The result is a giant widescreen *tricolore*, which integrates Napoleon's pallid face into France's national colors. In this way, black-and-white becomes color, joining black-and-red and black-and-blue. For the French nationalist, white – not green – is the third primary color. Six-and-a-half decades later, Krzysztof Kieslowski again chose white as the central color of his post-Communist *Three Colours* trilogy (1993–4), emphasizing that blue, white, and red carry potent political meanings.

The cooperative interaction between black-and-white and color, which had been developing since the beginning of cinema, reached its apex in *Napoléon*. Subsequently, black-and-white and color progressively disengaged: first they separated, and then they became opposites. Separation occurred in the late 1920s in tandem with two parallel developments: the end of tinting and toning and the rise of "natural" color. Widespread tinting and toning began to die out after (or possibly even slightly before) the rise of sound in the late 1920s. The first sound films remained untinted because the addition of color dyes interfered with their optical soundtracks.[12] A solution to this obstacle soon appeared: in 1929, Eastman Kodak announced "Sonochrome," a range of pre-tinted print stocks available in 17 colors (Jones 1929: 221). However, these stocks were not commonly adopted within the industry, and most sound films remained uncolored. Steve Neale hypothesizes that tinting was abandoned because the rise of sound led to a new aesthetic orientation favoring verisimilitude over rhetoric, resulting in a perception that the most appropriate color technology to accompany sound was photographic color (1985: 119). Tom Gunning offers two alternate explanations, both rooted in the rise of sound in the late 1920s. His first explanation is that "maybe there's a rather similar sense of making sure people are listening, rather than distracting them with colour … of concentrating on one dominant channel of meaning or sensation at a time" (Hertogs & de Klerk 1995: 47). His second explanation is that "the primary thing in the classical era becomes the story with dialogue – maybe this becomes so dominant that colour becomes marginalized and associated with the spectacular" (Hertogs & de Klerk 1995: 47). These three (not necessarily contradictory) explanations together problematize the still too common assumption that there is a simple causal connection between changing technology and changing artistic practices. In the following section, I discuss not only the technological but also the economic and ideological context within which black-and-white and color progressively disengaged.

The Rise of Technicolor, 1915–35

In the mid- to late 1920s, as tinted color disappeared, cinema – contrary to all models of historical evolution that one might apply to it – became black-and-white. Of course, the film industry's attraction to color did not end there. Rather, it entered a new phase. The late 1920s also saw the first wide-spread use of Technicolor, an early "natural" cinematographic color process. Technicolor Inc. was established in 1915 by three M.I.T. graduates: Herbert Kalmus, Daniel Comstock, and W. Burton Wescott, though by the late 1920s only Kalmus remained (Basten 1980: 32). Technicolor was both the name of the company and the name of the color film process that the company repeatedly refined and re-released between the late 1910s and early 1950s. Like many other start-ups of the period, Technicolor aimed to create the best and most successful color film process in the world.[13] Unlike most of its prospective competitors, who typically went bankrupt within a few years or less, Technicolor benefited not only from strong research personnel but also from the exceptional resilience and economic inventiveness of Herbert Kalmus, its CEO.[14] Nonetheless, despite Kalmus's business acumen, Technicolor struggled to stay solvent in the late 1910s and throughout the 1920s.[15] By 1928, it had already adopted and abandoned two different technologies for recording and reproducing the various color frequencies of light. The most recent, Technicolor Number II, had been made commercially available in 1922, even though it was still experimental. Its use in several major productions, notably the Douglas Fairbanks star vehicle *The Black Pirate* (Albert Parker, 1926), had resulted in technical problems and additional costs that left producers wary of Technicolor's new technology. This wariness subsided following the introduction to the market in 1928 of Technicolor Number III, a far more reliable process. In the opinion of Kalmus, the release of Technicolor Number III was timely: the radical changes being undertaken by studios during the move to sound resulted in their openness to the somewhat less radical changes involved in adopting color.

All of the various Technicolor processes involved using a specially constructed "beam-splitter" camera, which divided light passing through the lens into two or three separate beams, each of which passed through a different color filter and exposed a separate black-and-white negative.[16] Technicolor Numbers I to III were two-color processes: two negatives were exposed through two filters (red-orange and blue-green), resulting in the reproduction of slightly over two-thirds of the full spectrum of color frequencies.

Technicolor Number IV (1932) was a three-color process, in which three negatives were exposed through three color filters (red, green, blue), allowing the full spectrum of color frequencies to be reproduced. In terms of inscribing color onto a negative, Technicolor was thus an additive process. In terms of projecting color onto a screen, only Technicolor Number I (1915) was additive. In Technicolor Number I, color was added to black-and-white prints in cinemas, by means of special projectors that included red-orange and blue-green filters. The complexity of the projectors required an operator who, in the oft-repeated words of Herbert Kalmus, "was a cross between a college professor and an acrobat" (1967: 52). So Kalmus's researchers subsequently developed processes in which films' colors existed on the print itself, allowing Technicolor films to be screened using conventional white light projectors. Technicolor Number III and Number IV, for example, utilized a subtractive dye-transfer process: prints of each of the two or three negatives of an image had color dyes applied to them and became printing plates. The dye on each of these plates was then transferred onto a final print, which ended up with two or three layers of color dye added to it.

Technicolor was thus – like hand painting and stenciling – technologically still a form of film color, a refinement of the various processes used in early cinema to add color dyes to black-and-white prints. The Handschiegl process, for example, had already been using dye-transfer printing since 1916 as an alternative to stenciling. What made Technicolor's dye-transfer process different was the fact that it added dyes in variable and precise combinations, reflecting the color frequencies captured by the Technicolor camera, rather than adding dyes evenly across the gelatine. Color thus became incorporated into the cinematographic process and "naturalized." Of course, the intense colors of early Technicolor did not even come close to anything one might ordinarily regard as natural; however, they were still far more "natural" than previous dye-transfer processes, inasmuch as they were no longer perceptibly "superadded" to a black-and-white print. In this way, Technicolor bridged cinema's historical transition between film color and surface color. Though still technologically an example of film color, Technicolor made possible films whose colors derived from the colors of surfaces in front of the lens. As I discuss further in Chapter 4, throughout classical Hollywood and beyond, surface color was cinema's dominant color mode.

The establishment in the 1930s of black-and-white as a chromatic default, together with the rise of cinematographic color, resulted in a visual

segregation between color and black-and-white. No longer did they visibly coexist in the same frame. A shot appeared *either* as black-and-white *or* as color. For the time being, there appeared between them an iron curtain. Segregation in turn carried within it the beginnings of opposition, though this opposition developed gradually. For a codified opposition between black-and-white and color to develop, chromatic decisions needed to be taken during pre-production. Until the decision to add color was brought forward in the production process and placed within the director's sphere of responsibility, there was little room for color to carry meaning. And unless the presence of color signified something, the presence of black-and-white could not signify the opposite.

Few details are known about how decisions regarding color fitted into the production process in early cinema, but what evidence there is points to the fact that color did *not* play a major role in directors' thoughts. The knowledge that blue tinting could be used to make a scene shot during the day appear to take place at night may have encouraged directors to film day-for-night, but there is little evidence that any more sophisticated color decisions were taking place during pre-production. Nico de Klerk suggests that throughout early cinema "colour wasn't considered when the film was being made, but was simply added in the production companies' buildings ... a bit like gift-wrapping in fact, just an extra" (Hertogs & de Klerk 1995: 22). Ennos Patalas adds a crucial piece of evidence reinforcing this claim:

> I've been through Murnau's own annotated copies of his scenarios, hoping to find something on colour. All I could find was a point in the scenario for *Vogelöd Castle* [1921] where he notes: "dream sequences – leave them black-and-white." (Hertogs & de Klerk 1995: 46)

If F. W. Murnau, one of the great stylistic innovators of 1920s cinema, did not pay much attention to color, it is unlikely many other directors did either. Despite isolated uses of individual colors for thematic reasons, in most films of the 1920s color seems to have remained largely an afterthought.

Color's place in the production process changed in the 1930s. With the end of tinting and toning, and the rise of Technicolor, color could no longer be added to a film as an afterthought; color films had to be shot in color. To shoot in color, a studio needed to draw up an agreement with Technicolor well in advance of production. The film's producers needed to reserve special Technicolor cameras, rent extra lights, budget for dye-transfer printing,

and so on. The movement of color from something that only needed to be considered in post-production to something that needed to be considered during pre-production favored its integration into films' aesthetic, narrative, and thematic schemata. The first stage in this integration occurred soon after the release of Technicolor Number III. 1929 and 1930 were boom years for Technicolor. However, the limited capacity of the company's factories soon resulted in supply lagging behind demand (Kalmus 1967: 55). As a result, most of the initial burst of Technicolor production in 1929 and 1930 took the form of color sequences inserted into films that were primarily black-and-white. Though clearly a stop-gap, this rationing brought immediate benefits for both client and supplier: it gave producers a chance to use Technicolor without feeling they were taking a major risk, and allowed Technicolor to gain its first significant foothold in Hollywood (Gomery 1992: 234). Ironically, it also encouraged the studios to take their first steps in a codification of color that, as I discuss later in this chapter, would cause Technicolor corporate neurosis for many years.

Before 1929, Technicolor was such a rare presence that there was little opportunity for the development of any industry norms for how color should be used. The circumstances surrounding the inclusion of color in *The Ten Commandments* and *The Black Pirate* were unique to those films – their use of color did not follow an established pattern because none had yet been established. The mismatch between supply and demand that occurred in 1929 changed this. The limited availability and high cost of Technicolor meant that it could not be used for sensual effect in films throughout the industry, as had tinting and toning. Producers needed to choose which films would benefit most from color. Their initial choice was to use color primarily for musicals. Of the 18 films to include Technicolor in 1929, 14 were musicals; of the 29 films to include it in 1930, 25 were musicals (Limbacher 1969: 269).

Color and music have historically been regarded as having a natural affinity, and the word "chromatic" is used with reference to both. When Aristotle asserted the presence of seven primary colors, it was so that they might correspond to the seven notes of the diatonic scale. His classification was a means of suggesting that harmony existed in color as well as music (Kemp 1990: 286).[17] Similarly, when Newton divided the infinite colors of the spectrum into seven "simple" colors in his 1671–2 revision of the "Optical Lectures," he tentatively explained this arbitrary division by suggesting that color harmonies were "perhaps analogous to the concordance of sounds" (Shapiro 1994: 619). Later, more confidently, Newton likened

the eight boundaries of the seven colors to "the eight lengths of a Chord" (1721: 186). Color cinema provided a new means by which the affinity between color and music could be expressed. Sergei Eisenstein went so far as to regard film as the fulfilment of their shared destiny:

> The higher forms of organic affinity of the melodic pattern of music and of tonal construction of the system of succeeding color shots are possible only with the coming of color to cinema. (1983: 257)

According to Eisenstein, film-makers needed to transform their work into "a symphony of colour" (1977: 181). One might speculate that were it not for early Technicolor musicals and animations (in particular, Disney's color *Silly Symphonies* of the 1930s, which Eisenstein greatly admired), Eisenstein and many subsequent artists might not have surrendered themselves so willingly to the chromatic song of the siren.

Given the synaesthetic link between color and music, it is fitting that cinematographic color sounded its feature film debut in the form of the musical.[18] At the same time, there was a much more banal reason for producers' choice to use musicals as the vehicle for their first engagement with color: the presence of musical numbers. The division of musicals into discrete dialogue sequences and musical sequences provided an obvious solution to the dilemma of how to ration their limited supply of color. The presence of color did not at this stage function to communicate narrative information. The chromatic hybrid movies of 1929 and 1930 did not, for example, use the appearance of color to signify shifts from reality to fantasy: such chromatic motivation was still a decade away. For now, the presence of color within a musical was simply dependent on the presence of singing in it, and its absence in other parts of the film was explainable by economic factors unrelated to the film's narrative.

Chromatic Cold War: Black-and-White and Color in Opposition

David Bordwell has observed that one of the key features of classical Hollywood films is motivation. Motivation is the explanation offered by a film for why its formal elements take the form that they do. Bordwell highlights three key forms of motivation in classical Hollywood: compositional, realistic, and intertextual.[19] Compositional (narrative) motivation refers to

the elements that allow a story to proceed. The most obvious narrative motivation is psychological causality. A character has a goal and acts to achieve it. The character's actions form causal story elements that are psychologically motivated. In classical Hollywood, the vast majority of a film's narrative, visual, and aural devices are explainable in terms of psychological causality. For example, classical Hollywood films motivate flashbacks by turning them into an act of remembering: through the flashback, a formal element of the film (narrative retardation) became motivated by a character-driven action within the story (a character thinking back to the past). Realistic motivation refers to the mobilization of elements in a film in order to increase its plausibility: "In a film set in nineteenth-century London, the sets, props, costumes, etc. will typically be motivated realistically" (Bordwell et al. 1985: 19). Intertextual motivation occurs when an element of a film is used in a particular way because it has been used the same way in similar films. The most common intertextual motivation is generic: when characters in a film repeatedly burst into song, they probably do so because they are in a musical. All three forms of motivation played a part in how the uses of color developed in classical Hollywood. Black-and-white was cinema's technological and aesthetic default, and so exempt from the need to be motivated. Color, less common and so more noticeable, was not.

Color evaded motivation for longer than most aspects of film form. As seen during the 1910s and 1920s, color remained an afterthought for most film-makers. This precluded it from being consistently motivated within a film. So, as films' other formal aspects (including camera movement, lighting, and editing) became incorporated into the Hollywood paradigm of character-driven motivation, color remained largely unmotivated. It was only when film-makers began to think about color earlier in the production process that narrative motivation began to take hold. The chromatic separation of early Technicolor musicals including John Murray Anderson's *The King of Jazz* (1930) and Cecil B. DeMille's *Madam Satan* (1930) was the first stage of this process.

Color still evaded motivation into the 1930s. In trying to satisfy the sudden surge in demand for color in 1929 and 1930, Technicolor over-extended itself. The resulting decrease in print quality combined with the onset of the Great Depression to cause an equally sudden collapse in demand (Kalmus 1967: 56). Within the period of a few months in 1931, Technicolor's workforce shrank from 1,200 to 230, and color's incorporation into the classical Hollywood paradigm stalled (Greene 1947: 410). As an alternative to increasing its live-action output, in 1932 Technicolor suggested a joint venture with

Disney. Following some hard negotiations, Disney agreed, on condition that it have exclusive access to Technicolor's technology for two years. Starting with *Flowers and Trees* (1932), the presence of color in Disney's *Silly Symphonies* proved highly popular, amply rewarding Walt and Roy Disney's decision to risk using color. The exclusive-use contract also worked for Technicolor. As J. P. Telotte notes, the company's detour into cartoons provided it with an opportunity to showcase its technology without compromising its claims to provide "natural color" in live-action film (2008: 47).

By the time demand for live-action color picked up again in the middle of the decade, Technicolor had released its first three-color process, completed its exclusive deal with Disney, and expanded its facilities. The first full-color feature film, Rouben Mamoulian's *Becky Sharp*, was released in 1935. Following its box-office success, further color features appeared rapidly. Despite this development, color sequences were still occasionally used for sensual or spectacular effect in films whose budgets precluded 90 minutes or more of Technicolor. Late 1930s films with color sequences include Herbert Wilcox's *Victoria the Great* (1937), in which color is reserved for a pageant, and George Cukor's *The Women* (1939), in which it is reserved for a fashion show.

Such uses of color soon became outmoded. In *The Wizard of Oz* (1939), in contrast to almost all previous hybrid black-and-white/color films, the presence of color is narratively motivated. Of course, the film still fits firmly into cinema's lineage of sensual and spectacularly colored surfaces. Oz is not a symphony but a cacophony of color. Vivid colors jostle for attention, boldly declaring their presence textually as well as visually: the yellow brick road, the ruby slippers, the Emerald City. A horse changes color from shot to shot, a visual *ne plus ultra* of silent cinema's non-referential use of additive color (Plate 1.8). As Edward Buscombe points out, color functions self-reflexively in *The Wizard of Oz* (1985: 91). By drawing attention to itself, the film's color manifests a technological fetishization typical of early Technicolor films. At the same time, black-and-white and color also function thematically, emphasizing the opposition between Dorothy's dull gray life in Kansas and the colorful fantasy life of Oz. Significantly, they are also psychologically motivated. In Baum's story, Dorothy is transported to Oz by a tornado that uproots her house; at the end of her adventure, she flies back to Kansas with the aid of a pair of magic "silver slippers." As Salman Rushdie observes, "in the book *there is no question that Oz is real*" (1992: 30). By contrast, in the film, Dorothy falls asleep at the climax of the tornado, *before* the fantastical uprooting of the house takes place; to get home, she is

told to repeat over and over again "There's no place like home," which she continues to do until a fade up reveals her asleep in bed. In this way, the film declares that we have just been watching a color dream sequence. In a quintessentially classical Hollywood turn, the film's use of color is made to signify the protagonist's mental state.[20]

The Wizard of Oz marked a key development in the evolving opposition between black-and-white and color. It was not the first film in classical Hollywood to make black-and-white and color signify opposition, but it was the most prominent.[21] By the late 1920s, chromatic mixture had given way to separation; by the late 1930s, separation had become opposition. Virtually all hybrid films made between the late 1930s and the late 1950s – within Hollywood and beyond – used transitions between black-and-white and color in order to signal moves between opposed physical spaces or perceptual states. Though the opposition itself was codified, the lines along which it was drawn were not, so the juxtaposition of black-and-white and color could signify a variety of oppositions. The most common of these were as follows:

Waking/dreaming. Surprisingly, *The Wizard of Oz* did not set off a trend in the use of black-and-white to signify waking and the use of color to signify dreaming. Nonetheless, the film's popularity inspired a few chromatic imitations, including Herbert Wilcox's *Irene* (1940) and Walter Lang's *The Blue Bird* (1940), and continued to be replicated as late as Jerome Hill's *The Sand Castle* (1961).

Sanity/insanity. A move to color could also signal the distorted perceptions of a mentally unstable character. For example, in Sam Fuller's *Shock Corridor* (1963), the memories, dreams, and delusions of patients in a mental asylum are somewhat bizarrely illustrated by color ethnographic footage of exotic locations that Fuller shot while working on previous projects. One patient remembers a Buddha he once saw in Japan. Another imagines he is a boy in an Amazonian tribe. In a climactic sequence, the film's protagonist (an investigative reporter who poses as an inmate to uncover a murder, and then gradually loses his sanity) hallucinates a rainstorm in the corridor of his ward. His hallucination is punctuated by color footage of waterfalls. The spectral colors refracted by the falling water are almost psychedelic: the chromatic chaos of these shots can be seen both as an evocation of the character's distorted vision and as a metaphor of what is happening inside his head.

Life/art. The codification of black-and-white and color also brought with it films that made explicit the historical connection between color and painting. In Albert Lewin's *The Picture of Dorian Gray* (1945), a melodramatization

of Oscar Wilde's aesthetic parable, the use of color is reserved for two inserts of Dorian's unnaturally aged portrait.[22] A more interesting, though no less literal, variation on the life/art dichotomy can be seen in Henri-Georges Clouzot's *Le Mystère Picasso* (1956). The film intersperses black-and-white documentary footage of Picasso at work with color stop-motion footage of brush strokes appearing on a canvas, as if Picasso's paintings were painting themselves. The first painting is black on white. The second begins with black strokes, but then color strokes also appear. Clouzot, often touted as France's answer to Hitchcock, turns the appearance of color into a source of surprise, adding it to a film that we have been deceived into assuming would be black-and-white. Though Clouzot shot the paintings on subtractive Eastman Kodak stock (whose color dyes already existed within the film negative rather than being added later), the film plays on the tradition of color as an addition: it seems as if Picasso is hand painting the film print itself.

Heaven/Earth. In Michael Powell's *A Matter of Life and Death* (1946), a wartime pilot finds himself miraculously surviving a plane crash, and unexpectedly caught between Heaven and Earth. Accordingly, *AMOLAD* is set both on Earth and in Heaven, but in an inversion of the model established by *The Wizard of Oz*, the scenes set on Earth are color and those set in Heaven are black-and-white. Color is reality not fantasy, essence not addition. In the film's most famous transition, a monochrome close up of a rose dissolves into color. Like the blush in *The White Rose*, color is intrinsic to living objects. It is also exclusive to living objects: it is not just that we *see* Heaven in black-and-white, Heaven *is* black-and-white: "One is starved for Technicolor up there!" an angel declares. Color is not an addition – black-and-white is an absence.[23]

Past/present. To regard the past and the present as opposites, it is necessary to disregard the future. In terms of cinematic tense, most films do just that: the future is frequently anticipated but rarely represented. Flashforwards are rare, leaving the past and the present as de facto opposites. In Otto Preminger's *Bonjour Tristesse* (1958), a man and a woman meet by chance in a jazz bar and reminisce about an idyllic summer they spent on the Côte d'Azur the previous year, prior to the suicide of a mutual friend. The scenes in the bar are in black-and-white while the flashbacks are color, evoking the sensual intensity of their holiday. Once again, black-and-white is color drained of its essential life. *Bonjour Tristesse* also reflects a twentieth-century preference for representing the urban spaces of modernity in the concrete grays of black-and-white, and pre-modern pastoral spaces in

"natural" color. For example, American crime melodramas rarely ventured out of the city or into color. By contrast, post-war German *Heimatfilme* sought a lost national innocence by withdrawing to an idealized country-side filmed in color (Kaes 1989: 14).

Underlying the apparent variety of these uses of black-and-white and color was a guiding principle. The various oppositions listed above can be regarded as the manifestations of a single binary, summarized by Philippe Dubois as the movement between reality and the imaginary (1995: 85). All of the above examples use black-and-white to signify temporal and spatial proximity, the "here and now" perceived by the films' characters. In all of the above examples except *AMOLAD*, black-and-white is objectivity not delusion, the clarity of consciousness not the mental fog of somnolence, the moment currently being experienced not the memory of a prior experi-ence. So too, just as these films demonstrate a codification of color, through opposition they demonstrate a codification of black-and-white. Commen-surate with the fact that black-and-white was cinema's aesthetic norm, black-and-white forms these films' default state and color their altered state. André Bazin observed in an article on *Le Mystère Picasso* that by filming only Picasso's paintings in color, Clouzot "makes us thus accept (so implic-itly that only some serious reflection reveals it to us) as a natural reality that the real world is in black and white, 'except for the paintings'" (1997: 216). In each of the above examples, again except for *AMOLAD*, the film begins in the black-and-white "real world."

Even *AMOLAD*, though an apparent inversion of classical Hollywood's chromatic norm, can be regarded as an example of what Bordwell calls "non-disruptive differentiation" – an allowed divergence from the classical Hollywood paradigm that provides the pleasure of novelty without causing undue confusion, thereby reinforcing the paradigm (1985: 71). Michael Powell's view of cinematic color was a conventional one: "that an ordinary street scene on the screen looks less real when coloured" (Powell & Heckroth 1950: 5). His reaction to Emeric Pressburger's idea of making the film a chro-matic hybrid was to assume that Heaven would be "all colour and gold and that sort of thing" (Macdonald 1994: 251). Pressburger's perverse chromatic choice was a model of allowed divergence: identify the dominant paradigm (in this case, the belief that color signifies fantasy), find a way to subvert it (make the fantasy black-and-white), but be sure not to question the basic assumptions of the paradigm (that black-and-white and color are opposed).

For all these intriguing temporal and spatial oppositions, narrative moti-vation did not become a common means of explaining the presence of

color in a film. Despite exceptional growth in color output in the post-war years, chromatic hybrids remained rare throughout the 1940s and 1950s. To a degree, this is not surprising; relatively few films are structured around narrative movements between opposed states. By demanding that transitions between black-and-white and color explicitly signify narrative transitions, the paradigm of opposition made chromatic hybridity less likely. But if narrative motivation was not enough to provide color with a raison d'être, what were the alternatives? Following Bordwell's tripartite division, the two remaining alternatives were realistic motivation and generic motivation. In the mid- to late 1930s and throughout the 1940s a covert conflict took place over which motivation would dominate. On one side was Technicolor and on the other side were the Hollywood studios. It was a conflict that shaped classical Hollywood's color aesthetics for almost 20 years.

"Technicolor *Is* Natural Color": Color and Realism, 1935–58

By late 1935, Technicolor had a collaboration with Walt Disney behind it and a busy production schedule ahead. Having spent almost 20 years refining its color process, the company was at last establishing itself within Hollywood as a reliable supplier. What the company most wanted now was for color to become an industry norm. In order for this to happen, color needed to dislodge black-and-white as the perceived index of reality, so that instead of requiring a reason to film in color, producers would require a reason *not* to film in color. Unfortunately for Technicolor, Hollywood producers and directors did not always share its aspirations that film color should be used "realistically." Vorticist painter Paul Nash aptly summarized the approach of many first-time color directors as follows: "They are like the children in the nursery again. They have been given a box of paints and they are having a fine time laying it on thick anywhere they can" (1937: 121). Nowhere was this childish excitement more apparent than in *Becky Sharp*, the first full-color Technicolor feature, which culminates in a ball scene whose swirling colors recall the serpentine dance films of the 1890s. Unsurprisingly, the film set alarm bells ringing at Technicolor's headquarters (Basten 1980: 66). Even more unfortunately for Technicolor, early "natural" color had an innate tendency toward excessive saturation. The company was struggling not only against Hollywood practitioners but also against the technological limitations of its own product. Steve Neale regards a Technicolor advertisement declaring that "Technicolor

is Natural Color" as symptomatic of the conventional Hollywood wisdom of the 1940s that color should be used in a restrained manner (1985: 147). To me, the advertisement suggests not an aesthetic consensus but a supplier desperately trying to elbow its product into the market. If the Technicolor process had indeed provided natural colors, then Technicolor would not have needed to emphasize the fact.

The alternative to realistic motivation was generic motivation. This was precisely what Technicolor did not want. If color became coded generically, then it would only be seen as an appropriate format for some films rather than all films. By the early 1930s, color was already being used for certain types of films over others: mainly musicals, but also some histories, fantasies, westerns, and films which variously included or combined these generic elements.[24] Given its expense, producers were understandably selective about which films they made in Technicolor. To pre-empt generic codification, Technicolor began to assert control over how its clients used color. Because its process was technologically far in advance of the competition, Technicolor was effectively a monopoly supplier to the "A-movie" market. Its only competition in the 1930s and 1940s came from Cinecolor and Magnacolor, both inferior two-color processes whose core market comprised "B-films" that could not afford three-color Technicolor.[25] Herbert Kalmus exploited his company's dominant position to insist that producers wanting to use Technicolor had to buy into an entire package of products and services. They had to rent a Technicolor camera, hire a Technicolor cameraman to work alongside the film's cinematographer, use special Eastman Kodak black-and-white film, use Technicolor make-up designed by Max Factor, and do all processing and printing at Technicolor's laboratories. They also had to employ the services of Natalie Kalmus (Herbert's ex-wife) as a "color consultant" (Haines 1993: 24).

Between the early 1930s and early 1950s, Kalmus's role as color consultant involved pretending to provide film-makers with creative expertise while actually suppressing "unnatural" uses of color. In conjunction with this imposed color consultation, Technicolor established its infamous "law of emphasis," first expounded in a 1935 article by Natalie Kalmus. Published less than two months after the release of *Becky Sharp*, in a trade journal that every film practitioner in Hollywood read, "Color Consciousness" was central to Technicolor's growth strategy. It was an ingenious piece of writing. The article's main argument is that color is the culmination of cinema's move toward perceptual realism, and "natural" color – i.e. Technicolor – is its future. At the same time, Technicolor was shrewd enough to realize that

directors might not be satisfied with mechanically reproducing the colors of nature. Given a new toy, they would want to play with it. So, having said its piece about the importance of "natural colors," the article also sought to establish a model for how directors should use them (Kalmus 1935: 141).

This model was the "law of emphasis," and it stated that, though the presence of color as a whole should be motivated realistically, individual colors should be motivated narratively. Overt color was allowable if, by drawing attention to itself, it drew attention to aspects of the film's narrative. Phrased negatively, as this was after all a law aimed at constraining directors' behavior: "Nothing of relative unimportance in a picture shall be emphasized" (Kalmus 1935: 146). An area of the frame could not be red unless its redness was narratively relevant, because it might distract from other areas of the frame of greater narrative relevance. As has been often noted, Technicolor thus tried to elbow its way into Hollywood by incorporating color into the pre-existing classical Hollywood ideology of narrative motivation. It prevented directors from using color in ways it disapproved of by making it easy for them to use color in ways it approved of. Accordingly, "Color Consciousness" provides examples of how individual colors can be motivated both realistically and narratively. When deciding how to fill the screen with color, directors should use realistic motivation and take "the colour schemes of natural objects" such as flowers (Kalmus 1935: 141). With respect to their choice of individual colors, directors should use narrative motivation. For each commonly used color, the article suggests a range of possible thematic associations: for example, red apparently suggests love, while "[t]he delicacy or strength of the shade of red will suggest the type of love" (Kalmus 1935: 143). Different colors are keyed to different emotions and moods.

Inevitably, some practitioners proved resistant to Kalmus's involvement; in Chapter 4, I discuss cinematographer Leonard Shamroy's repeated attempts to negotiate around the "law of emphasis." Others proved more conducive to Technicolor's assertions, which were after all formulated to be acceptable to the industry. Kalmus, in turn, was shrewd enough to allow interpretations of the "law" to vary. Scott Higgins suggests three distinct phases in 1930s Technicolor aesthetics (2007: 209). The first was a "demonstrational" use of color, typified by *Becky Sharp*, which indulged in experimentation and self-reflexivity. The second was a "restrained mode," typified by Richard Boleslawski's *The Garden of Allah* (1936), which minimized prominent color, restricting it to transitions and moments of emphasis. The third was an "assertive mode," typified by William Wellman's *A Star is Born*

(1937), which allowed color a more sustained and prominent presence within films. At the same time, there were overlaps between these three "modes"; all three, according to Higgins, featured uses of color that included "the spectacular embellishment of transitions, the gentle direction of attention, the momentary highlighting of actions, the development of motifs, and the general correlation of color with the mood or tone of the drama" (2007: 209). I question Higgins's methodology of extrapolating "modes" based on a small number of films made over only a few years. At the same time, his categories are still nominally useful inasmuch as they emphasize that, even within the short period of time discussed, different filmmakers used Technicolor in different ways.

Technicolor's goal that all Hollywood films should eventually use its color process was doomed to fail. It was doomed on at least three counts. The first factor weighing against Technicolor was that the results of its process fell far short of anything that might pass as realistic. In *The Naked and the Dead*, Normal Mailer refers to a nocturnal wartime air raid as "unreal like a technicolor movie" (1949: 13). Mailer's casual product placement is symptomatic of Technicolor's inability to become Hollywood's aesthetic default; throughout the 1940s, Technicolor remained a prominent brand presence within films, unable to achieve its ultimate goal of imperceptibility. As a result, it became popular in genres that placed relatively little value on realism, but was excluded from genres predicated on authenticity. Technicolor was typically used for musicals, westerns, costume romances, fantasies, and comedies, while newsreels, documentaries, war films, and crime films remained black-and-white (Buscombe 1985: 89). Thus the most common motivation for color in the 1940s was not realistic but generic. The second factor weighing against Technicolor was that it was not a production company; it was merely a supplier trying to influence how its product was used. The fact that Technicolor was able to influence Hollywood's color aesthetics to the extent that it did, and for as long as it did, is astonishing. However, despite its ingenious and brazen methods of muscling in on the studios' film productions, Technicolor was fighting a reactive battle. By the 1940s, the dominant attitude within the studios was summarized by veteran cinematographer Stanley Cortez as follows: "Everyone wanted to put more and more colour in" (Higham 1970: 98). If a producer or director had a strong preference for "more" color, then he would often find a way to get it. Michael Powell, for example, exploited the imperfect lines of communication between Technicolor's facilities near London and its headquarters in Los Angeles to make films – including

Black Narcissus (1947) and *The Red Shoes* (1948) – with overall levels of color far in excess of what would have been allowed in California.

The final obstacle to Technicolor's plans was the fact that its monopoly position was temporary. Throughout the 1940s, Technicolor milked film producers for money by offering its products and services in the form of a take-it-or-leave-it package. This led to resentment both from studios and potential competitors. The result was a 1948 anti-trust ruling that forced Technicolor to divulge a number of its patents (Haines 1993: 49). Far more damaging was the release over subsequent years of various subtractive 35mm color film stocks. Of particular significance was Kodak's 1953 release of Eastman Color (also known as Eastmancolor) type 5248, designed for use with artificial light (Dundon & Zwick 1959: 735). Subtractive color stock included three layers of color dyes within the negative, so color no longer needed to be added in the laboratory by means of Technicolor's dye-transfer process. Crucially, subtractive color negatives were also usable in standard black-and-white cameras, so making superfluous Technicolor's product and service packages. No longer did Hollywood producers need to use beam-splitter cameras and all the ancillary services that Technicolor had forced onto them. Conventional "black-and-white" cameras suddenly gained a new lease of life and became color cameras. The significance of Kodak's releases was immediately recognized within the industry, as demonstrated by a special section on Eastman Color in the *Journal of the Society of Motion Picture and Television Engineers* (Hanson & Kisner 1953). In it, practitioners explained in detail to their peers how to adapt their working practices so as to make the most of the new stocks. The implication was clear – everyone would soon be switching to subtractive film.

And indeed they did. The last three-strip Technicolor film, Joseph Pevney's *Foxfire*, was made in 1954 (Basten 1980: 146). By this time, Kodak, DuPont, Agfa, Ferrania, Gevaert, Ansco, and Fuji all had subtractive 35mm color stocks on offer. The problem for Technicolor was not simply that other manufacturers offered cheaper color, it was that its package deal had been rendered obsolete. The much-coveted patents divulged as a result of the anti-monopolistic 1948 Consent Decree had been made worthless before they could even be exploited (Haines 1993: 53). It was now film-stock manufacturers who provided screen color. Lacking the means to compete with them, Technicolor found itself with no choice but to remarket itself as a laboratory. The company downsized and developed a new dye-transfer process usable on all types of film stock, including the color stocks made by its former competitors. "Color by Technicolor" remained a

prominent label on the title credits of many Hollywood films until the 1970s, but from the mid-1950s onward the label referred only to the laboratory process used on the films. In an irony that could not have escaped Technicolor executives, "Technicolor" films were originated on the very stocks whose release had brought about the end of Technicolor's hegemony. Technicolor remains a film laboratory to the present day.

Following the end of Technicolor's monopoly, directors became free to use color without having a color consultant imposed on them. Inevitably, given Technicolor had just spent 15 years telling Hollywood how to use color, the "law of emphasis" remained a lingering influence. For example, as late as 1957, an industry guide to color by the Society of Motion Picture and Television Engineers (SMPTE) included two images aimed at demonstrating the benefits of emphasis (Holm et al. 1957: 38). A woman wearing colored clothes appears in front of a white background and a yellow one. The guide criticizes the image with the yellow background because it distracts from the narratively significant action of the woman smiling at a flower. Despite the residual influence of the "law of emphasis," many Hollywood film-makers – including Vincente Minnelli, Nicholas Ray, Max Ophüls, Alfred Hitchcock, and above all Douglas Sirk – responded to their new chromatic freedom by using more color.

Sirk's *All That Heaven Allows* (1955), for example, is drenched in the intense yellows, oranges, and reds of its autumnal New England setting. At the same time, individual colors still fulfil conventional narrative functions within the film. Sirk's film follows the developing relationship between repressed middle-class housewife Cary (Jane Wyman) and her earthy gardener Ron (Rock Hudson). As Mary Beth Haralovich observes, Cary lives in a house filled with cool colors and tasteful furniture, while Ron lives among warmer colors and rougher furniture (2006: 149). The two characters' choices of interior design are thus indicative of their different positions within society. Nonetheless, as Haralovich notes further, the sheer amount and intensity of color in *All That Heaven Allows* cannot be explained narratively. Even though the reds of Ron's house elaborate the narrative's themes by hinting at his sensual nature, they are *so* sensual that they exceed this basic thematic function. Like the red flag in *Potemkin*, they become affective.

Like Sirk, Hitchcock also intensified the law of emphasis until it transcended character psychology. In *Vertigo* (1958), a jealous husband hires retired cop Scotty (James Stewart) to follow and report on his beautiful wife Madeleine (Kim Novak). Scotty begins his observation in a plush red

restaurant. As the future object of Scotty's obsession walks past, the light momentarily surges. The intense redness that results fulfils a narrative function: it evokes a rush of blood to Scotty's head, hinting that his response to Madeleine exceeds his duties as a private detective. At the same time, the surging red also exceeds the narrative, burning directly into our retinas. Seen in a cinema, the effect is overwhelmingly sensual. Derek Jarman referred to the sensuality of 1950s Hollywood color as "better than the real thing" (1995: 3). Perhaps, as a cinephilic teenager in the late 1950s, Jarman already sensed in these films a latent camp aesthetic. Ten years older than Jarman, Sylvia Plath was less easily seduced:

> I hate technicolour. Everybody in a technicolour movie seems to feel obliged to wear a lurid new costume in each new scene and to stand around like a clothes-horse with a lot of very green trees or very yellow wheat or very blue ocean rolling away for miles and miles in every direction. (Plath 1996 [1963]: 39)

Plath's use of the term "technicolour," with its lower case "t" and anglicized spelling, is of particular interest. In the 1950s, Technicolor became technicolor, and technicolour: the brand name became an adjective that described a particular aesthetic of heightened color. For example, American press advertisements for Frederico Fellini's *Juliet of the Spirits* (1965) described it as "Fellini's dazzling technicolor masterpiece." Technicolor's inability to achieve realistic motivation lives on in the English language.

Chromatic Thaw: Hollywood's Transition to Color, 1950–67

Despite Technicolor's insistence that its product reproduced "natural" colors, throughout the 1940s and early 1950s genre continued to play a crucial role in producers' and directors' decisions about whether or not to use color. Different genres tended toward different chromatic poles. As Edward Buscombe notes, musicals, westerns, historical epics, fantasies, and comedies tended toward color; newsreels, documentaries, war films, and crime films in turn tended toward black-and-white (1985: 89).[26] The spread of color within Hollywood did not at this time manifest itself in a wider range of films using color. Rather, it manifested itself in an increasing number of color films within the genres that already tended toward color. As a result,

the distinction between "color" genres and "black-and-white" genres became more prominent. Unsurprisingly, this distinction left little room for the chromatic hybridity that had occurred in the 1930s and early 1940s. Generic motivation overwhelmed narrative motivation: either a film was black-and-white or it was color. Even when a film involved oppositions that could feasibly be signified by shifts between black-and-white and color, this technique was rarely used. For example, despite the fact that crime melo-dramas routinely involved narratives structured around flashbacks, and so provided plenty of opportunities for chromatic hybridity, they typically remained entirely black-and-white. The opposition between black-and-white and color was so pronounced that they could no longer even co-exist within the same film. A generic wall now separated them.

Movements between black-and-white and color no longer took place within films. Instead, they took place from film to film. Throughout the 1940s and 1950s, Hollywood directors moved between black-and-white and color according to a number of factors including their inclination, their status, the budget of their films, and – above all – the genre of their films. Even the films of Hollywood maverick Nicholas Ray typically used color according to genre. Ray's black-and-white films include two crime melo-dramas (*In a Lonely Place* [1950]; *On Dangerous Ground* [1952]), and a war film (*Bitter Victory* [1957]). His color work includes three westerns (*The True Story of Jesse James* [1957]; *Run for Cover* [1955]; *Johnny Guitar* [1956]), and a musical melodrama (*Hot Blood* [1956]). Inevitably, as generic segre-gation was a norm rather than an explicit rule, there existed counter-examples. Directors sometimes made chromatic choices at variance with Hollywood's generic norm. For example, Ray's social realist *Rebel Without a Cause* (1955) was color. Conversely, as late as 1963, John Ford made a west-ern (*The Man Who Shot Liberty Valance*) in black-and-white. The film's narrative takes the form of an extended flashback to the pioneering days of the Wild West, and its use of black-and-white looks back to the mono-chrome of Ford's early westerns.

Even when generic ideology was not at the forefront of a director's deci-sion about which direction to jump, it still typically exerted an indirect influence. For example, diverse explanations have been given for Alfred Hitchcock's choice to make *Psycho* (1960) in black-and-white. Hitchcock's own explanation was that it was pragmatic: having red blood in the shower sequence would have caused problems with the Motion Picture Associa-tion of America (MPAA), the industry body responsible for enforcing Hollywood's strict self-censorship (Gottlieb 1995: 311). Other explanations

hint at an aesthetic agenda. Jack Barron, one of the film's make-up artists, recounts Hitchcock asserting that the film "will have so much more impact in black and white" (Rebello 1990: 82). Economics also played a part. *Psycho* was conceived as a low-budget film, funded by Hitchcock himself. Black-and-white moderated the film's budget in a number of ways. The stock itself was cheaper than color, as were the processing costs. In addition, using color stock would have necessitated far more elaborate lighting. This would have cost more in itself, and would have substantially slowed down the film's production schedule. It is impossible to know which of these explanations are true. Some may be true, none may be true. All may be true, to varying degrees. But among this complex of factors there is one so obvious as to be almost invisible – genre. *Psycho* is first, if not foremost, a horror film; it also contains elements of social realism. Both these genres pulled toward black-and-white. This tendency was clearly not sufficient to make Hitchcock choose black-and-white, but it did make possible his choice. Hitchcock's pragmatic and/or artistic reasons for using black-and-white in *Psycho* were generically sanctioned. Had *Psycho* been a musical, it would have been color.

For a brief period, between the late 1940s and mid-1950s, it appeared that Hollywood's aesthetic ideology had facilitated a stable co-existence between black-and-white and color, granting spheres of dominance to each. Hitchcock's 1950s filmography provides clear examples of this territorial divide. Religious drama *I Confess* (1953) and quasi-documentary *The Wrong Man* (1956) are black-and-white; star vehicle *To Catch a Thief* (1955) and black comedy *The Trouble With Harry* (1955) are color. At the same time, this apparent generic stability was increasingly undermined from the mid-1950s onward by the spread of color. This too is evident in Hitchcock's filmography: though most contemporaneous reviews of *Psycho* did not consider the film's monochrome cinematography to be worth more than a passing mention, viewed in the context of Hitchcock's already substantial corpus of color work, the film's chromatic lack is anomalous. Hitchcock's filmography from *Rope* (1948), his first color film, to *Psycho* (1960), his last black-and-white film, shows an initial vacillation between black-and-white and color followed by a clear shift in the mid-1950s toward color.

As Hollywood's color film output continued to expand, color itself finally began to expand beyond its generic boundaries. One of the earliest commentators to notice this change was *Cahiers du cinéma* critic Eric Rohmer. Writing in 1956, he contrasted the generic codification of "fifteen, ten, even five years ago" with recent developments:

Today who would maintain that color is less at home in a modern setting than in an ancient one, in a civilized setting than in an exotic one, in a serious setting than in a comic one, in realism than in the fantastic? Go see *Rear Window*, *The Barefoot Contessa*, *A Star is Born*, to name only recent films. (1989: 67)

Despite a temporary decline in color production in 1957 and 1958, the trend continued. By the early 1960s, color had even encroached into film noir, a genre once defined by the blacks of its cinematography: Don Siegel's *The Killers* (1964) and John Boorman's *Point Blank* (1967) demonstrated that thematic darkness no longer required shadows. As color approached the status of cinema's visual default, it moved toward being motivated realistically rather than generically. What Technicolor had wanted to happen in the late 1930s at last took place: color came to be perceived as an element of films' photographic indexicality, something that functioned simply by being there. This change can be seen in the pages of *American Cinematographer*, a barometer of Hollywood's aesthetic preoccupations. From the late 1950s, references to color became less frequent. New preoccupations included the use of available light, handheld camerawork, and how to shoot for television. For example, an article on *The Great Escape* contains not a single mention of the film's use of color, apart from a vague observation in the headline that color film "can enhance a factual picture" (Gavin 1963: 336).

Of course, as Peter Wollen reminds us, "when a colour film is seen projected, the colour is not in the Bazinian sense a direct indexical registration of colour in the natural world; it is a dye" (1980: 24). Wollen's reminder draws attention to film color's chemical nature, and to how easy it is to ignore the chemistry of color. The first decades of cinema saw the progressive effacement from color moving images of the processes that created them. From hand painting and stenciling, through tinting and toning, to "natural" cinematographic color, the means of production incrementally became less overt. Over subsequent decades, with the release of each new color film stock, the chemical basis of cinematographic color also became less overt. The widespread realistic motivation of color in Hollywood films of the 1960s was a culmination of this process of chromatic de-emphasis. Color had achieved invisibility through ubiquity. This is not, however, to say that the history of screen color can be regarded as a linear progression toward a "realist" destiny. The "realistic" color of 1960s Hollywood was just one visual code among many. In the next chapter, I explore the counter-current of European art cinema, in which film-makers re-emphasized color in diverse ways.

A crucial question remains unanswered. Why did Hollywood's move to color occur when it did? According to Gorham Kindem (1979), factors that variously accelerated and retarded cinema's move to color include the following:

Simplicity. Making a film in color was a complex procedure. Early color processes including Kinemacolor (1908) and Technicolor Number I (1917) required special cameras and projection equipment. After the release of Technicolor Number II in 1922, color prints could be screened using standard black-and-white projectors, but special cameras and services were still required. In addition, for most of the 1920s, cinematographic color remained technologically flawed. Technicolor Number II involved cementing together red and green colored prints to create a single show print. After a number of screenings, the cemented prints tended to slip, and had to be returned to Technicolor on a regular basis for "decupping" (Kalmus 1967: 54). It was not until the late 1920s, with the development of dye-transfer, that Technicolor became a reliable process.

Production and distribution costs. Even following the development of its dye-transfer process, Technicolor remained prohibitively expensive for all but high-budget features. The equipment and services supplied by Technicolor entailed major additional expense. In addition, the extra lighting equipment required by color cost more to buy and took longer to rig, resulting in longer shooting schedules and increased budgets.[27] It was only in the 1950s, again following the release of subtractive film stocks, that full color became affordable for films without Hollywood A-movie budgets, and only in the 1960s that the speeds of color film stock increased, and lighting requirements decreased, to levels close to those of black-and-white stocks (see Cushman 1958; Foster 1959).

Availability. The total footage printed by Technicolor in the 1940s exceeded the combined footage printed in the same period by its two closest competitors, Cinecolor and Magnacolor (Parker 1973: 26). Inevitably, Technicolor's stranglehold on the market served to limit the output of color films. The company had limited processing capacity, resulting in much potential demand for color remaining unsatisfied. Technicolor routinely refused to supply independents, and even studio productions often found that they could not immediately be scheduled in (Gomery 1992: 236). The effect of Technicolor's limited production capacity manifested itself most acutely in the early 1930s and late 1940s, but there remained a backlog of orders throughout these two decades (Chisholm 1990: 217). It was only with the rise of a free market in color film in the 1950s that supply and demand reached equilibrium.

Verisimilitude. For color to become cinema's aesthetic default, the results of film color needed to appear similar to color as it is typically perceived. This took several decades to occur. The intensely saturated images produced by early "natural" color processes made color an obvious means of creating heightened, sensual effects (Buscombe 1985: 87). Even the rise of subtractive film stocks in the 1950s did not immediately lead to an improvement in color film's perceptual realism. Many 1950s musicals were shot on Eastman Kodak negatives. However, over subsequent years technological improvements resulted in the release of stocks which registered profilmic color ever more accurately. The release of Eastman Kodak 5251 in 1962 provided a particularly significant advance in color reproduction (Simmons 1962).

Ideology. More important than the question of whether or not color was verisimilar was the question of whether or not it was *perceived* as verisimilar. As seen, black-and-white had for a long time been associated with reality, and color with spectacle. For color to become cinema's aesthetic default, it needed to be perceived as an essential element of filmic reality. This happened gradually over the course of the 1950s and 1960s. The faster color film stock became and the more accurately it represented natural color, the more it was used for "realistic" subject matter; the more it was used in this way, the more it was perceived as realistic. By the mid-1960s, these uses and perceptions had reinforced each other to a sufficient degree to allow color to become cinema's chromatic default.

Kindem also mentions the rise of television, which I discuss in more detail below. Though there is general agreement that most of these factors were relevant to Hollywood's move to color in the 1950s and 1960s, it is far from clear how precisely they interrelated. Kindem combines them in the form of a table, with each factor listed in a separate column on the x-axis and each decade from the 1920s to the 1960s listed in a separate column on the y-axis (1979: 29). In each of the table's cells he notes whether a particular factor in a particular decade favored black-and-white, color, or neither; for example, according to Kindem, availability favored the use of black-and-white up to and including the 1940s and subsequently favored neither. In his combined emphasis on technology, economics, and ideology, Kindem highlights the crucial fact that the move to color was the result of a multiplicity of processes working simultaneously. But his analysis has one major limitation: though the text of his article contains reasonably detailed discussion of each of the above factors, it is only in the table that these factors are brought together. As a result, the implication is that each factor was

self-contained and had equal relevance: in the 1960s, enough factors favored color over black-and-white, and so cinema completed its transition.

Though Kindem's chart is a useful simplification, its explanatory power is limited. The factors at work in any historical development do not take the form of discrete causal motivators, each with a quantifiable degree of influence. Rather, they are interdependent, existing in a complex matrix featuring causalities running in multiple directions. For example, color's influential association with reality was itself influenced by aesthetic factors: the more accurately films were able to represent color, the more they were perceived as realistic. These aesthetic factors were in turn influenced by technological factors, especially increases in the speed of film stocks and lenses. Technological development was driven by economic motivations – specifically, revenue maximization via product differentiation. Yet economics was an effect as well as a cause. For example, the economic factors that restricted the uptake of color in the 1930s were themselves in part a result of the complexity of the Technicolor process. And so on.

The only way to make sense of this multiplicity of causal relationships is to focus on some more closely than on others. Which relationships should we privilege? Brad Chisholm (1990) privileges the influence of television. He starts by reiterating the common view that Hollywood perceived the spread of television in the early 1950s as a threat and responded with various attempts at product differentiation (Chisholm 1990: 222). Product differentiation was implemented both through subject matter – for example, historical epics – and through the uptake of the new(ish) technologies of widescreen, 3-D, and color. Despite these various developments, box-office returns declined throughout the early to mid-1950s (1990: 224). In addition, as film companies began to distribute their films on television, which in the mid-1950s was still black-and-white, the marginal benefit of using color for a time actually *declined*. Meanwhile, television networks were not in a hurry to initiate the expensive process of switching to color broadcasting unless there were clear economic benefits to be gained (1990: 225). So color production became less of a priority in Hollywood, and black-and-white experienced a brief revival. Between 1956 and 1957, the number of black-and-white Hollywood releases increased by 70 percent (1990: 224). However, this revival was short-lived. By the early 1960s, the number of black-and-white television sets owned by American households was nearing market saturation. In 1950, less than 10 percent of American homes owned a television; by 1962, only 10 percent did not own one (1990: 227). To sustain their profits, television manufacturers needed new products. As a result, in 1959, in conjunction with television

manufacturer RCA's decision to push the sale of color televisions, NBC initiated a switch to color programming (1990: 227). A surge in color television sales in 1964 resulted in an accelerated move to color by NBC, culminating in an autumn 1965 prime-time schedule in which only two shows remained black-and-white (Castleman & Podrazik 1982: 181). NBC's lead was followed the same year by CBS and a year later by ABC (Chisholm 1990: 227). Hollywood also responded rapidly, with its largest single-year decrease in black-and-white production (1990: 228). In 1967, in acknowledgment that there was no longer enough black-and-white film production to warrant specific attention, the Academy of Motion Picture Arts and Sciences merged its Oscars for "Best Black-and-White Cinematography" and "Best Color Cinematography" into "Best Cinematography."

It is difficult to dispute Chisholm's carefully researched findings. Yet clearly his is only a partial answer to the question of why Hollywood's move to color accelerated in the 1950s and 1960s. Moreover, this question is itself a subdivision of a broader question: why did cinema move to color *at all*? In his seminal article "Sound and Color," Edward Buscombe addresses this broader question. Chisholm treats economics as a cause. By contrast, Buscombe treats it as an effect, privileging the influence of ideology on economic decision-making:

> Economic theories can only partially explain technological innovations, since economics cannot say why innovations take the form they do, only why they are an essential part of the system. Economics can explain the necessary but not the sufficient conditions for innovation. No new technology can be introduced unless the economic system requires it. But a new technology cannot be successful unless it fulfils some kind of need. The specific form of this need will be ideologically determined; in the case of cinema the ideological determinant most frequently identified has been realism. (1985: 87)

According to Buscombe, it was the film industry's obsession with realism that prompted the economic choices that moved it to color. Yet as well as initiating the move to color, ideology also obstructed it: color did not approach the status of cinema's chromatic default until the mid-1950s because it was not perceived as verisimilar until then (1985: 88). Buscombe's article moves lightly over historical details, and a number of his claims – for example that color could not be accommodated in early cinema – have been contradicted by subsequent research. Nevertheless, Buscombe's first step in placing ideology at the heart of a history that had previously only been approached from technological and anecdotal perspectives was a

significant one. The only reason that I do not here discuss Buscombe's ideas directly, with the attention that they deserve, is that they have already been interrogated, elaborated, and qualified indirectly throughout this chapter.

So which of the above best explains cinema's transition to color? In my view, they all do. Though Kindem's, Chisholm's, and Buscombe's answers are independent of each other, they are not incompatible. Kindem lists the most important factors. Chisholm focuses specifically on the cluster of causalities associated with the rise of television, exploring factors whose timeframes are measurable in months and years. Buscombe asks the broader question of why cinema moved to color, highlighting factors whose timeframe was decades. Other articles focusing on other influences could hypothetically be added to these answers *ad infinitum*, to create a progressively more sophisticated explanation of cinema's chromatic transition. Indeed, the coexistence of these three approaches draws attention to the crucial fact, that cinema's transition to color was not one transition but many. Cinema's transition to color was the sum of the moves to color within various genres, sectors of the film industry, and countries. Each of these moves followed a different timeline and was influenced by different combinations of causal factors. The most significant factors underlying cinema's transitions to color (the availability of color film stock, the rise of television, etc.) were relevant to all genres, industry sectors, and countries. However, they interacted differently in each – different factors had different causal weight according to the context within which they operated. The question of why cinema's transition to color occurred when it did can thus be seen not as one question but as a multiplicity of questions. Accordingly, it requires a multiplicity of answers. In the following chapter, I provide a few additional answers.

2

Surface Color

"We've accepted color. Good. Let's do more, let's welcome it."
 Eric Rohmer (1989 [1956]: 68)

Color in European Film, 1936–67

Color film production was a rarity outside the United States until the late
1950s. It is no surprise, then, that as the chromatic excitability of 1950s
Hollywood abated, film-makers in countries new to color began to immerse
themselves in it. Chromatic experimentation was particularly prominent in
art cinema of the 1960s. Of course, the term "art cinema" referred to a very
different category of films then than it does now. Over recent decades, art
cinema has become a global phenomenon, of which European cinema is a
relatively insignificant sub-set. In the 1960s, by contrast, art cinema was still
essentially a sub-set of European cinema. Beyond Europe, only Japan had a
well-developed and internationally influential commercial art cinema.
Accordingly, in this chapter I focus primarily on European, and – to a lesser
extent – Japanese, art films. Clearly, startling uses of color also occurred in
popular cinema during the 1960s, not least in the United States itself: one
need think only of *Masque of the Red Death* (Roger Corman, 1964) to
appreciate that Hollywood's ideological shift toward "realistic" color could
never entirely overwhelm color's sensual appeal. However, in my view, the
uses of color in European and Japanese art cinema of the 1960s were par-
ticularly interesting and diverse. Color was used "realistically" (for example,
by Rohmer), symbolically (Bergman), graphically (Godard), and sensu-
ously (Chytilová); it was emphasized (Suzuki), and suppressed (Antonioni).
Before exploring these various uses of color further, I begin with a brief
background to the delayed uptake of color in Europe and beyond.

Color played a prominent role in early European cinema. Indeed, many of the most significant developments in early color technology occurred in Europe. Stenciling was first used by French production company Pathé in 1905 (Usai 1996: 24); Kinemacolor, the first commercially successful "natural" color process, was pioneered in Britain in the mid-1900s.[1] However, the quality of the various European color technologies developed over subsequent decades lagged behind those of the United States. European attempts at "natural" color occasionally achieved moderate initial success, but the results generally palled next to the aesthetic benchmark of Technicolor, and failed to establish themselves even within their national markets. For example, one of the few British color technologies to find a market was Dufaycolor. Dufaycolor was an additive process, which featured tiny lenses ("lenticules") embossed onto the base of the film print. These lenses split the light falling onto them into red, green, and blue components, which – when viewed from a sufficient distance – appeared to blend into a single color image (Coe 1981: 124). First released in 1937, Dufaycolor was used for advertising and travel films, documentaries by directors including Humphrey Jennings, and one feature film – *Sons of the Sea* (Maurice Elvey, 1940). However, there were technical drawbacks: its additive nature led to relatively dark images, and the lenticular process led to a slight mosaic effect on large screens. After a wartime production hiatus, Dufaycolor reappeared on the market but failed to re-establish itself.[2] Much the same occurred in a number of other European countries. In his brilliant essay "The Post-War Struggle for Colour," Dudley Andrew cites two slightly later French processes: Thomsoncolor (another additive lenticular process) and Rouxcolor. Both were released, and discontinued, in the late 1940s (1980: 65).

Though Andrew's essay focuses on the uptake of color in French cinema and on the debates within France that surrounded it, it also goes a significant way toward explaining why color was relatively slow to appear across Europe. Andrew observes that before the war, the only European color process with the potential to compete with Technicolor was Agfacolor (1980: 62). First released in a 16mm version by German film manufacturer Agfa in 1936, Agfacolor was an early example of the next generation of subtractive three-color film stocks. Agfacolor's advanced technology, together with Agfa's international production and distribution network (which included an American subsidiary, Ansco), made the process a potential market leader. However, Agfacolor's availability was interrupted by the outbreak of World War II; the process continued to improve as a

result of military research, but its international distribution halted (Andrew 1980: 62).[3] After the defeat of Germany, Afga's patents became a spoil of war and former technological secrets spread across the globe at the speed of a transatlantic flight (Anon. 1946: 122). Agfacolor technology again became poised for commercial release, except this time by its former competitors. However, the technological complexities involved in bringing together Agfa's latest research and the difficulty of raising venture capital caused varying degrees of delay in bringing it to the market (Andrew 1980: 72). The first Agfa-derivative, Gevacolor, was released by Gevaert, a former Agfa affiliate, in 1947. Anscocolor was released in Europe by Ansco, now an independent American company, in 1949; Ferrania-color was released by Italian manufacturer Ferrania in 1952; Fujicolor was released by Japanese manufacturer Fuji in 1955 (Ryan 1977). The development of Sovcolor, a Soviet derivative of Agfa, took even longer (Salt 1992: 241). Meanwhile, as Technicolor continued to face a backlog of orders, it showed no immediate desire to expand internationally (Andrew 1980: 69). So non-American production remained largely without the option of color throughout the 1940s. Only in Great Britain, where Technicolor had opened a laboratory near London in 1936, was there sustained color production, amounting to about a dozen films a year (Coe 1981: 135).[4]

Having privileged the role of availability, Andrew moves his analysis into the 1950s by highlighting the reluctance of an unstable and relatively impoverished French film industry to prioritize color production (1980: 71). He concludes his article by suggesting that it was the rise of television that finally impelled French cinema toward color in the mid-1950s (1980: 72). As in the United States a few years previously, color became a form of product differentiation, used to give cinema added value over television. As added value entailed added cost, the first wave of European film-makers to employ color mainly comprised established directors working with large budgets. High-budget European productions directly competing with American products routinely mimicked the stylistic norms of classical Hollywood; Jean Renoir's *French Cancan* (1955) and Max Ophüls's *Lola Montès* (1955), both by French directors who had worked in Hollywood, demonstrate the degree to which popular European and American products were often stylistically indistinguishable. Alternative uses of color were rare. Though some non-industry film-makers including Jean Rouch and Stan Brakhage experimented in the 1950s with 16mm Kodachrome, which carried the appeal of being both cheaper and faster than 35mm color, 16mm was still stigmatized within the film industry as an amateur format and so

generally avoided.[5] Alain Bergala notes that when budgetary limitations confronted them with a choice between 16mm color and 35mm black-and-white, the French *Nouvelle Vague* directors of the late 1950s initially chose 35mm black-and-white: 35mm was the industry standard, so it was 35mm that they used to storm the fortress of the film establishment (1995: 129). There thus developed the paradoxical situation in which a "new" mode of representation was co-opted in the mid-1950s by a coterie of "old" directors (in France, it included Jean Renoir, Max Ophüls, and Roger Vadim), while "new" cinema used, and became recognized by its use of, the "old" format of black-and-white (Bergala 1995: 127).

It was not until the early to mid-1960s that most European film-makers gained the opportunity to use color. This delayed access to color ensured that at the same time that it was dropping down the aesthetic agenda in Hollywood, it was at the forefront of the aesthetic agendas of many European film-makers including Eric Rohmer, Jean-Luc Godard, and Michaelangelo Antonioni.[6] These and many other directors' eagerness to engage with color was accompanied by a relative absence of external constraints on how color could be used. Working with low budgets, new wave film-makers faced relatively little interference from producers. Working outside the Hollywood system, they were not compelled to follow its generic paradigms. Nor were they subject to the standardizing influence of professional bodies including the Society of Motion Picture and Television Engineers (SMPTE) and the American Society of Cinematographers (ASC), both of whose monthly journals – the *Journal of the Society of Motion Picture and Television Engineers* and *American Cinematographer* – disseminated and reinforced Hollywood's favorite aesthetic ideologies. Free of these influences, European art film-makers' uses of color proved exceptionally diverse. To give a sense of this diversity, I begin with a brief summary of three very different film-makers' first color features.

With the exception of a garish title sequence, the color in Eric Rohmer's *La Collectionneuse* (1967) is predominantly natural, by which I mean the film relies on colors inherent in nature. For example, a field outside the villa in which Rohmer's main characters while away their summer is filled with yellow flowers, resulting in shots overwhelmed by yellow. At other times, natural color is less abundant – a dusty street in a nearby village yields only bleached earth tones. Both these extremes are photographed seemingly *as is*, without the insertion of overtly production-designed or costume-designed color. Though the actors occasionally wear brightly colored clothing, the colors do not exceed what one might expect to see

people wearing on a summer holiday. Indeed, anticipating many Hollywood films of the 1970s, the cinematography seems primarily to focus on light.[7] The film repeatedly returns to the same locations at different times of day, allowing Rohmer's static camera to observe varying light conditions with typical detachment. Color is a by-product of natural light: the bleached white walls of a street in the mid-afternoon become deep orange at sunset and gray at night.

By contrast, in Jacques Demy's musical *Les Parapluies de Cherbourg (The Umbrellas of Cherbourg* [1964]), color is an artificial additive. The chromatic excess of musical sequences in 1950s Hollywood movies including Vincente Minnelli's *An American in Paris* (1951) is extended over the entire length of Demy's film – almost every available surface is painted, printed, or dyed in synthetic hues. The walls of the umbrella shop in which Geneviève Emery (Catherine Deneuve) and her mother (Anne Vernon) work are painted pink and lined with dozens of colored umbrellas. A gilted doorway leads to rooms with walls papered with striped and floral patterns, as if having just one solid block of color was not enough. The wallpaper in the entrance to the Emerys' upstairs flat features prints of orange oranges with blue leaves, and opens out onto a living room candy striped in green and pink (Plate 2.1). Similarly, Geneviève and her mother routinely wear clashing colors – for example a blue dress with a pink coat, or a brown jacket with a cyan shirt – which themselves also clash with the wallpaper. In a *reductio ad absurdum* of classical Hollywood's law of emphasis, every item of clothing, every prop, and every flat surface is emphasized.

As distinct from Rohmer's as it is from Demy's, the color in Jean-Luc Godard's *Une Femme est une femme* (1961) is simultaneously overt and restrained. Godard restricts himself to a limited palette of primary colors: red, blue, yellow, and less frequently green. The film's interiors form visual fields of red, blue, and yellow surrounded by the bare white walls of the apartment shared by problem couple Angela (Anna Karina) and Émile (Jean-Claude Brialy). Most of the color derives from props and costumes: for example, a red umbrella, yellow flowers, a blue suit (Plate 2.2). The red-yellow-blue color scheme also extends beyond the apartment, into the film's occasional location sequences. Though the streets of Paris are gray not white, Godard approximates his interior color scheme by inserting red, yellow, and blue objects into location shots. Sometimes the film's interior colors are literally taken outside, as when Angela skips through the streets with her red umbrella. Sometimes nature itself does Godard's work for him, as when it supplies a sky almost as blue as Émile's suit.

The consistency with which Godard uses color in *Une Femme* is startling. Even more startling is the consistency visible across Godard's color work in this period. For over six years, from *Une Femme* to *La Chinoise* (1967), Godard stuck rigidly – almost perversely – to the same red-yellow-blue and white color scheme in each of his color feature films. What was the point of doing this? How do these colors function in Godard's films? It is perhaps first worth suggesting some ways in which they do *not* function. In his seminal article on *2 ou 3 Choses que je sais d'elle* (1967), Edward Branigan uses the film to highlight the inadequacy of a number of stock critical responses to cinematic color. For example, he suggests that Godard's use of color in *2 ou 3 choses* "does not provide clues to, or mirror, the psychological states of the characters" (1976: 28). He continues:

> For most critics this is the sole, or at least paramount, way color is interpreted in film. A weaker claim stemming from the same approach is that color sets the mood or tone of a scene – "vivid" colors for a "lively" scene, and so forth. The essence of this method is to shift adjectives and nouns from the narrative and attach them to the appearance of colours, as in "a chromatic sensuality that sharpened the hedonism of the plot" or "an aberrant grayness of alienation" which later "is modulated into a murky grayness to underline the barrenness of a mind drained of dreams and emotions." To the extent that this method also makes claims about the responses of the viewer, it is only speculation from out of the blue, so to speak. All other uses of color for these critics are shelved in the broad category of "symbols" or "comments" by the director; that is, if colors are not emotional they must be "intellectual." (1976: 28)

Of course, the fact that an emotional reaction cannot be quantified does not mean that it cannot be felt – perhaps color cannot "set" the mood of a film but it can influence the mood of the viewer. Nonetheless, Branigan's key point cannot be overstated. Much of the time, the color in Godard's films is unrelated to emotion or intellect.

The bland emotional and intellectual explanations offered by critics for film-makers' uses of color owe much to the conventional way in which color has been used from classical Hollywood onward. For example, a few years after it was released, Paul Sharits (an artist whose work with color in the 1970s was far more interesting than his film criticism might suggest) wrote of *Une Femme* as follows: "Jerry wears a blue coat and a red tie; he drives a red sports car. Jerry is composed of both blue (dominant) and red so we may infer that the attraction he will feel towards Paul's wife will be lust rather than love" (1966: 27). What Sharits here describes is not how

color functions in Godard's films, but how color was made to function in classical Hollywood. Sharits interpreted Godard's colors thematically, regarding them as means of emphasizing characters' emotions, because this was the most common way in which color had been used for over 20 years. Technicolor's "law of emphasis" based itself on emotional explanations. For example, in "Color Consciousness," the article that epitomized Technicolor's campaign to dictate how directors should use color, Natalie Kalmus declared:

> Just as every scene has some definite dramatic mode – some definite emotional response which it seeks to arouse within the minds of the audience so, too, has each scene, each type of action, its definitely indicated color which harmonizes with that emotion. (1935: 142)

Whenever a sequence with strong reds appears in a Technicolor film it can be almost guaranteed to indicate simmering passions. By contrast, Godard's use of color cannot be explained by factors internal to the film; color is detached from the diegesis. Regardless of whether his main characters were students, film stars, or gangsters, throughout his 1960s films they all had the same taste in color, namely Godard's own. In Godard's early color films, the reds, whites, blues, and yellows can perhaps be seen as primarily a graphic phenomenon. They give his films a supratextual identity, identifying them as the work of an individual auteur. Nowhere is this more apparent than in the films' standardized title sequences, comprising red, white, and blue sans serif text on a black background, immediately announcing that what we are seeing is a Godard film. By the time of *2 ou 3 Choses que je sais d'elle* (1967), Godard's typography was so iconic that he did not even need to put his name on the film's credits. Despite his radical leanings, Godard was one of the 1960s' great brand strategists.[8]

Alain Bergala suggests that, though the French *Nouvelle Vague* directors used color in various ways, they were essentially all responding to the same thing – the use of color in classical Hollywood (1995: 133). There is certainly some truth in this. Many of the *cinéastes* of the 1960s (including Jacques Rivette, Eric Rohmer, Claude Chabrol, Jean-Luc Godard, and François Truffaut) had been *cinéphiles* for much of the 1950s, penning regular opinion pieces for *Cahiers du cinéma* on the latest Hollywood releases. These articles included recurrent critiques of what Des Esseintes, aesthete protagonist of J. K. Huysmans' novel *À Rebours*, refers to as "those bourgeois optics that are insensible to the pomp and glory of the clear, bright

colours" (1968: 29). Rohmer's call for realistically motivated color was an obituary written in anticipation of the death of Natalie Kalmus's law of emphasis. Jean-Luc Godard also explicitly rejected the law of emphasis: in a review of Nicholas Ray's *Hot Blood* (1956), he celebrated the film's iconoclastic chromatic violence, suggesting that it provided a compelling rebuke to those who believed colors should be "soft" ("doux") (1998a: 98). The ambivalent relationship with Hollywood expressed in the *Nouvelle Vague* film-makers' writings of the 1950s inevitably informed their later practice. Godard's first use of color was an elaboration of that seen in 1950s Hollywood musicals, a self-conscious move beyond emphasis. At the same time, in other branches of art cinema, the use of color often owed less to Hollywood. As Thomas Elsaesser has observed, though Hollywood has always figured large in European film-makers' psyches, post-war European cinema was subject to divergent compulsions. Hollywood, still the "big Other," continued to occupy Europe's cultural imaginary (2005: 499). Another forceful presence was that of the Soviet Bloc, (Western) Europe's own Other. Equally potent was the "historical imaginary" of Europe's past (2005: 325). Each of these influenced European film-makers' uses of color. For example, Godard's later uses of red, white, and blue are overtly political, referencing both French past and Soviet present. By contrast, as I discuss later in this chapter, the strongest influence on Michaelangelo Antonioni's and Andrei Tarkovsky's uses of color was the historical imaginary of European art history.

Chromatic Ambivalence: Art Cinema's Transition to Color

The absence of chromatic paradigms in art cinema also manifested itself in the nature of directors' movements between black-and-white and color from film to film. In Hollywood, until at least the mid-1950s, such movements were most often dictated by genre. By contrast, working on relatively low budgets and outside industrial paradigms, 1960s art film-makers were able to move between black-and-white and color with relative freedom. Sometimes the choice of which to use was guided by Hollywood – Jean-Luc Godard described *Une Femme est une femme* as "the idea of a musical" (1972: 182). Sometimes economics also played a part – Godard's second color film, *Le Mépris* (1963), was made with a relatively high budget, necessitating both color and a nude scene with Brigitte Bardot (Godard

1998b: 33). In general, however, as Alain Bergala observes, 1960s European cinema was a site of peaceful coexistence between black-and-white and color (1995: 127). Consumers seemed willing to watch films in either format, and film-makers moved from one to the other at will.

Of course, as was also the case politically, the equilibrium implied by the coexistence of two alternative systems was an illusion. The easing of Cold War tensions in the 1960s can be seen with hindsight as a distraction from a far more significant development – the consolidation of the United States' global economic hegemony. Analogously, the seemingly peaceful coexistence between black-and-white and color in 1960s European cinema also masked a more fundamental change – the inexorable rise of color. The movements of individual film-makers between black-and-white and color were both a response to and an intrinsic element of an industry in the latter stages of transition from the one mode of representation to the other.

My analogy between color and politics may seem a bit tendentious, but in fact the two have often directly interrelated. Cinematic color can be seen politically and *has been seen* politically. A memorable on-screen example is Sergei Eisenstein's *The Battleship Potemkin* (1925), in which a red flag raised by revolutionaries on the battleship is synechdochic of the rise of Communism. An example of chromatic politics in action beyond the screen is detailed in Dudley Andrew's analysis of post-war French discourse on which color system to invest in. Both of the leading color film systems of the late 1940s were regarded as politically suspect by the French media. Technicolor was perceived as a product of post-war American expansionism, while Agfacolor smelt of German occupation (Andrew 1980: 66). So the question of which color technology French films should use was as much political as it was aesthetic. Though the release of new brands of color film stock in the early 1950s soon made this particular debate obsolete, it was hardly a secret that the driving force behind the spread of color was the United States. In the uptake of color, as in many other economic and cultural spheres, the United States led and the rest of the world less than wholeheartedly followed.

Conscious of the irresistible economic pull toward color but temporarily free to use black-and-white, individual European film-makers effected their own microcosmic transitions. Inevitably, some moved to color more eagerly than others. Rohmer, Demy, and Godard responded with cinephilic enthusiasm (though even they still occasionally went back to using black-and-white in later films). Claude Chabrol's response was one of indifference:

when asked what adjustments he had been forced to make in the face of color, his answer was "None" (Bergala 1995: 129). For other film-makers, the transition was as much a problem as an opportunity. The prospect of working in color often required a wholesale overhaul of working practices developed through and geared toward making black-and-white films. For example, for much of the 1950s and 1960s, Ingmar Bergman and cinematographer Sven Nykvist had been gradually perfecting their use of black-and-white to explore the play of light on surfaces, as seen in *Through a Glass Darkly* (1961) and *Winter Light* (1962). Black-and-white film stock, which registers light but not color, was the ideal agent for Bergman and Nykvist's visual research. How now to respond to color? How to put it to use? Bergman's initial response, in *All These Women* (1964), was to use it "entirely by the book" (Björkman et al. 1973: 261). Unsatisfied with the results, Bergman avoided color for another five years. When at last he returned to it, in *A Passion* (1970), he developed an ulcer and his relations with Nykvist turned bilious (Björkman et al. 1973: 261). The shock of color hit Bergman in the gut.

Faced with the shock of color, many other art film-makers also clung to black-and-white. Some managed to avoid color entirely until the late 1960s: Roman Polanski's first color film was *The Fearless Vampire Hunters* (1967), Hiroshi Teshigahara's was *The Ruined Map* (1968), Akira Kurosawa's was *Dodesukaden* (1970). This delay is partially explainable by the fact that it took time to work through color's stylistic implications and to harness its power. But there is perhaps an additional motivation underlying the resistance to color. In *The Decay of Lying*, Oscar Wilde wrote, "No great artist sees things as they really are. If he did, he would cease to be an artist" (1908: 47). This Romantic view of art was undermined during the twentieth century by numerous provocations, from Marcel Duchamp's ready-mades to Andy Warhol's Campbell's soup cans. Nonetheless, within cinema, the idea of art as a transformative process retained currency long after it had become discredited in painting and sculpture. Film was still an adolescent, and in order to assert its status as the seventh art it needed to demonstrate that it could achieve more than just mechanical reproductions of visual reality. So early film theorists including Béla Balázs, Jean Epstein, and Rudolf Arnheim emphasized cinema's transformative potential. Many art film-makers also regarded transformation as a core element of their work, and of their self-definition as artists. In a 1955 article on color, Carl Dreyer (another director who kept using black-and-white in the 1960s) summarized this view as follows:

Simplification. This is the task of any creative artist: To let himself be inspired by reality and after that withdraw from it in order to give the work the form that the inspiration suggested to him ... it is not the director's aesthetic sense that should yield to reality – no, the opposite: reality should obey his aesthetic sense. (Skoller 1973: 179)[9]

Black-and-white is highly compatible with such a credo. One of its most obvious characteristics is that it limits the potential for visual chaos within an image. The chaos of color is flattened into points on a one-dimensional scale with black at one end and white at the other. The visual result, as Rudolf Arnheim observed, is that "[e]verything fits. You cannot get discord. You can still louse up your picture all right, but not because of the gray scale" (Fell 2000: 2). Even when a black-and-white film features a wide range of tonalities, there is not the distraction of multiple colors, so other visual elements including space, perspective, and especially texture become more prominent (Arnheim 1958: 66).[10]

A world in black-and-white would be beautiful, but it would also be unbearable. In *An Anthropologist on Mars*, Oliver Sacks discusses the case of an artist, "Mr. I," who after being involved in a car accident finds that he can only see in black-and-white. After 40 years of painting, he was formerly so attuned to color that he could give a Pantone reference for the baize on a pool table. Now he neither sees color nor understands what it is. Not surprisingly, his condition at first causes him to fall into depression:

The "wrongness" of everything was disturbing, even disgusting, and applied to every circumstance of daily life. He found foods disgusting due to their greyish, dead appearance and had to close his eyes to eat. But this did not help very much, for the mental image of a tomato was as black as its appearance. (Sacks 1995: 5)

Mr. I's initial response is reminiscent of Maxim Gorky's professed despondency after his first experience of moving pictures. Gorky too claimed that the experience of seeing life in shades of gray was a depressing one:

This mute, grey life finally begins to disturb and depress you. It seems as though it carries a warning, fraught with a vague but sinister meaning that makes your heart grow faint.... (Leyda 1960: 409)

Mr. I's depression passes, as did Gorky's. Eventually, he begins to value the fact that he can appreciate textures and patterns usually obscured by color,

and comes to see his vision as "highly refined" and "privileged" (Sacks 1995: 35). Mr. I's view that color obscures form is echoed in numerous other artists' responses to color film. For example, in an early panegyric against "natural" cinematic color, Vorticist painter Paul Nash opined: "To an artist, the appearance of the average color photography picture is more or less of an abomination. It lacks everything he prizes – form, definition and subtlety" (1937: 118). Thirty years later, Andrei Tarkovsky made a similar complaint:

> One of the greatest difficulties in the graphic realisation of a film is, of course, colour. Paradoxically, it constitutes a major obstacle to the creation on screen of a genuine sense of truth…. Why is it, when all that the camera is doing is recording real life on film, that a coloured shot should seem so unbelievably, monstrously false? The explanation must surely be that colour, reproduced mechanically, lacks the touch of the artist's hand; in this area he loses his organising function, and has no means of selecting what he wants. (1986: 138)

Tarkovsky's fear was not of color per se but of its anarchic tendency. The fear of color's subversiveness, of its tendency to resist control, was also shared by other practitioners less precious about their artistry. For example, following his first experience of working with color, cinematographer James Wong Howe warned that even just a "splash" of strong color in a shot could distract from other areas of the frame (1937: 408). Of course, chromatically attuned directors have often used primary colors' visual insistence to their advantage. For example, in Akira Kurosawa's black-and-white *High and Low* (1963), the kidnapper of a wealthy industrialist's child is given a ransom payment in a briefcase that, when burned, will release red smoke, allowing the police to locate him. Sure enough he burns it, and reveals himself: the detectives in the industrialist's penthouse apartment look out across the urban cityscape and notice a column of (hand-painted) red smoke emanating from a nearby slum (Plate 2.3). Kurosawa's use of red is visually astute, but its effectiveness is dependent on the fact that the rest of the image is black-and-white. Had the red smoke appeared in a color film, it would have had to compete for our attention with other colors. Of course, natural color can usefully order perception as well as confuse it – the redness of red apples in green trees help us see them, and so pick them, eat them, and spread their seeds. However, for the film-maker, whose intentions typically diverge from nature's, the natural superabundance of color is always a potential threat.

Having left behind the simplicity of black-and-white, art film-makers who favored visual discipline used a range of techniques to restrain the natural superabundance of color. The easiest and most effective means of controlling color was exclusion, especially if working on a limited budget. This was the approach favored by Nagisa Oshima in *Naked Youth* (1960), his first color film. In the eighteenth century, Japanese Benigirai-e painters banished red from their work. In *Naked Youth*, Oshima banished green. To Oshima, green signified gardens and hedges and the aestheticization inherent in bourgeois art, and had no place in a political cinema (2006: 118).

Rudolf Arnheim proposed an alternative solution to the problem of natural color, suggesting that "if you do your film in a studio and you have control of the make-up and the costumes and the walls and everything else, then you have no problems, but you limit your film to a world without windows" (Fell 2000: 3). Arnheim's strategy is reminiscent of that followed by Des Esseintes in Huysmans' novel *À Rebours*. Des Esseintes lives at night, because only then can he completely reject nature by closing his shutters. Within the controlled environment of his shuttered living room he builds an enclosed set, a room within a room that takes the form of the stateroom of a ship. Inside this stage set of a room, Des Esseintes indulges in a flamboyant mixture of artificial colors: he hangs colored tapestries on the walls, puts colored shades onto his lamps, and shines blue light through the portholes to create an aquatic atmosphere.

In *2001: A Space Odyssey* (1968), Stanley Kubrick built his sets within the windowless sound stages of Pinewood studios.[11] In contrast to Des Esseintes's stateroom, the interiors of Kubrick's spaceships are void of color. Indeed, as Alexander Walker observes, *2001: A Space Odyssey* can in some ways be regarded as a black-and-white film shot in color (1999: 224). The film's production design uses an extremely limited palette, ranging from the pale tan decor of the moon shuttle to the clinical white walls, floors, and ceilings of the space station and the Jupiter spacecraft. Through the windows, usually a source of natural color and light, there is only black space. The manner in which the sets are lit is similarly achromatic – in contrast to Des Esseintes's colored lighting, Kubrick's lighting is white. On the few occasions that he uses optical color, it is monofrequency. In the moon buggy that takes a group of scientists to the site of the alien monolith, the lighting is blue; when Dave Bowman (Kier Dullea) enters HAL 9000's access chamber in order to shut down the homicidal computer, the whites of the Jupiter spacecraft's living areas briefly give way to the red of HAL's electronic internal organs (Plate 2.4). Apart from these occasional moments of chromatic punctuation,

marked by the use of intense monochrome color, *2001* creates a bi-polar chromatic environment dominated by black "exteriors" and white interiors.

In his third color film, *Cries and Whispers* (1972), Ingmar Bergman conducted a similar chromatic experiment to Kubrick's. The film traces the run-up to the death of Agnes (Harriet Andersson), a bed-ridden cancer victim, and the effect of her illness on her two sisters Marie (Liv Ullmann) and Karin (Ingrid Thulin), and her maid Anna (Kari Sylwan). It begins in the grounds of a mansion, with a series of images that, though shot in color, appear to be monochrome. The presence of early morning mist turns the air white; the position of the camera facing the sun and the use of a stopped-down aperture combine to turn all else into shadow (Plate 2.5). For a few moments, Bergman returns to the exploration of pure light that he conducted in his black-and-white films. Subsequently, the film moves inside and remains almost completely confined to the interior of the three sisters' family home. Like Kubrick, Bergman excludes nature, but instead of absorptive black beyond the windows of his sets, there is the pure white of tungsten lights diffused through white fabric stretched across the window frames. As a result, soft, white light floods into the set and touches everything in its path, like an ice queen's wand. Even the characters' complexions are drained of color when faced with the immersive whiteness of the lighting. The bleaching effect of the light is complimented by the bleached whites of textiles within the house, in particular the white bed sheets and nightgown that Agnes wears to counterbalance the cancerous blackness spreading inside her body.

Black figures equally prominently in the film. Notable blacks include the furniture inside the mansion, the wine that the characters drink (dark as bile), the mourning clothes that they wear after Agnes dies, and the shadows that engulf the house every night. Out of these shadows come memories: scenes from the past are introduced with a facial close-up shot of a character in front of a black background, gazing into camera, conjuring the subsequent scene out of the shadow of her memory. Eyes also appear black; the actors' eyes are often meticulously lit so that just a point of white appears in the center, as if their irises have responded to the white light by closing to the size of a pinhole. But despite the prominence of both black and white, *Cries and Whispers* is dominated by shades of red: for most of the film's length, the screen is filled with the expansive reds of the mansion's wallpaper, carpet, and curtains (Plate 2.6). Watch the film in an unlit room with white walls, and these walls too become drenched in red. Other on-screen reds include blood, the result of a suicide attempt by Marie's husband and

of Karin's self-mutilation, and the sisters' lipstick, mimicking a life-blood that – like so many of Bergman's characters – they desperately lack. Structurally too, the film is dominated by red. It begins and ends with title credits that appear as white-on-red rather than the conventional white-on-black. Similarly, between scenes, instead of fading to black for a few moments, the film fades to red. The film emerges from red, returns to red in the spaces between scenes, and concludes with red.

In its use of black and white, *Cries and Whispers* can be regarded as the fulfilment of an aspiration expressed by Carl Dreyer in his 1955 article. Dreyer suggested that for the chromatically attuned director "the general rule should be as few colors as possible, possibly combined with black and white colors, which are used much too little in these [Technicolor] films" (Skoller 1973: 171). Looking beyond the re-integration of black and white into color, Dreyer imagined a time of true chromatic freedom, when all environmental color could be manipulated at will:

> Of course, one can find poetry in a slice of everyday life but a film in color doesn't become art by meticulously and precisely copying the colors of nature.... So often we have seen the grass green and the sky blue that we sometimes have wished, just once, to see the sky green and the grass blue, for then perhaps an artist's intention could be felt behind the whole thing. (Skoller 1973: 120)

Dreyer's aspiration has since been made possible by digital technology. Digital colorists can easily target specific color ranges during post-production and transform them into different hues. Until the 1990s, however, profilmic color remained stubbornly inalterable: blue remained blue when filmed, no matter what color film stock was used. If a film-maker wished to exert a transformative influence on natural color, this required extreme techniques focused on the colors present in front of the lens. Perhaps the most extreme transformative techniques were those used by Michaelangelo Antonioni in his first color film, *Il Deserto Rosso* (1964). The film traces the mental breakdown of housewife and mother Giuliana (Monica Vitti). Giuliana's boredom and claustrophobia is intertwined with the smoggy grayness of the post-war industrial town in which she lives. In *Il Deserto Rosso*, Antonioni suppressed and transformed natural colors to create what Rudolf Arnheim referred to in discussion about the film as a "cosmetic correction on reality" (Fell 2000: 2). On the subject of a forest that he wanted to film, Antonioni commented:

That green had to be eliminated if I wanted the scenery to acquire something of an original beauty, made up of arid grays, imposing blacks, and even pale pink and yellow spots – distant pipes or signs. And so ... I was suddenly certain, to the extent one can be certain in this order of things, that the forest should be painted white, a dirty white that, at best, would turn out gray in Technicolor, like the sky of those days, or like the fog, or like the cement.... (1996: 98)

The problem with the forest was not its color – green appears throughout the film – but the fact that Antonioni had not chosen green. For Antonioni, color needed to be expressive of the artist's ideas rather than representative of the chromatic chaos of the world. Regardless of what the white forest was meant to be expressive *of* (the film's emotionally flatlining characters, the extraction of life from nature by industry, etc.), Antonioni's underlying assumption was that to make color express *anything*, it is necessary to break the indexical link between objects and the colors with which they are associated. The orange-ness of an orange, for example, is a purely decorative phenomenon; so, for one of the film's most famous scenes, Antonioni had a fruit cart and all the fruit on it painted gray (Plate 2.7). Unfortunately, as Rudolf Arnheim observed, in his attempt to prevent natural color from overrunning his film, Antonioni inadvertently created chromatic distractions (Fell 2000: 2). In photographic media, in which the iconic link between object and image is so strongly felt, oranges that are not orange draw attention to themselves by virtue of their unnatural color. The gray oranges of Antonioni's fruit stand invite a distasteful fascination similar to that felt by Mr. I when faced with black tomatoes.

"Painting with Light": Cinema's Imaginary Art History

Il Deserto Rosso is a film of painted colors. In one shot, Giuliana sits next to a pot of blue paint, speculating about what color to paint the interior of her new shop. In interviews and articles about the film, Antonioni also repeatedly referred to painting. In one interview, for example, he cited Picasso's blue period, in which color fulfils a sensual rather than a representational function (Antonioni 1996: 99). Elsewhere, he extended his analogy with painting to the practice of working with color on film:

I'm forced to modify or eliminate colors as I find them in order to make an acceptable composition. Let's suppose we have a blue sky. Who knows if it's going to work; or, if I don't need it, where can I put it? So I pick a grey day for

neutral background, where I can insert all the color elements I need – a tree, a house, a ship, a car, a telegraph pole. It's like having a white paper on which to apply colors. If I begin with a blue sky, half the picture is already painted blue. (1996: 161)

The connection between painting and film-making has been a running theme in discourse on cinema for over a century. As the above quotations by Dreyer, Tarkovsky, and Antonioni demonstrate, the historical imaginary of painting has provided a major reference point for how film practitioners have perceived their own work.[12] At the same time, the impulse to make connections between painting and cinema has extended far beyond art film-makers. Rouben Mamoulian (the director of *Becky Sharp* [1935], the first full-color Technicolor feature film) boldly asserted that "we, the makers of colour films, are actually painters. We are painting with light…." (1960: 71). *Painting with Light* was also the title of cinematographer John Alton's influential 1940s textbook on lighting. Lacking clear cultural antecedents, cinema adopted art history as its own.

Of course, painting and cinematography are fundamentally distinct processes. Painters use colors that come out of jars and tubes; their works are the result of the application of pigments. Cinematographers use cameras; their works derive from the passage of light through a lens. The visual results of the technology that each group takes for granted are for the other an impossible dream. Throughout the history of art, especially from the late *quattrocento* onward, painters have struggled to represent light with pigments. In film, by contrast, *color* is represented indirectly and *light* is represented directly: the monochrome tonality of an image captured on a film negative is an index – a physical trace – of the light passing through a lens, while its color is the result of a mixture of dyes. For several decades, these dyes reproduced color extremely imprecisely, resulting in the intensely saturated colors that came to typify Technicolor films. Materially, technologically, and aesthetically, painting and cinema thus have little in common. They have also followed very different evolutionary trajectories. For example, as Jacques Aumont observes, at the same time that cinema was struggling to achieve accurate color representation, painting was embracing non-representational color and abstraction (1994: 181).

In a sense, the connection between painting and cinema is an imaginary one. But imaginary connections produce real connections. By imagining itself to be connected with painting, cinema created a connection. Jacques Aumont characterizes cinema's connection with painting, for which read

film-makers' attitude to painting, as one of "fascination, fear" (1994: 182). The fascination stems from painting's supposed proximity to the act of creation. Directors aspire to the freedom and control of a painter, so look longingly to painting as a model. Yet they can never achieve this aspiration, hence fear. Their fear is that they are not, and will never be accepted as, true artists. I would add a third element to cinema's imaginary relationship with painting: validation. Painting is a cause of cinema's feelings of cultural inferiority, but also a solution to them. Many film-makers have used the historical imaginary of painting to legitimize their work. In interviews and writings, Andrei Tarkovsky used analogies with painting to assert the position of cinema as "a great and lofty art form" and, by implication, to assert his own importance as an artist (Golovskoy 1986: 120). In the face of a Soviet bureaucracy dismissive of his films, he asserted their value by giving them an art historical genealogy.

Asserting cinema's art historical credentials is rarely a neutral act. Connecting cinema with art history can serve a wide variety of agendas, even contradictory ones. For example, when making *Becky Sharp*, Rouben Mamoulian emphasized the fact that the film was in full color by using as much color as possible (Higgins 2007: 32). To justify the aesthetic choice of filling his film with intensely saturated colors, Mamoulian referenced painting: cinematic color is like paint, he implied, so let's spread it thick. This approach to color did not fit with Technicolor's business plan, so – following the release of *Becky Sharp* – Natalie Kalmus published her seminal article "Colour Consciousness." In it, she established the "law of emphasis," an alternative paradigm for how films should use color. Color should not draw attention to itself, Kalmus asserted, unless it is narratively significant. Kalmus also mobilized cinema's imaginary art history to further her argument, suggesting that film-makers should take inspiration from Rembrandt, Goya, and Velásquez (1935: 140). In order to legitimize Technicolor's goal that its technology be used to achieve "realism" rather than spectacle, Kalmus plundered art history for antecedents. The "law of emphasis" was a good law, implied Kalmus, because Rembrandt himself had followed it. In this way, Kalmus re-imagined art history in a form more supportive of Technicolor's economic goals.

Of course, cinema's imaginary art history not only manifests itself in discourse; it has also directly influenced film-makers' uses of color. Sergei Eisenstein noted that the rise of Technicolor in the 1930s unleashed a torrent of lurid biopics about painters (1970: 206). Though this trend soon abated, painting continued to influence screen aesthetics. It provided color cinema

with one of its visual paradigms – the paradigm of color as a surface phenomenon. As I discuss further in Chapter 4, throughout the classical Hollywood era and beyond, color manifested itself not as colored light but as pigments inherent in and applied to objects' surfaces. Despite his claim, Rouben Mamoulian did not "paint with light." Instead, he filled *Becky Sharp* with surface colors – painted stage sets and props, dyed costumes, and applied make-up – and then filmed them. Though the term "painting with light" attempts to resolve the differences between the action of the brush and that of the camera, in fact it emphasizes their irreconcilability. The more film-makers have attempted to exploit perceived connections between painting and cinematography, the more apparent the discrepancy between the two has become. Watching his production crew at work painting branches, Antonioni soon realized the absurdity of his dream of a white forest:

> Painting a bush is simple; but the top of a forty-meter-tall pinion pine which looks, from the ground, like a small patch of green, becomes, for the painter who sees it from the ladder pushed far up in the tree, a tangle of branches that you cannot finish whitewashing. (1996: 84)

Antonioni reminisces that the following day the sun came out behind the forest and the whitewash disappeared into shadow. Natural light over-whelmed his attempt to control profilmic color, providing his painterly aspirations with a glaring reality-check.[13] He abandoned the shot.

Given the difference between painting and filming, it is no surprise that after an intense but brief period of chromatic experimentation, art cinema's bright pigmentary colors soon faded. In the late 1960s and early 1970s, art cinema followed New Hollywood's move away from heightened color and toward a more active engagement with natural light. After the sensuous color of *Il Deserto Rosso*, Antonioni explored the grays and whites of mod-ernist London in *Blow Up* (1966). After the graphic reds, whites, and blacks of *Cries and Whispers*, Bergman allowed more banal everyday colors into his television film *Scenes from a Marriage* (1973).

Unmotivated Chromatic Hybridity

Color played a central role in the visual culture of the 1960s. It provided a focus for experimentation by artists, film-makers, graphic designers, and fashion designers. With hindsight, the 1960s appears to us as the decade in

which the media landscape erupted with color: it was the decade of Warhol screen prints, of *Sergeant Pepper's Lonely Hearts Club Band*, of tie-dye T-shirts and acid trips. But black-and-white was also prominent during this time. As a result, the 1960s' media landscape involved countless chromatic juxtapositions. For much of the decade, television stations' nightly schedules and movie theaters' weekly programmes included a mix of black-and-white and color material. The *oeuvres* of individual film-makers also typically involved a mixture of black-and-white and color films. In addition, the presence of what I previously identified as a chromatic thaw between black-and-white and color also manifested itself *within* films. The juxtaposition of black-and-white and color shots or sequences within films was not new – it had been common in Hollywood musicals in the late 1920s, and again had become briefly fashionable after the popular success of Victor Fleming's *The Wizard of Oz* (1939).[14] However, chromatic hybridity conventionally required explanation. Even Sergei Eisenstein had felt the need to explain the color banquet scene in *Ivan the Terrible, Part 2* (1946) by suggesting that it was expressive of Ivan's delirious psychological state.[15] By contrast, in films including Claude Lelouch's *Un Homme et une femme* (1966), Pier Paolo Pasolini's *Teorema* (1968), Oshima's *Diary of a Shinjuku Thief* (1968), and Lindsay Anderson's *If....* (1968), black-and-white and color sequences alternate apparently at random. In these films, the various compositional motivations used to explain the coexistence of black-and-white and color in classical Hollywood films (black-and-white signifying reality and color signifying art, dreams, flashbacks, etc.) are absent. In addition, not only do the above films reject the various oppositional meanings conventionally given to black-and-white and color, they also reject the opposition itself. In Pasolini's short film *La Ricotta* (1963), a prototypical example of what I refer to as unmotivated chromatic hybridity, there is still a faint historical afterimage of opposition. Color footage of a *tableau vivant* of the crucifixion (art/painting) is interlaced with black-and-white behind-the-scenes footage (documentary/realism). In the other films listed above, black-and-white and color no longer even perform the minimal function of separation. Chromatic transitions occur independently of any other changes taking place within the film. The relations that the films establish between black-and-white and color cannot be explained by reference to story, character, or theme.

Clearly, the principles of compositional, realistic, and intertextual motivation that I discussed in the previous chapter are not applicable here. At the same time, the above films' chromatic hybridities are not the result of chance.

Making a film is a protracted process that precludes the option open to a painter of making instantaneous, intuitive choices about what hues to use. Film stocks need to be budgeted, ordered, delivered, and tested. It is therefore no surprise that Lindsay Anderson cited pragmatic reasons for his choice to include black-and-white and color sequences in *If....*: "To shoot the picture entirely in color would have meant another week on the schedule and more money on electrics" (Gelmis 1971: 108). At the same time, unmotivated chromatic hybridity is such an unconventional aesthetic choice that economics can never quite provide a sufficient explanation for its use. If money was tight, why did Anderson not cut out a scene or simplify his camera set-ups? The answer is that unmotivated chromatic hybridity had already become an aesthetic modus operandi for him, an element of his consciously counter-paradigmatic personal style. Anderson's seemingly ingenuous explanation conceals the fact that he had already combined black-and-white and color sequences the previous year in *The White Bus* (1967).

It is at this point worth invoking Raymond Williams's concept of the dominant, residual, and emergent. Williams uses these three terms as a means of complicating the simplistic view of history as a linear series of "epochs." Though it is not unreasonable to define an epoch by the dominant cultural practice that exists within it, for example "feudalism" or "bourgeois capitalism," a more precise analysis demands that the "internal dynamics" at work within specific epochs should also be examined (R. Williams 1977: 121). According to Williams, these internal dynamics involve the interplay between dominant, residual, and emergent cultural practices and meanings. "Residual" refers to practices and meanings originating in the past that continue into the present, but which are no longer an element of dominant culture – examples include organized religion and homophobia; "emergent" refers to new practices and meanings that are fundamentally alternative or oppositional to dominant culture (1977: 122). These terms can usefully be applied to cinema's chromatic history. The codified opposition of black-and-white and color was an element of the dominant cinematic practice of *motivation*. Unmotivated chromatic hybridity was an example of emergence. It was a new practice that developed in dialectic response to Hollywood's codification of black-and-white and color, and formed part of a broader rejection of the classical Hollywood paradigm of motivation.

Given the political climate of the late 1960s, it is possible also to see the counter-paradigm of unmotivated chromatic hybridity in counter-cultural terms. It is surely no coincidence that the film-makers who used this technique the most – Anderson, Pasolini, Oshima, as well as Alexander Kluge

and the Straub-Huillets – were all political as well as stylistic radicals. Unmotivated chromatic hybridity was one of an arsenal of techniques with which they assaulted bourgeois cinema. A startling example of the counter-cultural potential of this technique can be seen in Vera Chytilová's Czech new-wave film *Daisies* (1966). *Daisies* follows the progress of two young women in their quest to challenge as many social conventions as possible. For example, in a scene set in an exclusive restaurant, Marie I (Jitka Cerhová) and Marie II (Ivana Karbanová) stuff themselves with food as noisily and messily as possible. Their grotesque display is put on for the benefit of the other patrons and of their dining companion, a horrified male establishment-figure, who is of course following social convention by paying for their gluttony. Chytilová's socially anarchic film is also chromatically riotous. The film is full of saturated diegetic color. For example, the two Maries wear dresses dyed in acidic colors and eat magazine photographs of colored foods. Black-and-white and "natural" color shots alternate with such frequency that neither can be regarded as the film's chromatic default. However, the real source of chromatic anarchy in *Daisies* is chemical.

In addition to the cinematographic color, monochrome shots are themselves often colored through tinting and toning. In one shot, for example, black-and-white is toned green and tinted purple, resulting in what Phillipe Dubois might refer to as "green-and-purple" (Plate 2.8). Needless to say, the film's chromatic movements are entirely unmotivated, fluctuating between black and white, tinted, toned, and natural color sequences seemingly at random. Unmotivated chromatic transitions also take place within sequences – for example, in a dialogue sequence between two characters, a color shot of one character may be followed by a monochrome reverse angle of the other. Indeed, the film's various chromatic configurations and reconfigurations appear to be almost entirely independent of the diegesis. In an extreme example of diegetically unmoored color, a single monochrome shot cycles through various toned variants – green, blue, orange, purple, yellow. The colors change every second, timed to synchronize with the sound effect of a ticking clock: the non-diegetic sound of the clock motivates the changes from one non-diegetic color to another. No wonder the two Maries sit bored against a wall throughout this scene, oblivious to the visual games that are taking place around them. The colors and even the mis-en-scène in this shot are influenced by the famous party scene in Godard's *Pierrot le Fou* (1965), in which a black-and-white shot of Jean-Paul Belmondo standing next to veteran director Sam Fuller cycles through red, blue, and green tints. But Chytilová plays Godardian games with color

to an even greater extent than Godard himself; what Godard sustains for a few minutes, Chytilová sustains for the length of an entire film. As a result, in the chromatic heterotopia of *Daisies*, the separation between color and diegesis becomes absolute. All colors (including black and white) run free.

Like most emergent practices of the 1960s, unmotivated chromatic hybridity failed to establish itself within dominant culture. Though temporarily obscured by the chromatic thaw of the 1960s, the opposition of black-and-white and color survived and took on a new form in the 1970s, as I discuss in the next chapter. Nonetheless, the above films' unmotivated fluctuations between black-and-white and color were not a historical dead-end. Unmotivated chromatic hybridity remained an art film topos throughout the 1970s and 1980s, perhaps most notably in the films of Andrei Tarkovsky. Tarkovsky's first short film, *The Steamroller and the Violin* (1960), was color; his first feature film, *Ivan's Childhood* (1962), was black-and-white. His subsequent six feature films, made between the mid-1960s and mid-1980s, all combined black-and-white and color.

Tarkovsky's approach to color was superficially similar to that of Antonioni. Both went to extremes to suppress natural color in their films. In *Il Deserto Rosso*, Antonioni made his crew paint a forest white, while in *Stalker* (1979) Tarkovsky made his crew remove all the yellow flowers from a field one by one (Turovskaya n.d.). At the same time, this similarity conceals difference. Antonioni's goal was to control natural color, while Tarkovsky became increasingly obsessed with minimizing the presence of color altogether. Antonioni's control of color could, for example, involve painting a wall bright red; what mattered was that he chose the color. By contrast, Tarkovsky's control involved removing as much color as possible so as to create a visual environment in which color was "spaced out, toned down" (Tarkovsky 1986: 138). In an interview dated 1966, the year he completed *Andrei Rublev*, Tarkovsky said:

> On the screen colour imposes itself on you, whereas in real life that only happens at odd moments, so it's not right for the audience to be constantly aware of colour…. In real life the line that separates unawareness of colour from the moment when you start to notice it is quite imperceptible. Our unbroken, evenly paced flow of attention will suddenly be concentrated on some specific detail. A similar effect can be achieved in a film when coloured shots are inserted into black-and-white. (1994: 356)

Andrei Rublev was Tarkovsky's first attempt at inserting color details into a colorless environment. The film is black-and-white for all but its last few

minutes, at which point color makes a startling appearance in a montage of close-up tracking shots across a fresco painted by Rublev. Though the visual effect is startling, there remains a residuum of conventional opposition in this transition. Black-and-white represents the reality of Rublev's outer life – nowhere in the film is there a single shot of him practicing his art – which gives way to the transformative color of his painting, the product of his inner life. The opposition also works inversely: after a fictionalized account of Rublev's life, we see a real example of the artist's work. Either way, the transition involves opposition.

In *Solaris* (1972), Tarkovsky's next film, the two formats exist in a far more fluid relationship. The film begins in color, on the eve of a journey by Kris Kelvin (Donatas Banionis) to a space station in orbit around the mysterious planet Solaris. Years previously, an astronaut returned to Earth claiming that the ocean on Solaris had communicated with him by turning his thoughts into material reality. Since then, the space station has become run down. Kris's job is to decide whether it should be decommissioned. Before he leaves, he receives a visit from Berton (Vladislar Dvorzhetsky), the astronaut who experienced the manifestation. The film's first move from color to black-and-white occurs when Berton plays a videotape of the official investigation into his claim. The debrief, in which various government functionaries question Berton, is first seen in the form of a framed black-and-white moving image played on a screen in the living room of Kris's colorful family dacha. There is then a cut to full frame black-and-white, as the questioning continues. The separation of color reality and black-and-white representation initially appears quite conventional. But there then occurs a chromatic *mise en abyme*: in the videotaped debrief, Berton suggests that his interrogators watch a videotape that he recorded of his manifestation. Everyone turns to look at a screen in the meeting room. An on-screen countdown commences, and when it reaches zero, there is a cut to a full-screen *color* shot of the ocean on Solaris. The color of the film-within-the-film-within-the-film then cuts back to a color shot of Kris's living room, the film's outer skin of reality. Rather than signifying temporal or spatial segregation, the movements between black-and-white and color serve to collapse space and time: Tarkovsky emphasizes spatial and temporal separation only to undermine it. Subsequent movements between color and black-and-white also resist diegetic explanation. Often the transitions are barely even perceptible. For example, as Berton returns home in a taxi, the sequence alternates between black-and-white and color. However, as the color values in the tunnels through which he passes are muted by

darkness, the alternation is not always apparent. Even more subtle is the film's transition from Earth to space. It takes place in a single cut between an exterior shot of Kris's family home and a starscape. Though this cut is also a transition from black-and-white to color, the stars are white on black, so it is only in the subsequent close-up of Kris's eyes that it becomes apparent the film has moved to color. For a few moments, in the shot of the stars, the film floats in perfect ambiguity between monochrome and color.

In the above examples, the visual evidence that there has been a chromatic transition is deferred and the line that separates black-and-white and color is made indistinct. At other times, the transition serves to create the momentary awareness of color that Tarkovsky aspired to in his 1966 interview. For example, as the door to the closet in Kris's bedroom slides shut, the red interior light, visible through a small circular window, switches off. At the same moment the image becomes black-and-white. Through the window there is now only black; the small circle of red suddenly becomes prominent in its absence. The result of such stylistic sleights of hand is a sense that black-and-white and color exist in a dynamic relationship, sometimes flowing into each other, sometimes impacting against each other. This protean relationship is augmented by the fact that *Solaris* also includes blue and amber tinted images. When Kris arrives at the space station, he discovers that his friend Gibarian (Sos Sargsyan), one of the station's crew of three, has recently committed suicide, leaving behind a videotaped message. When Kris watches the tape on the screen in Gibarian's room, the room is black-and-white, but the screen is tinted blue (Plate 2.9). However, when the film cuts to a full-screen shot of the video, it turns from blue tinted monochrome to grayscale monochrome. Gibarian talks to Kris in black-and-white, and Kris listens in black-and-white. Again, time and space are flattened – it appears that Kris and Gibarian are physically next to each other. Ghostly monochrome brings Gibarian back to life despite his suicide several weeks ago, just as the ocean brings Kris's ex-wife Hari (Natalya Bondarchuk) back to life despite the fact that she too killed herself. In a sense, *Solaris* does not alternate between black-and-white and color, but rather ebbs and flows through a range of chromatic alternatives. These include color shots filled with saturated color (for example, the space station's yellow landing bay), color shots void of saturated color (the space station's white corridors), and color shots with small fragments of saturated color (Kris's closet). Other alternatives include pure black-and-white shots, and tinted black-and-white shots. For example, when Hari comes back from the dead in Kris's bedroom after drinking liquid Nitrogen, the scene is amber tinted.

Color floats through *Solaris*, unmoored from meaning. It is no surprise, therefore, that people with whom I have discussed the film have repeatedly misremembered color sequences as black-and-white and vice versa. *Solaris* emphasizes how unreliable our chromatic memory is. Cognitive research suggests that our memory of the color characteristics of objects is weaker than our memory of other characteristics including shape (Davidoff 1991: 109). So we rely on colors' cultural associations to help us. For example, when we remember films, our memories of what is black-and-white and what is color are influenced by our memory of how the two modes of representation have typically been used. A black-and-white flashback sequence is more easily remembered as black-and-white because it is a flashback; art films too are typically remembered as black-and-white because they are art films. In films with chromatic fluctuations unconstrained by convention, our chromatic memory often also finds itself adrift. Once the vagaries of memory are combined with the material changeability of film itself, in which colors vary from print to print and fade over time, chromatic confusion ensues.

By way of example, I return to the shot of Kris watching Gibarian's final message. In a Kino Films video and DVD release of *Solaris* dating from the late 1990s, the entire sequence has the same blue tint as the video monitor: the shots of Gibarian, the shots of Kris, and the shots of Kris watching Gibarian are all tinted blue. Following the Kino release, a number of cinephiles who remembered seeing the film in a cinema questioned whether this blue was present in original prints of the film.[16] For a time it appeared that nobody could remember for sure whether the sequence in question had originally appeared as blue or not. This uncertainty was compounded by the fact that when black-and-white negatives are printed on color stock, as they would have been on the release prints of *Solaris*, the black-and-white adopts a slight blue cast. The confusion was eventually resolved by the film's cinematographer, Vadim Yusov, who confirmed in an interview filmed for Criterion's 2002 DVD release of the film that the original footage had been shot in pure black-and-white. Accordingly, the Criterion DVD "restores" the sequence in question to pure black-and-white, even though the film's cinema audiences continue to see it with a slight blue tone. Tarkovsky would have appreciated these ambiguities.

Clearly, Tarkovsky's repeated transitions between monochrome and color, in *Solaris* and in each of his subsequent films, are not the work of an artist stuck in a rut, unable to let go of an obsolete mode of representation. Rather, they reflect an appreciation that accepting color does not necessitate

rejecting black-and-white, and that the two can interrelate in a manner that transcends opposition. In *A Film By Andrei Tarkovsky* (1988), Michal Leszczylowski's documentary about the production of Tarkovsky's last film *The Sacrifice* (1986), Tarkovsky sits in what may have been his death bed, and explains to cinematographer Sven Nykvist that he wants the viewer to see a specific detail in both black-and-white and color versions. Tarkovsky does not privilege color over black-and-white or black-and-white over color, he treats the two as ontologically coexistent. By extension, it is possible to see Tarkovsky's films as the product of a refusal to accept that black-and-white had been invalidated by the rise of color. His films are not merely a response to a mediated world in transition from black-and-white to color, they are a manifestation of the moment of transition, replayed again and again. Each film is a new attempt to renegotiate the inversion of the balance of power between color and black-and-white that occurred in the 1960s. Cinema's transition to color is repeatedly undone and then redone.

Contemporaneous film-makers including Edgar Reitz, Raúl Ruiz, and Derek Jarman also habitually mixed black-and-white and color in unconventional ways. The results of this experimentation include Edgar Reitz's *Cadillac* (1974) and *Heimat* (1984), Raúl Ruiz's *City of Pirates* (1984), and Derek Jarman's *The Last of England* (1987) and *The Garden* (1990). Each of these films includes movements between black-and-white and color that defy schematization. For example, Edgar Reitz's landmark television series *Heimat* moves between black-and-white and color not only from sequence to sequence but also within sequences, from shot to shot. As Reitz emphasized in an interview, the chromatic shifts are determinedly indeterminate: "Black-and-white does not mean either present or past, dream or reality. It remains a peculiarity of this film" (Weyand 1984). However, such uses of color and black-and-white were not – yet – common practice in dominant cinema. The chromatic fluctuations in *Heimat* were so alien to prime-time viewers that before every episode a television announcer had to warn viewers not to adjust their sets (Weyand 1984).

Far more common, and comprehensible, were chromatic hybridities premised on opposition. Oppositions signaled by the use of black-and-white and color typically replicated those seen in 1930s and 1940s Hollywood movies: they included waking/dreaming, Earth/Heaven, and life/art. There was however one pivotal difference between the two periods: they existed on opposite sides of the 1960s, a turning point in the history of black-and-white and color. In the 1960s, color became cinema's chromatic norm and black-and-white a divergence from this norm. As a result, the two formats'

connotative polarities reversed: what black-and-white had signified in the 1940s, color now signified and vice versa.[17] The *here and now* of perceived reality was color not black-and-white. Commensurate with this reversal, color became the default in hybrid films, and black-and-white the altered state. For example, in François Truffaut's *La Nuit Américaine* (1973), the recurrent nightmares experienced by a beleaguered film director, played by Truffaut himself, are black-and-white; everything else is color. In Vincent Ward's *Navigator: A Mediaeval Odyssey* (1988), a group of villagers living in a chiaroscuro stylization of the English Middle Ages dig a tunnel to the color *here and now* of 1980s New Zealand. For the villagers, the move to color is an escape from life in the shadow of the Black Death to a fantasy world of synthetic hues and electric light; for the viewer, the move to color is a return to reality. The film's oppositions between reality and fantasy run in both directions along the axis of the villagers' tunnel.

There is another opposition at work in *Navigator*, which since the late 1960s has come to occupy a central position in the relationship between black-and-white and color. This opposition is of course that of past and present. Time was not a common axis of opposition in classical Hollywood; the only classical Hollywood film of which I am aware that uses black-and-white and color to separate two different periods in time is Otto Preminger's *Bonjour Tristesse* (1958). By contrast, since the late 1960s, the separation of past from present has gone from being the least common to the most common motivation for including the two modes of representation in one film. The monochrome tonalities of the past, and of *pastness*, cast a long shadow over color cinema and over the rest of this book.

Monochrome Purgatory: Absent Color in the Soviet Bloc, 1966–75

The global rise of color was in large part an economic phenomenon driven by the United States. The abandonment of black-and-white by the United States' media in the late 1960s inevitably encouraged other countries' media to follow. The final transition of cinema and television to color occurred almost simultaneously across all countries whose entertainment industries competed with those of the United States: French, Spanish, Mexican, Italian, British, German, Japanese, and many smaller film and television industries had all completed their move to color by the start of the 1970s. At the same time, there remained a small number of countries in which the transition

did not occur as quickly. Before moving on to discuss the evolving connection between black-and-white and the past, I explore some of the countries in which black-and-white remained a mode of representing contemporary experience for several years after its global demise.

India, for example, moved slowly to color. Though it is now difficult to imagine a Bollywood film without color, before the mid-1970s India's film output had been almost entirely black-and-white. A few Bollywood films including the early blockbuster *Aan* (Mehboob Khan, 1952) had used Technicolor in the early 1950s, but the process had proved prohibitively expensive even for high-budget productions. A temporary surge in color had occurred following the opening of a local Gevaert factory in 1954, resulting in a number of Gevacolor Bollywood films.[18] However, though I have not been able to discover the fate of this factory, the near absence of color film production in India from the late 1950s until the mid-1970s suggests that Gevaert's overseas venture did not last long.[19] With the exception of this brief detour into indigenous color production, India did not produce its own color film stock until 1973 (Rajadhyaksha & Willemen 1994: 27). Nor was the use of imported stock an option. From the mid-1960s, a handful of Bollywood films, including Vijay Anand's odd-couple comedy-melodrama *Teesri Manzil* (1966), began to use Eastman Color. However, Eastman Kodak products came with punitive import duties, peaking at a staggering 250 percent in 1973 (Rajadhyaksha & Willemen 1994: 27). The aim of these duties, imposed by Indira Ghandi's socialist Congress government, was apparently to encourage directors to use East German Orwocolor (Mahajan 1996: 8). The actual result was that most directors used black-and-white.

In addition, a number of the demand-side factors that pulled other countries toward color in the late 1960s were less pronounced in India. Exposure among the populace to television was extremely low, so even when national television moved to color in the early 1970s, the effect on domestic film production was not as pronounced as in countries where television and film were in more direct competition. Exposure in India to American movies was also low. The variety and popularity of domestic features ensured that Hollywood did not have the same stranglehold over exhibition as it did in most other countries, resulting in relatively weak market-driven pressure to switch to color. The overall result of these factors was the combination until 1973 of a strong supply-side incentive to use black-and-white and a relatively weak demand-side pull toward color, leading to a continued use of black-and-white in all sectors of Indian cinema. Even Hindi musicals, for

example *Lagaan* (Ramanna, 1971) and *Anubhav* (Basu Bhattacharya, 1971), continued to appear in black-and-white.

Black-and-white also lingered into the early 1970s in socialist Soviet Bloc countries.[20] Its dying breath, however, took place in the Soviet Union itself. Black-and-white remained the chromatic default in Soviet cinema for much of the 1970s. In 1974, an official press release boasted that 60 percent of Soviet film output was already in color (Trosko & Komar 1974: 923). Considering the fact that the figure in most of the rest of the world was close to 100 percent, what is notable is that at least 40 percent of Soviet production remained black-and-white. Given the tendency of the Soviet authorities to exaggerate their achievements, the figure is probably far greater. Why this lag?

The most obvious explanation for the Soviet Union's delayed transition to color is that the economic forces that helped propel the free-market and mixed economy industries to color in the late 1960s were far weaker in the centralized economy of the Soviet Union. All Soviet films of the period were produced under the aegis of Goskino, the administrative superstructure in charge of all aspects of Soviet cinema including production, national and international distribution, foreign film imports and even film criticism. In a political structure where conformity was the sine qua non of success, the bottom line was not money but ideology. What mattered most to the bureaucrats at Goskino and its subsidiary film studios was that their production conformed to official doctrine and that it was acceptable to members of the Central Committee, as well as to the numerous other individuals and committees – from army generals to local unions – that could and often did voice objections to the ideological content of films. If a film failed to make a profit, only the state bank lost out; if a film was criticized on ideological grounds, the reputation of everyone involved in its production and distribution was tarnished. The priorities of Gyorgy Yermash, chairman of Goskino (1972–86), are eloquently summarized in the following entry in Tarkovsky's diary, written after Yermash refused to take *Mirror* (1975) to Cannes: "*Mirror* could bring in foreign currency – but that is of no interest to Yermash. All he cares about is having his arse in a comfortable chair, and to hell with the interests of the nation!" (1994: 107).[21]

As a result of Goskino's politicized monopoly, whether a film was made in black-and-white or color was more dependent on the availability of resources than the anticipation of revenues. For a number of reasons, the logistics of supply favored black-and-white for much of the 1970s. Perhaps the most important factor was the limited availability of good quality color

film stock. Before World War II, the only commercially established color film processes were Technicolor in the United States and Agfacolor in Germany. Attempts at color in other countries occasionally achieved a degree of success, but they lagged behind technologically. The Soviet Union lagged especially far behind, having only reached the two-color additive stage of film color's technological evolution (Leyda 1960: 338). The Soviet Union's first exposure to subtractive three-color technology came toward the end of World War II when it seized Agfa stock from occupied German territory; famously, Sergei Eisenstein filmed the color sequence in *Ivan the Terrible, Part 2* (made in 1946, but unreleased until 1958) on Agfa stock (Eisenstein 1970: 206). However, the Soviet Union was slow to capitalize on its exposure to this new technology. Over time, most of the post-war color processes derived from Agfacolor managed significantly to improve on the original wartime film's specifications (Andrew 1980: 67). Sovcolor, however, did not: not only were its color values relatively limited in range, but they also often changed from one batch of raw stock to another, leading to frequent continuity problems.

In response, Goskino began to import a limited amount of Kodak negative. Bought with western currency through Western European intermediaries, it was strictly rationed and highly prized. Of course, the choice of which projects to allocate imported stock to was highly political. Kodak was a mark of favor, reserved for Goskino's preferred projects. The films that received it most often were those granted "highest category" and "first category" status, flagship films including Jean Dréville and Isaak Menaker's *Nights of Farewell* (1966) and Sergei Bondarchuk's *War and Peace* (1968).[22] Less privileged directors had two options: black-and-white or Sovcolor. By the early 1970s, Sovcolor was the preferred choice. However, those who wished to continue using black-and-white were not only allowed to indulge this preference, they were actively encouraged to do so. It is another typically Soviet irony that while many art cinema directors working in capitalist industries struggled to hold on to black-and-white, the struggle in the Soviet Union should be faced by those directors wishing to move to color. In an interview with Vilgot Sjöman, Andrei Tarkovsky recalled a Goskino bureaucrat's words during pre-production on *Stalker*: "Comrade Tarkovsky! Please use black-and-white!"[23] Most silver ore mined in the Soviet Union went to military projects, so Goskino had limited raw materials with which to manufacture color stock (Golovskoy 1986: 47). As a result, even Sovcolor was scarce. Encouraged by Goskino's chromatic anxiety, numerous Soviet directors predisposed toward

black-and-white (including Alexei German, Otar Iosseliani and Larisa Shepitko) continued making black-and-white films for much of the 1970s. Their individual motivations for using black-and-white generally conformed to the motivations detailed in this and other chapters: they used it variously because of its perceived authenticity, because of its aestheticizing properties, as a mark of seriousness, and as a means of coping with inadequate budgets. On an industry level, however, black-and-white's continued presence was motivated by supply-side economics.

At the same time, contrary to Tarkovsky's implication, throughout the 1970s Gyorgy Yermash was responsible for a discreet commercialization of Soviet cinema. Under his guidance, Goskino took its first steps in creating mechanisms through which demand could influence supply. For example, a computerized method was implemented in the mid-1970s for collating and analyzing the box-office figures of recent releases and anticipating potential market performance of proposed films (Golovskoy 1986: 51). Evidence from the period suggests that there was not the overwhelming demand for color in the Soviet Union that there was in most capitalist countries. In one of the earliest economic reports carried out within the Soviet film industry, nine key factors were singled out as crucial for audience appeal. Color was not one of these (Iosifyan 1976). Considering the continued presence of black-and-white in the Soviet media landscape, this is not altogether surprising. Numerous films continued to be released in black-and-white, including films that had originally been made in color; the scarcity of color stock resulted in many second-, third-, and fourth-category color films being released regionally on black-and-white prints (Golovskoy 1986: 47).[24]

Nor did the global dominance of color have much effect on the Soviet media landscape or influence on Soviet cinemagoers' expectations. Goskino rigorously vetted foreign material, and the number of theatrically released American films rarely reached even double figures per annum (Golovskoy 1986: 134). Of this small number, most films were released after a delay of anything between a few years and a few decades – Charlie Chaplin's *The Gold Rush* (1925) took 52 years to secure a release in the Soviet Union. As a result, the limited international competition faced by Soviet films in the 1970s came in the form of a mixed collection of black-and-white and color films. Exhibition of a broader range of non-Soviet cinema was restricted to film societies, which through various official and unofficial means often managed to secure prints of post-war auteur films.[25] Yet even this means of exposure to international material was unreliable – film

societies prospered in the 1960s, but ideological criticism led to the majority of these organizations being dissolved in the 1970s (Golovskoy 1986: 58). Inevitably, international trends exerted a limited influence not only on viewers' expectations but also on directors' motivations. The absence of any institutional motivation for directors to move to color was reinforced by a cultural environment in which the global film industry's move to color was viewed with a degree of detachment. Soviet directors were able to observe the rise of color through their relatively privileged – albeit still limited – exposure to Western films, but often felt no pressure to follow. Like Tarkovsky, a large minority of Soviet directors translated the equivocal response to color felt by their capitalist colleagues into a body of work that continued to use black-and-white.

Considering the range of factors holding color at bay within the Soviet Union, one can perhaps marvel after all at the Soviet boast of 60 percent color production in 1974. Though all relevant economic and social factors within the Soviet Union mitigated *against* the transition to color, the transition nonetheless took place: the global momentum toward color was so overwhelming that, by the late 1970s, even the Soviet Union had succumbed to it. Black-and-white had experienced a global death. In the next chapter, I explore its afterlife.

3

Absent Color

"Black and white are, for me, cinema's most beautiful colours."

Rainer Werner Fassbinder (2004: 587)

Black-and-White as Technological Relic, 1965–83

Underneath every black-and-white image there is a trace of color reality, albeit implied or imagined. We know, though we cannot see, the color of Buster Keaton's devil suit in *Out West* or that of the blood washing down the plughole in *Psycho*. We may imagine other colors not specifically suggested by the film-maker: for example, the colors of the shop-window displays in *Sunrise* (F. W. Murnau, 1927), and of the actors' costumes in *Les Enfants du Paradis* (Marcel Carné, 1945). By the mid-1960s, color had surfaced throughout mainstream media, and no longer required implication or imagination to be felt. Nonetheless, for various reasons, numerous film-makers continued to use black-and-white into the 1970s and beyond. Black-and-white remains a common presence within all areas of moving image culture to the present day. In this chapter, I explore black-and-white film since color. I begin with a key moment in the transition from black-and-white to color.

Cinema's transition to color was the sum of innumerable transitions to color. The transitions of thousands of directors across more thousands of films can be seen as fractals of longer duration transitions, such as those of dozens of national industries, themselves fractals of cinema's overall transition. Cinema's transition to color was itself a fractal of the media's transition to color, a transition that – judging by the evidence of contemporary newspapers, book illustrations, fine art photography, and comic

strips – remains perpetually incomplete. Clearly, only limited explanatory benefit can be gained by extracting specific dates and specific causal factors from this complex network of transitions. Nonetheless, I highlight a single year and a single historical development. The year is 1965 and the development is the movement en bloc of American television news to color newsreel.

Network and local stations' transitions to color reportage were spread across several years, but in 1965 they reached critical mass. The rush to color in 1965 was so great that it resulted in a processing bottleneck reminiscent of that experienced by Technicolor in 1929, as laboratories struggled to cope with the surge in demand (Shafer & Alley 1966: 115). The frantic pace of change can be inferred from contemporaneous issues of *American Cinematographer*, which featured a slew of articles on subjects including how to light color, how to process color in-house, and how to process color through external labs (Stensvold 1966; Nelson 1965; Mulheren 1965). Practitioners with recent experience of moving to color offered advice to those in transition, and encouragement to those still vacillating. Arguments in favor of the move were overwhelming. By 1965, almost all network programming was color, and black-and-white reportage was becoming a broadcast anachronism. The delay in its transition was due to a number of obstacles preventing color from becoming incorporated into newsreel praxis. One by one, in the early to mid-1960s, these were overcome. Color versions of the 16 mm reversal film stocks used in newsreel photography became fast enough to allow filming in most lighting conditions, including artificially lit interiors (Anon. 1966: 198).[1] Laboratories responded to newsroom deadlines by decreasing typical turnaround times for film processing from a few days to two hours (Mulheren 1965: 785). Finally, in 1965, Eastman Kodak released a range of film stocks pre-striped with a magnetic soundtrack that allowed news stations' existing camera and magnetic sound equipment to be used with color (Shafer & Alley 1966: 113).

I highlight the switch of television newsreel to color in 1965 for two reasons. The first is that it was the final stage of American network television's transition to color, and was followed by Hollywood's largest ever single-year cutback in black-and-white film production (Chisholm 1990: 228). If any one year provided a historical turning point between the eras of black-and-white and color, 1965 was it. I also highlight television newsreels' switch to color because it was a symbolic turning point. Newsreels did not always represent viewers' *here*, but they did come as close as film could come to representing their *now*. When news reports also became

color, color became a format of the present – of *current* affairs – and black-and-white, by default, became a format of the past.[2]

Black-and-white film was a technological relic. The black-and-white film print was a material leftover of the past; it referenced the past in a direct, indexical manner. An early example of black-and-white indexically referencing the past is Alain Resnais's *Nuit et brouillard* (1955). In Resnais's elegiac documentary, black-and-white wartime stock footage is juxtaposed with color footage of concentration camp sites a decade later, overgrown with grass. The wartime footage is black-and-white because it was filmed in black-and-white. Throughout the 1960s and into the 1970s, a large proportion of television programming also comprised black-and-white indexes of the past. These included old movies, repeated serials, and fragments of stock footage in documentaries and news reports. The closer television came to full color production, and the more people bought color televisions, the more it became noticeable that the surviving examples of black-and-white were technological relics. In turn, as the old chromatic format of the present turned into a format of the past, it became perceived as a format of the past. In a 1966 article on color, film critic William Johnson used *Nuit et brouillard* as evidence that "color, being more specific, has more immediacy than black and white – the scenes in color appear closer in time and space" (1966: 16). No such temporal distinction was made by reviewers when *Nuit et brouillard* was originally released in 1955.

Before I explore black-and-white's developing association with the past in more detail, it is worth glancing back one last time at television and cinema's transition to color, but from a cultural perspective. The transition to color occurred startlingly close in time to what Fredric Jameson refers to as the cultural *coupure* between modernity and postmodernity (1984: 53). The most significant stages in the transition to color occurred between 1965 and 1967; David Harvey, perhaps the most persuasive theorist of the postmodern, regards the arrival of full postmodernity as having occurred between 1968 and 1973 (1989: 38). Clearly, from a twenty-first century viewpoint, it is no longer possible to regard the late 1960s as a cultural watershed that neatly separates historic past from extended present. What Siegfried Kracauer called "the border region between the present and the past" has already advanced into more recent decades (1960: 57). Nonetheless, if one accepts the argument that the late 1960s was a cultural turning-point, then the temporal co-incidence between the cultural and chromatic transitions of the late 1960s is so close as to appear to be more than just coincidence.

How were the two transitions connected? It seems implausible to suggest a direct causal connection in either direction. It would be a *reductio ad absurdum* of technological determinism to suggest that the move to color led to the diverse cultural changes associated with the rise of postmodernity. If, as Terry Eagleton suggests, "postmodernism is such a portmanteau phenomenon that anything you assert of one piece of it is almost bound to be untrue of another," then any cause that may be attributed to one facet of the postmodern is also almost certain to be untrue of another (1996: viii). It would be equally extreme to reverse this causality and suggest that the move from black-and-white to color was a direct consequence of the decline of modernity. The choice to increase color production throughout the 1960s was not the result of television executives' cultural *ennui* with modernist paradigms. Rather, as I have already suggested, it was the result of many specific technological, economic, and ideological factors. In fact, few academic discussions of the rise of color have felt the need to reference postmodernity at all.

Nonetheless, given their co-incident timing, there must be *some* connection between the completion of television and cinema's transition to color and the broader cultural transition to "postmodernity," even if it is only an indirect one. Perry Anderson clearly believes so, saying of the rise of color television: "If there is any single technological watershed of the postmodern, it lies here" (1998: 88). Anderson sensibly avoids asserting any direct causal link. Instead, he suggests that the rise of color television was a necessary condition for postmodernity. In Anderson's view, three things made the postmodern possible: the decline of the bourgeoisie, the anti-establishment eruptions of the late 1960s, and television's move to color (1998: 84). Anderson echoes numerous cultural commentators from McLuhan to Jameson in suggesting that early television's power to command attention made it the ultimate means of disseminating capitalist ideology. But he adds a caveat: "So long as its screen was only black-and-white, the medium – whatever its other advantages – retained a mark of inferiority, as if it were technically still a laggard stepchild of the cinema" (1998: 88). Color made consumerism more persuasive. This fact is particularly obvious in television commercials. Color provides sensory stimulation, thereby heightening desire, a fact long since noted by Aldous Huxley in *Brave New World*, where "scent and colour" shows help keep the population sensually fixated and politically docile (2004: 78). Compared to the televisual grays that preceded it, color better conveyed and further augmented the erotic appeal of the product: the luscious oranges of fruit juice and the fresh blue-whites of

laundry detergent became even more saturated and archetypal on color television screens.[3] Of course, black-and-white also aestheticizes, but this aestheticization results in a product that provokes detached appreciation. Its abstraction of perceptual reality makes it less able to induce sensual desire, a fact that explains why pornography and cookery shows are rarely black-and-white. Though Oliver Sacks's patient eventually came to appreciate his monochrome vision, he never overcame his aversion to black tomatoes (1995: 35).

Anderson is careful not to overstate his case, but it still seems slightly excessive to suggest that the absence of color moving imagery could have retarded the spread of global capitalism in the 1970s. Nor, for the purposes of this history, is there any need to make such a broad claim. Instead, I suggest two alternative ways in which the visual and cultural transitions of the 1960s interlaced. Firstly, color allowed the full diversity of postmodern visuality to express itself. In contrast to the unifying monochrome favored by cinema's arch-modernists (Antonioni, Tarkovsky, Bergman, et al.), color made possible a myriad of visual contrasts, clashes, and mixtures, providing additional means by which play, chance, anarchy, parataxis, antiform, indeterminacy, and so on, could appear on screen. I discussed anarchic color in the previous chapter, so I restrict myself here to a few brief examples, in the form of the mid-1960s Beatles films. The playful stylistic techniques of Richard Lester's *A Hard Day's Night* (1964) are subdued by the gray midtones of the cinematography, while in Lester's sequel *Help!* (1965) primary colors emphasize the film's exuberant tone. Looking beyond the varied but still scrupulously art-directed splashes of color in *Help!*, we find the uninhibited psychedelia of George Dunning's *Yellow Submarine* (1968), whose tie-dye colors soak into and cycle through each other, disobeying the more rigid connections between color and object that exist beyond the screen.

Secondly, the transformation of black-and-white into a mode of representation associated with the past provided a new means of coding the past.[4] From the mid-1960s onward, filming in black-and-white became a means of signifying that a film was set in the past. Of course, the past itself was never black-and-white, it was only *filmed* in black-and-white. Accordingly, black-and-white initially referenced the past indirectly, by referencing the obsolescent technology of monochrome cinematography. The earliest example that I have found of scenes being shot in black-and-white in order to signal the past occurs in Robert Wise's *Star!* (1965). The film begins in black-and-white with a quasi-documentary about fictional Broadway star Gertrude Lawrence, played by Julie Andrews. The "documentary" takes the form of a

compilation of key moments from Lawrence's early life, including the moment she was abandoned in an empty street by her father, all implausibly caught on film. Black-and-white creates the illusion that the footage we are watching was filmed in the 1940s. A few minutes into the documentary, a blurry color head appears in the foreground of the frame, and it becomes apparent that the documentary is being projected for Lawrence in a private screening room (Plate 3.1). As the projector stops and the film gives way to a wider shot of the screening room, the dubious historical authenticity of the black-and-white footage recedes behind the incontrovertible *here and now* of color.

The nascent convention of opening a film with black-and-white footage and following with a transition to color was developed further in George Roy Hill's *Butch Cassidy and the Sundance Kid* (1969). The film is set in the early years of the twentieth century, in the era of early cinema. While the presence of black-and-white in *Star!* is restricted to a discrete film-within-the-film, in *Butch Cassidy*, for the first five minutes the diegesis itself is sepia.[5] By way of introduction to a stylistic flourish that could have been a source of confusion for late-1960s viewers, the monochrome scenes in which Butch (Paul Newman) and Sundance (Robert Redford) meet are foreshadowed in the opening title sequence. The title sequence comprises simulated stock footage of Butch and Sundance holding up a train (Plate 3.2). The footage is "projected" in a rectangle to the left of the frame, surrounded by auditorial blackness, and accompanied by the aural flicker of a film projector. The framing device of the film-within-the-film makes explicit the fact that *Butch Cassidy* is not an old film but a new film referencing the era of early cinema. By referencing the familiar iconography of old cinema technology, the title sequence trains the film's late-1960s audience to perceive black-and-white as a signifier of the past.

Throughout the 1970s and beyond, films continued to reference the past through overt references to past technology. For example, Frederico Fellini's *And The Ship Sails On* (1983) begins in black-and-white with a scene set in the early twentieth century. A ship prepares to leave port. On the dock, accompanied by the aural flicker of rolling film, a man looks self-consciously toward the camera and tries on a selection of hats. In fact, he is looking at not one but two cameras – Fellini's camera and a diegetic camera. In a sly *mise en abyme*, Fellini then reveals that we are watching a movie being made; in the following reverse shot, we see a cameraman operating a silent movie camera (Plate 3.3). Though the scene remains black-and-white, one camera has split into two: the black-and-whiteness that we see on screen

now belongs to Fellini's camera, not the diegetic hand-cranked camera. This disengagement from using black-and-white to signify the presence of old film technology is metonymic of a broader historical trend. Over the course of the 1970s, once its use to signify the past became a known technique, black-and-white became codified. Gradually, it began to signify the past "directly," without explicitly referencing past representational technology. By the early 1980s, its mere presence was enough to endow moving images with a sense of pastness. The codification of black-and-white in turn made possible a re-codification of its opposition with color. The culmination of this re-codification was the black-and-white flashback.

Black-and-White Flashbacks: Codifying Temporal Rebirth

The word "flashback," originally "flash-back," has been used to describe narrative anteriority in films since at least 1916.[6] The same word also describes a vividly experienced memory, a use which the OED suggests derives from its cinematic meaning.[7] The term thus encompasses the documented past of the *kino eye* and the perceived past of the mind's eye. In the 1970s, black-and-white began to function in a manner that reflected this etymological overlap.

Before the late 1960s, the world was not black-and-white. It was *filmed* in black-and-white. As long as its primary referent was past technology, black-and-white represented technologically mediated *representations* of the past. In *Star!* and *Butch Cassidy*, the black-and-white sequences mimic documentary footage filmed in the past. Black-and-white only represented aspects of the past public enough or significant enough to be recorded by a film camera – events communally experienced or intended to be communally experienced. Hence the black-and-white "documentary" shots of Gertrude Lawrence as a working-class child at the beginning of *Star!* Black-and-white transforms a personal past into movie history, making clear to all Gertrude Lawrence fans that she was destined to be in the public eye, even as a baby. By contrast, black-and-white was not an appropriate means of representing aspects of the past invisible to the public eye. For example, the opening title sequence of Don Siegel's *The Beguiled* (1970) comprises a montage of Alexander Gardner and Timothy O'Sullivan's photographs of the American Civil War. These monochrome images fulfilled the role of document, and were intended for public consumption

through newspapers and monographs. Later in the film, however, when the injured infantryman played by Clint Eastwood experiences flashbacks of combat, his worm's eye view is in color. Black-and-white represents a public, communal, and mediated past. Color represents a private, individual, and "directly" perceived past.

Over the course of the 1970s, the status of black-and-white as a techno-logical relic became less explicit and its signification of the past less overtly mediated. For example, in the opening sequence of Kinji Fukasaku's cult gangster epic *Graveyard of Honour* (1975), black-and-white signifies that the film is set in the past by simple virtue of its presence. The sequence is set in a bustling side street and contains few obvious period-specific markers; there is little to connect the sequence to the past, *except that it is black-and-white*. With black-and-white codified as a signifier of the past, the con-ditions became set for the re-codification of the opposition between black-and-white and color by means of the flashback. As long as black-and-white was tied to representing a past mediated by past technology, it was tied to representing a public past. It was also tied to representing the era in which black-and-white photography and cinematography was the norm, an era that extended from approximately the 1830s to the 1960s. Once freed from its technological referent, black-and-white became able to signify any form of past: private as well as public, remembered as well as recorded, postmodern as well as modern, recent as well as distant.

An embryonic black-and-white flashback occurs in Brian De Palma's *Sisters* (1973). The film culminates in a sequence in which psychotic mur-deress Dominique Blanchion (Margot Kidder) is placed under hypnosis and experiences a flashback to a childhood trauma. The flashback is estab-lished with a zoom in to an extreme close up of her eye, which dissolves to a shot of a circular mask increasing in size to reveal a scene of her childhood filmed in black-and-white (Plate 3.4). In early cinema, the use of a circular mask (iris) to signal point of view was symptomatic of the fact that the subject–object point of view shot structure with which we are so familiar was not yet codified. A shot of a character looking was not enough to imply that the subsequent shot would show us what she was looking at; the object shot still needed to include a visual reminder of the subject's act of seeing. This reminder initially took the form of an iris, as if the eye of the subject were casting a spotlight onto the object perceived. The use of an iris in *Sisters* suggests that in the early 1970s the black-and-white flashback was also not yet codified. The transition to black-and-white was not itself enough to signify narrative retardation, so De Palma provided a surplus of

signification. He used a point of view shot structure, a classical Hollywood technique for introducing flashbacks that makes explicit the fact that – to use Edward Branigan's phrase – "vision is character introspection (1984: 75)." De Palma further clarified that Dominique is looking into her past by using an iris. The iris seems to suggest that when *Sisters* was made black-and-white had not yet escaped its explicit connection with past technology. A few years later, however, De Palma's excess of signification was no longer necessary. In George Romero's *Martin* (1977), color scenes set in the 1970s interlace with black-and-white flashbacks to the late-nineteenth-century past without any additional signposting. In *Martin*, as in *Graveyard of Honour*, black-and-white is a visual code, a formal device that signifies past-ness in the same codified way that a slow dissolve signifies time passing.

Of course, as Christian Metz observed, cinema contains no pure codes (1974: 105). Whenever a film utilizes a recognized formal device, this device brings with it connotations derived from previous uses in other films. Despite its transformation into a flashback cue over the course of the 1970s, black-and-white could not escape the fact that it was an afterimage of past cinema and television. In the following section, I discuss black-and-white's various accumulated connotations in detail. For the moment, I highlight the specific tension between its association with various modes of documentary (newsreel, Neo-Realism, *cinéma vérité* …) and its use as a visual code for pastness. In Alan J. Pakula's *Sophie's Choice* (1982), Holocaust survivor Sophie (Meryl Streep) is haunted by memories of her traumatic experiences at a concentration camp. Black-and-white signifies an experienced rather than a documented past; all it takes is a slight zoom in to Sophie's face and a cut to black-and-white to make it clear that she is looking inward and backward in time. However, the fact that the flashbacks are memories, and so subjective, is soon forgotten. Because the scenes set in the concentration camp are black-and-white, they have a documentary feel. This is reinforced by the graininess and high-contrast of the cinematography, and by a camera position that allows the viewer to see things Sophie herself cannot have seen, so implying the presence of a documentarist (even though a camera would of course never have been allowed to film what happens to her). Pakula's real camera references an imaginary documentary camera, an imaginary camera whose imaginary presence attests to the truthfulness of the images filmed.

In *Sophie's Choice*, rather than acting as a pure cinematic code, black-and-white implies historical authenticity. In my view, the same happens whenever black-and-white is used to reference the past. Even if it does not

overtly mimic old documentary footage, black-and-white still evokes past representations, implying that the image we see is something a camera once saw. Frame-by-frame, black-and-white declares: "This happened." It is notable that out of over 50 color films with black-and-white flashbacks that I viewed in preparation for this chapter, in all but one the truthfulness of the flashback is beyond doubt. A flashback that involves lying, misremembering, uncertainty, or distorted consciousness (as a result, for example, of being drugged), cannot be black-and-white. Black-and-white flashbacks may represent a personal past, but they must be "objective." In this, they fit perfectly within the classical Hollywood flashback conventions observed by David Bordwell:

> Classical flashbacks are motivated by character memory, but they do not function primarily to reveal character traits.... Extended flashback sequences usually include material that the remembering character could not have witnessed or known. Character memory is simply a convenient immediate motivation for a shift in chronology; once the shift is accomplished, there are no constant cues to remind us that we are supposedly in someone's mind. (Bordwell et al. 1985: 43)

In classical Hollywood, the flashback was stripped of its etymological ambiguity and became a code for narrative retardation. By removing consciousness from the equation, classical Hollywood film-makers also removed the flashback's potential for expressing ontological uncertainty. Hitchcock's inclusion of a false flashback at the beginning of *Stage Fright* (1950) was greeted with critical hostility, even though Hitchcock himself regarded it as a relatively minor narrative trick (Truffaut 1984: 275). In post-classical Hollywood, black-and-white has further limited the flashback's potential for ambiguity. The black-and-white flashback, a product of the *kino eye* not the mind's eye, gives the past its own inviolable aesthetic certainty.

As well as eliminating ontological ambiguity, the use of black-and-white for flashbacks eliminates temporal ambiguity. Black-and-white is a particularly efficient means of coding the cinematic past; the move from color to black-and-white signals narrative retardation unambiguously, and does so in the time it takes for one shot to cut or dissolve to another. It also signals narrative retardation continuously throughout the flashback, not just during the initial transition.

The black-and-white flashback is thus the functional opposite of art films' unmotivated chromatic hybridities. It also refutes art cinema's broader engagement with what Deleuze labeled the time-image. As numerous

commentators from Bazin to Cubitt have observed, cinema's tense is ambiguous. Many art films embraced this ambiguity, allowing "past" and "present" to seep into each other. No longer closed off and able to be "put behind" one, the past became a problematic presence. For example, Nicholas Roeg's *Don't Look Now* (1973), one of the last of the new wave of 1960s and early 1970s British art films made with Hollywood money, makes explicit the dangers of temporal ambiguity. After the accidental death of their daughter, John Baxter (Donald Sutherland) and Laura Baxter (Julie Christie) go to Venice, to escape from the traumatic memory of their drowned child. In a scene late in the film, after Laura has returned to England and John has stayed in Venice to oversee the restoration of a church, John stands on a vaporetto. As he looks across the water, he sees his wife, dressed in black, on a passing boat. The shot of Laura carries no temporal clues: it is color, it is filmed in the same style as any other shot, and it is cued with a shot of John looking. As a result, it carries the same disturbing sense of presentness for the viewer as it does for John. Is Laura still in Venice? Or is this a flashback to a moment in the past that John has already forgotten? The final horror of the story hinges on the fact that it is neither of these. It is, as we realize at the end of the film but John himself never has a chance to realize, a flashforward to his own funeral. Oblivious to this warning, he wanders the streets of Venice alone, unconsciously searching out his own death. Unaware of his gift of foresight, John's confusion of present and future costs him his life.

Black-and-white flashbacks provide an antidote to art cinema's troubling mixture of past, present, and (less often) future. They make representations of the past axiomatic, guarding against the danger of temporal ambiguity. Beyond Vincent Ward's *Nagivator*, few tunnels have ever been dug between a black-and-white "past" and a color "present." It is no coincidence that, once safely codified in the form of the flashback, black-and-white soon became re-absorbed into dominant cinema. Indeed, since the mid-1980s, it is in Hollywood films that the monochrome flashback has most often appeared. Examples range from Clint Eastwood's *Heartbreak Ridge* (1986), via Walter Hill's *Wild Bill* (1995), to countless Hollywood sequels referring to the history established by their own franchise (for example, Sam Raimi's *Spiderman 3* [2007]). Also common are films with black-and-white opening sequences. These can be regarded as uncued flashbacks – a move to color, often occurring just before or after the title sequence, retroactively confirms the black-and-white sequence to have been anterior to the film's main narrative. Films in which a black-and-white opening sequence provides narrative backstory include Philip Kaufman's *The Right Stuff*

(1983), Michael Winterbottom's *Jude* (1996), and Martin Campbell's *Casino Royale* (2006). Since the mid-1990s, the black-and-white flashback has also spread to television, becoming a common means of framing narrative backstory in everything from crime series to reality shows.

The opposition of color present and black-and-white past by means of the flashback appears at first glance to be an example of what Raymond Williams refers to as emergent cultural practice (1977: 122). However, I wish to suggest an alternative interpretation. In my view, the "emergence" of this new relation between color and black-and-white was simply a reorientation of classical Hollywood's paradigm of chromatic opposition. In hybrid films of the 1930s and 1940s, black-and-white signified the *here and now* of perceptual reality, and color signified divergences from it (dreams, fantasies, memories, etc.). As previously observed, in the early 1970s an inversion occurred – color became the norm and black-and-white began to signify divergences from the norm. The ways in which the opposition of black-and-white and color expressed itself changed, but the opposition itself remained in place. Far from being a counter-cultural response to dominant ideology, the division of films into color present and black-and-white past was simply part of what Williams labels a "new phase of the dominant culture" (1977: 123). One is reminded of Don Fabrizio's observation in *The Leopard* that for things to stay the same, they must change.

At about the same time that the black-and-white flashback established itself as a visual cliché, a move toward narrative and temporal fragmentation became noticeable at the experimental fringes of popular cinema, as seen in films including Robert Altman's *Short Cuts* (1993) and Quentin Tarantino's *Pulp Fiction* (1994). The increased narrative complexity of much post-1990s cinema highlights just how conventional the black-and-white flashback is. For example, in Alejandro González Iñárritu's *21 Grams* (2003), multiple narrative strands interlace and overlap to such an extent that any attempt to separate "past" from "present" is pointless. Nor is there room for chromatic opposites in what Thomas Elsaesser refers to as "mind-game films" (2009). As already discussed, the use of black-and-white guarantees a flashback's veracity. By contrast, the mind-game film asserts equivalence between narrative modularity and the imperfect workings of the mind. In films including David Fincher's *Fight Club* (1999) and Michel Gondry's *Eternal Sunshine of the Spotless Mind* (2004), temporal ambiguity cedes to an even greater ontological ambiguity; these films' ambiguities no longer center on *when* particular events are taking place but on *whether* they are taking or ever took place. *Fight Club* focuses on a character with a split-personality, and *Eternal Sunshine*

on a character who spends most of the film adrift in his own memories. In contrast to the temporal indeterminacy of narratively complex films and the ontological indeterminacy of mind-game films, the black-and-white flashback is a retrogressive, and so reassuring, presence.

Several paragraphs earlier I mentioned that of all the color films with black-and-white flashbacks that I have viewed, in only one is the truthfulness of the flashbacks uncertain. That film is Chris Nolan's *Memento* (2000). As well as including unreliable black-and-white flashbacks, *Memento* also defies the convention that black-and-white and color sequences should remain temporally unconnected. The film's action follows two main narrative timelines. The first comprises scenes in which amnesiac avenger Leonard Shelby (Guy Pearce) drives around Los Angeles, trying to discover who killed his wife. The second comprises shorter scenes set in a motel room, in which Leonard attempts to piece together all his collected scraps of evidence. The film uses a combination of color for the journey and black-and-white for the motel to keep the two timelines separate. However, this chromatic segregation is rather more ambiguous than it initially appears to be. The two timelines are always separated by a few moments of black, and there is never any segue between them – such as a voice-over – to clarify the nature of their connection. Either could be anterior. The black-and-whiteness of the motel scenes raises the possibility that they are flashbacks, but additional stylistic signifiers suggest otherwise. The motel scenes are grainy, handheld, occasionally overexposed; they have what Nolan referred to in an interview as a deliberate *cinéma vérité* style (Mottram 2002: 122). In addition, they are accompanied by an urgent present tense voice-over, a verbal reminder of Leonard's imprisonment in the *here and now* of his immediate perceptions. Furthermore, the black-and-white scenes move forward in time toward an anticipated climax, while the color scenes recede in time toward an indefinite starting point, drip feeding us elements of backstory, each scene further in the past than the last. The weight of this stylistic evidence encourages us to regard the black-and-white scenes as the film's "present."

In fact, in a brilliant inversion, Nolan reveals that the black-and-white scenes are anterior after all. Leonard finally acquires his last piece of evidence, leaves the motel room and kills "John G," the apparent killer of his wife. He takes a Polaroid of the corpse, and as it develops, the shot of Leonard holding the photo slowly turns from black-and-white to color. In a stunning *coup de cinéma*, the final black-and-white sequence transforms in front of our eyes into the earliest color sequence of the film's chronology. The ending that the film has been leading us to anticipate is revealed to be

just another beginning. The convention of using black-and-white to circumscribe the past, previously exploited, is now exploded.

Folded into this temporal ambiguity is an equally troubling ontological ambiguity. In the motel scenes, Leonard narrates the story of Sammy Jankis, another amnesiac, whose memory loss Leonard scrutinized when he was an insurance investigator. Poor Sammy was such a basket case that his wife eventually committed suicide by exploiting his forgetfulness and persuading him to give her repeated doses of insulin. Leonard's narration is accompanied by low-contrast black-and-white flashbacks, creating a third narrative strand visually distinct from the high-contrast black-and-white of the motel scenes that frame it. Because his encounter with Sammy Jankis predated the death of his wife, Leonard remembers this story clearly and narrates it with certainty. Lending further credence to Leonard's story is the fact that the flashbacks include scenes of Sammy alone with his wife. They appear to us not as mind's eye flashbacks but as *kino eye* flashbacks. Toward the end of the film, however, the *kino eye* begins to malfunction. For example, there appears a brief monochrome shot of Leonard's wife – not Sammy's wife – receiving an insulin injection. Other brief shots allow us the revise our understanding of the flashbacks and hypothesize that the story of Sammy is in fact Leonard's own story: the *kino eye* flashback is perhaps a mind's eye flashback after all. The visual subtlety with which the story of Sammy Jankis unravels cannot be summarized in words, but the result of the unraveling can – the flashbacks that appeared to provide *Memento* with its few reassuring moments of narrative certainty are revealed to lie at the heart of its subjectivity.

Memento is a masterpiece of misinformation. But the film's juxtaposition of color and black-and-white sequences nonetheless limits temporal ambiguity. Despite the modularity of Leonard's memories, the film's two narrative time-lines ultimately join to form a linear story; despite Nolan's narrative ingenuity, the film still separates time into two discrete units in the same way as a classical Hollywood flashback movie. The film's hybridity protects, and prepares for the revelation of, its linearity. Had *Memento* been shot entirely in color, it would have provided a far more disjunctive viewing experience; its two main time-lines would not have been so easily distinguishable, and the final revelation of their temporal continuity might not even have been noticeable.

Memento also conforms to another rule of hybridity implicit in dominant cinema, namely that whenever black-and-white and color coexist in a film, black-and-white must be a minority presence. In *Memento*, the running time of the color sequences is approximately twice that of the black-and-white sequences. The reasoning behind this rule is economic. As I discuss

further in the following section, since the late 1960s producers and consumers have been prejudiced in favor of color. As a result, hybrid films in which the running time of the black-and-white sequences exceeds those of the color sequences have generally been restricted to the low budget and art film margins of the industry, in which the pull to color has been counterbalanced by budgetary constraints favoring the use of black-and-white, or by the stubbornness of an auteur with a proven market value. Examples of films in which color is a minority presence include Andrei Tarkovsky's *Mirror* (1975), Sally Potter's *The Tango Lesson* (1997), and Guy Maddin's *The Saddest Music in the World* (2003). Dominant cinema's craving for color is so insistent that in hybrid films featuring long duration flashbacks, it has often been the flashbacks that have been color, and the shorter framing scenes that have been black-and-white. Sometimes this inverted hybridity can be explained thematically. The main characters in Alan Rudolph's *Mrs Parker and the Vicious Circle* (1994), Peter Bogdanovich's *The Cat's Meow* (2002), and Claude Miller's *Un Secret* (2007) – like those in Otto Preminger's *Bonjour Tristesse* (1958) – look back from a gray present to a colorful past that is now lost to them. Other times, for example in Brian De Palma's *Carlito's Way* (1993) and Steven Soderbergh's *Che* (2008), explanation is neither needed nor given.[8]

The demand that black-and-white remain a minority presence within films is of course symptomatic of its marginalization throughout cinema. Even when there is good reason for its use, black-and-white typically remains unused. Though it is an exceptionally efficient means of signaling the past, since the late 1960s color flashbacks have far outnumbered black-and-white flashbacks. At the same time, this marginalization is only part of cinema's chromatic story. Black-and-white is more than just a signifier of its own obsolescence. It remains a living presence on the fringes of dominant cinema, where it has been used since the late 1960s for numerous reasons and carried numerous – albeit often imprecise – meanings. In the following section, I delve deeper into these various uses and meanings, and into the complex interactions that exist between them.

Black-and-White Films, 1967–2007

Black-and-white has continued to appear throughout color cinema since the late 1960s in the form of old footage, both genuine and simulated. It has also found a niche for itself within dominant cinema in the codified form

of the flashback. But what has happened to black-and-white *films*? The most obvious answer is that they have almost disappeared. Since 1967, the number of black-and-white films in the annual *Variety* Top 50 has never exceeded three. Black-and-white's minority presence within hybrid films parallels its marginal presence across cinema as a whole.

A director wishing to make, and to secure a release for, a black-and-white film faces multiple obstacles. The most significant tend to be the film's executive producers. Patrice Leconte wanted to make *The Girl on the Bridge* (1999) in black-and-white, but France 2 Cinema – the film's principal backer – stipulated that the negative be delivered in color. It was only through the resourcefulness of his cinematographer Jean-Marie Dreujou that Leconte was able to get what he wanted: the color negative was printed onto black-and-white interpositive, resulting in black-and-white release prints (Anon. 1999b).[9] Even Steven Spielberg had to negotiate in order to make *Schindler's List* (1994) in black-and-white, agreeing to forego his salary and defer his percentage of gross film rentals until Universal made their money back on the film's $22 million budget (McBride 1997: 416). Despite this concession, Universal chairman Tom Pollock still entreated Spielberg to shoot the film on color negative, so that it could have a color video release (McBride 1997: 432).

Why are producers and distributors so prejudiced against black-and-white? The answer is simple – they believe, with good reason, that consumers are prejudiced against it. Referring to Tim Burton's decision to make *Ed Wood* (1994) black-and-white, co-writer Larry Karaszewski casually exaggerates that he knew it would "eliminate 90% of our audience."[10] It is of course impossible to provide precise figures for the comparative revenue potential of black-and-white and color. At the same time, circumstantial evidence does suggest that consumers have a strong preference for color. For example, in 1986, Frank Capra's *It's a Wonderful Life* (1946) was re-released on video in colorized and original black-and-white versions. Though the colorized version cost four times more, by October 1986 it had sold between 70,000 and 80,000 units, compared to 15,000 units of the black-and-white version (Ross 1986: 4).

Of course, the popular aversion to black-and-white did not emerge out of nowhere. Supply influences demand as well as responding to it. By migrating from black-and-white to color production, the film industry created the conditions for changing consumer preferences; as color became cinema's chromatic norm, consumers came to expect that new releases would be color. Yet black-and-white films still continue to be made every year. Despite

the resistance offered by studios and consumers, there is one group within which an interest in black-and-white still thrives – film-makers themselves. Many of the most celebrated film-makers of recent decades have at one or more points in their careers made the choice to work in black-and-white instead of color. This group includes François Truffaut, Peter Bogdanovich, Chantal Akerman, Rainer Werner Fassbinder, Wim Wenders, David Lynch, Raoul Ruiz, Woody Allen, Martin Scorsese, Francis Ford Coppola, Jim Jarmusch, Béla Tarr, Shinya Tsukamoto, Andrzej Wajda, Andrei Sokurov, Guy Maddin, Aki Kaurismäki, Lars von Trier, Steven Spielberg, Abel Ferrara, Tim Burton, Sogo Ishii, John Boorman, Patrice Leconte, the Coen Brothers, Robert Rodriguez, Steven Soderbergh, Luc Besson, and Michael Haneke.

When color became cinema's visual default in the mid-1960s, making a black-and-white film became a deliberate choice. But though the choice was necessarily a conscious one, the reasoning behind it was not always easily articulated. Though it seems sensible to look first to directors themselves for clarification, their explanations for choosing to use black-and-white are often extremely vague. Of his trend-setting use of black-and-white in *Down by Law* (1986), Jim Jarmusch has stated: "*Down By Law* was always black-and-white in my head. I don't exactly know why."[11] Joel Coen has also found it difficult to explain his use of black-and-white in *The Man Who Wasn't There* (2001): "For a lot of intangible reasons that aren't easy to explain, it seemed as if black-and-white was appropriate for this story. It's a period movie, and black-and-white helps with the feeling for the period" (Holben 2001: 49). Though his primary explanation involves citing "intangible reasons," Coen's vague invocation of "period" suggests that film-makers' uses of black-and-white *can* be explained, though perhaps not always by them. Specifically, Coen's comments on *The Man Who Wasn't There* suggest that he was strongly influenced by past uses of black-and-white. Though there are various reasons why a contemporary film-maker might choose to make a film in black-and-white, past uses invariably play a key role in this choice – whether or not the film-maker realizes it. In this section, I explore the various reasons why film-makers have continued using black-and-white since the late 1960s, and the meanings that have accompanied these uses. Ultimately, however, these various uses and meanings together lead me back again to cinema's monochrome past.

As I suggested in Chapter 2, the choice to film in black-and-white was commonly motivated in the 1960s by economic and aesthetic factors. Both these factors continued to motivate black-and-white production into the 1970s and beyond. Despite a steady decrease in the cost of color film stocks

and processing from the early 1950s onward, black-and-white remained cheaper than color until the mid-1990s. The savings made possible by filming in black-and-white made it an attractive option for producers and directors faced with tight budgets. So, as the film industry switched en masse to color between 1965 and 1967, the low budget sector lagged behind. This is not to say that no low budget films were made in color. Experimental filmmakers Stan Brakhage and Kenneth Anger had been working in color since the mid-1950s. Roger Corman's output as producer and director had been almost entirely color since 1962, even though his budgets rarely exceeded half a million dollars (Gray 2000: 219). But as black-and-white was still not quite obsolete, its use did not yet necessarily damage box office returns, and so many low budget films continued to keep down costs by avoiding color. Prominent low budget black-and-white films of the period include Vilgot Sjöman's *I Am Curious Yellow* (1967), George Romero's *Night of the Living Dead* (1968), John Cassavetes's *Faces* (1968), and Werner Herzog's *Even Dwarfs Started Small* (1969). Black-and-white was even sometimes used in this transitional period to save money on films with less acute budgetary pressures. For example, the films made in the 1960s by Nikkatsu, Japan's oldest studio, were sometimes shot on 35mm color and sometimes on 35mm black-and-white. According to Seijun Suzuki, Nikkatsu's most eccentric director, the deciding factor was economics.[12] The films featuring the studio's biggest star, Ishihara Yujiro, had a ¥40–45 million budget. Otherwise, a typical budget was about ¥20 million. To film in color cost about ¥3 million extra; sometimes it proved affordable, sometimes not. Seijun cites his own film *Fighting Elegy* (1966) as an example of a production that was intended to be in color but ended up being made in black-and-white due to budgetary constraints.

By the turn of the 1970s, black-and-white was perceived as an unacceptable box office liability. The savings that resulted from its use became ever less significant when offset against the potential loss of revenue that this entailed. So most low budget film-makers followed the precedent set by Hollywood and also abandoned black-and-white. The budgets of Cassavetes, Sjöman, Romero and Herzog remained low, but by 1971 they too were all working in color. Economically motivated black-and-white production became restricted to films with no commercial potential and films made for so little money, and by such unconventional means, that simply getting them completed was achievement enough. Many South American Third Cinema films, for example, had no economic potential. *The Hour of the Furnaces* (1968–73), made by Octavio Getino and Fernando Solanas over a

period of years, was exhibited at clandestine political meetings as a means of generating debate. In capitalist democracies, non-commercial black-and-white production centered on more figuratively underground film-making, especially on short and experimental film, where black-and-white remained – and remains – common. Every year hundreds of short black-and-white films continue to be made and screened at festivals, film clubs, and art galleries across the world, from ResFest to Tate Modern.

A weakened pull to color was also felt at the low budget extreme of feature film production, in independently-financed "no-budget" films. The dividing line between low budget and no-budget films is imprecise, a separation made even less clear by the use of "no-budget" as a buzz word in 1990s American independent ("indie") cinema. Though it is a little crude, I follow Chris Holmlund's classification of films with budgets of below $1 million as low budget, and of those with budgets of below $100,000 as no-budget (Holmlund & Wyatt 2005: 3). I qualify Holmlund's classification by adding that low budget films are usually financed by means similar to higher budget films: they gain funding from established production companies, sales agents, and government agencies, and involve completion bonds. "No-budget" films are funded by less institutional means. Instead of waiting for backing that may never come, "no-budget" directors typically work with whatever resources are immediately available. Instead of trying for years to secure a deal with a major studio, they gain funding through family, friends, personal savings, loans, and in-kind contributions. "No-budget" feature films were a rarity in the 1970s and early 1980s – film distributor John Pierson only slightly exaggerates when he claims that throughout 1970s "you could count total new [American independent] production on two hands" (Pierson 1995: 14). Among the even fewer examples of black-and-white "no-budget" films of the 1970s, one can perhaps count Chantal Akerman's *Je, Tu, Il, Elle* (1974), Charles Burnett's *Killer of Sheep* (1977), and David Lynch's *Eraserhead* (1977). The patchwork manner in which these films were financed ensured that full control remained in the directors' hands, at least until the films were distributed. For this reason, "no-budget" films had funding structures that tended not to pull toward color. Lynch faced no pressure from distributors to make *Eraserhead* in color, because he had no distributor until after the film was completed.

After remaining underground for almost a decade and a half, low budget black-and-white cinema resurfaced in the United States in the mid-1980s, in conjunction with the rise of American indie cinema. The rise of indie was precipitated by the breakthrough of a number of personally financed

"no-budget" films into mainstream distribution. Two films in particular led the way, both black-and-white: Jim Jarmusch's *Stranger than Paradise* (1984) and Spike Lee's *She's Gotta Have It* (1986). *Stranger than Paradise* cost just over $100,000 (Pierson 1995: 24).[13] The total budget of *She's Gotta Have It*, according to an estimate made by Spike Lee just before the film's completion, was about $113,000, accumulated in increments of a few thousand and often even a few hundred dollars at a time (Lee 1987: 241). The "guerilla" production methods used in Jarmusch's and Lee's prototypical indie features, though by no means new, became the model for thousands of subsequent films. In 1985, 50 independently financed feature films were made in the United States; in 1998 the number was 1,000 (Levy 1999: 44). The highest concentration of "no-budget" black-and-white films occurred in the early 1990s, at the peak of the indie boom. Examples of black-and-white American indies include Rose Troche's *Go Fish* (1994), Michael Almereyda's *Nadja* (1994), and Kevin Smith's *Clerks* (1994). The success of the American indie sector was paralleled by an equally significant, though more culturally diverse and so less prominent, surge in international "indie" cinema, also accompanied by an increase in black-and-white "no-budget" production. Examples include Shinya Tsukamoto's *Tetsuo: Man of Iron* (1988), Ilkka Jarvi-Laturi's *Darkness in Tallinn* (1993), Shane Meadows's *Twentyfourseven* (1997), Nuri Bilge Ceylan's *Kasaba* (1997), and Chris Nolan's *Following* (1998).

Despite these various high profile examples of black-and-white indie films, the economically motivated use of black-and-white was nowhere near as widespread in the 1980s and 1990s as it had been in the 1960s. In the 1960s, black-and-white was used for budgetary reasons in all sectors of the film industry, across all forms of moving imagery. In the 1980s and 1990s, its economically motivated use was generally restricted to indie films aimed at a theatrical release. In areas of low budget production where theatrical release was not a goal and aesthetics was of little importance, video was now the standard format. Video was not especially suited to projection in cinemas and was not beautiful, but it was far cheaper than even black-and-white film. Corporate films, pornographic films, educational films, and artists' films were by the 1980s most often not films but videos. Even within the independent sector, black-and-white was only a minority presence. Though several hundred indie films were released in the United States during the 1980s and 1990s, the total number of black-and-white low budget features released in the same period was less than 30 (Pierson 1995). By the early 1990s, the burgeoning independent sector had become an established

industry and included a number of independent "majors" including Miramax, Lion's Gate, and New Line. Indie films produced by these companies typically involved seven-figure budgets. Almost none were black-and-white. Black-and-white was no longer a low budget format; it was now a "no-budget" format.

At the lowest end of the budgetary scale, black-and-white was not just an expedient way of cutting costs, it was sometimes a financial necessity. According to director Kevin Smith, *Clerks* cost $26,685; using color would have increased the budget by at least 50 percent and made filming impossible (Pierson 1995: 228). Most "no-budget" films were made on slightly higher budgets, making the use of color at least conceivable. However, a significant minority of "no-budget" film-makers still perceived black-and-white as a necessity because of the aesthetic implications of using color. Darren Aronofsky made his first feature *Pi* (1998) for about $70,000, explaining his decision to use black-and-white as follows: "We knew we couldn't pull off color. First, we could only afford 16mm. And the way 16mm color looks blown up, I'd never be happy with that, no matter whose process we used" (Kaufmann 1998). In fact, 16 mm color often looks fine when blown up, but it needs to be properly lit. This involves more elaborate lighting setups than black-and-white and additional expenditure on lighting equipment. The difficulty of lighting cheaply in color is summarized by Chris Nolan in an interview on his first feature, *Following* (1998):

> When you have no money, it can be shrewd to find subject matter that lends itself to that sort of black and white, noirish type approach, because you can do harder lighting. You can do quicker lighting set ups. You're not worrying about color balance from the tungsten lamps and things like that. I think at the end of the day, hard shadows and that sort of lighting looks a lot better in black and white than it does in color. If you have no money, it's quite often that you're better off shooting like a documentary, and shooting what's really there. You try to use the available light. The sort of light from windows that you can get in London has a gloomy, cold feel to it. In black and white, you can make that look stylish in the way that you want. (Margolis 1999)

If budgetary factors are acute, a director will want to light as quickly as possible and to use as few lights as possible. Unless filming a daytime exterior, using few lights will result in a stylized, high contrast image – some areas of the frame will be extremely bright, some areas will remain in shadow due to the absence of fill lighting. In Nolan's view, black-and-white minimizes the visual damage that can be caused by crude lighting. For this

reason, black-and-white has historically provided a means of minimizing the visual trace of the economic limitations within which "no-budget" film-makers have worked.

Of course, the aesthetic allure of black-and-white has always extended far beyond "no-budget" film. In his 1934 essay *The Author as Producer*, Walter Benjamin famously commented, with reference to the monochrome photography of the time: "[I]t is now incapable of photographing a tenement or a rubbish-heap without transfiguring it. Not to mention a river dam or a cable factory: In front of these, photography can now only say, 'How Beautiful'." (Benjamin 1999: 775). Benjamin's personification of monochrome photography as a decadent aesthete, unable to comprehend the stench and suffering underlying the play of shadow and light, holds true for monochrome cinematography too. For directors seeking what cinematographer Chris Doyle calls "a lazy way out" of the stench of color, black-and-white provides easy gratification (Doyle 2004: 8). In the previous chapter, I discussed the stylization that occurs whenever monochrome reproduction takes place. Stylization, a result of simplification, also involves aestheticization. For example, all faces look beautiful in black-and-white, including that of a starving African woman as photographed by Donald McCullen or that of Robert Mapplethorpe looking into his own camera while in the final stages of AIDS. Color can contribute to ugliness as well as beauty; by removing color, monochrome reproduction removes a potential source of ugliness.

The power of black-and-white to make ugliness less ugly also translates into representations of violence. Without color, violence becomes less visceral, and thus more palatable. Hitchcock's preferred explanation for using black-and-white in *Psycho* (1960) was that it would allow him to get the blood in the shower scene past the censor (Gottlieb 1995: 311). More recently, the mangled face of an accident victim in Scott McGehee and David Siegel's *Suture* (1993) and the wedding-day carnage at the start of Quentin Tarantino's *Kill Bill 2* (2004) would have been simply unbearable in color. Through the use of black-and-white, at least a part of these films' ugliness and horror is left to our imagination.

Unsurprisingly, black-and-white has proven popular not only among "lazy" film- and video-makers but also among cinema's most obsessive aesthetes. In a review of the seminal documentary *Housing Problems* (Edgar Anstey & Arthur Elton, 1935), Graham Greene called the film "superbly untroubled by the aesthetic craving" (Greene 1980: 108). Anstey and Elton shot *Housing Problems* in black-and-white because they had no choice. Now, by contrast, black-and-white is a means of satisfying

the aesthetic craving. It is no coincidence that so many of the most style-driven directors of recent decades have used black-and-white. Martin Scorsese's *Raging Bull* (1980), Rainer Werner Fassbinder's *Veronika Voss* (1982), Francis Ford Coppola's *Rumble Fish* (1983), Lars von Trier's *Europa* (1991), the Quay brothers' *Institute Benjamenta* (1995), Sogo Ishii's *Electric Dragon 80,000 Volts* (2001), and Anton Corbijn's *Control* (2007) are all beautiful films. It is inconceivable that these directors' chromatic choices were not at least partially motivated by the desire to make their films beautiful. In a diary entry, written just before he started shooting *She's Gotta Have It*, Spike Lee gives the game away, writing: "We will shoot this film in beautiful black and white" (1987: 125). The continued existence of black-and-white moving imagery owes much to its beauty.

I have so far highlighted economic and aesthetic reasons for the survival of black-and-white beyond the 1960s. Additional answers to the question of why and how directors continued to make black-and-white films are rooted in the various meanings that became attached to black-and-white as it declined. Prominent among these was "realism." In Chapter 1, I discussed classical Hollywood's association of black-and-white with the *here and now* of perceptual reality.[14] Until the 1950s, this association remained implicit; black-and-white was so common that its presence was invisible. So too, for as long as it remained pervasive, black-and-white's developing connections with Neo-Realist, low budget, and documentary filmmaking also went unnoticed. It was only in the late 1950s and early 1960s, as its presence became less pervasive and so more prominent, that black-and-white began to assume meanings. Its long-standing but implicit association with reality became an explicit connotation.

By the late 1960s, black-and-white's connotation of realism had become a residual meaning. Raymond Williams defines the residual as a practice, meaning, relationship, or type of relationship initiated in the past but which "is still active in the cultural process, not only and often not at all as an element of the past, but as an effective element of the present" (1977: 122). I have already identified the rise of unmotivated chromatic hybridity as an emergent, and the codified opposition of black-and-white and color as a dominant. Williams's concepts can also be applied to black-and-white itself. In the 1940s, the dominant of black-and-white and color's opposition and the dominant of black-and-white's connotation of realism mutually reinforced each other. By the 1970s, this was no longer the case. The dominant of chromatic opposition now interacted with black-and-white's new dominant of "the past," resulting in the appearance of black-and-white flashbacks. Nonetheless, the association of black-and-white with unmediated

reality continued into the 1970s, remaining a potent enough meaning to influence film-makers' work. While some used black-and-white to signify the past, others used it to signify realism. Examples of "realistic" black-and-white films include Martin Ritt's *Hud* (1963), Mike Nichols's *Who's Afraid of Virginia Woolf?* (1966), and Richard Brooks's *In Cold Blood* (1967). Just as meaning influenced usage, so usage in turn reinforced meaning – the above films not only exploited but also reinforced black-and-white's connotation of realism. There thus developed a connotative feedback loop that helped keep the connection between black-and-white and realism alive for several decades more.

A similar feedback loop of use and connotation resulted in another of black-and-white's most prominent meanings – "art." As black-and-white developed into a minority format in the mid-1960s, its continued use in art films became more obvious. Of the Top 50 grossing films in the USA in 1967, seven were black-and-white; all but one were European art films (Lyon 1989: 166–170).[15] Once the connection between black-and-white and art film became common knowledge, it entered its reflexive phase. Black-and-white became a means of asserting a film's artistic credentials. Jonathan Rosenbaum refers to Woody Allen's aesthetic choices in *Manhattan* (1979) as the equivalent of erecting "a shield labelled 'Art' that's intended to intimidate non-believers" (1995: 239). This is slightly unfair; even derivative directors probably take themselves seriously enough not to seek kudos by mimicking previous styles. However, it is notable that since the early 1970s black-and-white has been used by a disproportionately large number of directors who aspire to auteur status. The use of black-and-white by film-makers to label their own works as "art" is a curious inversion of the use of color by many 1960s auteurs to assert film's equivalence to painting and thus also assert its status as art. Once films alluded to painting to justify their quality, now they allude to other, older (and implicitly better) films to do the same.

The association of black-and-white with art film reached a second stage of reflexivity when its use as an expression of directors' auteur aspirations itself became a target of parody. In a mid-1990s episode of *The Simpsons*, Barney Cumble makes a short black-and-white film focusing on the existential angst that he suffers because of his alcoholism. Barney's opus exploits the full gamut of stereotypical art-house techniques: Dutch angles, top shots, slow motion curtains rippling in a breeze, time-lapse cloud shots, non-melodic piano music, and a symbolic close-up of petals falling off a flower. Through it, *The Simpsons*' writers parody films including Francis Ford

Coppola's *Rumble Fish* (1983) and Gus Van Sant's *My Own Private Idaho* (1991), which use art film techniques to bolster their art film credentials.

Another meaning to have shaped uses of black-and-white since the 1970s is of course "the past." In hybrid films, black-and-white references the past through flashbacks. In black-and-white films, it references the past through parody and pastiche. Parodic uses of black-and-white include Mel Brooks's *Young Frankenstein* (1974), which targets 1930s Universal horror films, and Carl Reiner's *Dead Men Don't Wear Plaid* (1982), which targets 1940s film noirs. Noël Burch has observed that cinema is Frankenstinian, in that it aims to reanimate the dead (1990: 26). *Young Frankenstein* and *Dead Men Don't Wear Plaid* reanimate dead cinematic styles and conventions in order to poke fun at them. Parody uses past styles to ridicule deviant works – works which are either genuinely eccentric or appear eccentric because they were made in the past, according to conventions which have been superseded and now seem absurd. The ideal parody draws attention to the absurdities of its target film or genre while remaining indistinguishable from it. So, though *Dead Men Don't Wear Plaid* includes plenty of broad swipes at Humphrey Bogart, Lauren Bacall, et al., cinematographer Michael Chapman respectfully mimicked the style of 1940s film noir, even going so far as to degrade the film's negatives to make them appear 40 years old (Goodhill 1982: 1186).

Like parody, pastiche mimics the past by using past techniques. Fredric Jameson has famously defined pastiche as "blank parody," arguing that the proliferation of idiolects in postmodernity has left parody "without a vocation" (1984: 65). According to Jameson, the cultural pluralism of postmodernity means there is no norm for parodies to re-assert through their mimicry of deviant works. The target of a postmodern parody has as much claim to normalcy as the parody itself. Without a suitable target, parody's purposeful mimicry becomes pastiche, "a neutral practice of such mimicry, without any of parody's ulterior motives" (1984: 65). Barney's art film, for example, is a pastiche of various art film techniques used over the previous 30 years. Through it, *The Simpsons'* writers parody bad art films. However, following Jameson, one might suggest their parody is itself overwhelmed by pastiche. Films that pastiche art film techniques are often perceived as art films, not pastiches – they get away with their deception. Instead of dismissing Barney's film as a simulacrum, the audience at the Springfield Film Festival salutes Barney as an auteur, awarding him the grand prize of a tanker full of Duff beer.

Evidence of Jameson's claim that pastiche has become a dominant mode of representation can be seen throughout the cultural landscape – especially

in the voracious recycling of styles visible across fashion, print design, and product design in recent decades. It can also be seen in the rarity of parody among black-and-white films since the early 1970s. *Young Frankenstein* and *Dead Men Don't Wear Plaid* remain almost the only feature-length black-and-white parodies to have been made in the last 40 years. In the same time, there have been dozens of feature-length black-and-white pastiches. These typically take the form of period films that use black-and-white to evoke the period in which they are set. For example, David Lynch's *The Elephant Man* (1980) is set in the 1880s, Guy Maddin's *Dracula: Pages from a Virgin's Diary* (2003) is set in 1890s, Alexei Balabanov's *Of Freaks and Men* (1998) is set in the 1900s, Guy Maddin's *Archangel* (1990) is set in the 1920s, Peter Bogdanovich's *Paper Moon* (1973) is set in the 1930s, Shohei Imamura's *Black Rain* (1989) is set in the 1940s, and Sogo Ishii's *Labyrinth of Dreams* (1997) is set in the 1950s. Pastiche also encompasses black-and-white films that evoke the past without being set in it. For example, *Rumble Fish* is ostensibly set in the present – the skyline of the city in which the action takes place is populated by glass skyscrapers. But in fact the film occupies an ersatz 1950s world. High schools are filled with guys in baseball jackets and girls in knee-length skirts, motorbike gangs cruise the streets and occasionally stop off at a diner for a fight, while Matt Dillon and Mickey Rourke fight it out to see who will become the new James Dean. Somewhat less explicitly, *The Girl on the Bridge* evokes the post-war decadence of the Côte d'Azur, even though the streets are teeming with Renault 21s. Like its main character, who travels the world without a credit card, the film acknowledges the contemporary and then cheerfully ignores it.

Over the last five decades, use and meaning have interacted in a causal feedback loop, resulting in a continuation of black-and-white's connotations long after they might have been expected to disappear. For example, in the 1960s black-and-white became recognized as a past mode of representation, and so came to be used to signify the past; as a result, its very obsolescence helped save it from extinction. Such causal loops help explain why cinematic style has historically been slow to change, with many contemporary films still following visual codes established nine decades ago. Once a use or meaning is established, its dominance becomes self-perpetuating. New uses of a particular style legitimate themselves by referring back, with or without irony, to its previous uses and meanings.

As if the historical development of each of black-and-white's self-referential uses and meanings is not complicated enough individual uses and meanings also interact with other uses and meanings. Back when

color was fantasy and black-and-white was reality, color was perceived in the same way that it was used – in *The Wizard of Oz* (1939), director Victor Fleming used color for fantasy sequences, and viewers understood it as a signifier of fantasy. Such simple matches are far less common in recent black-and-white films. Given the profusion of meanings attributable to black-and-white since the 1960s, uses based on one of black-and-white's codes now typically give rise to connotations based on another. For example, Mathieu Kassowitz's *La Haine* (1995) is a slick, cinematically self-conscious image of life in a Paris *banlieue*. It includes stunning compositions, elaborate crane shots, and cinephilic visual references to the films of Martin Scorsese. Its most famous visual reference occurs when Vincent Cassel points a finger at himself in his bathroom mirror and repeats "Tu parle à moi?," echoing words also spoken to a mirror by Robert De Niro in *Taxi Driver* (1976). The use of black-and-white in *La Haine* complements these flourishes to create a highly stylized representation of the *banlieues'* squalor. Despite this stylization, many journalistic and academic commentators interpreted the film according to another code, referring to its use of black-and-white as "gritty" and "realistic" (Elstob 1997: 46; McCabe 1995: 54).

Even when an example of black-and-white appears to conform unambiguously to a single circuit of meaning and use, the truth is often more complex. For example, Peter Bogdanovich's *The Last Picture Show* (1971) is a black-and-white film made in the 1970s and set in small town Texas in the 1950s. Its style evokes that of 1950s films, and so it appears to be an example of pastiche. Jean Baudrillard remarked that the film could almost pass as "a very good [1950s] film about the customs in and the atmosphere of the American small town. Just a slight suspicion: it was a little too good, more in tune, better than the others, without the psychological, moral, and sentimental blotches of the films of that era" (1994: 45). It was as a superior example of pastiche that a number of critics perceived the film. John Russell Taylor, for example, admired the way it achieved "the look of a Hollywood film of the 1950s" (1972: 13). In fact, Bogdanovich's use of black-and-white was not intended to allude to the 1950s:

I was discussing with Orson Welles at breakfast one day how I wanted to have a tremendous amount of depth of field. He said, "You'll never get it in colour." So I said, "Well I don't know how I'm going to do it." He said, "Do it in black-and-white." I said "They won't let me." He said, "Well why don't you ask them?"… so I said to [the film's producer] Bert Schneider, "I'd like to shoot

it in black-and-white," and he said, "Why?" ... so I said something like, "Well, I think the period would be easier to convey in black-and-white," ... Well, Bert went back to the studio and came back a week later and said, "All right."[16]

Clearly, individual uses and meanings do not exist in isolation from others, but interact with them, overlap with them, confuse, compliment, contradict them. Sometimes they even fuse with each other to create new meanings at the interstices of other meanings: for example, the connotations of realism and art combine to connote "seriousness" and "quality." This connotation is particularly noticeable in commercial short-form works (news features, television commercials, pop promos, etc.), which often need to establish a serious tone in an extremely short time. It finds its ultimate expression in *Brass Eye* (1997), Chris Morris's landmark parody of investigative television journalism. At one point, with bored outrage, newscaster Morris observes: "This situation is clearly grave enough to merit a black-and-white freeze-frame." In making this observation, Morris foregrounds a connotation exploited every day in newsroom edit suites across the world.[17] The use of black-and-white to signify seriousness also extends to print media. Paul Grainge observes that a 1990s redesign of *Time* that aimed to emphasize its quality involved an increased use of black-and-white photography (2002: 73). Conversely, when *USA Today* moved to color in 1982, even though its editorial content remained largely unaltered, it was criticized for its lack of seriousness (Grainge 2002: 74).

If one looks at more than one film at a time, black-and-white's networks of reference become almost inextricable. For example, Spike Lee made *She's Gotta Have It* in black-and-white partially for aesthetic reasons, to make a "beautiful" film; his aesthetically motivated use of black-and-white was, at the same time, highly compatible with the fact that he had a very low budget. In his choice to use black-and-white, Lee was also strongly influence by his director of photography, Ernest Dickerson, who loved *Raging Bull*. Though Scorsese had used black-and-white primarily for aesthetic reasons, Dickerson interpreted *Raging Bull*'s absence of color as a mark of realism, seeing it as an evocation of 1950s *Life* magazine covers (Lee 1987: 110; Scorsese 2003: 80).

Until the 1960s, black-and-white was a type of film stock and a format. It enriched many films in many ways, but in isolation it carried as little meaning as a camera or a bank of lights. Since the 1970s, the black-and-white image – like *La Haine*'s reflection of Travis Bickle's own reflection in *Taxi*

Driver – has become one of screen culture's many facing mirrors. The surfeit of intertextuality now attached to black-and-white makes it impossible to provide a linear, historical account of the changes over the last 40 years in monochrome's various uses and meanings. There are too many intertextual loops. At the same time, I believe that there is one connotation that permeates all black-and-white films made since the early 1970s. In my view, all of the meanings associated with black-and-white of the last four decades in one way or another rely on and refer back to black-and-white's connection with the past. For this reason, in the following section, my history loops back and returns once more to the past.

Nostalgia and Pastiche

"Chapter One. He adored New York City." At the start of *Manhattan*, Isaac Davis (Woody Allen) tries out possible opening lines for a novel about New York, including: "To him, no matter what the season was, this was still a town that existed in black-and-white." Of course, New York was *never* black-and-white. Davis/Allen is conflating the history of the city with old movies and photographs of it. Whenever post-1960s black-and-white films reference past events, their black-and-whiteness references not the past itself but past representations.[18] The distinction between past events and past representations is especially important when considering nostalgia, a concept frequently discussed in connection with black-and-white. Paul Grainge, for example, repurposes a phrase coined by Fredric Jameson to call black-and-white a "nostalgia mode" (2002: 59). What is nostalgia? The *Oxford English Dictionary* defines it as follows: "Regret or sorrowful longing for the conditions of a past age; regretful or wistful memory or recall of an earlier time." Nostalgia for a past age can be all-inclusive, or it can be targeted at specific aspects of that period. One can, for example, be nostalgic for the expanding welfare states of post-war Europe without being nostalgic for the institutional racism and sexism of the post-war decades. In my view, Grainge goes too far in calling black-and-white a nostalgia mode. Given the fact that black-and-white references past representations, I believe it is specifically an expression of *cinematic* nostalgia.

Cinematic nostalgia need not express itself either by mimicry of old styles or by being set in the past. For example, Patrice Leconte's *The Girl on the Bridge* – a present-day story of Gabor (Daniel Auteuil), an itinerant knife-thrower, and Adèle (Vanessa Paradis), his suicidal sex-addicted

assistant – is not a pastiche. It uses contemporary techniques including handheld camerawork, fast cut montage sequences, and virtuoso trick shots including a point of view shot of a fly landing on a sugar cube. Even the film's use of black-and-white is contemporary. Leconte used Kodak Vision 500T 5279, the latest color film stock available at the time. Sometimes the stock was exposed at 800ASA for interior shots and exterior night shots, four times faster than the typical ASA of mid-1950s black-and-white film stock, resulting in a film in which even night sequences are full of light. The color negatives were processed as color, and then transferred onto black-and-white interpositive (Anon. 1999a). The result is a film that is both technologically and aesthetically a product of its time. Nonetheless, its *black-and-whiteness* still refers to past cinema. In an interview following the film's release, Leconte was open about his desire to achieve in his film what his favorite classic French films of the 1940s and 1950s had achieved: "They were full of light and glamour; inventive, rich and multifaceted ... I wanted a film where the black dares to be black and the light is startling" (Anon. 1999a).

The use of black-and-white in *The Last Picture Show* is also an expression of cinematic nostalgia, inasmuch as it provided Peter Bogdanovich with a means of achieving the deep focus that he so admired in Orson Welles's *Citizen Kane* (1941). Cinematic nostalgia has even taken the form of technological nostalgia for black-and-white processes. Martin Scorsese's choice to make *Raging Bull* black-and-white was strongly influenced by his discovery that color prints of films he had made only a few years previously were already fading (Scorsese 2003: 80). By shooting *Raging Bull* in black-and-white, Scorsese articulated the paradox that before the rise of digital processes the only way to prevent a film's color from dating it was to shoot it in the dated format of black-and-white. Equally paradoxically, though the film is predominantly set in the 1950s, it has an aura of timelessness to it. Its monochrome cinematography evokes the past while simultaneously concealing the specific period in which it was made. Perhaps learning from Scorsese, film-makers and advertising creatives have, as Paul Grainge notes, used black-and-white to evoke "timelessness" ever since (2002: 71). The use of black-and-white to suggest timelessness is most obvious in television commercials, which routinely use monochrome to advertise "timeless" luxury goods from diamond rings to fast cars. Paradoxically, by using an aesthetic associated with the past, advertisers assert that the display of personal wealth is not obsolete and not tied to any specific period. Rich people have

always bought diamonds, and always will. So should you, if you are rich, or want to appear rich.

Manhattan is also an example of cinematic nostalgia, and equally paradoxical in its expression of temporality. Woody Allen was only five at the turn of the 1940s, so his character's nostalgia for mid-century New York is nostalgia for an idea of New York derived from old black-and-white movies and photographs. Allen's image of a New York in which fireworks explode over mid-town skyscrapers and romantic couples watch the day break across Queensboro Bridge coexists on screen with a more "realistic" representation of the city, in which neurotic artists bicker in heath-food stores and restaurants. These two parallel New Yorks also manifest themselves stylistically. Gordon Willis, the film's cinematographer, referred to the film's style as "romantic realism" (Goodhill 1982: 1189). Willis used the term to suggest that the film achieves a composite style, but in fact its romantic and realistic images are distinct. On the one hand, *Manhattan* features stunningly photographed panoramas of urban modernism, such as the iconic poster shot of Woody Allen and Diane Keaton sitting on a bench beside Brooklyn Bridge (Plate 3.5). Willis set up this shot with punctilious precision. He shot Brooklyn bridge at 4.30 am, just as it was getting light; he also used diffusion to soften the image, and exposed the film at two-and-a-half stops below the "correct" exposure in order to turn Allen and Keaton into silhouettes (Goodhill 1982: 1189). When filming shifted to the multicultural, decidedly postmodern streets of Greenwich Village, Willis no longer worked so hard to aestheticize New York. Instead of creating carefully framed postcard shots, he used a Steadicam to follow his actors down busy streets that had not been closed to traffic. Instead of holding out for the luminous light of magic hour (the period around sunset, when everything is at its most beautiful), he allowed actors to be lit by streetlights, shop windows, and any other practical light sources that they happened to pass by (Goodhill 1982: 1189).

Accompanying cinematic nostalgia, one can also see in *Manhattan* evidence of what Fredric Jameson calls "nostalgia for the present" (1989). For Jameson, a key element of postmodern culture is the replacement of history with historicism, the transformation of the past into "a vast collection of images, a multitudinous photographic simulacrum" (1984: 66). If the past has been telescoped into the present via pastiche, and if past and present have both been semantically eviscerated and transformed into representations of themselves, then how can people living in

the present have any sense of what it is to be alive in this time? Put in Jean Baudrillard's more aphoristic terms, throughout modernity "*at least* there was history, at least there was violence (albeit fascist), when at least life and death were at stake" (1994: 44). Now there is just "this void, this leukaemia of history," this absence of historical struggles through which we might define ourselves.[19] Lacking a historical identity, one is left with nostalgia for the present, "a time yearning for itself at an impotent, covert remove," craving authentic experience and concrete meaning (Anderson 1998: 63). Allen's partner-swapping comedies encapsulate the void of the present. People sit around talking about great works of art, the products of other people's struggles. When not talking about art, they talk about their own or each others' relationships. Even their actual relationships seem to involve talking about the relationship. Once in a while, a character breaks up with a partner and then hooks up with someone else. Nobody suffers physical pain, nobody loses a home or a livelihood, nobody dies.

Cinematic nostalgia and "nostalgia for the present" are symbiotic. In *Manhattan*, the former provides an escape from the latter; the film's monochrome cinematography conceals the lost referent of the real. Davis/Allen lacks profound experiences, but when he appears in black-and-white with Diane Keaton in front of Brooklyn Bridge, the breathtaking beauty of the image makes his vacuous courtship ritual appear like a movie romance. By placing Isaac in compositions that evoke New York's mythologized history, Allen gives his protagonist at least a few moments of true romance. Through monochrome, Allen turns New York in the setting for the movie of his life: he turns Manhattan into *Manhattan*.[20]

All black-and-white films of the last four decades that are set in or reference the past create a Baudrillardian hyperresemblance, a resemblance of a representation. So, with the exception of a few parodies, they are all examples of pastiche. Black-and-white is now inherently intertextual, and cannot avoid referencing past representations. Even black-and-white films that reference historic events are pastiches. For example, Steven Spielberg made *Schindler's List* in black-and-white because he wanted it to be authentic (or rather, to *appear* authentic):

> I think black and white stands for reality ... I don't think color is real. I think certainly color is real to the people who survived the Holocaust, but to people who are going to watch the story for the first time, I think black and white is going to be the real experience for them. My only experience with the

Holocaust has been through black-and-white documentaries. I've never seen the Holocaust in color. (Schleier 1994)

Unlike Woody Allen, Spielberg here acknowledges that his mental image of the past is a mediated one. Ultimately, however, black-and-white functions in *Schindler's List* much the same way as in *Manhattan*.

It is not my goal to revisit old debates about whether or not *Schindler's List* provides a worthwhile response to the Holocaust. Nor do I wish to add to discussions about whether Spielberg's use of black-and-white "makes a false claim to authenticity" (Horowitz 1997: 122), or manages "to create greater empathy with the protagonists than any 'real' documentary" (Bartov 1997: 44). Instead, I restrict myself to the question of what precisely the film's black-and-white cinematography refers to. Like *Manhattan*, *Schindler's List* alternates between two forms of pastiche. The first is pastiche documentary, as Spielberg himself points out. Less obviously, the film's cinematography also references old movies. Miriam Hansen has observed a range of stylistic similarities between *Schindler's List* and *Citizen Kane*, notably the film's expressive low-key lighting (1997: 97). In my view, Spielberg's cinematic referent is less specific – it is simply 1940s movies. Like any true cinephile, Spielberg approaches the past by means of filmed interpretations of it. Screen history is especially prominent in scenes focusing on Liam Neeson, playing Schindler, who is often lit as meticulously as the romantic leads of classical Hollywood. When he first appears on screen, his head is rim lit and his face is illuminated by a soft rectangle of light emphasizing his eyes – an overt declaration of his status as a leading man (Plate 3.6).

Even when the action moves to Auschwitz, Neeson's angelic halo of rim light follows him wherever he goes. Though most of the camerawork in the Auschwitz scenes is handheld quasi-documentary, Neeson is repeatedly filmed with three-point lighting and elegant tracking shots that befit his status within the narrative. At moments like these, the traumatic history of the twentieth century clashes with movie history, and Spielberg's goal of paying testimony to past suffering clashes with his cinephilia. The memory of black-and-white as a mode of realism clashes with the present reality that black-and-white is a form of pastiche.

Post-1960s black-and-white is not a nostalgia mode but a pastiche mode. At the same time, I do not wish to suggest that its use necessarily involves superficiality, indifference to the past, or meretriciousness. Referencing past representations need not be as insidious as Fredric Jameson makes out. Over recent years, many cultural theorists have begun to question the idea

that individual re-presentations of the past combine to create an aggregated de-realization of history. For example, Andreas Huyssen – always a more pragmatic postmodernist than Jameson – observes: "To insist on a radical separation between 'real' and virtual memory seems quixotic, if only because anything remembered – whether by lived or imagined memory – is itself virtual" (2000: 38). Analogously, the past can *never* be directly accessed through film. Whenever a film represents the past, it mediates it – if not through the use of black-and-white, then through camerawork, lighting, editing, etc. Many great works of art involve pastiche, and are none the worse for it. Who could criticize Martin Scorsese's use of black-and-white in *Raging Bull* when it resulted in some of the most startling sequences in cinema history?

Furthermore, the use of black-and-white as a form of pastiche has turned it into a postmodern mode of representation, thereby helping save the art of monochrome cinematography from oblivion. In the 1970s, black-and-white was moribund in all but a handful of countries. Since the 1980s, it has found new life throughout the media landscape, especially in short-form moving imagery, which provides contemporary viewers with brief and so tolerable exposure to black-and-white. Black-and-white can be seen everywhere from television commercials – for example, the 1950s sci-fi pastiche of Traktor's *Asteroid: Nike* (2002) – to pop videos – for example, the animated quasi-Soviet graphic design of Jonas Odell's *Franz Ferdinand: Take Me Out* (2004). At the same time, given that it always ends up referring to products of the past, it is difficult to avoid the conclusion that black-and-white is obsolete, tied to residual meanings, permeated by technological and aesthetic nostalgia, and has nothing new to offer digital culture. Even its afterlife as a signifier of the past may prove only transitory – as the era of black-and-white cinema recedes ever further into history, black-and-white may at some point in the future cease to signify the past, signifying instead a brief and increasingly distant period within the past, viz. the 1890s to the 1950s.

If black-and-white cannot escape its ties from this receding past, does it have a future? Does it even have a present? In the final chapter, I suggest that it does. With the rise of digital color, a new chromatic orientation has developed, which renders old black-and-white/past and color/present oppositions irrelevant. Before discussing digital color, however, I need first to explore color's third dimension: light.

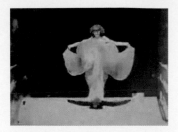

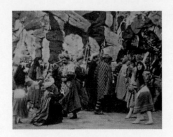

Plate 1.1 Hand-painted color in *Annabel Serpentine Dance*. Producer William Heise

Plate 1.2 Stenciled color in *Ali Baba et les quarante voleurs*. Producers Adry De Carbuccia and Roland Girard

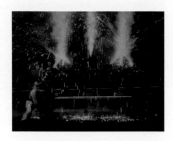

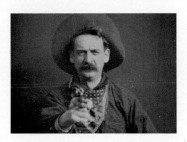

Plate 1.3 Stenciled color in *Le Scarabée d'or*

Plate 1.4 Hand-painted color in the *Great Train Robbery*. Producer Thomas A. Edison

Plate 1.5 Tinted "black-and-color" in *Der Golem*. Producer Paul Davidson

Plate 1.6 "Black-and-color" in *Die Abenteuer des Prinzen Achmed*

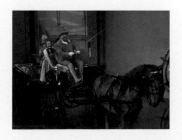

Plate 1.7 Redness and redness in *Battleship Potemkin*. Producer Jacob Bliokh

Plate 1.8 Spectacular color in *The Wizard of Oz*. Producer Mervyn LeRoy

Plate 2.1 Artificial color in *Les Parapluies de Cherbourg*. Producer Mag Bodard

Plate 2.2 Color as auteurist branding in *Une Femme est une femme*. Producers Carlo Ponti and Georges de Beauregard

Plate 2.3 Hand painted smoke in *High and Low*. Producers Ryuzo Kikushima, Akira Kurosawa, and Tomoyuki Tanaka

Plate 2.4 Monochrome red in *2001: A Space Odyssey*. Producer Stanley Kubrick

Plate 2.5 *Cries and Whispers*: black-and-white in color. Producer Lars-Owe Carlberg

Plate 2.6 *Cries and Whispers*: black, white, and red. Producer Lars-Owe Carlberg

Plate 2.7 Gray oranges in *The Red Desert*. Producer Antonio Cervi

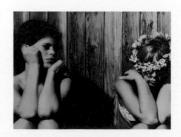

Plate 2.8 Anarchic color: tinting and toning in *Daisies*. Producer Rudolf Hájek

Plate 2.9 *Solaris*: color in black-and-white. Producer Viacheslav Tarasov

Plate 3.1 Black-and-white overruled in *Star!* Producer Saul Chaplin

Plate 3.2 Black-and-white as technological relic. Producer John Foreman

Plate 3.3 Self-reflexivity in *And The Ship Sails On*. Producers Franco Cristaldi and Daniel Toscan du Plantier

Plate 3.4 *Sisters*: looking into cinema past. Producer Edward R. Pressman

Plate 3.5 *Manhattan*: black-and-white and the "aesthetic craving." Producer Charles H. Joffe

Plate 3.6 Classical Hollywood lighting in *Schindler's List*. Producers Steven Spielberg, Kathleen Kennedy, and Branko Lustig

Plate 4.1 *The Garden of Allah*: black-and-white in color. Producer David O. Selznick

Plate 4.2 *Written on the Wind*: white light and blue night. Producer Albert Zugsmith

Plate 4.3 *Betty Blue*: "blue-and-yellow" as soft black-and-white. Producer Jean-Jacques Beineix

Plate 4.4 *Singin' in the Rain*: white faces and colored light. Producer Arthur Freed

Plate 4.5 Lens filtration and ambiguous skin colors in *South Pacific*. Producer Buddy Adler

Plate 4.6 Reprographic color in *2 ou 3 Choses que je sais d'elle*. Producers Anatole Dauman and Raoul Lévy

Plate 4.7 A color swatch in *Le Mépris*. Producers Carlo Ponti, Georges de Beauregard, and Joseph E. Levine

Plate 4.8 Daylight and desaturation in *Days of Heaven*. Producers Bert Schneider and Harold Schneider

Plate 4.9 Night light: Deckard's apartment in *Blade Runner*. Producer Michael Deeley

Plate 4.10 *One From The Heart*: learning from Las Vegas. Producers Gray Frederickson and Fred Roos

Plate 4.11 Color and white light: a *tableau vivant* in *Passion*. Producers Armand Barbault, Catherine Lapoujade, and Martine Marignac

Plate 4.12 *Querelle*: a world without white light. Producers Michael McLernon, Sam Waynberg, and Dieter Schidor

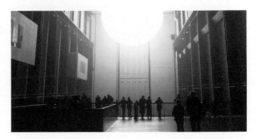

Plate 4.13 Olafur Eliasson's *The Weather Project*

Plate 4.14 Unmotivated color in *Suspiria*. Producer Claudio Argento

Plate 4.15 Unbalanced lighting in *Chungking Express*. Director Wong Kar-wai. Producer Chan Yi-kan

Plate 4.16 *Fallen Angels*: color in motion. Director Wong Kar-wai. Producer Jeffrey Lau

Plate 4.17 Prismatic color in *Chungking Express*. Director Wong Kar-wai. Producer Chan Yi-kan

Plate 4.18 Hitchcock's *Psycho*: "realistic" mid-tone grays. Producer Alfred Hitchcock

Plate 4.19 Van Sant's *Psycho*: pastel pinks and fake tans. Director Gus Van Sant. Producers Gus Van Sant and Brian Grazer

Plate 4.20 The menacing blackness of a doorway…. Producer Alfred Hitchcock

Plate 4.21 … becomes quite welcoming in color. Director Gus Van Sant. Producers Gus Van Sant and Brian Grazer

Plate 4.22 Unmotivated shadow: a noir convention. Producer Alfred Hitchcock

Plate 4.23 But where is the light source? Director Gus Van Sant. Producers Gus Van Sant and Brian Grazer

Plate 4.24 Norman emerges from darkness. Producer Alfred Hitchcock

Plate 4.25 Norman separated from darkness by color. Director Gus Van Sant. Producers Gus Van Sant and Brian Grazer

Plate 5.1 Chromatic mixture in *Wings of Desire*. Producers Wim Wenders and Anatole Dauman

Plate 5.2 Red and blue in the fake digital green of *The Matrix*. Directors The Wachowski brothers. Producer Joel Silver

Plate 5.3 Technicolor desaturation in *Moby Dick*. Producer John Huston

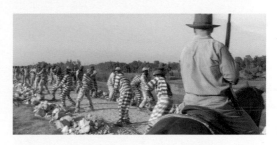

Plate 5.4 Digital sepia tone in *O Brother Where Art Thou?* Directors Joel Coen and Ethan Coen. Producers Tim Bevan, Eric Fellner, Ethan Coen, and Joel Coen

Plate 5.5 Grayface in *Cypher*. Director Vincenzo Natali. Producers Paul Federbush, Wendy Grean, Casey La Scala, and Hunt Lowry

Plate 5.6 Grayface in *Pleasantville*. Director Gary Ross. Producers Steven Soderbergh, Gary Ross, Jon Kilik, and Bob Degus

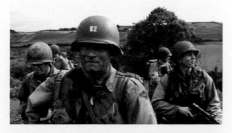

Plate 5.7 Silver-retention in *Saving Private Ryan*. Director Steven Spielberg. Producers Steven Spielberg, Ian Bryce, Mark Gordon, and Gary Levinsohn

Plate 5.8 Fake silver-retention in *Band of Brothers*. Producers Steven Spielberg, Tom Hanks, Preston Smith, Erik Jendresen, and Stephen Ambrose

Plate 5.9 Colorization in *Sky Captain and the World of Tomorrow*. Director Kerry Conran. Producers Jon Avnet, Sadie Frost, Jude Law, and Marsha Oglesby

Plate 5.10 *Sin City*: graphic cinema. Directors Frank Miller, Robert Rodriguez, and Quentin Tarantino. Producers Elizabeth Avellan, Frank Miller, and Robert Rodriguez

Plate 5.11 Color cycling in *Hero*: from diegetic surface yellow…. Director Zhang Yimou. Producer Zhang Yimou

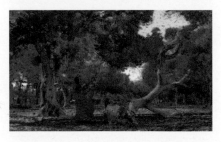

Plate 5.12 … to excessive digital red. Director Zhang Yimou. Producer Zhang Yimou

Plate 5.13 Anarchic color-movement in *Waking Life*. Director Richard Linklater. Producers Tommy Pallotta, Jonah Smith, Anne Walker-McBay, and Palmer West

Plate 5.14 Line tames color-movement in *A Scanner Darkly*. Director Richard Linklater. Producers Tommy Pallotta, George Clooney, Steven Soderbergh, Anne Walker-McBay, Palmer West, Jonah Smith, and Erwin Stoff

Plate 5.15 Colorization in *Mughal-E-Azam*. Producer K. Asif

Plate 5.16 Painted film color in *Black Ice*. Director Stan Brakhage

4

Optical Color

"Colour, to continue, had to occur in space."
 Donald Judd (Batchelor 2008: 205)

Cinema's Newtonian Optics

For color to be perceived, there must be light. Without light, there is only the ghostly monochrome of the night vision camera. Light is inherent in color, and in its history. So far, I have sidelined this fact, treating color predominantly as a surface phenomenon. In doing so, I have been guided by the aesthetic norms of the periods I have been discussing. In early cinema, color took the form of pigments or dyes added to the surface of black-and-white film prints by methods including hand painting, stenciling, tinting, and toning. In classical Hollywood, color was "naturalized"; it became incorporated into the cinematographic process, no longer occupying the surface of the film but surfaces within the film. From the late 1920s to the 1960s and beyond, film-makers typically explored cinematic color by placing colored surfaces in front of the camera, in the form of colored sets, costumes, make-up, and props. Film-makers' historical focus on color as a surface phenomenon is reflected in most of what has so far been written on screen color. Analyses of color in film have so far tended to treat it as if it were painted onto the screen. But there is an extra dimension to color in film: its interaction with light. Gilles Deleuze refers to this manifestation of color as "atmospheric colour" (1986: 118). I refer to it as optical color, and define it as the color that results when white light is decomposed into colored light by means of prisms or colored filters. In this chapter, I trace cinema's move toward a creative engagement with optical color, the

culmination of which – in my view – occurred in the 1970s and 1980s. To do so, it is necessary, in a sense, to begin this history again.

Optical color occurs naturally, for example when sunlight is refracted through atmospheric particles to create a red sunset. However, its exploitation for scientific, technological, and (eventually) artistic ends only began in force with Isaac Newton's famous optical experiments of 1666. Newton made a hole about a centimeter in diameter in the closed shutter of a window, and placed a prism in front of it. By studying daylight refracted through the prism, he discovered that white light "is a confused aggregate of rays that separately would exhibit all sorts of colours as they are promiscuously emited [sic] from the various parts of luminous bodies" (1721: 21).[1] This discovery exploded the residual Aristotelian belief that color is somehow derived from the interaction of black and white, demonstrating instead that white is not a source of color but a composite of all spectral colors. The question of how colored pigments mix had already been answered by four early seventeenth-century scholars, who independently demonstrated that (almost) all colors could be created through combinations of red, yellow, and blue pigments (Shapiro 1994: 606). Newton in turn answered the question of how optical colors mix, at least until the complication of quantum theory.[2]

There remained an unanswered question: how do surface color and optical color interact? Newton's theory contradicted every painter's knowledge that colored pigments combine to create darker colors, and coexisted uneasily with the recent discovery of the three subtractive primaries. Until the seventeenth century, there had been no adequate model of how colors combine; now there were two, both demonstrably true. Newton's optical discoveries foregrounded the apparent contradiction between additive and subtractive color and turned it into a locus of scientific debate. They also caused further confusion. Alan Shapiro notes that Newton initially called decomposed colors, i.e. colors created by shining white light through a prism, "primary" before settling on the terms "simple" and "homogeneal" (1994: 618). Yet, having distanced himself from the term "primary," Newton subsequently reused the word at the beginning of the *Opticks* (1721: 4). Shapiro suggests that Newton deliberately reintroduced the term in an attempt to bridge the gap between his infinite spectral colors and the three primary colors of painting (1994: 619). Pursuing the same musical analogy as Aristotle, Newton also divided the spectrum into seven "primary" colors: red, orange, yellow, green, blue, indigo, and violet (1721: 186).

The confusion caused by Newton's blurring of the distinction between subtractive and additive color can be seen in the groundbreaking but flawed

chromatic hypotheses of George Palmer. In his *Theory of Light* (1786), Palmer suggested a physiological explanation for the existence of primary colors, asserting that "the retina must be composed of three kinds of fibers, or membranes, each analogous to one of the three primary rays and susceptible of being stimulated only by it" (MacAdam 1970: 48). So far, Palmer was correct. There are two types of photoreceptor cells in the human eye: rods and cones, both of which convert light into nerve signals. Rods are attuned to low light conditions and are not sensitive to color; cones function best in daylight and are extremely sensitive to color. There are, in turn, three different types of cone cell, each sensitive to a different range of color frequencies (Baylor 1995). Together, the three types of cone are sensitive to all the frequencies of the visible spectrum, allowing full color vision. Unfortunately, Palmer assumed that mixed light behaves in the same way as mixed pigments in paintings, and so chose the wrong three color frequencies: red, yellow, and blue (Sherman 1981: 81). In 1807, Thomas Young – best known for proposing the wave theory of light – hypothesized the existence of trichromatic vision as follows:

> It is certain that the perfect sensations of yellow and of blue are produced respectively, by mixtures of red and green, and of green and violet light, and there is reason to suspect that those sensations are always compounded of the separate sensations combined: at least, this supposition simplifies the theory of colours: it may, therefore, be adopted with advantage, until it be found inconsistent with any of the phenomena; and we may consider white light as composed of a mixture of red, green, and violet, only.... (Young 1807: 439–40)[3]

In 1851, Hermann von Helmholtz invented the ophthalmoscope, an instrument for examining the interior of the eye. His subsequent studies provided physiological evidence in support of Young's theory of trichromatic vision. In his monumental *Handbuch der Physiologischen Optik*, published between 1856 and 1867, Helmholtz also made explicit the distinction between subtractive and additive color mixture, putting to rest almost 200 years of confusion (2000: 125). Building on an assertion made by James David Forbes in 1849 that mixing pigments involves the absorption of color, Helmholtz explained subtractive color optically, with reference to wavelengths and reflected light. The cumulative work of Palmer, Young, and Helmholtz at last reconciled the existence of three primary colors with the countless "homogeneal" colors observed by Newton. Newton was unable to settle on a single set of additive primaries because there was nothing in

his discoveries that pointed to the importance of any color above any other. Palmer, Young, and Helmholtz realized that if optical color was indeed divisible into three "primary" ranges of color frequency, the explanation for this division had to exist within the eye.

In 1855, James Clerk Maxwell proposed that the Young–Helmholz theory of the existence in the eye of photosensors responsive to red, green, and violet frequency ranges could be demonstrated by photographic means. He speculated that if three photographs of the same object were taken from the same position, each through a different colored filter (red, green, and violet), the result would be analogous to the chromatic trifurcation performed by the retina (Kemp 1990: 321). The three images could then be projected onto a screen through red, green, and violet filters, and reconstituted to create a photographic image in full color. In 1861, Maxwell successfully carried out the experiment, transplanting the chromatic mixture that takes place in our heads into the body of a projector (Maxwell 1861). Despite using photographic emulsions that were not yet sophisticated enough to reproduce the full visible spectrum, Maxwell created out of three black-and-white prints a projected image with tolerable photographic color (Evans 1961: 118).[4]

Maxwell never patented color photography, perhaps because he regarded his discovery as a scientific rather than a technological one. Nonetheless, his work provided a starting point for early attempts to reproduce "natural" color on film. Maxwell's demonstration had been only partially successful because the photographic film of the time was only sensitive to the blue end of the visible spectrum. Between the 1870s and early 1900s, new dyes that made negatives sensitive to red and green light became available (Coe 1981: 116). There followed a deluge of experimental color film processes. For a time, it appeared that almost every self-respecting inventor was working on a color process. Léonce-Henri Burel, cinematographer on Abel Gance's *J'Accuse!* (1919) and *Napoléon* (1927), recalls working for the French studio Gaumont in the early 1900s with a Russian inventor who attempted to create a camera that divided white light into the three additive primaries by means of prisms. Unfortunately, the process proved too complicated to be economically viable, and never even received a name (Predal 1975: F1). Having abandoned a similar attempt to use prisms, British inventor William Friese-Greene revisited Maxwell's 1861 experiment. Maxwell shot the same object three times in succession using red, green, and violet filters one at a time. Clearly, this three-stage process was unworkable for all but motionless objects, so instead Friese-Greene used three simultaneously rolling movie

cameras placed next to each other (Nowotny 1983: 29). This also failed. Each of the three cameras filmed from a slightly different angle, making it impossible to register the three images accurately when projecting them onto a screen. The three colors never quite lined up, resulting in "color fringing."

There were scores, perhaps even hundreds, of similar experiments. Of these, dozens were marketed, but only a handful survived more than a few years (see Ryan 1977). The most prominent early commercial process was Kinemacolor, a "two-color" technology first demonstrated in 1908 that reproduced red and green, but not blue, wavelengths of light (Nowotny 1983: 49–53). The process involved filming alternate frames through red and green filters: as a black-and-white film negative passed behind the lens of a specially modified camera, a rotating disc placed red and green filters alternately in front of the lens. The resulting print could then be reconstituted by a projector fitted with a similar spinning disc. Though briefly successful, Kinemacolor – like many other early color processes – was dogged by color registration problems and failed to last beyond the 1910s. Another notable early color technology was Technicolor, first released in 1916 (Ryan 1977: 77).[5] Returning to the idea of using prisms to split light, the inventors of the Technicolor camera reproduced Newton's darkened room as a wooden box, and metamorphosed it into a unit of production.

Rather than lingering further on Technicolor's three-color technology (already summarized in Chapter 1), I highlight instead a less obvious implication of Newton's discoveries. Newton's experiments demonstrated that the three subtractive and three additive primaries not only mix in different ways but also mix under different – in fact, opposed – conditions. Subtractive color mixture typically takes place on white or near-white surfaces: cotton, canvas, paper, plaster. As Olafur Eliasson observes, white "claims to be what comes before colour" and appears to us as a surface "yet to be marked" (2006: 246–7). Subtractive color also demands white light. In order to manifest its own color, a colored pigment must be perceived *under white light*. Of course, "white light" is not itself white. The term in fact describes light that carries no perceivable color value. Nonetheless, white light is uniquely important in color reproduction because it is the combination of wavelengths under which all color is labeled: indigo, blue, and violet are only indigo, blue, and violet under white light. White light is the a priori condition for all descriptions of subtractive color.

Inversely, additive color is premised on an absence of light: the darker the environment, the more pronounced the color. Shine a colored light on a white wall in daylight and you will still see a white wall. Newton's

experiments required him to shut himself away in a darkened room, with only a narrow gap in his blinds, so as to avoid the possibility that "these Colours be diluted and weakened by the mixture of any adventitious light" (1721: 44).[6] In other words, though the zero point of subtractive color is white, the zero point of additive optical color is black. Aristotle's theory that all color derives from white and black was therefore, in a sense, not deluded at all; it was just excessively literal.[7] In the following sections, I explore the ways in which black and white each underpin chromatic cinema. I begin with white.

White Light: Hollywood's Invisible Ideology

Color film owes its existence to an intellectual genealogy that began with Newton's optical experiments and culminated in the invention of color photography by James Clerk Maxwell. Despite this technological connection, optical color did not become a visual archetype for color cinema. Color cinema's most common early manifestations – hand painting, stenciling, tinting, and toning – all involved surface color. Jacques Aumont observes that in early cinema, "colour generally seems to possess an independent material existence, more or less detached form the objects represented in these films" (Hertogs & de Klerk 1995: 54). This is not surprising, as much of it was painted onto the black-and-white film print. If done with cheap dyes, color further asserted its independence by fading from the print, sometimes after only a single screening (Yumibe 2005). As discussed in Chapter 1, the pigmentary nature of early color in turn influenced how it was used: on the film print, the "objects" most commonly colored were walls, props, and costumes, objects which would in reality also have been dyed or painted. Only an extreme minority of early films used colored pigments to approximate optical color. Among this minority is Pathé's *Le Scarabée d'or* (1907), which includes a firework display stenciled in assorted colors, creating the illusion that the colored light of the fireworks has been caught on film (Plate 1.3). The applied color appears to be intrinsic to the filmed image not only because it appears on a background of black, so reducing the risk of photographed and stenciled outlines mismatching, but also because the exploding sparks draw the color into the action. As in Edison's serpentine dance films, color is motion, and so appears to be diegetic. Nonetheless, even in Pathé's exceptional trick film, the color is still obviously painted onto the black-and-white print. Indeed,

it is this contradiction that makes *Le Scarabée d'Or* so fascinating. The fountains of color startle precisely because we know that they are the visual trace of a handful of dyes brilliantly failing to capture the gradations and fluctuations of infinite spectral colors.

Paradoxically, black-and-white cinematography exploited Newtonian optics from the very start; in fact, it began with blackness. As Trond Lundemo observes, Edison's earliest Kinetoscope films involved figures shot on a black background, so as to maximize visibility in the peephole machine (2006: 92). Early cinematography also embraced light of all colors: throughout the black-and-white era, directors and cinematographers freely mixed different colored lights, knowing that they would all appear on screen in shades of gray. This fact could also be exploited for creative ends. By using colored lens filters or placing colored gels over lights, cinematographers could light a scene in such a way that only a certain range of light frequencies was reproduced on the black-and-white negative. Unfiltered white light allowed the full spectrum of colors to be translated into black-and-white, resulting in an image with a full range of tones. Red filtration prevented all but the red wavelengths of the spectrum from reaching the film negative, so that on the final film print, instead of showing up in shades of gray, red surface colors (which absorb red light) became black. So popular was this use of colored lighting that by the late 1910s, several loose conventions were already in place for how colored lighting should be used. For example white light was used for comedies and blue-green light was used for what a contemporaneous commentator referred to as "sad scenes, such as death-bed scenes" (Mott 1919: 13).

The earliest examples of full-color Technicolor also demonstrate extensive use of colored light. In a test for *La Cucaracha* (Lloyd Corrigan, 1933), the first full-color live-action Technicolor short, "color designer" Robert Edmond Jones made John Barrymore read the ghost scene from *Hamlet* in blue light, signifying moonlight (Higgins 2007: 29). This then changed to green light when the ghost appeared. Jones also used "mood lights" to emphasize characters' emotions in the final film, notably red light to evoke feelings of anger (Higgins 2007: 34). However, the liberal attitude to colored light manifested in Jones's tests and *La Cucaracha* itself did not last long. Already in 1935, an article in the *Journal of the Society of Motion Picture Engineers* expressed its allegiance to white light, and thus also to surface color, by emphasizing the need for lighting units that approached the color temperature of daylight (Handley 1935: 423). As Scott Higgins points out, though Technicolor cinematographers of the mid- to late 1930s frequently used light expressively,

it was rarely colored (2007: 86). In films including *The Garden of Allah* (Richard Boleslawski, 1936) and *A Star is Born* (William Wellman, 1937), scenes featuring directional "low-key" lighting tended to eschew color and mimic black-and-white cinematography's focus on tone (see Plate 4.1). In scenes with less overt lighting, by contrast, color was allowed greater prominence, appearing in the form of pigments inherent in, or applied to, surfaces in front of the camera.

The perception within classical Hollywood that color should be a surface phenomenon is also apparent within practitioners' discourse. For example, Rouben Mamoulian, director of *Becky Sharp* (1935), the first full-color Technicolor feature film, asserted that "we, the makers of colour films, are actually painters. We are painting with light ..." (1960: 71). Of course, as I suggested in Chapter 2, "painting with light" is an oxymoron, highlighting rather than reconciling the difference between subtractive and additive color mixture. In fact, Mamoulian did not "paint" with light. He created white light conditions under which his costume designers, make-up artists, and art directors could display their colored surfaces. White light and surface color were symbiotic: the former privileged the latter, and the latter demanded the former. This symbiosis was clearly expressed in an *American Cinematographer* feature from 1947, reporting that the dominant view among its members was that "white light only should be used for Technicolor, the shades of settings and costumes being allowed to account for contrast" (Lightman 1947: 201). Throughout the era of Technicolor's hegemony, only Victor Fleming's *Gone with the Wind* (1939) featured sustained use of colored lighting. According to Scott Higgins, "Twenty-one of the film's seventy segments incorporate some degree of colored illumination or the play of color temperature" (2007: 183). The appearance of blue, yellow, and other colored light in *Gone with the Wind* distinguishes it among color films of the period; however, despite the film's success, Hollywood practitioners continued to favor white light.

Hollywood practitioners favored, and still favor, white light because the alternative involves asking hard questions about light sources. Perhaps the hardest question of all is: how can the artificial light sources used to illuminate a film be made to appear "natural" to the diegesis, so that they do not draw attention to the film-making process? Using David Bordwell's terminology, the question becomes: how can artificial light sources be realistically motivated? In the first two decades of cinema, realistically motivating light was not a problem. As long as cinematographers used diffused daylight and the hazy light of mercury vapor lamps, the resulting lighting was

soft and had no distinct source. It appeared ambient, like the light on a cloudy day. However, as Kristin Thompson observes, when directional arc lamps began to be used in the mid-1910s, they drew attention not only to what was being spotlit but also to where the light was coming from (Bordwell et al. 1985: 223). Visible rays of light connected source with destination, inviting the eye to follow their path in both directions.

Directional light was not a particular problem in black-and-white cinematography. Because black-and-white is an intrinsically stylized mode of representation, it accommodates directional lighting more easily than color. In black-and-white, a table lamp can cast a long shadow on a wall without looking unrealistic, even though we know that table lamps tend to be soft light sources. Another benefit of monochrome cinematography is that it erases the different color temperatures that result when different types of light source mix on film. In black-and-white, light is simply light; the light from a table lamp and a fluorescent tube merge into each other, so obscuring their sources. In color, however, the yellow white of an incandescent light is clearly distinct from the green white of a fluorescent light and the blue white of daylight. All colored light, even soft colored light, makes us conscious of its source. Thus, if colored light is not to contradict a fictional film's reality effect, it must – to use cinematographers' preferred word – be "justified." In other words, it must appear to emanate from diegetic sources: sunlight, streetlights, interior lights, and so on. Unless our eyes can be fooled into believing that the light's non-diegetic source is in fact diegetic (for example, that the light coming from an overhead lighting grid in fact comes from a ceiling lamp in a living room), colored light draws attention to a film's means of production. This is typically allowable in documentaries and avant-garde films, but not in films that partially conceal their mediation. White light retained, and continues to retain, ideological power within narrative cinema in direct proportion to the extent that codes of realism also continue to retain their ideological power.

Classical Hollywood cinematographers wishing to experiment with colored light thus had to find ways of realistically motivating it. Even the startling orange light that fills the screen as Scarlet O'Hara and Rhett Butler first kiss in *Gone With the Wind* is realistically motivated by being set at sunset. Chromatically adventurous cinematographers also faced another obstacle: Technicolor Inc. As I discussed in Chapter 1, until the early 1950s, Technicolor was almost a monopoly supplier of color technology. Utilizing the power that comes from being a monopolist, Technicolor established the "law of emphasis," which demanded that cinematographers who used its

services should use color in moderation, and should motivate it realistically. Colored lighting, because of its tendency to draw attention to the film-making process, alarmed Technicolor executives even more than colored surfaces. If a film included overt surface color, Technicolor executives would probably object; if it included overt optical color, they were sure to object. For example, the colors in *The Black Swan* (Henry King, 1942) do not now seem particularly extreme, even when digitally "restored" on DVD. The only overt optical color in King's film occurs during a brief early morning scene bathed in bright, diegetically motivated yellow light. Yet despite the fact that director of photography Leon Shamroy won an Academy Award for his work on the film, Technicolor executives expressed dissatisfaction at the result (Douchet 1963: 34). As no cinematographer could afford to ignore Technicolor's "law of emphasis" if he wished to continue working in color, Shamroy subsequently moderated his use of colored lighting. In his next project, *Forever Amber* (Otto Preminger, 1947), he used pale colored filters to create more polite areas of warm (yellow) and cool (blue) light. Even this relatively bland use of lighting pushed against the boundaries of what Technicolor was willing to tolerate, so Shamroy used an *American Cinematographer* feature about *Forever Amber* to emphasize his conformity to Technicolor's chromatic doxa (Lightman 1947). Throughout the article, Shamroy repeatedly refers to "balance" and "emphasis." By invoking "balance," he emphasizes that his use of colored light occurs within the context of an overall lighting scheme dominated by white light. By invoking "emphasis," he asserts that he uses color not for its own sake but for the sake of the narrative. Shamroy also tones down his reputation for chromatic excess by comparing his techniques to those of Rembrandt (Lightman 1947: 201). Not coincidentally, as I observed in Chapter 2, Rembrandt was one of the painters whose subdued colors were singled out by Natalie Kalmus as examples of what Technicolor cinematography should aspire toward (Kalmus 1935: 140).

Following the decline of Technicolor in the early 1950s, Hollywood's use of color became less constrained. Though the law of emphasis lingered, film-makers typically emphasized dramatically relevant information more emphatically, with more intense colors, against more colorful backgrounds. However, the dual chromatic paradigm of white light and surface color continued to exert undiminished influence. Coded reminders of white light's continued dominance surface throughout a key 1957 publication by the Society of Motion Picture and Television Engineers (SMPTE). Reflecting the views of the powerful industry body that prepared it, *Elements of Color*

in Professional Motion Pictures includes detailed guidelines on how to light in color, beginning with the proclamation that "the color quality of a light source should be that for which the film is balanced" (Holm et al. 1957: 76). Different light sources (for example, sunlight, moonlight, firelight, and the various forms of artificial light) have different color temperatures. Color temperature is based on the changing colors of metal as it is heated. At about 3,000 degrees Kelvin, metal glows yellow, at about 5,000K it glows white, and above 6,000K it begins to glow slightly blue. A tungsten lamp has a color temperature of about 2,800K, which means that – like metal heated to 2,800K – it produces yellow light. Daylight typically has a color temperature of between 5,000K (white) to 6,500K (slightly blue). We tend to see light bulbs as white, not yellow or green, because the human eye adjusts to make the dominant light source in our visual environment appear white. Color film, however, needs to be "balanced" to make a light source appear white. Color film stocks have historically been manufactured in two versions, one balanced for daylight and the other for tungsten light. Daylight balanced film stock registers daylight as white, tungsten balanced film stock registers tungsten light as white. By stipulating that daylight balanced film should be used for daylight, and tungsten balanced film for tungsten light, *Elements of Color* asserts that all light should appear on screen as white.

The SMPTE's guidelines did, however, sanction occasional divergences from white light. For example, colored light could be used to "glamorize, or to create a striking effect for attention-getting purposes" (Holm et al. 1957: 76). In other words, colored light could be used as a brief counterpoint to, and thus reassertion of, the dominance of white light. In *The Robe* (Henry Koster, 1953), as Christ dies on the cross, a storm arises and momentarily illuminates the faces of observers with flashes of supernatural purple. Color could also be used to "alter or enrich the color of fabric backgrounds or drapes, particularly in shadow areas. To give the effect of light being reflected from nearby colored objects" (Holm et al. 1957: 76). In other words, colored light could also augment and mimic surface color. The most significant allowed divergence to be sanctioned, and the only one that allowed for the use of colored light for an extended period of time, was the simulation of "outdoor lighting effects on the stage," especially moonlight (Holm et al. 1957: 76). Like the sunlight that it reflects, moonlight is white. However, this reflective white is too dim to provide films with conventional levels of illumination. Hence, a contradiction: "realistic" darkness broke the classical Hollywood rule that characters should be clearly visible, but standard levels of white lighting resulted in precisely the kind of artifice that Hollywood so

loathed. Either way, white light was not appropriate for lighting night. As a result, cinematographers used blue light for night scenes in color films, making possible clear definition without excessive levels of lighting.[8] The blue light of filmed night was, and continues to be, a necessary evil.

At night, colored light escapes the hegemony of white. Unsurprisingly, sequences set after dark were a key site of tension in 1950s Hollywood between colored light and white light. Films including Max Ophüls's *Lola Montès* (1955), Douglas Sirk's *Written on the Wind* (1956), and Alfred Hitchcock's *Vertigo* (1958), challenged the hegemony of white light. Perhaps the most extreme challenge came from the director-cinematographer partnership of Douglas Sirk and Russell Metty. For example, in *Written on the Wind*, even daylight sequences include colored light. The image of a doorway in the film's title sequence includes pools of pale blue and orange light, even though it is daytime. In scenes set at night, Sirk and Metty used even more overtly colored lighting. They also embraced directional light, unafraid to cast hard shadows onto walls. In a particularly startling scene, Mitch Wayne (Rock Hudson) talks to Marylee Hadley (Dorothy Malone) in an unlit room. The opening of the scene is illuminated solely by the electric blue of artificial night, banding the room in black and blue. The effect is astonishing, but Sirk and Metty are unable or unwilling to follow through. After Mitch and Marylee have exchanged a few lines, Marylee switches on a table lamp, illuminating both their faces in white light (Plate 4.2). For the rest of the scene, the two characters remain close to the white light, moth-like, unable to escape its pull.

Even in musicals, which according to the SMPTE were a special case and had free chromatic rein, white light continued to overrule colored light (Holm et al. 1957: 42). For example, in Stanley Donen and Gene Kelly's *Singin' in the Rain* (1952), Gene Kelly and Debbie Reynolds shine colored spotlights at each other as they sing "You Were Meant For Me" on an empty sound stage. Though none of these spotlights are white, the sequence is nonetheless key lit with white light (Plate 4.4). Where does this mysterious white light come from? The answer, of course, is that it shines down from the pages of the SMPTE's rulebook. Despite the aforementioned concessions to colored light, there remained two surfaces onto which it could not fall for more than the briefest period: faces and food. The SMPTE declares that a "green face or a purple slice of bread, for example, is almost intolerable" (Holm et al. 1957: 76). The overall cinematic dominance of white light is not difficult to understand. For most of the day, we see the world in white or near-white light. Classical realist cinema demanded the same illumination

for its films. But why should colored light have been so intolerable that even in a musical sequence, set in a dark space full of colored spotlights, white light remained inviolable? Beyond the need for motivation, and beyond the realist demands of classical cinema, there must have been other reasons. I wish tentatively to suggest the additional presence of an ethnic motivation.

Like the visible spectrum, skin color occupies a chromatic scale. With a taxonomic zeal reminiscent of Newton's classification of spectral color, though infinitely more damaging, Orientalism reduced the world's spectrum of ethnicities to two: white and black. But what do white and black actually describe? Richard Dyer observes with reference to his own ethnicity: "White people are neither literally nor symbolically white. We are not the colour of snow or bleached linen, nor are we uniquely virtuous and pure. Yet images of white people are recognisable as such by virtue of their colour" (1997: 42). Whiteness and blackness are constructs, created by "white" people to give themselves an illusory racial stability. Classical cinema reinforced this illusory stability through various technological sleights of hand. For example, it was common practice to expose film for white faces so that all darker skinned faces flattened out into underexposed blackness (Winston 1996: 41). Dyer also reminds us that "much of the history of Western make-up is a history of whitening the face" (1997: 48). Perhaps white light too served to reinforce this polarization. Max Factor make-up provided actors with a surface coating of whiteness. For this cosmetic whiteness to be effective, it demanded white light. Colored light blurs pigmentary distinctions. Under yellow light, all faces appear at least partially yellow. Everyone becomes a stereotypical oriental. Perhaps the true horror in classical Hollywood was in fact not a green face, but a yellow face or a pale brown face, a face whose "true" whiteness or blackness was obscured by colored light.

I have found only two examples of classical Hollywood films that exclude white light for extended periods of time. The first is Vincente Minnelli's *An American in Paris* (1951), in which a fantasy ballet sequence photographed by "noir" cinematographer John Alton takes place in colored key light. The sequence is self-contained, with the beginning and end of the fantasy – and the optical color – clearly signaled. Figures remain in wide shot throughout, their individuality subsumed to the overall design of the choreography and the lighting. Though Alton's use of colored light is beautiful, it is unthreatening. By contrast, in Joshua Logan's *South Pacific* (1958), optical color intrudes unexpectedly throughout the film, suddenly transforming whites into yellows, reds, purples, or blues. Photographed by now-veteran colorist Leon Shamroy,

the film features multiple long-duration sequences in which white is not merely stripped of its power, but completely exiled from the frame (Plate 4.5). Shamroy removed white by placing colored filters directly in front of the camera's lens (Gavin 1958: 295). This filtration is concentrated around the film's musical numbers, but it is not restricted to them; often "natural" color gives way to filtered color in anticipation of a musical number, and often the filtered color remains after the singing has stopped. Logan and Shamroy also repeatedly moved from one state to another *within* shots, by sliding a graduated color filter in front of the lens while the camera was rolling (Gavin 1958: 295). In this way, they further emphasized the unnaturalness of the film's filtered colors and the arbitrariness of their chromatic choices.

In the post-Technicolor era of 1950s Hollywood, Shamroy was able to voice his agenda more explicitly, asserting in an *American Cinematographer* feature on *South Pacific*: "Color no longer requires a rational source" (Gavin 1958: 295). Re-invoking the concept of "painting in light," he opined:

> I think the secret of successful color photography is not to shoot a scene to make it look as it looks to the eye. You have to put something additional into it – something to give it impact – otherwise the scene can be commonplace if not monotonous. Straight, ordinary cinematography is for newsreels. (Gavin 1958: 319)

In the same article, Shamroy also expressed relief that at last he could use colored filters "openly" (1958: 296). But Shamroy's chromatic bullishness was again slightly out of step with the industry. By the time he shot *South Pacific*, at the cusp of the 1960s, Hollywood's chromatic taste was moving toward realistically motivated color. Studio executives hated the film's filtered colors (Gavin 1958: 318). Though critical responses to the film varied, its color was also questioned in the media. In otherwise positive reviews, both *Variety* and *The New York Times* labeled the tinted sequences "disconcerting" (Anon. 1958; Crowther 1958). Other critics found the colored faces particularly intolerable. For example, a *Sunday Express* critic observed that "[Logan] makes his cast look as if they are suffering everything from a raging fever to deepest jaundice" (Shulman 1958). I wonder if this aesthetic disdain was not in fact a sublimation of racial anxiety. Perhaps the on-screen illness that the *Sunday Express* critic in fact decried was the illness of losing one's racial characteristics. It is telling that all contemporaneous reviews of the film greeted with silence the musical's premise of American soldiers and Pacific islanders romantically intermingling.

The unmotivated colors and ethnic ambiguities of *South Pacific* did not prevent the film from breaking box office records (Anon. 1962). However, Shamroy never again repeated his experiments with filtration. The following year, he lit Otto Preminger's *Porgy and Bess* (1959) using the same principles of balancing colored and white light that he had used in *Forever Amber* (Gavin 1959: 498). By the late 1960s, Shamroy had publicly renounced even this moderate use of colored light:

> I feel that colored light should be used sparingly – not purely for decorative effect, but to simulate realistically a light source that would naturally have a special color cast to it. I believe in trying for a certain realism, even when shooting a fantasy. (Lightman 1968: 278)

The fantasy in question is *Planet of the Apes* (Franklin J. Schaffner, 1968). The final work in Shamroy's 40-year career, it takes place predominantly in the white light of day.

Before I move on to discuss Hollywood's shift in the late 1960s and 1970s toward a more active engagement with various forms of natural light, it is important to emphasize that the hegemony of white light was not specific to classical Hollywood. Even 1960s art cinema, a cinema with a strong proclivity toward stylization, relied on white light. Jacques Aumont observes that in art cinema, as in classical Hollywood, having colored objects in a frame was by far the most common means of using color (1992: 18). Despite agendas that often directly contradicted those of classical Hollywood, and styles closer to modernist painting than Old Masters, art film-makers nonetheless relied on painted, printed, and dyed colors. In *Cries and Whispers*, Ingmar Bergman's minimal palette of black, white, and red is made possible by the superabundance of white light. Bergman's inky colors create a visual environment that is as much graphic as cinematographic (Plate 2.6). Jean-Luc Godard's color 1960s films take the graphic potential of pigmentary color to an even further extreme. Godard's principal colors – red, blue, and yellow – are the subtractive primaries. Edward Branigan observes that these colors most often appear as blocks, shot head-on in diffused light, resulting in compositions dominated by flat planes of solid color. The result, he suggests, is similar to the paintings of Piet Mondrian (Branigan 1976: 27). Alain Bergala extends Branigan's analogy by likening the white walls of Godard's interior locations to a blank canvas, onto which Godard added pigmentary color in the form of props and costumes (1995: 134).

I choose an alternative metaphor: not a blank canvas (canvas is rarely such a pure white as Godard's walls) but a blank sheet of paper. For me,

Godard's colors evoke not a painter's pigments but the subtractive primaries of CMYK printing. In painting, red, yellow, and blue are only three of a wide range of pigments at the artist's disposal. In CMYK printing, *all* color derives from the combination of the three primaries, plus black: the infinite colors of the world are simplified on paper in the form of tiny dots of cyan, magenta, yellow, and black ink that recombine as we look at them into seemingly solid colors.[9] In Godard's films, a similar red/yellow/blue fragmentation and recombination takes place over time. Branigan notes that Godard's primary colors repeatedly splinter into fragments and recombine back into larger blocks of color from shot to shot. A shot of a wall in *2 ou 3 Choses que je sais d'elle* (1967), covered with the remnants of countless (red, yellow, and blue) advertising posters, provides a typical example of Godard's chromatic fragmentation (Plate 4.6). Through such shots, "Godard's color serves notice that nature will be radically reassembled, not imitated, and in a way which questions the dominant forms of assembly or representation" (Branigan 1976: 26). The dominant forms of representation invoked by Godard's color are thus not the artisanal products of high art but the mass-produced products of popular culture: posters, magazines, cartoons, packaging, and so on. The most appropriate metaphor to use when describing Godard's use of color is therefore not that of a painter's palette but that of a printer's swatch. Godard's use of color is more than graphic; it is *reprographic*. It mimics not artisanal but industrial production. When making *Une Femme est une femme* (1961), Godard largely restricted himself to using red, yellow, and blue. Once his chromatic formula proved viable, he reproduced it for the next six years. Ever playful, Godard foregrounded his Fordist reproductions of color by including shots of swatches in two subsequent films. In *Le Mépris*, a multi-colored swatch is placed in front of a classical statue with eyes painted blue (Plate 4.7). In *La Chinoise*, a camera pans momentarily across a white card on which is printed a swatch of blues. Under, around, and in front of the blues, is white.

Darkness Visible: From Natural Light to *"Neo-Noir,"* 1968–83

Godard liberated cinematic color from its connotation of painting, but he did not liberate it from the pigment. Nonetheless, over the course of the 1960s and 1970s, saturated surface color became a less prominent feature in

contemporary cinema. As discussed in Chapter 2, this chromatic moderation occurred first in 1960s Hollywood, at a time when many film-makers in other parts of the world remained hypnotized by color. By the early 1970s, desaturated color was an international norm. Michaelangelo Antonioni followed *Il Deserto Rosso* with the modernist whites and concrete grays of *Blow Up* (1966); Ingmar Bergman followed *Cries and Whispers* with the made-for-television midtones of *Scenes from a Marriage* (1973).

Prominent among 1970s film-makers' and cinematographers' interests was natural light, an interest encouraged by recent increases in color film speeds. Until the mid-1960s, black-and-white film stock was significantly faster than color. Eastman Kodak's Tri-X, released in 16mm and 35mm versions in 1954, had a daylight-balanced speed of 250 ASA and a tungsten-balanced speed of 200 ASA (Huse 1954: 335). This was fast enough to allow for interior and some night filming using available light sources. By comparison, the fastest 35mm color film at the time, Eastman Kodak 5248, had a daylight speed of 24 ASA (Ryan 1977: 151). It was only with the release of Eastman Color 5254 in 1968, with a daylight ASA of 100 and a tungsten ASA of 64, that available light sources began to play a significant role in color cinematography.

In tandem with these changes, the cinematic dominance of white light modulated into the dominance of ambient light. Film-makers and cinematographers returned their attention to the original source of white light: the sun. Exemplary of New Hollywood's natural light aesthetic is Terrence Malick's *Days of Heaven* (1978), set in the wheat fields of Texas. Shot by Nestor Almendros, whose work with Eric Rohmer in the 1960s had – together with that of Sven Nykvist and Ingmar Bergman – set a new standard for the use of natural light, the film documents the various light conditions that predominate throughout the day. Regardless of whether Almendros filmed at dawn, in full daylight, at twilight, or at night, he used little or no artificial light (Almendros 1979: 562). When shooting in the hard light of a sunny afternoon, he discarded the Hollywood convention of using fill light, allowing faces to remain in partial shade. In daylight interiors, inspired by the light that floods through Vermeer's paintings but in fact – due to limitations in the sensitivity of the film stock he used – achieving a result closer to the directional spotlighting of Rembrandt, he allowed location interiors to remain illuminated only by the daylight shining through their windows (Almendros 1979: 630). Even in the film's climactic night-time sequence, in which a fire rages out of control across the wheat fields, Almendros did not follow the convention of using colored light to augment

the light of the flames. Instead, he lit fire with fire, using flames from a gas pipe laid next to the camera to provide additional illumination (Almendros 1979: 627).

New Hollywood directors' and cinematographers' interest in natural light was often accompanied by a tendency toward desaturation. Though the conflagration sequence and the famous "magic hour" shots in *Days of Heaven* allow for spectacular natural eruptions of color, for most of the film Almendros and Malick actively suppressed color. For example, Almendros exposed daytime exteriors for halfway between highlight and shadows areas, so that brighter areas including the sky would be over-exposed, and would lose some of their color, as seen in Plate 4.8 (Almendros 1979: 564). Cinematographer Conrad Hall used the same technique in *Butch Cassidy and the Sundance Kid* (George Roy Hill, 1969). Hall overexposed his negatives during filming and then had them underexposed when transferred onto positives in the lab in order to reduce the saturation. In an interview, Hall stated that he had been particularly keen to remove the "picturesque" blue of the desert sky (Lightman 1970: 474). Other cinematographers achieved similar effects through a range of different means. In order to mimic the faded colors of aging photographs, Vilmos Zsigmond pre-exposed ("flashed") the film stock that he used to shoot Robert Altman's *McCabe & Mrs Miller* (1971).[10] By briefly exposing it to white light prior to filming, Zsigmond achieved a similar effect to Hall's overexposure. Another similar effect was achieved by different means in Roman Polanski's *Chinatown* (1974); director of photography John Alonzo used extensive filtration in the laboratory to maintain the film's uniform brown-beige tonality (Alonzo 1975: 585). Needless to say, in all of the above films, art direction, production design, and costume design were also complicit in the exclusion of overt color from the frame.

New Hollywood's interest in desaturation and available light reached both a culmination and a conclusion in Michael Cimino's *Heaven's Gate* (1980). In *Heaven's Gate*, director of photography Vilmos Zsigmond took his work on *McCabe & Mrs Miller* a step further, flashing not only the negatives but also the print stock onto which the negatives were transferred (Zsigmond 1980: 1110). The result is prints in which the desaturation is so extreme that the film sometimes seems to cross an invisible threshold, drifting imperceptibly – like the films of Andrei Tarkovsky – between color and black-and-white. Zsigmond also employed the sun as his main source of light, softening the hard edge of daylight with dust (Zsigmond 1980: 1164). However, as *Heaven's Gate* moves from day to night, the film's style changes.

When shooting night sequences, Zsigmond followed the same principles as he did in his daylight sequences, using available lighting as much as possible and softening it with smoke (Zsigmond 1980: 1112). However, the effect is drastically different: rather than disappearing into the film's soft browns, light now reveals itself to exist in three dimensions. Rays of light slice through the smoke, taking on an architectural quality reminiscent more of film noir than early cinema. The transitions from day to night in *Heaven's Gate* are metonymic of a broad stylistic shift that took place at the cusp of the 1980s within Hollywood and beyond. For Zsigmond, the move from diffused daylight to directional night-light was unwelcome:

> Another hazard of the smoke treatment was that if I used lights near the frame-line, I would sometimes get unwanted rays of light. Since I believe in realism in lighting, I couldn't let this happen. I would sometimes have to "invent" a light source – like placing a lantern in the scene, so that I could justify the light rays. (1980: 1111)

By contrast, for many of most prominent 1980s Hollywood film-makers – including Adrian Lyne, Michael Mann, and Ridley Scott – the move from day to night provided a stylistic opportunity. This opportunity involved using black, not white, as a creative zero point.

Black and white are opposites, each what the other is not. As such, they are intimately related: they imply each other, enfold each other, precede, and succeed each other. Black is the achromatic blackness of the frames before a movie begins, as film leader passes through projector. White is the light of the projector before the film print is threaded through it. Black is the darkness of the auditorium before the projector is switched on. White is the blank page of the movie screen before the auditorium lights are turned down. Optically, too, black and white provide alternating zero points. White is the reflection of all the wavelengths of light, black their absorption. All color exists within the visual limits set by the reflectivity of white and the absorptiveness of black. Neither black nor white is anterior to the other. It is, however, possible to create circumstances in which one or the other is conceptually anterior in the gestation of a specific work of art. Black-and-white cinema followed both courses; according to their preference, directors based their films' cinematography on either black or white. Carl Dreyer's *Vampyr* (1931) emerges not out of shadow but out of luminous, overexposed daytime whites. Inversely, Fritz Lang's *Siegfried* (1924) is engulfed by black. Shots take the form of high contrast images surrounded by black

vignettes. It is often impossible to pinpoint the border at which the darkness of the shadows transforms into the blackness of the vignettes; blackness and shadow become a single entity, threatening to drown characters in their viscous spillage across the screen.

Black-and-white cinema as a whole was premised on both black and white. This was not the case with color cinema: it initially chose white. Black did not become a common zero point for color films until the 1980s. Typical, perhaps even prototypical, of cinema's belated movement into shadow is Ridley Scott's *Blade Runner* (1982). Only one scene in the entire film, when Rick Deckard (Harrison Ford) visits the penthouse of cybernetics magnate Eldon Tyrell (Joe Turkel), is set in full daylight, though even this "daylight" was simulated on a sound stage. Otherwise, an atmospheric blackness engulfs the film's dystopian near-future Los Angeles. The city is so polluted that daylight never makes it down to street level. Black pigments of pollution hang in the atmosphere, forcing the city's population to live in darkness, like the Cimmerians in Homer's *Odyssey* (11, 14). All light is artificial and evanescent. Fluorescent lights flicker, neon lights flash, beams of lights from passing air traffic cut through the shadows of interior spaces and then move on (Plate 4.9). Even the daylight of Tyrell's apartment only lasts for a few moments, before Deckard asks for the blinds to be drawn so he can test to see if Tyrell's assistant is a replicant.

The most prominent shadow in *Blade Runner* is that of black-and-white cinema. Though black-and-white films were a marginal presence by the early 1980s, the influence of black-and-white remained – and still remains – pervasive. Cinema's aesthetic legacy includes eight decades in which monochrome was an aesthetic norm, an ineradicable expanse of cultural memory. Black-and-white endures in our cultural memory of both cinema and the twentieth century. Its presence subsists on-screen whenever the basic aesthetic principles of monochrome cinematography – for example, the use of chiaroscuro and close attention to tonality – assume prominence in a film. As cinema moved into the third dimension of color in the 1970s and 1980s, films began to engage with light in ways that glanced back to black-and-white cinematography. The specific cinematographic style evoked by *Blade Runner* was of course that of film noir. The most obvious overlap between noir cinematography and that of *Blade Runner* is the presence of directional light. The rays of light so disliked by Zsigmond because of their lack of "realism" here become a key element of the film's aesthetic. Yet the film's lighting also distinguishes it from classical noir. *Blade Runner* relies for its look on backlight. Scott and Cronenweth inverted the low-key,

directional light sources of classical noir, placing them in front of the camera not behind it, and directing them back at the lens (Plate 4.9). The lights pointing at the camera fill the screen with atmospheric white but also turn everything in their path, including actors, into shadows. Of course, back-light demands motivation. Accordingly, Scott, Cronenweth, and "visual futurist" Syd Mead together ensured that *Blade Runner*'s production design provided explanations for the backlight. Says Cronenweth:

> Ridley liked the feeling of shafts of light in *Citizen Kane*, so we used them for the first time in the Tyrel Corporation scene. Ridley loved it but how could we justify it in other scenes? The next scene where we wanted to use this motif was in the Blade Runner's apartment. It was decided to justify it by establishing the light sources as advertising on the side of the dirigibles float-ing around outside. (Carmichael 1982: 1157)

This loosely "justified" directional backlighting combines with Scott and Cronenweth's enthusiastic use of smoke. In contrast to *Heaven's Gate*, the sense of depth resulting from *Blade Runner*'s smoke is a key element of the film's aesthetic. The smoke allows light rays' journeys through space to become visible, creating atmospheric vectors. It also smudges these geo-metric orthogonals of light, making them both prominent and indistinct, softening the hard lines of conventional film noir.

What of colored light? Like the black in *Siegfried* and so many works of German Expressionist cinema and film noir, Blade Runner's blackness is more than just a layer of emulsion; it is the three-dimensional blackness of architectural spaces filled with shadow, an atmospheric darkness equivalent to that of Newton's study. Originating films in Newtonian darkness made possible an increased use of optical color. The film's production design relies heavily on neon light. On-screen neon is further augmented by Cronenweth's regular use of off-screen neons to light scenes (Lightman & Patterson 1982: 721). Neon is additionally reflected, and so multiplied, by the puddles of water that lie scattered throughout the streets. But though prominent, optical color is not dominant in *Blade Runner*. Though the film's interior spaces, shielded from the exterior by Venetian blinds, provide an environment evocative of Newton's study, the beams of light that pass through the gaps in the windows do not refract into their constituent colors. The film's directional backlight always remains white. Inspired by the low-key cinematography of German Expressionism, of *Citizen Kane*, and of film noir, Scott and Cronenweth privilege tone over color.

Blade Runner's tentative engagement with colored light reflects a widespread tendency in mainstream cinema throughout the 1980s. Despite the increased use of black as a chromatic zero point, colored light remained a divergence from the norm. The cinematography of *Blade Runner* proved to be immensely influential, providing visual inspiration for films including Michael Mann's *The Keep* (1983) and Adrian Lyne's *Flashdance* (1983). Directional backlight and smoke are common features in both films, but the light remains white. In *The Keep*, colored light is used only in occasional special effect sequences. In *Flashdance*, colored light is restricted to the diegetic reds of a nightclub – even though one might imagine (based on the example of classical Hollywood musicals) that Lyne's musical might have a relatively carefree approach to color. Within 1980s Hollywood, only Francis Ford Coppola's ill-fated *One From The Heart* (1982) – also a musical – made widespread use of colored light; in doing so, Coppola drew inspiration from the film's Las Vegas setting rather than any generic norms (Plate 4.10).

The dominion of white light extended beyond Hollywood. A striking example of its continued hold on art cinema can be seen in Jean-Luc Godard's *Passion* (1982). *Passion* is a film about a film about painting. It focuses on a fictional Polish director who films a series of *tableaux vivantes* of famous paintings. Its use of light approximates that of such "cinematic" painters as Rembrandt and Goya, both of whom the director uses as sources for his tableaux. *Passion* was the first film since *Week-End* (1967) that Godard made with Raoul Coutard, the cinematographer with whom he had established his reprographic aesthetic in the 1960s. In *Passion*, Godard also returned to the intertextual color of his 1960s films. Many of the film's costumes and props are again red or blue. However, the pre-chromatic state in *Passion* is not white but black; the blank white walls of the apartments in Godard's 1960s films are replaced by the darkness of the sound stage in which the Polish director stages his chosen paintings (Plate 4.11). Godard moves beyond pigmentary color and embraces the paradox that in order to mimic classical painting most closely, he must use light. So color is not layered on top of white but coaxed out of the shadows by spotlights. In a few virtuosic shots, Godard and Coutard extend the reach of black into daylight exteriors. By pointing a camera at the sun and stopping down the aperture of the lens, they neutralize the white light of day and cause it to sink into shadow. Rarely has daylight been so efficiently rejected.

So too, the color space implied in *Passion* is not that of the subtractive primaries, in which white is a pre-chromatic surface coated with reds, yellows, and blues. Instead, the film's blackness implies the additive color space

of the red, green, and blue primaries. RGB appears to have replaced CMYK, a fact emphasized by the proliferation in *Passion* of video monitors. Yet though the images on the film's numerous cathode ray tubes result from RGB video inputs, the three additive primaries do not appear elsewhere as light. Instead of filling the sound stage with optical color, Godard and Coutard inscribe it with white light. Like Scott and Cronenweth, they privilege tone over color. Even Godard's trademark reds and blues seem weak here, submerged in the darkness of the sound stage and bleached by the light of the studio lamps.

Cinematography and Color Filtration, 1977–97

Newton observed colored light by closing the shutters of his room and refracting light rays through the darkness. Of course, as *Blade Runner* and *Passion* demonstrate, though originating a film in Newtonian darkness makes possible various techniques for decomposing and reconstituting white light, it does not guarantee the use of such techniques. Between the 1970s and 1990s, white light remained the cinematic default across all genres, national cinemas, and movements. At the same time, though ultimately not widespread enough to form anything approaching a post-classical trend, sustained uses of colored light became more common. For example, colored light routinely featured in style-focused films of the French *cinéma du look*, including Jean-Jacques Beineix's *Diva* (1981) and *Betty Blue* (1986), and Luc Besson's *The Big Blue* (1988). In *Betty Blue*, Beineix and cinematographer Jean-François Robin use orange as a key light and blue as a background light for scenes set at night. On occasion, optical color even penetrates daytime interiors, as when Beineix and Robin turn a shadowy corner of a piano shop into an island of night, filling the darkness with orange and blue light (Plate 4.3). By the mid-1980s, orange and blue lighting was also a common feature of "neo-noir" and its bastard offspring, the erotic thriller. For a time, all dark alleys were illuminated by orange streetlight, and all bedrooms bathed in electric blue moonlight streaming through half-closed venetian blinds. Blue even became a prominent presence in the lexicon of "neo-noir," finding a place for itself in the titles of films including *Blue Thunder* (John Badham, 1983), *Blue Velvet* (David Lynch, 1986), and *Blue Steel* (Kathryn Bigelow, 1990), as well as in blue movies.

Though eye-catching, after-dark oranges and blues only skimmed the surface of additive color mixture's potential. Blue and orange light remained

separate, facing each other off in a visual détente, consigned to different areas of the frame. Alternatively, the two colors occupied different planes, with orange dominating the foreground and blue the background. Instead of advancing cinema into a realm of panchromatic Newtonian color, blue-and-orange films existed in the shadow of black-and-white. In his *Farbenlehre*, Goethe suggested a connection between blue and black, and yellow and white: "As yellow is always accompanied with light, so it may be said that blue still brings a principle of darkness with it" (1971 [1810]: 170). Just under two centuries later, Deleuze – writing in the midst of the *cinéma du look* – rephrased this tonal homology with reference to film lighting, inviting the reader to perceive "blue as lightened black, yellow as darkened white" (1986: 52). By reiterating Goethe's observation, Deleuze was able to make the provocative claim that "it is undoubtedly Expressionism which was the precursor of real colourism in the cinema" (1986: 52). Though I do not see the juxtaposition of yellow (or orange, its more common on-screen variant) with blue as "real colourism," Deleuze's invocation of Expressionism is apposite. It draws attention to the fact that 1980s films' use of orange key light mimicked black-and-white films' key light, and their use of blue light mimicked black-and-white films' black shadows and gray penumbrae. The visual juxtaposition of orange and blue was therefore itself little more than an optical colorization of black-and-white. The result was a softened noir aesthetic that, for a time, satisfied those who liked old movies but could not tolerate black-and-white in new ones. Needless to say, come day, blue and orange almost always gave way to white.

Nonetheless, in my view, these uses of color as light suggest a developing acknowledgment (at least among film-makers) of color's spatial nature. Symptomatic of the broadening appreciation that color is more than a surface characteristic was the failure of media tycoon Ted Turner's plan to colorize his back catalogue of black-and-white films. In 1986, alerted by the financial success of a number of recent experiments in colorization, Turner announced his intention to create colorized versions of many of the films to which he owned the rights (Edgerton 2000: 26). The subsequent battle between Turner and an alliance of industry figures is enshrined in film history. Turner found himself faced with a chorus of opposition that included veteran directors (Frank Capra, John Huston, Fred Zinnemann), celebrity actors (Jimmy Stewart, Bette Davis), and contemporary directors (Woody Allen, Martin Scorsese, Steven Spielberg, even George Lucas), as well as powerful lobby groups including the Directors' Guild of America, the Screen Actors' Guild of America, the American Film Institute, and the National Council on the Arts.

Such concerted opposition did not make life easy for Turner. However, even at the height of the controversy, Turner remained indifferent to the arguments ranged against him. When asked why he chose to have *Casablanca* (Michael Curtiz, 1942) colorized, he answered: "I did it because I wanted to. All I'm trying to do is protect my investment" (Edgerton 2000: 24). Turner strove to make his black-and-white movies economically viable by obscuring the most obvious trace of their technological obsolescence – their lack of color. Like Pathé had done in the 1900s by stenciling dyes onto films from its back catalogue, Turner gave his aging products a surface coat of color and sold them as new. One might develop Roland Barthes's metaphor of cinematic color as "a cosmetic (like the kind used to paint corpses)" to suggest that colorization was a cosmetic attempt to give the corpse of old film new life (1981: 81). Early reports suggested that Turner's colorized films were earning more in home video sales and achieving higher viewer ratings on television than their original versions (Anon. 1986: 32). However, by the time of Casablanca's color debut on video in 1988, colorization was no longer significantly improving sales (Edgerton 2000: 31). The novelty had faded, leaving behind products in which the added color was no more persuasive than the hand-painted and stenciled colors of early cinema. In some instances, it was even less persuasive. For example, in John Huston's *The Maltese Falcon* (1941), the uniform blocks of color generated by primitive 1980s post-production technology remained clearly distinct from the underlying images' contouring of shadow and light. In the context of the increased synchronicity between light and color occurring in 1980s cinema, Turner's applied color did not give old black-and-white films new life. In fact, it did the opposite: it highlighted rather than concealed the fact that they were technological artifacts. Turner's digitally painted movies looked like painted corpses.

The failure of Turner's attempts at colorization suggests that color's optical nature could no longer be contradicted. But how could it be exploited? An extreme answer is provided by Rainer Werner Fassbinder's final film, *Querelle* (1980), in which white light is completely excluded. Early in the *Opticks*, Newton punctuates his description of an experiment with an idle speculation of staggering brilliance, suggesting that "if the Sun's light consisted of but one sort of Rays, there would be but one Colour in the whole World, nor would it be possible to produce any new Colour by Reflexions and Refractions" (1721: 108). Though the hegemony of white light cannot be resisted in our world, it can be resisted in our imaginations and in films shot on enclosed sound stages. *Querelle* follows

the progress of a young sailor's (homo)sexual education on the quays and in the bars of a mid-twentieth-century Brest. Fassbiner's studio-bound city exists in a perpetual orange dusk, in which white light is replaced by the light of a giant setting sun similar to the indoor sun of the *Weather Project*, Olafur Eliasson's acclaimed 2002 installation in the turbine hall of Tate Modern (Plates 4.12 and 4.13). The film's chromatic profile is thus "black-and-orange": highlights are orange, shadows are black, midtones are somewhere in-between. Many scenes additionally feature small amounts of blue light, highlighting details that would otherwise be lost in the orange. For example, in a sly subversion of classical Hollywood's black-and-white lighting conventions, Fassbinder at one point highlights a character's eyes with a bar of blue light.

Querelle is a startling example of on-screen optical color, but the film's substitution of white with orange still seems a far cry from Newton's promiscuity of color. Though it challenges our chromatic assumptions about color, Fassbinder's film does not express on-screen the prismatic "separations" of white light taking place in Newton's darkened room and in the body of the Technicolor camera. By contrast, Dario Argento's *Suspiria* (1977) provides a full spectrum of optical color. In Argento's visually excessive *giallo*, white is overrun by a multiplicity of colors. The ballet school that provides the setting for *Suspria*'s elegantly choreographed murders is littered with stained glass windows, which filter the white of day into panoplies of optical color. Not that Argento and director of photography Luciano Tovoli worry too much about motivation. By creating an environment with a superfluity of colored light, they make it impossible for the viewer to attach specific motivators to specific colors, freeing themselves to use whatever color they like whenever they like. Faces are lit in color even when no stained glass is visible. A shot lit in red is cut together with a counter-shot lit in green. In a red room, lightning flashes green (Plate 4.14). In a blue room, lightning flashes pink, perhaps because a window somewhere is pink, or perhaps because we are looking into an imagined world in which Newtonian optics has been perverted.

Argento and Tovoli also use surface and optical color in combination, allowing each to modify the other. For example, in order to achieve intense facial colors, Tovoli placed colored fabric in front of powerful carbon arc lamps, which allowed the lamps to be placed closer to the actors' faces than is usually possible. The result is further intensified color.[11] Similarly, much of the wallpaper in the school is partially reflective, again allowing surface color to become a source of optical color. Inversely, optical color also

becomes a source of surface color. For example, in one scene, white sheets are erected in the school gym, creating a temporary dorm after the girls' bedrooms have become infested with maggots. The sheets are white, but when the lights are switched off, they are suddenly backlit in red. Unlike Douglas Sirk, Argento is happy to play out the entire five minute scene in colored light. Later in the film, at a climactic moment when Suzy Bannion (Jessica Harper) discovers a hidden door that will reveal a witches' coven deep inside the school building, optical color momentarily disappears. The door's handle takes the form of a stem of three wrought iron flowers: one red, one blue, one yellow. This detail is highlighted with a white spotlight, virtually the only white light in the film's final 15 minutes. The lone white light spotlights the subtractive colors of the flowers, which in turn (because she has previously been warned to look out for the red, yellow, and blue flowers) alert Suzy to the presence of the secret door. In *Suspiria*, it is white light and surface color – not colored light and optical color – that is made noticeable by its scarcity.

There is, however, a limit to the chromatic excess of *Suspiria*. Though multiple optical colors share the frame at once, these colors generally remain separate. The impression may be – to use Newton's evocative word – of colors "promiscuously" interacting, but in fact Argento and Tovoli rigorously separate colors into different spatial zones. Faces are key-lit in one color, figures rim-lit in another, backgrounds floodlit in yet another. The multiple colors that appear to emanate from off-screen stained-glass windows take the form of autonomous blocks or bands of optical color, not of multiple optical colors dynamically commingling. *Suspria*'s pristine compositions also tend toward the static – too much motion would disturb Argento and Tovoli's careful chromatic zoning. The overall effect is that of a motionless kaleidoscope. Yet motion is precisely what Newton's promiscuity implies – different frequencies of light moving into and out of each others' spheres of dominance, combining, separating, and recombining.

Is this asking too much of cinema? I believe that it is not, and that there already exist examples of such uses of color. Prominent among them are the mid-1990s collaborations between director Wong Kar-wai and cinematographer Chris Doyle. In *Chungking Express* (1994), *Fallen Angels* (1995), and *Happy Together* (1997), Wong and Doyle moved beyond the oranges and blues of the 1980s, pressing against the visual limits of optical color. The subject-matter and tone of the three films varies: *Chungking Express* and *Fallen Angels* are set in the neon-lit side streets of Hong Kong, and oscillate between frenetic violence and rueful romance. *Happy Together*, a study of

the dysfunctional relationship between two Hong Kong expatriates stuck in Argentina, is more intimate; its focus on their monotonous lives anticipates the more drawn-out character drama of Wong's later films. Despite these differences, in their handheld camerawork, disjunctive editing, and various uses of optical color, these films are immediately identifiable as stylistic companion-pieces.

In Wong and Doyle's loose trilogy, white is only one of many optical colors. As in *Suspiria*, the diversity of color makes looking for specific light sources pointless. The mixture of orange and red light on the face of a depressive assassin in *Fallen Angels* might have drawn attention to itself if the film had included more white light, but in these films colored light is the norm. White light still plays a prominent role, but its presence is less a chromatic norm than an unwelcome intrusion into Hong Kong's spectral after-dark colors. In contrast to Sirk's characters, Wong's characters avoid white light. White light reveals all frequencies of color; colored light conceals certain frequencies in favor of others. So Wong's characters hold their most important discussions in bars and doorways, their feelings colored – and perhaps deliberately obscured – by the optical color of their environment.

What is particularly startling about these films is the sheer diversity of the optical techniques that they encompass. For example, as well as placing colored filters in front of his lights, Doyle also plays with color temperature. Much of *Chungking Express* takes place under incandescent light, but the light often appears blue, suggesting that the film stock used for these scenes was daylight balanced (Plate 4.15). Similarly, fluorescent light in *Fallen Angels* appears as unbalanced green. Doyle also often uses extreme lens filtration. For example, in a subterranean McDonald's, a young woman attempts to entertain the depressive assassin as he eats a Happy Meal. The whole scene is shot through a yellow filter, giving the image a translucent surface of cheerfulness. In other scenes, variously colored light sources, unbalanced film stock, and lens filtration combine in ways impossible to classify.

In contrast to the films I have so far discussed in this chapter, the color in Wong's films is dynamic. Doyle's camera is constantly on the move, alternately pressing up against characters' faces and distractedly exploring the spaces that they occupy. As the camera explores, it moves through different localities of color. The bodies onto which Doyle's colored lights fall are also in constant motion, resulting in seemingly arbitrary intersections of color. For example, as two characters in *Fallen Angels* motorbike through a tunnel,

their faces move through orange and white, while the fluorescent tunnel lights in the background appear unbalanced green (Plate 4.16). The dynamic colors of this shot are also writ large over the entirety of Wong's films. The films are full of movements between different colors, different combinations of lighting, film stock, and filtration, and even between different formats: the chromatic diversity of *Fallen Angels* and *Happy Together* also extends to the use of black-and-white and Super-8 film stocks. In their entirety and in their parts, Wong's films are intermediaries through which white light fragments into color. Tarkovsky's ebbs and flows of monochrome and color created a chromatic polyphony, diverse but unified. Wong and Doyle create chromatic cacophony.

Wong and Doyle's inclusion of optical color even extends to prismatic reflection. Prismatic decomposition of white light is not easy to achieve. Though, as Newton observed, mathematicians usually consider rays of light to be lines, prisms do not in fact function like the triangle on the cover of Pink Floyd's *Dark Side of the Moon*, dividing a beam of light into neat geometric slices of color (Newton 1721: 2). At most angles of incidence, white light passes through prisms intact. In *Chungking Express*, there nonetheless exists a perfect example of Newtonian color: a jukebox playing compact discs in a bar (Plate 4.17). As the discs rotate, they reflect the light that falls onto them into rainbows of color. In this shot, Newtonian optics at last achieves its on-screen fulfillment.

Despite Wong Kar-wai and Chris Doyle's pioneering work in the 1990s, colored light remains a minor presence in contemporary cinema. It seems so far to have remained restricted to reflexive avant-garde films, stylized horror films, and occasional art/mainstream crossovers. Even the celebrated lighting style of Doyle and Wong has become ghettoized into East Asian crime movies (for example, Chan-woo Park's *Old Boy* [2003] and Tung-Shing Yee's *One Night in Mongkok* [2004]). The ghettoization of colored lighting is also evident in Hollywood. In *Mission: Impossible III* (J. J. Abrams, 2006), white light dominates until the action moves to Shanghai, at which point the lighting temporarily becomes low-key and colorful – like an East Asian crime movie.

In the light of these examples, it is hard not to echo the dissatisfaction voiced in the early 1990s by the great cinematographer Henri Alekan about the state of screen color. Alekan's eloquently phrased perspective on color is worth quoting at length:

[F]or me, colour film doesn't exist, at least not yet. Of course we see the world in colour, but this colour, especially in films, is too realistic for my taste. I believe film should transcend the banal world, and it would almost be more interesting to change the whole colour scheme to achieve a more unrealistic effect, to break through colour as it were. Of course, many interesting films have been made in colour that try to stretch the boundaries of the medium – *One from the Heart* by Coppola, the films of Bertolucci, the cinema of Tarkovsky – and there are many interesting uses of colour in the video format, perhaps more so than in cinema. But I still find it inferior to the colour you see in the paintings of the great masters – Velasquez, Rembrandt, Goya. In these paintings, the shadings of the colours create a three-dimensional effect similar to the effect light and shadow can create in black and white films. Colour films never seem to break the two-dimensional plane, which is why I say there isn't a colour cinema yet. (Trainor 1993: 17)

Alekan's plea for a "three-dimensional shading" similar to that achievable in black-and-white can be read as a plea to film-makers to free themselves from the flat expanses of surface color that so often accompany white light. It is notable that the three painters that Alekan refers to are the same three that Natalie Kalmus cited in *Color Consciousness* as exemplars of protocinematic color (1935: 140). In Velásquez, Rembrandt, and Goya, Kalmus saw only an absence of offensive hues. Alekan, by contrast, sees through the subdued pigments that surface their canvases, admiring instead the three painters' contrasting techniques of reconciling color, light, and space. Rather than weakly reiterating the cliché of "painting with light," Alekan engages with the paradox that cinema must learn from painting in order to diverge from it.

Clearly, to break the two-dimensional plane, color needs to engage with light. Placing colored gels in front of artificial lights seems a simple enough task. Why, then, has it been so rarely carried out? A number of reasons suggest themselves. The first is that optical color only exists as a prominent presence after dark and in enclosed interiors, thereby limiting the range of films in which it is usable. What is appropriate for crime melodrama and horror, genres of the night, is less appropriate for daytime genres. Sculpting space with colored lighting is also time-consuming, and so expensive. Though an ardent colorist, Dario Argento has only been able to afford a repeat of *Suspiria*'s optical polyphony twice: in *Inferno* (1980) and *Opera* (1987). Easier, cheaper, and so more common is soft, white lighting like that used by Jean-Luc Godard and Raoul Coutard in their 1960s films. Godard quips: "Seven out of ten directors waste four hours over a shot which should take five minutes of actual shooting: I prefer to have five minutes work for

the crew – and keep the three hours to myself for thought" (1972: 174). Whether or not Godard actually spent 97 percent of his time on set thinking, his reliance on soft, white lighting sped up his shooting schedules immeasurably.

In my view, however, the most persuasive explanation for cinema's wariness of optical color is again, or rather still, motivation. Motivation transcends classical Hollywood ideology and interacts directly with how we perceive the world and what we accept as realistic representations of it. Because colored light draws attention to itself and thus to its source, the sustained use of unmotivated optical color is only a viable option in forms of moving imagery that do not need to conceal the fact that filming is taking place: avant-garde films, video art, pop promos, television commercials, and so on. In any form of moving imagery that has not entirely abandoned its reality effect (and this includes almost all commercial feature films) optical color still needs to be justified. Unless a film is set among the late night neons of Hong Kong or Tokyo, optical color and realistic motivation exist in tension. Nowhere is this tension more apparent than in the product of Chris Doyle's first and last experience of working in California on a mainstream Hollywood film.

Case Study: Seeing Red in *Psycho*

Gus Van Sant's *Psycho* (1998) is the closest commercial cinema has yet come to creating a film predicated on similarity to another film. Narrative, dialogue, production design, music, camerawork, and editing are all almost the same as in Alfred Hitchcock's *Psycho* (1960). There is, however, one significant formal difference between the two films: Hitchcock's is black-and-white, Van Sant's is color. Hitchcock's film was shot by a relatively unknown television cameraman, John Russell; Van Sant's was shot by Doyle, one of the great contemporary cinematographers. Yet the cinematography of Van Sant's *Psycho* repeatedly fails to achieve what the cinematography of Hitchcock's achieves. In my opinion, this failure is due not to any major creative mistakes on the part of Van Sant or Doyle, but to the tension between optical color and realistic motivation.

Hitchcock's *Psycho* was made at a time when realist film was most often black-and-white, and black-and-white most often signified realism. Italian Neo-Realism, *cinéma vérité*, television news, and French *Nouvelle Vague* films were at the time almost exclusively black-and-white. *Psycho*'s lack of

color encouraged viewers to place it in this tradition. For example, a reviewer in *Films and Filming* commented: "Hitchcock has copied the camera styles of the Continental realists. He has tried to achieve the casual looking-in on reality" (Baker 1960). At the same time, filming in black-and-white necessarily entails a visual transformation. Images are transposed onto the film negative minus their hue and saturation. Regardless of how a black-and-white film is lit, by simple virtue of being black-and-white it is a partial abstraction of what the human eye sees. It was not only documentaries and social realist fiction that tended to be black-and-white in the 1950s, but also film noirs and horror films, films whose mood often depended on stylized visuals. From the perspective of the late 1950s, black-and-white can thus be seen as both realistic and unrealistic.[12] It connoted realism, yet it also simplified and stylized visual reality.

In *Manhattan* and *Schindler's List*, Woody Allen and Steven Spielberg vacillate uncertainly between realist visual codes and stylization. In *Psycho*, Hitchcock shows no such uncertainty. Instead, he exploits black-and-white's stylistic flexibility to create a film of transitions between daytime grays and the deep shadows and high contrasts of night, of the horror genre, and of Norman's psyche. *Psycho* begins with a flat, gray, televisual aesthetic. In the opening scene, set in a hotel room, Marion Crane (Janet Leigh) is having a lunchtime encounter with a lover. As James Naremore observes, the Venetian blinds in the bedroom do *not* cast expressive noir-ish shadows on the walls (1973: 28). Bright, flat lighting remains the norm throughout the film's Phoenix sequences, providing it with an initial visual connotation of realism (Plate 4.18).[13] The grayness of the images can also be regarded as a visual analogue to what Slavoj Žižek refers to as the "dreary, grey 'leaden time'" of Marion's daily routine (Žižek 1992: 226). This leaden time manifests itself most obviously in her regular lunchtime trysts – an attempt to break out of her repetitive life has become incorporated into it. As the setting moves from day to night, from Phoenix to the Bates Motel, the cinematography bifurcates from the low-contrast, flat grays of realist monotony to the deep shadows of the horror genre and the high contrast black and white of expressionism. There is nothing especially unrealistic about the Bates Motel, yet the lighting creates an acute sense of foreboding. The screen is often filled with large areas of darkness, such as the doorway from the motel's reception to Norman's parlor, and disconcerting shadows, such as those cast by the stuffed birds inside the parlor (Plates 4.20 and 4.22). Given the isolated location of the motel and the fact that it is night, there is more than enough motivation to make the darkness and shadow visually plausible. However, it is also expressive. The dark

areas on screen suggest places the camera should not go, just as Marion's conversation with Norman Bates (Anthony Perkins) throws up psychological locations upon which it would be safer not to impinge. Marion's entry into Norman's parlor is a hesitant and abortive entry into his mind. She leaves prematurely, having seen only this single (not quite innocuous) antechamber, and so never discovers the truth about him. It remains up to her sister to complete the architectonic journey into Norman's psyche. It is only in the film's climax, when Lila Crane (Vera Miles) enters the darkest recesses of the cellar at the Bates mansion that Norman's psychosis is revealed.

Throughout Hitchcock's *Psycho*, the narrative fluctuation between day and night is paralleled by visual transitions between light and shadow, low contrast and high contrast, and realism and expressionism. The film's structural tension between light and darkness takes place over time, but it is also present metonymically in the contrasting whites and blacks of individual frames. For example, when the detective Arborgast (Martin Balsam) questions Norman about Marion's disappearance, Norman leans over to inspect the guest book. His face is shot from below, with shadows so deep as to be almost a parody of horror movie lighting conventions; the film's narrative dialectic is mapped onto the contours of his face, reminding us that the film's narrative, geographic, and cinematographic oppositions also articulate the film's dominant binary – Norman's split-personality.

Color does not have the benefit of black-and-white's intrinsic ability to transform images into metaphors. So, in Gus Van Sant's remake, the stylization, abstraction, and symbolization achieved by Hitchcock through the use of black-and-white is partially unmade. The presence of color moors Van Sant's film in verisimilitude: the blood remains red. Van Sant and Doyle nonetheless take a good shot at trying to mimic black-and-white in color. Van Sant comments: "In each shot, we'd go to the original DVD to try to match the lighting, except in colour...."[14] Sometimes, this strategy is quite effective. In the Phoenix sequences, for example, Doyle's mimicry of Russell's high-key lighting transforms flat grays into flat surface colors (Plate 4.19). After dark, however, when Hitchcock and Russell's lighting becomes low-key and directional, Van Sant and Doyle's strategy of duplicating it in color becomes impossible. In color, extreme low-key lighting is irreconcilable with realistic motivation. On the few occasions that Doyle closely follows the original film's low-key lighting, the result immediately draws attention to itself. For example, though the deep shadows cast by the stuffed birds in Norman's parlour survive into the remake, in color they prompt the question of where the light is coming from

(Plates 4.22 and 4.23). It is certainly not coming from the soft glow of the table lamps that appear to illuminate the room.

The alternative that Doyle settles on for most after dark sequences is to replace high contrast black-and-white with intensely saturated color.[15] Just as the presence of night makes possible the high contrast lighting of the original, so it makes possible the saturated lighting of the remake, allowing one form of visual intensification to give way to another. In the absence of the flattening white of daylight, all it takes to motivate orange lighting is an orange lampshade. So Doyle uses diegetic color to provide motivation for his intensely colored lighting. For example, the pink and green neon of the motel sign turns Marion's first minutes at the Bates Motel into a chromatic phantasmagoria. As she drives up to the motel, the back window of her car is a cascade of green, motivated by the combination of a green neon vacancy sign and pouring rain. From the green light of the car, Marion moves past a solid orange door, into the orange and white interior light of reception (motivated by an orange ceiling light and the white light of two desk lamps), then back out into the pink light of the veranda (presumably motivated by the red neon of the motel sign). When Norman shows Marion her cabin, his face is lit with a mixture of (wall lamp) orange and (bedside lamp) white.

The neon-infused colors of the Bates Motel are breathtaking. Unfortunately, they are also largely redundant. The heightened atmosphere achieved through the high contrast blacks and whites of Hitchcock's film cannot be achieved through saturation. For example, in Hitchcock's *Psycho*, the view from reception into the black space of Norman's parlor is profoundly menacing (Plate 4.20). In Van Sant's film, the same space is affectively neutralized by the surrounding oranges and pinks (Plate 4.21). In addition, the sheer amount of colored light inevitably makes the ambient lighting levels at the Bates Motel much brighter, resulting in a *Psycho* stripped of its blackness. In *The Analysis of Film*, Raymond Bellour opens his chapter on *Psycho* by observing how unnervingly "obscure" the photography is (2000: 238). No such claim could be made for the remake. In Hitchcock's *Psycho*, when Norman appears on the motel veranda with a tray of sandwiches, he remains a part of the darkness he has just stepped out of (Plate 4.24). In the remake, the increased amount of fill light clearly separates him from the black background (Plate 4.25). An even more extreme example can be seen when Lila Crane (Julianne Moore) approaches Mrs Bates in the cellar. The epicenter of the original film's Freudian darkness is transformed into a brightly lit aviary with a background wash of blue daylight.

Slavoj Žižek regards Van Sant's remake as not only not quite different enough from the original to be revelatory, but also not quite similar enough to it. It is not different enough to provide an original reworking of Hitchcock's themes, nor is it similar enough to achieve "the uncanny effect of the double" (Žižek n.d.). This view can be replicated with reference to the film's cinematography. It is too close to the original but not close enough. Van Sant and Doyle's use of color lighting to mimic Hitchcock and Russell's stylized use of black-and-white contradicts the visual topoi of realism. At the same time, Van Sant and Doyle were not free to duplicate Hitchcock and Russell's expressive low-key lighting precisely. Doing so in color would have resulted in a an "unrealistic" lighting style, which might have alienated multiplex audiences. In short, Van Sant and Doyle found themselves trapped between verisimilitude and stylization, aspiring to expressive color but constrained by realistic motivation, satisfying the demands of neither.

Had Van Sant and Doyle made the film a few years later, they might have found a way out of this deadlock, through the use of digital technology. Much has been written in recent years about how digital technology has brought an end to the indexical connection between reality and image. Less has been written on the aesthetic implications of this change. Beyond the narrow realm of the special effects film, one of the most immediately obvious aesthetic changes associated with digital cinema has occurred in color space. Since the rise of Digital Intermediate (DI) post-production technology in the late 1990s, it has become possible to manipulate all aspects of an image's color. Digital color is independent of the light that passes through a lens when an image is captured by a camera; it exists in digital space. As a result, color has – to a certain extent – released itself from the demands of realistic motivation.

5

Digital Color

"I tinted an entire forest gray to make it seem like cement, but it rained and the color ran off. With video cameras, all of this can be done electronically; it is like painting a film."

Michaelangelo Antonioni (1996: 204)

Crossing the Chromatic Wall in *Wings of Desire*

The basic unit of digital images is the pixel. A pixel is definable as a unit of color value assigned to a specific location on a screen. On a technological level, all digital images thus comprise digital color. The way in which I refer to digital color in this chapter, however, is more specific. I refer to it as the color that results when the color values of an image are digitally manipulated. Digital color became prominent within mainstream media in the 1990s. Looking back from the end of the decade, Thomas Elsaesser noted that the 1990s had seen a major shift in the film industry's division of labor toward post-production (1998: 204). In the years since, the amount of money and time spent on post-production has expanded so much that production can sometimes be regarded as little more than a preparatory stage in the film-making process. For example, the production stage of Zack Snyder's *300* (2006), a compulsively gruesome depiction of the Battle of Thermopylae, involved filming actors in front of a blue screen. Larry Fong, the film's cinematographer, notes that Snyder and he carried out most of the film's key chromatic decisions in post-production (Williams 2007: 55). It was in post-production, for example, that they gave the film its comic book aesthetic by clipping highlights, crushing shadows, and desaturating colors. It was also in post-production that they settled on yellow as the film's chromatic major and blue as its minor. Every shot reeks

of late nights spent in visual effects and color grading suites. Though the intensity of the film's digital color is unusual within mainstream cinema, the extent of its reliance on post-production is not. *300* exemplifies the extent to which color (and, indeed, film as a whole) has now become dependent on extensive post-production. How has this changed what appears on screen? In this chapter, I explore the relationship between digital color and the color modes (surface color, etc.) that preceded it. In particular, I suggest that though digital technology has drastically changed the ways in which color is generated and manipulated, digital color still exists in continuity with analogue color.

I begin by lingering briefly at the historic border between analogue and digital cinema. To my mind, the film that stands closest to this border is Wim Wenders' *Wings of Desire* (1987). *Wings of Desire* follows a group of angels as they wander through Berlin, listening in on and cataloguing the thoughts of the city's populace. The film mixes black-and-white and color footage in roughly equal proportion, providing two distinct points of view – black-and-white shows the city and its inhabitants as observed by the angels, color shows the city as experienced by human beings. The angels do not know color, taste, smell or touch; an obvious cinematic way of expressing their lack of physical sensation is to use the pure light and shadow of black-and-white. Already denied smell and touch by the fact that we are watching a film, we are now denied color too, and see Berlin from the angels' perspective. In this, *Wings of Desire*'s chromatic hybridity can be seen as an elaboration of the formal strategy used in Michael Powell's *A Matter of Life and Death* (1946), where the physical world of the senses is portrayed in color, while the disembodied world of the afterlife is portrayed in black-and-white. In *Wings of Desire*, the use of black-and-white to provide an angelic vantage point has added relevance. In *A Matter of Life and Death*, the only unusual thing about Powell's use of black-and-white sequences was that they alternated with color sequences. By contrast, considering *Wings of Desire* was made in 1987, the fact that it uses black-and-white at all is highly unusual. The presence of black-and-white provides a formal interference between the real world and the "real" (i.e. color) world that the viewer expects to see when sitting down to watch a film. Black-and-white is all the angels know; seeing in black-and-white distances them because they know humans see in color but they cannot. Color is all most contemporary viewers know; seeing in black-and-white distances them because they are not being allowed to see the world in the manner in which they usually see it. Angels and viewers are thus placed in an equivalent position.

Mid-way through the film, the angel Damiel (Bruno Ganz) chooses to forsake his immortality and become human. His transformation is evoked by a move from black-and-white to color. As David Batchelor notes, Damiel's first response to being alive is astonishment at the colors that he finds himself immersed in (2000: 36). He touches a graze on his head and is intoxicated by the redness of his own blood, an essential redness that confirms he is now alive. Having made his first connection between the word "red" and the visual perception of redness, he excitedly asks a passer-by to identify the various colors on the graffiti-strewn Berlin Wall behind him.[1] This transition to color evokes the chromatic transitions of *A Matter of Life and Death*, in particular the film's famous dissolve from a shot of a monochrome rose to one of a red rose. Damiel's move from black-and-white to color also keys in with the contemporary association of black-and-white with timelessness. By moving to color, the film demonstrates that Damiel now inhabits human time as well as a human body.

Just before he started pre-production on the film in 1986, Wenders wrote a set of preparatory notes for the project. In them, he comments:

> And so I have "BERLIN" representing "THE WORLD". I know of no place with a stronger claim. Berlin is "an historical site of truth". No other city is such a meaningful image, such a PLACE OF SURVIVAL, so exemplary of our century. Berlin is divided like our world, like our time, like men and women, young and old, rich and poor, like all our experience. (1991: 74)

Film too, Wenders might have gone on to say, has historically been divided – between the legacies of Lumière and Méliès, between the theories of Eisenstein and Bazin, between art and entertainment, and of course between black-and-white and color. It is only appropriate, then, that Damiel's transition from divinity to humanity occurs at the Berlin Wall. Damiel becomes human in no man's land, and it is only through the angelic help of Cassiel (Otto Sander) that he finds himself alive on the west side of the Wall not dead on the east. Wenders' choice to locate the film's main chromatic transition on the border between East and West emphasizes the political significance of color, juxtaposing the uniform grayness of East Berlin with the chromatic pluralism of capitalist democracy, as typified by the graffiti on the Wall.

An equally resonant chromatic juxtaposition occurs elsewhere in the film, when Wenders cuts together black-and-white and color archive footage of Berlin shot at the end of World War II. The black-and-white footage

is the work of Soviet military cinematographers, the color footage is Kodachrome shot by American soldiers. Ironically, though the black-and-white footage looks more "realistic" (because it is black-and-white), the shots of advancing Soviet troops were in fact staged for the camera after hostilities had ceased; the raising of the Soviet flag over the Reichstag was apparently shot over 30 times (Raskin 1999: 9). Despite the multiple takes and the cast of thousands, the Soviet footage lacks a key production value – color. In Chapter 2, I applied the metaphor of the Cold War to the opposition between black-and-white and color; I suggested that, just as the presence of two "superpowers" belied the developing global hegemony of the United States, the post-war coexistence of black-and-white and color masked the fact that color was becoming hegemonic.

Wings of Desire was released in 1987, barely 18 months before the fall of the Wall, and can be regarded as one of the last Cold War films. Technologically too, the film stands at the border between two eras: analogue and digital. At the end of the film, we see a shot of Cassiel – still an angel – sitting in a halo of monochrome within an otherwise color shot, watching his friend Damiel enjoying human life (Plate 5.1). The visual effect, doubtlessly achieved through complex laboratory processes, provides a thematic resolution between the film's chromatic binaries, suggesting that there is no border that cannot be crossed. But it looks clumsy; it draws attention not to Wenders' celebration of eternal love but to film's technological limitations. Within a few years, such crude mixtures of black-and-white and color would be made obsolete by the far more nuanced chromatic adjustments achievable through Digital Intermediate. The chromatic Wall between black-and-white and color would soon be irrevocably breached.

An Archaeology of Digital Intermediate, 1989–2000

The historical border-crossing between analogue and digital cinema began in the late 1980s and continues to the present day. It has taken so long because it is not one technological transition – as was, for example, the transition from silent to sound cinema – but the sum of many. These include the transition from analogue to digital sound recording and mixing (mid- to late 1980s), from analogue film- and tape-based editing to digital "non-linear" editing (early to mid-1990s), and from analogue to digital cinematography (late 1990s to present). In this section, I focus specifically on the transition

from laboratory printing to Digital Intermediate (early 2000s). "Digital Intermediate" (DI) refers to the phase of post-production that occurs between the conversion of film negatives into digital files (for editing, visual effects work, color manipulation, etc.) and the conversion of digital files back onto film for projection in cinemas. The term "Digital Intermediate" is itself also transitional – as cinematography and projection also complete their analogue to digital transition, digitality will no longer be an "intermediate" phase of movie production. Nonetheless, for the moment, "DI" remains the standard industry label for describing both the technologies and the processes associated with digital post-production.

This section provides a brief archaeology of DI, emphasizing the aspects of it that have most influenced digital color aesthetics. Considering that DI is barely 20 years old, it may seem strange to be using the metaphor of archaeology. I use it not in a Foucauldian sense, but simply because many of the digital technologies of the 1990s have already been buried under products of the more recent past. Though museum collections often include cinematic paraphernalia, from Edison's kinetoscopes through to Kubrick's wheelchair dollies, the curatorial interest attached to the technologies of production does not extend as eagerly to those of post-production. Most of the early artifacts of digital cinema have already been discarded; the Ursa telecine machines and Silicon Graphics workstations of the 1990s lie decomposing in landfill sites. Analogously, post-production professionals' memories of the technologies and workflows of the 1990s have become layered over by the details of more recent technologies and workflows. In this section, I attempt to retrieve some memories of post-production technologies and practices that are shallowly buried.

Before color grading, as digital color manipulation is now typically called, the color in "natural" color films was an approximation of profilmic color by dyes within film negatives and prints (Wollen 1980: 24). As seen in previous chapters, to control the color of their films, directors needed to control the colors in front of the lens. Doing so was often a major logistical challenge, and typically involved mobilizing storyboard artists, make-up artists, costume designers, props masters, and production designers. Once a film was in the can, there was not much that could be done to change its color in a film laboratory. What few options there were involved color timing. Color timing took place when a film's negatives were passed through an optical printer to make an interpositive print. During this process, the white light of the optical printer could be decomposed into red, green, and blue light. By adjusting the relative amount of each primary color that the

interpositive was exposed to – i.e. by adjusting the length of time that the print was exposed to each primary color – a lab technician could alter the relative amount of red, green, and blue in the image (Probst 1997a: 79). The process involved a complex balancing act. For example, decreasing the red value of an image involved removing reds throughout the image, so yellows would also appear bluer. In addition, if the amount of red, green, or blue light passing through a print decreased, the total amount of light passing through it also decreased, resulting in a darker image. Unsurprisingly, though a film's director and cinematographer would often sit with a technician at a special viewing machine before the interpositive was printed, using a work print to anticipate what would happen if the interpositive's RGB values were adjusted, the actual adjustments possible were extremely limited. For this reason, the adjustments most commonly carried out through color timing were not color adjustments but exposure adjustments (Probst 2000: 151). Adjusting the amount of white light shone through interpositives allowed color timers to compensate for underexposed or overexposed negatives by making prints lighter or darker. Pulling back the details hidden in an overexposed negative was particularly easy, so cinematographers often slightly overexposed shots while filming, in the expectation that they could be printed darker later.

Attempts to make film laboratories the site of more creative chromatic adjustments did occur, but their success was limited. The results of one such attempt can be seen in John Huston's 1956 adaptation of Herman Melville's *Moby Dick*. Having mimicked Impressionist painting in *Moulin Rouge* (1952), Huston and his director of photography Oswald Morris moved toward desaturation in *Moby Dick* (Plate 5.3). Morris shot the film on Eastman Color negatives, but then used the Technicolor dye-transfer process to print them. In addition to adding three color dyes, he put the film stock through a black-and-white pass, resulting in release prints that mixed black-and-white and color (Calhoun 2003). The effect of Morris's technical ingenuity was subtle, perhaps even too subtle; the lack of critical response to his experiment suggests that many viewers may not even have noticed the desaturation. I have found only one contemporaneous review that references the film's color, saying, "Colour in films can be a nullity, a nuisance, or a commonplace. In 'Moby Dick' it is an important feature of the publication, and one leaves the theatre with the impression that a new adventure in cinema history has begun" (Lejeune 1956).[2] The adventure had to wait almost 40 years to be continued, until telecine machines provided a more versatile means of desaturation.

The earliest television broadcasts involved only live video feeds. Telecine developed in the 1940s as a means of allowing television stations also to broadcast pre-existing filmed material including newsreels and movies – hence its hybrid name, combining *tele*vision and *cine*ma.[3] The earliest telecine machines comprised film projectors pointed into the lens of a video camera. In this way, a film print could be translated into an analogue video signal for immediate broadcast or – following the invention of videotape in the 1950s – copied onto tape for future broadcast. In response to the rise of color television, telecine machines were developed that could transfer full color film to video. They did so by shining white light through the film and decomposing it by means of mirrors into red, green, and blue wavelengths, which could then be picked up by red, green, and blue photoreceptors and transformed into RGB video signals. As telecine hardware evolved, an additional sensor became incorporated into telecine design, allowing the machines to capture luminance values as a separate signal. By increasing and decreasing the sensitivity of individual sensors, a video operator could alter the color balance and brightness of an image. The ability to adjust luminance made possible a slightly wider range of adjustments than was possible by means of laboratory color timing, but still the only way to manipulate color involved adjusting red, green, and blue values throughout the image (Kaufman 1996a: 14).[4]

For many decades, as Lev Manovich notes, media technology developed parallel to but separate from computing technology (2001: 20). In 1989, the border between the two was crossed by means of the "Ursa," a digital telecine machine. Instead of translating light into electronic video signals, the Ursa translated light into code. Its digital sensors made it possible to adjust the color values of an image without altering its brightness – red could be added, for example, without making the image darker (Kaufman 1996a: 14). Nonetheless, color adjustments were still restricted to global alterations, i.e. alterations that applied to the entire image. Red, green, and blue were interdependent – increasing the red in an image meant removing green and blue. So digital color remained dependent on surface and optical color. If something was to *appear* green on screen, it needed to *be* green in front of the camera.

Over subsequent years, digital color incrementally freed itself from environmental color. This was in large part due to advances in the functionality of color correctors, the interfaces between telecine machines and their operators. For example, the release of the "da Vinci" color corrector in 1993 made possible "secondary" color adjustments in addition to "primary"

color adjustments. Telecine operators became able not only to alter the balance between the three primary colors – red, green, and blue – but also to isolate and manipulate individual colors without altering global color values (Harrell 1993: 62). All the blues in an image, for example, could be transformed into green without affecting any other hues. As secondary color correction technology improved, telecine operators also became able to select and change colors based on pixels' saturation or luminance values, and thus to isolate very specific color ranges – for example, only light blue. In 1996, "power windows" (also known as vignettes or masks) were added to the da Vinci toolset, allowing specific areas of the frame to be isolated for local color adjustments. Blue sky could be isolated and made green without causing blue sea to change to green also. Vignettes could also be animated, allowing the area of a frame affected by a color transformation to move – if a camera tilted up so that the horizon between sky and sea moved down within the frame, the area transformed from blue to green could be animated to follow the horizon line (Kaufman 1996b: 12). Color correctors also made it possible to apply multiple color transformations in sequence: RGB adjustments, brightness adjustments, contrast adjustments, selective color adjustments based on hue, and selective color adjustments by means of vignettes could all be carried out in combination (Kaufman 1996b: 14).

The first industry sector to use digital telecine and color correction technologies was television advertising (Fisher 1998: 61). There are a number of obvious explanations for this. Firstly, television commercials were made for broadcast, so they did not make impossible demands on the limited processing power of mid-1990s computers: color correction could take place using standard definition image sizes (typically 720 × 576 pixels for PAL) rather than the much larger 2K (1920 × 1440 pixel) image sizes deemed necessary for feature films to be screenable in cinemas. Secondly, television commercials are rarely longer than 90 seconds, so they required only a small fraction of the hard drive space that a 90-minute feature film would have required. Thirdly, commercials producers work with relatively high budgets and clients alert to opportunities for product differentiation; they have less reason to be hesitant about new technology than many feature film or television producers, who typically appeal to viewers by mimicking previously successful products.

By 1997, Carl Dreyer's dream of a green sky was being realized daily in ad breaks across the world. Digital color spread more slowly to cinema. An early experiment in DI occurred in 1993, with the digital restoration of Walt Disney's *Snow White and the Seven Dwarfs* (1937) at Kodak's fledgling

post-production facility Cinesite (Fisher 1993: 51).[5] Though the total resto-ration involved 15 terabytes of data, only a small proportion of this data could be stored on computer at any one time. As the restoration of *Snow White* was a painstaking shot-by-shot process anyway, the fact that restorers could only access a handful of shots at once was not a significant problem (Fisher 1993: 54). However, for a feature film still undergoing editorial changes, such piecemeal color manipulations would have taken far too long to be economically worthwhile. Unsurprisingly, for most of the 1990s, the use of DI remained restricted to special effects sequences. Not all special effects were digital, but all digital images comprised special effects (Anon. 1995: 30).

So how could feature films, still largely analogue products, avoid appear-ing obsolete when even the ads that preceded them in cinemas (for exam-ple, Jonathan Glazer's *Stella Artois: Last Orders* [1998]) were digital? An obvious way for feature film-makers to respond to digitality was to incorpo-rate elements of it into their films, in the form of more computer-generated special effects, motion graphic title sequences, and so on. A slyer response involved emulating digital color. Many feature films of the mid- to late 1990s approximated digital color by means of film color, manipulating the chromatic mixtures that occurred within the film stock through chemical techniques including silver retention. Silver retention involved retaining a variable amount of the silver in a film negative when processing it, thereby adding density to areas with the most exposure (Probst 1998b: 82). Blacks became blacker, resulting in the high contrast look of films including *Seven* (David Fincher, 1995) and *Lock, Stock and Two Smoking Barrels* (Guy Ritchie, 1998). The process also desaturated color, in direct proportion to the amount of silver retained in the negative. For example, the extreme desaturation of Steven Spielberg's *Saving Private Ryan* (1998), as seen in Plate 5.7, is the result of an exceptionally high level of silver retention (Probst 1998a: 83).[6]

Other films used optical color to emulate digital color. For example, at first sight, Andy and Larry Wachowski's *The Matrix* (1999) seems to be a quintessentially digital film. Its subject is digitality itself, as dramatized in the struggle by a group of humans living in the "real" world to destroy the "simulated" world of the Matrix (Rodowick 2007: 4). A crucial signifier of the Matrix's (and so, by implication, the film's) digitality is its greenness (Plate 5.2). The film begins with an array of green digits on a black back-ground, raining down from the top of the screen. The Matrix, seen here from the outside, is thus color coded in green. Inside the Matrix too, digital

green dominates, in contrast to the cold blue-white of the physical "reality" that Neo (Keanu Reeves)wakes up into. Yet though, diegetically, digital simulates physical, in terms of the film's production, physical in fact simulated digital. Most of the film's "digital" greens are not digital at all – only the film's special effects sequences were put through DI. The murky greens of the Matrix sequences were achieved through the use of green lighting during filming, and the green light was then slightly accentuated through conventional color timing (Probst 1999: 36).

Another variant of fake digital color can be seen in Vincenzo Natali's *Cypher* (2002). Instead of simulating a digital color tint, *Cypher* simulates digital desaturation – its key color is white not green. The frame often features large areas of diffused white light reminiscent of Ingmar Bergman's *Cries and Whispers* (1972). But white light is not enough to transform full color into monochrome – green light pushes all surface colors toward shades of green, but white light leaves them intact. So, rather than using chemical techniques, *Cypher* suppresses surface color: costumes, sets, and props all tend toward white or black. Even the surface color of actors' faces is desaturated. Occasionally, in extreme close-ups, one can spot the telltale signs of white make-up. For example, in Plate 5.5, though most of Jeremy Northam's face is white, the areas around his eyes and lips remain slightly pink. In the mid-1930s, Technicolor enlisted the help of Max Factor in its battle to persuade Hollywood that Technicolor was natural color, employing him to create a special range of make-up designed, in his words, "to enhance the subject's natural coloring" (Basten 1980: 71). Like Gorky, Technicolor understood that the accurate reproduction of flesh tones is crucial for color images' reality effect. So it commissioned a range of cosmetics to help desaturate the emphatic color of its dye-transfer process. *Cypher*'s use of make-up to suppress color echoes Technicolor's, though the technique is used for very different ends. By disguising the natural colors of actors' faces, *Cypher* implies that its desaturated colors are the result of digital grading. In this, like its main character, the film conceals its underlying nature. Its digital color is surface color in disguise.

These various "fake digital" aesthetics are so visually persuasive that they draw attention to the fact that early digital color was itself often just analogue color dressed-up. Film color, surface color, and optical color were able to mimic digital color because digital color took their visual paradigms as its model – a textbook example of Jay David Bolter and Richard Grusin's concept of remediation (2000). Films of the late 1990s and early 2000s mimicked the digital color of mid-1990s television commercials; mid-1990s television

commercials in turn derived many of their visual terms of reference from cinema's past use of film color, surface color, and optical color. Monocolored tints, desaturation, and even spot color all had a genealogy. The spot color of the girl in the red raincoat in *Schindler's List* (1994) appears as a startling intrusion of digital color into a black-and-white pastiche of a classical Hollywood film, but it is also itself part of a network of allusion stretching back decades: from the red goldfish in Coppola's *Rumble Fish* (1983) and the red smoke in Kurosawa's *High and Low* (1963; Plate 2.3) to the red flag in Eisenstein's *Battleship Potemkin* (1925; Plate 1.7) and the red blush in Griffith's *The White Rose* (1923).

Over the course of the 1990s and early 2000s, DI permeated the film industry.[7] *Schindler's List* features less than 20 seconds of digital color. Gary Ross's *Pleasantville* (1998) features about 113 minutes of it (Fisher 1998: 60). In Ross's film, digital color is not an intrusion but a default – the whole film is one long visual effect. Two teenage siblings, David and Jennifer, acquire a magic remote control with which they accidentally zap themselves into *Pleasantville*, an old black-and-white television show set in a fictional town of the same name. David is a fan of the show and soon reconciles himself to life in this idealized 1950s world, where firemen forever save cats trapped in trees and mom always makes meatloaf for dinner. Jennifer, however, finds Pleasantville's serial banality constricting and so introduces her more liberated morality to the town's teenagers. As she does so, color seeps into the black-and-white diegesis. Pleasantville's transition from black-and-white to color is thus a diegetic phenomenon – within the film, characters "physically" become color. It is also a metaphor for America's transition from modernist Cold War authoritarianism to postmodern social pluralism. Color accompanies social and sexual liberation: the first color in Pleasantville is the red of a rose, the first characters to become color are the teenage couples who drive down to Lovers' Lane and actually do some loving. Of course, these narratively motivated transitions are also themselves opportunities for the director to explore the technological conceit of a film in which color gradually displaces black-and-white. At the end of the film, the conversion to color of the last of Pleasantville's conservative old guard coincides with the completion of the film's own transition to color. A few moments later, we see a sign in a shop window advertising color televisions. The film's technology and narrative are metaphors of each other.

Ironically, over the course of its production process, *Pleasantville* moved in the opposite direction – from color to black-and-white. The film was shot on color stock, and digital technology was used not to change or create

colors but selectively to remove them (Fisher 1998: 62).[8] DI was only used for shots that involved the visual effect of black-and-white (Kaufman 1999: 128). *Pleasantville* was a technologically pioneering film, marking a significant advance in the spread of DI into film production, but its chromatic manipulations remained special effects. Nonetheless, the film demonstrated to industry practitioners that fully digital post-production was within reach, and that DI could provide a workable means of manipulating color (Higgins 2003: 68). As the processing power of computers increased and terabyte storage replaced gigabyte storage, DI began to be used not only for specific special effects but also to achieve broader aesthetic effects. For example, director Dominic Sena used DI for the last 15 minutes of *Gone in Sixty Seconds* (2000) to minimize the chromatic and tonal differences between the multiple shots of the film's climactic car chase (Probst 2000: 151).

The film commonly credited as the first feature to use DI as an aesthetic tool for its entire length was the Coen brothers' *O Brother Where Art Thou?* (2000).[9] *O Brother* focuses on a trio of escaped convicts as they travel through Mississippi during the mythic era of the Great Depression. Like *Butch Cassidy and the Sundance Kid*, *McCabe & Mrs Miller*, and *Heaven's Gate*, the film's desaturated images evoke old photographs whose fading colors hypostatize the fading of our cultural memory (Plate 5.4). Unlike its predecessors, *O Brother* was shot among the lush greens of the Deep South. In order to achieve the look of fading postcards, director of photography Roger Deakins needed to alter the locations' colors drastically (Fisher 2000: 38). He initially experimented with analogue techniques including bleach bypass and the creation of hybrid prints combining color and black-and-white interpositives, but the results did not provide the Coens with the chromatic control they sought (Fisher 2000: 38). So instead Deakins followed *Pleasantville*'s post-production route, using the same facilities house, the same telecine technology, and the same colorist (Fisher 2000: 39). Though he finally used digital color, Deakins' experiments with film color suggest that his terms of reference remained analogue, and his use of digital color manipulation was a means of improving on the chemical color manipulation that he had initially intended. Inasmuch as *O Brother* succeeds in emulating the look of old postcards, its "fake analogue" color provides a further example of remediation. Other examples of "fake analogue" include Martin Scorsese's *The Aviator* (2004) and Robert Rodriguez's *Planet Terror* (2007). *The Aviator* remediates Technicolor two- and three-strip color processes, moving from the former to the latter as the film's narrative moves from the 1920s to the 1930s; *Planet Terror* remediates the pale reds

of aged 1970s Eastmancolor film prints, whose cyan dyes – as film-makers including Scorsese discovered within only a few years of using them – faded exceptionally quickly (Gschwind & Fornano, 2009).[10] Rodriguez's film is a particularly ironic addition to this list, as the same technology through which its colors were made to appear faded will also ensure their stability. Because it was mastered digitally, the film will not be subject to decay and its images will fade no more.[11]

Chromatic remediation also, of course, extends to television drama. In discussing the first season of television crime series *CSI* (2000 onwards), series producer/director Danny Cannon enthused about his access to DI technology by referring to the laboratory techniques that it enabled him to mimic: "We were hyper-crushing, overlay saturating, going into the base of the film, pulling the grain back up and doing all of the things you'd do in bleach-bypass without actually *doing* bleach-bypass" (Bankston 2001: 62). In order to make his television series appear more "cinematic," Canon mirrored a form of film color used in feature films of the period, which mirrored the digital color of television advertising, which mirrored other uses of color in film. Mirrors faced mirrors in an allusional *mise en abyme*.

Clearly, attempting to trace these various remediations back to an original source is futile. Better to look at them as examples of the reciprocity that Foucault describes in his famous account of Velásquez's *Las Meninas* (2002: 5). What interests me most, however, is not the detail of what mirrored what and how but an outcome of this reciprocity – namely, that the various remediations discussed above provided early digital color with a dominant color aesthetic. This aesthetic can be characterized as "color monochrome," and is achieved by partially desaturating a full color image and then adding a single colored tint to it. The pale metallic blues of countless car commercials are particularly obvious manifestations of this form of digital color, but the greens of *The Matrix*, the browns of *Saving Private Ryan* and *Band of Brothers*, and the yellows of *O Brother* all exemplify it too (regardless of whether or not they were achieved using digital technology). Color monochrome was, and to an extent still is, digital color's most prominent visual cliché.

Digital Color Aesthetics, 2000–9

During the 1990s and early 2000s, screen color increasingly became a facet of post-production. In doing so, it moved from physical space to digital space. Lev Manovich notes:

Once live-action footage is digitized (or directly recorded in a digital format), it loses its privileged indexical relationship to pro-filmic reality. The computer does not distinguish between an image obtained through the photographic lens, an image created in a paint program or an image synthesized in a 3-D graphics package, since they are made from the same material – pixels. (Manovich 2001: 300)

Manovich makes a crucial point, echoed by many other digital theorists, but his use of the term "material" is misjudged. It is precisely the *immateriality* of pixels that distinguishes them from pigments and photons. Of course, pixels manifest themselves through molecules of liquid crystal; they also appear to us as light stimulating the photosensors in our retinas. But they cannot be defined in these terms. A pixel is definable as a unit of color information mapped onto a specified location on a screen. Each pixel comprises three sub-pixels: red, green, and blue. Each sub-pixel has a single numeric value. In the 24-bit color space of a domestic computer, the numeric value of each sub-pixel ranges from 0 to 255. The number of potential color values attributable to a pixel is thus somewhat over 16 million. Though, as I discuss later, there remain restrictions on how digital color can be manipulated, these restrictions are no longer material – if the numeric values of a pixel change, its color changes.

The dematerialization of screen color has brought an end to black-and-white and color's technological separation. In the introduction, I referred to the historical uncertainty expressed by commentators from Aristotle to Wittgenstein on the question of whether black and white are colors. Throughout the twentieth century, cinema played out this uncertainty. In terms of screen production, there is an unambiguous answer: yes. Black, white, and gray are RGB color values. In 24-bit color space, a pixel with values of R0 G0 B0 is black; a pixel with values of R255 G255 B255 is white; a pixel with equal values that are somewhere in-between (for example, R125 G125 B125) is a shade of gray. The difference between black, white, and color is now quantitative not qualitative.

There is no wall between black-and-white and color in digital space. The implications of this for contemporary color aesthetics cannot be overstated. I have already mentioned the current prevalence of "color monochrome," which involves a process of partial desaturation followed by the emphasis of a single hue. This form of digital color is now so common as to have become a global visual cliché. An easy way of giving a film a coherent visual aesthetic, monochrome color transcends budget, genre, and continent. A more

sophisticated chromatic mixture occurs in Kerry Conran's *Sky Captain and the World of Tomorrow* (2004). Though the film is a retro-techno pastiche of 1940s thrillers, its digital color looks to the future not the past. *Sky Captain* is a film without sets – Conran filmed actors in front of blue screens, and then composited them onto motion graphic images (Probst 2004: 40). In order to reconcile the film's live-action and motion graphics elements, Conran completely desaturated the film's cinematographic elements – namely, its actors – in post-production and then selectively colorized them (Probst 2004: 40). There are still sometimes quite obvious differences between filmed and computer-generated areas of the frame, but their common digital color helps to soften the edges. In *Pleasantville*, David paints his "mother's" face gray after her extra-marital desire causes her to become color. The screen effect of erasing her color was achieved by the use of gray make-up on actress Joan Allen's face; surface color mimicked digital color's mimicry of Pleasantville's monochrome environment (Plate 5.6). In *Sky Captain*, these layers of disguise are stripped away. There is no more camouflage. Though the film nods to early Technicolor aesthetics, not least by including a scene in which two characters meet at a cinema showing *The Wizard of Oz*, its color mixtures are emphatically digital. The impossibly red lipstick of roving reporter Polly Perkins simultaneously evokes Technicolor movies and sets the film ironically apart from the physicality of surface color (Plate 5.9).

An equally satisfying chromatic mixture occurs in *Sin City* (Robert Rodriguez & Frank Miller, 2005). Based on the comic book by Frank Miller, *Sin City* meticulously reproduces the black ink on white paper of its source. Co-director Robert Rodriguez did not even storyboard the film – the comic book was his storyboard (Sloane & Baughan 2005: 58). Rodriguez notes:

> In Frank's drawings, because of the way the black and white is done, you say, "Oh yeah, that isn't naturally possible to have it like that." It feels real, but it's not actually possible if you were to put a light on somebody. In the graphic world, however, you can do those tricks. So I wanted to do that with cinema as well. (Gross 2005: 28)

He did so, as did Conran, by filming actors in a studio – this time in front of a green screen (Gross 2005: 29). But though the production process used for *Sin City* was similar to that used for *Sky Captain*, the two films are visually very different. By lighting actors with low-key light, desaturating the results and increasing the contrast, Rodriguez transformed color into black and white. Adulterating the film's pure blacks and whites are

occasional spot colors: a red pool of blood, a blue car, blonde hair, a red dress (Plate 5.10). Color, removed, is again selectively added, though the colors added are not the same colors as those that were removed. For example, Rodriguez makes one particularly toxic character's face bright yellow. The effect, and the aim, of this selective colorization is far more confrontational than it is in *Sky Captain*. In language appropriate to the film's narrative, in which every character exists only to inflict violence or be the victim of violence, Rodriguez says he used individual colors "as weapons." He continues:

> When we take all the color out but leave just the blood in on someone who has been beaten up, you really feel the pain. It's like a color close-up because all you really see is the red and you're, like, "Holy shit, he's really gotten his ass kicked." (Gross 2005: 28)

Yet though these colors spring out at us at like assassins, and though *Sin City* may bring to mind Renaissance debates about *disegno* and *colore* (indeed, the word "cartoon" is derived from *cartone*, the Italian for a preparatory drawing), there is no technological distinction here between colors and blacks and whites. All is digital color.

Through digital color, black-and-white has been given new life. Monochrome images now appear on screen more often than they have at any time since the 1960s. But digital color has simultaneously given black-and-white a coup de grâce. Previously, black-and-white could still be regarded as a distinct format, with its own technological and aesthetic identity. This is no longer the case. Just as the fall of the Berlin Wall was followed by the absorption of communist economies into capitalism, so the end of the historical détente between black-and-white and color technologies has led to the absorption of black-and-white into color.

There is no point mourning the passing of black-and-white film. Director of photography John Lindley considered filming *Pleasantville* on black-and-white negatives and then digitally adding color, until he realized how technologically inferior black-and-white film stocks were to the latest color stocks: "Modern color films have multiple T-grain layers and therefore record much sharper and cleaner images" (Fisher 1998: 62).[12] The mixture of color film and Digital Intermediate can achieve anything black-and-white film could, and far more. What perhaps can be mourned, however, is the power that black-and-white once had to question color. As I discussed in Chapter 2, the unmotivated chromatic hybridity of the 1960s was an

emergent cultural practice. The arbitrary movements between black-and-white and color in films including Vera Chytilová's *Daisies* (1966) and Lindsay Anderson's *If....* (1968) played a counter-cultural role. They highlighted the arbitrariness of making a black-and-white image signify realism, or a color image signify fantasy, encouraging the viewer to acknowledge the arbitrariness underlying these films' (and all films') visual codes. Unmotivated chromatic hybridity resisted dominant aesthetic practice because it was not realistically motivated. Now digital color is typically also not realistically motivated. As the color monochromes of *Band of Brothers* demonstrate, even "realistic" films need not feature realistically motivated color. In the previous chapter, I noted how innovations in color cinematography frequently hit the ideological wall of motivation. Optical color needed to be "justified" by appearing to emanate from a diegetic source (see Holm et al. 1957). Digital color no longer needs to be diegetically motivated because it is no longer diegetic; it exists in digital space, and so need not approximate Newtonian color.

One consequence of color's newly found freedom is that unmotivated chromatic hybridity no longer exists as a counter-cultural phenomenon. There is no longer any aesthetic reason preventing color and black-and-white from mixing. Accordingly, black-and-white has been a common feature within dominant media since the mid-1990s. In television series from *NYPD Blue* to *Queer Eye for the Straight Guy*, brief fragments of black-and-white – typically lasting no longer than a few seconds – provide a form of visual punctuation, taking their place among a bricolage of styles.[13] The absorption of unmotivated chromatic hybridity within mainstream cinema is symptomatic of the fact that emergent processes become incorporated into the dominant so easily that, as Raymond Williams noted, "any significant emergence is very difficult" (1977: 126).[14] Inevitably, the process by which emergence is assimilated into dominance "conditions and limits the emergence" (1977: 124). The chromatic mixtures and hybridities attempted with varying success by art film-makers of previous generations (Dreyer, Antonioni, Tarkovsky, et al.) now carry little of their former ideological potency. In Jonas Odell's seminal pop video, *Franz Ferdinand: Take Me Out* (2004), monochrome images evoking Soviet constructivism are pasted into a digital landscape featuring band members playing their instruments. Odell's video is a beautiful piece of work. But it also demonstrates capitalism's ability to assimilate and co-opt even those practices that oppose it.

The degree to which digital color is recognized as both immaterial and free from the constraints of realistic motivation can be demonstrated by returning to the once vexed question of colorization. In the previous chapter, I noted the widespread opposition to Ted Turner's decision in the late 1980s to colorize Hollywood classics including *The Maltese Falcon* and *Casablanca*. Of course, it was video masters of the films, not the films' original negatives or prints, which were colorized; Turner created alternative color versions of popular films, targeted at domestic exhibition. Black-and-white film and colorized video thus coexisted, as had black-and-white and color versions of the same films in early cinema. Nonetheless, Turner's critics thought that making a color version of a black-and-white film would undermine the integrity of the original and perhaps even displace it entirely. Believing that there can exist only one authentic version of a cultural product, they did not yet understand the immaterial, and so nondestructive, nature of digital colorization. As people's familiarity with digitality has improved, colorization has ceased to be a cause célèbre. In fact, digital colorization can help sell products dulled by age. For example, following the success of ITV's documentary *The Second World War in Colour* (1999), which made use only of footage shot in color, the broadcaster released *World War 1 in Colour* (2003). Of course, *no* footage of World War One was shot in color, so the series was digitally colorized, but this was precisely the point – the colorization transformed commercially worthless footage into prime-time television. Colorization has also become common in Bollywood, again without controversy. Digitally colorized Bollywood films include Chetan Anand's *Haqeeqat* (1964), and Karimuddin Asif's *Mughal-E-Azam*, (1960), the colorized re-release of which made $8.3 million in India (Iyer 2005: 11).[15] The colorized *Mughal-E-Azam* combines the excessiveness and sensuality of early hand painting and that of the 1950s Technicolor that its director could not afford to use (Plate 5.15). The lack of controversy surrounding these various colorizations reflects the fact that digital color is now intrinsic to the production process. Even the seemingly verisimilar colors of television news broadcasts and nature documentaries typically involve at least some color grading to compensate for "below-par" footage (Hilton 2004: 24). It is now not only true to say that everything *can be* digitally colorized but also that almost everything *is* digitally colorized.

Given that digital color no longer requires environmental motivation, it is not surprising that discussion of it frequently reverts to the metaphor of

painting.[16] With reference to his work on Jean-Pierre Jeunet's *A Very Long Engagement* (2004), cinematographer Bruno Delbonnel opines:

> In the past, I always thought it was false to compare cinema to painting.... However, the DI is a new setup in the creation of a film. With this process, we can start to work with elements that are close to painting, and we can work on contrast and color relationships that were impossible with photochemistry. (Bergery 2004: 69)

Delbonnel's comment highlights two distinct ways in which the metaphor of painting tends to be applied to digital color. Firstly, it is typically used to describe the process of manipulating digital color. For example, rotoscoping involves freehand mark-making on a graphics tablet by means of a pressure-sensitive pen; the results of these marks appear on screen as the strokes of a pencil, paintbrush, or airbrush – what Manovich aphoristically refers to as the "Kino-Brush" (2001: 307). In this specific sense, the metaphor of painting is more than a metaphor – rotoscoping is functionally equivalent to painting. Secondly, by referring to effects "impossible with photochemistry," Delbonnel embraces the metaphor of painting in a broader sense, as an expression of digital color's freedom from constraint. Used in this sense, the metaphor of painting is much weaker. It implies an analogous relationship between the surface color of painting and the digital color of video without acknowledging the two different spaces within which they exist. Of course, one can paint a blue sky green. Nonetheless, painting carries material limitations – oil paints, for example, cannot escape the physical properties of their oil base. By contrast, digital color is immaterial. As the opening sequence of *The Matrix* reminds us, all digital processes are the product of variable numeric values. Thus D. N. Rodowick surmises that when "space becomes information, it wants not to be preserved in an analogous record of duration, but to be transformed, manipulated, and exchanged" (2007: 118). Perhaps the most significant characteristic of digital color is its partiality to transformation. In digital space, all colors carry the possibility of all other colors within them. Digital color is itself a variable.

Digital color's protean nature manifests itself in diverse ways. As already discussed, it manifests itself in color attributes (for example, green sky) freed from environmental limitations. It also manifests itself in dynamic variations in color. Virtually any color change carried out in post-production can also be keyframed, so that it occurs over time, in front of our eyes. At the end of a sword fight in a forest in *Hero*, the autumnal yellows of the

leaves become red, as though the trees were soaking up the spilled blood of the loser (Plates 5.11 and 5.12).[17] In an affective sense, the red is excessive, like the red of the flag in *Battleship Potemkin*. In a technological sense, however, the red is already latent in the yellow.

Digital color-movement can also occur over even longer periods of screen time. For example, Steven Spielberg's and Tom Hanks's World War Two mini-series *Band of Brothers* (2002) takes the chemical desaturation of *Saving Private Ryan* as its chromatic dominant, and then subtly modulates it from scene to scene and episode to episode (Plate 5.8). The colors in *Ryan* move to-and-fro between desaturated brown and desaturated green, depending on the color of each location. By contrast, the colors in *Band of Brothers* advance through browns, greens, yellows, blues, blacks, and whites. The changes in color follow, but remain unconstrained by, the changing colors of the seasons and locations through which the soldiers of "Easy Company" advance. As successive episodes' colors move from muddy brown autumn, through snow-white winter, culminating in golden yellow spring, they color-code the company's progress through the war.

Digital color-movement also manifests itself within the production and distribution chain. Of course, one might imagine that digital color, immaterial and so not directly prone to decay, might be more stable than film color. Certainly, film color is notoriously variable. All materials and processes involved in the production of film color also change it. The colors of a film negative differ from profilmic color; the colors of prints derived from the negative differ from the colors of the negative. Film color's instability across the production and distribution process is compounded by the fact that the color of film prints changes (i.e. decays) over time. Light destroys color – over the course of 20 years, a print can fade from full color to monochrome red. Color cinema, by shining pure white light through film prints, has consumed itself. The colors of old film prints typically bear little relation to the colors that were first printed onto them. As a result, aging directors are cajoled into color correction suites to supervise the remastering of their films for DVD. But their memories have faded too, so their films' colors change again. Chromatic memory is particularly unreliable. Scott Higgins notes that each time *Gone With The Wind* has been reprinted and reissued over the last 70 years, those responsible for the reissue have sought to increase the film's saturation – to make it more Technicolor. They have done so as a result of our erroneous cultural memory that *Gone With The Wind* was originally super-saturated (Higgins 2007: 9).

Though film color is indeed unstable, digital color has brought with it new, immaterial instabilities. It is not just that the color values of pixels *can*

be manipulated – they change of their own accord as digital video files are transferred, transcoded, copied, compressed, and recompressed. Digital color-movement cannot be avoided. In film color, the final print of a film existed at three degrees of separation from its original negative – from negative to interpositive to internegative to print. Digital color involves multiple degrees of separation. A typical production route involves filming onto negatives, encoding negatives as digital files by telecine, transferring these source files to workstations for visual effects work, transferring these recompressed files to edit suites for cutting, creating new master files, and then printing these files to film. Every time a digital film is displayed on a new screen, its appearance changes, even if its RGB values have not.

Unsurprisingly, since the mid-1990s, "color management" has become the bane of many post-production supervisors' working lives. Many solutions to the problem of color slippage have been proposed over the years. Much effort since the mid-1990s has centered on "look up tables," which attempt to provide a common term of reference for film color and digital color, and on calibration, which attempts to make color display consistently on different monitors (Kaufman 1999: 128). All such attempts to tame color have, to varying degrees, failed (see, for example, Steen, 1996). Even if a solution could be found to the problem of calibration, as soon as a digital file is compressed for broadcast, DVD release, or web distribution, the problem begins again. Nonetheless, attempts to standardize digital color continue. They do so because, as Sean Cubitt notes with reference to ephemerality of the dyes used in Walt Disney's *The Band Concert* (1935), the standardization of color is a "political-economic" motivation (2009: 25). It is an expression of the desire for property rights. Attempts by artists and cinematographers to control the color of "their" work are analogous to attempts by multinationals to control their brand identity. Though Yves Klein's assertion of intellectual property rights over "International Klein Blue" was tongue-in-cheek, it anticipated the dead-serious attempt by BP in the mid-2000s to patent the shade of green used in its logo. The desire to control color is also, as Cubitt gently insinuates, an actuarial obsession. Cinematographers, colorists, artists, visual effects supervisors, directors, designers, producers, and even film historians – we all, in our own ways, seek to impose order onto chaos by taming color. I continue by exploring in more detail how digital color is constrained.

Digital color has found unprecedented freedom on the atomic scale of the pixel, but when aggregated into moving images, it faces numerous constraints. I have already mentioned one in the previous section – lack of

imagination. Though all but the most technologically nostalgic film-makers now use digital technology, many still have difficulty thinking beyond film's traditional building-blocks: pans, tracks, cuts, dissolves, etc. Digital post-production is a recent development; our cultural imaginary is only beginning to comprehend its potential. At the same time, *the technology itself* is also shaped by imaginative limitations. The analogue terms of reference which continue to inform film-makers' decisions also extend to those who develop the software and hardware that they utilize. This point is worth elaborating.

In digital space, it is not the materiality of film but the functionality of computer hardware and software that inhibits color's anarchic tendency. Though the color value of each pixel carries the potential of all other colors within it, chromatic changes are obviously not carried out a pixel at a time – if they were, it would take a colorist years just to adjust a single frame of a film. Rather, they are carried out by changing groups of pixels based on their color values and their position on screen. The selection and transformation of groups of pixels takes place with the aid of algorithms that appear to the user as functions on a graphic user interface. I have so far deliberately avoided taxonomizing digital color aesthetics, but many of the most common digital "looks" are common precisely because the functionality of color correction technology favors them. Desaturation or increased saturation, monochrome color, high contrast, and simple dynamic adjustments are all common in part because they involve global color changes (i.e. changes that apply the same algorithm indiscriminately to all pixels in an image), and so can be achieved with a few clicks. Many of these global functions in turn developed through the remediation of analogue effects including filtration, flashing, and bleach bypass. In order to be sellable to producers, digital color needed to be able to achieve typical analogue color effects, except faster and cheaper. In a certain sense, therefore, analogue paradigms still permeate digital color. Digital color's ability to fulfill the aspirations of twentieth-century film-makers – Antonioni's desire for expressive color, Huston's desire for desaturation, Tarkovsky's desire for dynamic color – is a sign of its power. The fact that most of its functionality can be summarized in terms of these aspirations is a symptom of its limitations.

It is no surprise, then, that some of the most innovative examples of digital color in moving images have been achieved through authoring code rather than applying filters. The radically unstable colors of Richard Linklater's *Waking Life* (2001), for example, were achieved with the aid of software authored by film-maker and programmer Bob Sabiston. Sabiston

developed his "interpolated rotoscoping" software as a reaction against the geometric precision of 3-D computer modeling: "Modelling seemed to me too controlled and a far cry from the spirit of painting. I wanted to create the antithesis of *Toy Story*" (Pennington 2006: 36). *Waking Life*'s workflow involved ingesting Mini-DV footage shot by Linklater into a computer, desaturating it to emphasize line, and then "painting" over it in color with a pressure-sensitive graphics pen (Pennington 2006: 39). Viewed frame-by-frame, Linklater's film could therefore, in a sense, be regarded as a series of digital paintings. It could also be regarded as an example of color exceeding, overwhelming, and even transcending line. Though I have previously cautioned against applying the concepts of *disegno* and *colore* to films, in the specific case of animation, the historical binary of line versus color has been structural as well as rhetorical. For example, as Sean Cubitt reminds us, the animation process in Disney's Mickey Mouse films involved three stages – artists drawing images, inkers inking the artists' pencil lines, and colorists coloring in the inkers' outlines (Cubitt 2009: 13). The final image thus comprised black outline and color fill. In *Waking Life*, there is no "inking." A pen mimics a brush, "painting" over desaturated video, simultaneously over-writing its own history as a line-maker. When the underlying layer of monochrome video is finally removed, line disappears entirely, leaving pure digital color.

Waking Life also exemplifies pure digital color in its engagement with time. My reference to color exceeding line may recall Titian, but Titian's paintings, though they imply movement, are static. By contrast, the colors in *Waking Life* are dynamic, a visual echo of movement in the video footage – whenever characters and objects move, color moves. At the same time, like an echo, the colors' movements are a distortion of their source. The boundaries of the colors in *Waking Life* fluctuate chaotically from moment to moment; characters and objects sometimes verge on losing their form entirely (Plate 5.13). The extent of this color movement is shaped not only by the footage but also by Sabiston's algorithms. The film's animators typically painted over one frame, then painted over another frame five or six frames later, allowing the software to interpolate the frames in between based on these start and end frames (Shay 2006: 33). Sabiston deliberately designed imprecision into this interpolation, thereby inserting contingency into the animation. The shimmering colors that result are evocative of the haphazard hand-painting in early cinema – except that the underlying black-and-white image is absent. Freed from its source footage, the films' digital color moves beyond indexicality, beyond iconicity, and occasionally

beyond even figuration. In *Waking Life* all is color, and all color is movement, so color and movement fuse into what Deleuze referred to as "movement-colour which passes from one tone to another" (Deleuze 1986: 118).[18] When once there were whip pans, for example, now there are only smears of movement-color, the nature of which depends as much on Sabiston's code as on Linklater's camera.

Even Linklater and Sabiston, however, eventually found their use of digital color constrained. In addition to being constrained by (lack of) imagination, digital color is also constrained by economics. Though Linklater used Sabiston's software and expertise again on *A Scanner Darkly* (2006), an adaptation of Philip K. Dick's novel, the project did not reprise the cheerful experimentation of their first collaboration. *Waking Life* was a perfect conduit for Linklater's counter-cultural sensibility. Its narrative comprised short, loosely connected scenes of people discussing ideas over lattes. It used non-proprietorial technology. And it was low-budget, co-funded by the Independent Film Channel. It was also collaborative and non-hierarchical, as each of its separate segments was rotoscoped by a different artist, working autonomously. The overall film was the combined work of dozens of individuals in a P2P community (Burnett 2004: 220). Technology, economics, and aesthetics all pulled in the same direction. Linklater could not afford to employ a whole animation studio, so he found freelance digital artists; artists were drawn to the project because it was an experiment; Linklater was able to experiment because the film was independently funded and low budget. In this context, Sabiston's labor-intensive rotoscoping process did not obstruct the realization of the film; paradoxically, it was the technology that brought the film's disparate elements together.

Inspired by Sabiston's technology, Linklater said in an interview about *A Scanner Darkly*: "I don't believe there are limitations to what we can do in post. We've created another world, almost...."[19] The "almost" is telling: though the film repeatedly slides into the deluded imaginings of its drug-addicted characters, Linklater was not able to escape the reality of its conditions of production. The film had an $8.5 million budget, 12 credited producers, and a linear narrative. Each of these factors made *Waking Life*'s P2P production process impossible, necessitating instead a centralized, hierarchical process. Accordingly, Linklater established a rotoscoping studio along Fordist lines, whereby every artist had a specific task. Artists focused on individual scenes, individual characters, or even individual characteristics (eyes, hair, complexion, etc.). All followed a single style

guide.[20] Of particular interest is the fact that the rotoscoping was divided between two main departments: line and color. The re-emergence of line in *A Scanner Darkly* is significant. Line acts as a constraining element. It holds color in, making the image more visually and spatially coherent. Color no longer exceeds its boundaries, as it does so spectacularly in *Waking Life* when a scientist discusses the stochastic movement of atoms and the colors of his face break apart in demonstration (Plate 5.13). It no longer spreads through the sky, as a character floats through the air.[21] Despite the profusion of drugs being taken, no characters float in *A Scanner Darkly*; they remain tied down by the conventions of realist cinema and by the animators' lines. The result is a film that, though still visually compelling, looks like a conventional animation (Plate 5.14).

A Scanner Darkly demonstrates another factor constraining digital color: ideology. The use of line in *A Scanner Darkly* is not an aesthetic but an ideological necessity. Similarly, to return to my theme of the chromatic, ideology continues to influence recent interactions between black-and-white and color. Though they are no longer materially separate, their opposition remains a residual – and so active – cultural construct. As Raymond Williams observes, the residual may contradict the dominant while continuing to manifest itself within the dominant (1977: 122). Though the chromatic dominant has now absorbed the counter-cultural chromatic hybridities first manifested in 1960s art cinema, the use of black-and-white and color as a means of juxtaposing past and present remains common. In films as diverse as Clint Eastwood's *Space Cowboys* (2000), Cristian Nemescu's *California Dreamin'* (2007), and Chuan Lu's *City of Life and Death* (2009), the past remains a monochrome insert within the color present. Even in *Pleasantville*, despite technologically experimental chromatic mixtures, black-and-white and color remain compositionally motivated according to the classical Hollywood paradigm of opposition. Black-and-white signifies conformity, with characters' colorization signifying their adoption of postmodern social and sexual morality. Though color spreads gradually across Pleasantville, for each individual there is no middle ground: either s/he is black-and-white or color, sexless or sexed. Thematically too, the film culminates in an either/or courtroom showdown between the town's mayor (a mouthpiece for conservatism) and David (a mouthpiece for liberalism). Again, there is no room for the intermingling of ideas. Bad old loses out to good new, and the film ultimately becomes a liberal wish-fulfilment, in which the

population of Pleasantville looks forward to a tolerant and pluralistic future. The film's digitality and its narrative thus ultimately contradict each other – black-and-white does not merge with color, it is overrun by it. Technologically, *Pleasantville* anticipates the future, but compositionally it looks to the past.

Rather than encouraging mainstream cinema to overcome its predilection for oppositions, digital color has in fact provided new means of reasserting them. When once film-makers had only two chromatic alternatives – color or black-and-white – they now have a gamut of options for signaling oppositions such as past/present, reality/fantasy, and waking/dreaming. For example, the frequent flashbacks in *CSI* are signaled by a wide variety of digital color effects. These include partial desaturation, excessive saturation, color toning, color remapping, contrast adjustments, and overexposure.[22] Each episode uses a different combination of color effects for its flashbacks, often in combination with other visual effects such as motion blur. It is interesting to note also that *only* the flashbacks use color effects. The "here and now" of the investigation scenes invariably involves far less obviously manipulated colors. There is of course still some color manipulation evident – for example, the relatively warm tones of *CSI: Miami* (2002–present) provide the series with a subtly different look from the blues of its New York-based parent series. Nonetheless, these small divergences always occur within the confines of realistically motivated color. The historical trajectory of how color delineates space-time can thus be summarized as follows. In classical Hollywood, black-and-white signified the default spatio-temporal state and color the altered state. In post-classical Hollywood, color became the default state and black-and-white the altered state. In contemporary Hollywood, realistic color is the default state and digital color is the altered state.

The distinction within films between realistic and digital color also exists across genres. It is worth at this point reprising Edward Buscombe's summary of classical Hollywood genres' chromatic tendencies: musicals, westerns, costume romances, fantasies, and comedies were typically color, while newsreels, dramas, documentaries, war films, and crime films were typically black-and-white (Buscombe 1985: 89). Buscombe's generic division still holds true, except that genres that once preferred black-and-white now prefer realistic color and genres that once preferred color now prefer digital color. The only two genres that no longer fit Buscombe's list

are war films and comedies. War films are now typically desaturated and color graded to emphasize the obscene brown of combat. For example, such ideologically distinct films as Je-gyu Kang's humanist *Brotherhood* (2004) and Fyodor Bondarchuk's nationalist *9th Company* (2005) nonetheless appear to have been pressed from the same metal. Conversely, contemporary comedies tend to moderate their idealized depictions of love with relatively realistic color. For example, though the surface colors in *Definitely, Maybe* (Adam Brooks, 2008) are excessively cheerful, the film's chromatic bouquet never exceeds the bounds of realistic motivation. There is also a genre that I would add to Buscombe's list: science fiction. Contemporary science fiction favors digital color, typically using it to emphasize the inorganic over the organic. Over the last decade, monochrome color casts and desaturation have become a science fiction cliché, from the modernist whites of *Cypher* to the metallic blues of Paul Anderson's *Resident Evil* (2002). Though both these films are ostensibly set in the present, they use color to set themselves apart from reality, and place themselves in a parallel present in which our technological neuroses play out as entertainment. If realistic color signals the "here and now," then perhaps digital color signals the other times and places of our cultural imaginary: the beach landings of Normandy, Depression-era America, Sin City, the Matrix....

I end this book, as I began it, by highlighting an arbitrary chromatic opposition. The distinct processes of mark-making and rendering in color formed the basis in the Renaissance of a rhetorical opposition: *disegno* versus *colore*. Though historically unconnected to the chromatic debates of the sixteenth century, the technological distinction between black-and-white and color film also made possible rhetorics of opposition. Digital video has since annulled this technological distinction, and chromatic mixtures and hybridities have become commonplace throughout the media landscape. Nonetheless, the rhetoric of opposition continues to inform feature film production. This is a shame. The most exciting chromatic mixtures and hybridities hold black, white, and color in creative tension rather than placing them in opposition. Similarly, many of the most exciting examples of screen color have occurred when film color, surface color, absent color, optical color, and digital color have interacted, blended, pressed against each other, informed and inspired each other. I conclude by suggesting that these chromatic categories – though useful – exist to be overcome.

Conclusion: Painting by Numbers?

"Colour outside the lines, colour beyond the page!"

<div style="text-align: right">Waking Life</div>

This history has in large part been a history of the limitations imposed by the materiality of film and the institution of cinema on film-makers' uses of color. It has also been a history of film-makers' responses to these limitations. Many internalized these limitations in their films – recall the hybrid black-and-white and color musicals of the late 1920s and early 1930s. Others struggled to overcome them – recall the heroic absurdity of Antonioni's attempt to paint the face of a forest white in *Il Deserto Rosso*. A recurrent metaphor used by those who have sought to push the boundaries of chromatic cinema, those who have wished to assert its status as art, and even those who have wished to suppress experimentation within it, has been that of painting. For Andrei Tarkovsky, painting was an aspirational association, describing cinema not as it was but as it could be; it was also a means of elevating the status of the film-maker to that of an artist. For Erwin Panofsky, painting was a historical association; it was also a means of emphasizing cinema's art-historical genealogy, and so justifying the Museum of Modern Art's establishment of a film library in 1935 (Levin 2003: 86). For Natalie Kalmus, the metaphor of painting was a justification for her imposition of Technicolor's (economically motivated) chromatic agenda onto Hollywood film-makers and cinematographers.

Digital color has problematized this metaphor. In my view, it has also made it obsolete. Of course, digital color *can* brilliantly approximate painting. For example, individual frames of Zack Snyder's *300* at times look virtually indistinguishable from those in the watercolored comic book by Frank Miller on which the film is based (Williams 2007: 54). But digital color can also do much more, and to refer to digital color as a whole in terms of painting is to privilege surface color. Surface color is an essential element of contemporary screen color, but so are optical color and digital color. All three are distinct, and all three need to interact for screen color to express itself fully.[23] What I mean by interaction is not the use of one form of screen color to create a forgery of another but the use of all forms of screen color in ways that explore their difference. There is an excitement when two forms of color appear in tension: to my mind, one of the most startling examples of screen color remains *Annabelle Serpentine Dance*

(Edison, 1895), in which hand-painted color fails to mimic optical color, and in so doing provides a flashforward to limitless chromatic possibilities still untried. Though even Bob Sabiston references cinema's imaginary art history, the films created with the aid of his software transcode the excitement of *Annabelle Serpentine Dance* into digital space. Painting stabilized the chaos of color; interpolated rotoscoping in turn destabilizes painted color. A character walks down a street in *Waking Life*. As he does so, the sun comes out and a small polygon of brown on his shirt turns to white. In this tiny chromatic movement, we get a glimpse of the added complexity that digital color has brought to screen color: the initial brown is digitally "painted" onto the source video clip, the move from brown to white is the product of a programmed interpolation, and the inspiration for this change is the variability of color as reflected light. The resulting "digital light" is as mesmerizing as it is intangible.

I believe that the continued vitality of screen color depends on practitioners like Sabiston who explore its shifting boundaries. Many of the most exciting chromatic works of the past (from *Annabelle Serpentine Dance* to *Suspiria*) have achieved this excitement by negotiating between surface and optical color. Perhaps the most exciting chromatic works of the future will be those that negotiate the distinctions, ambiguities, and overlaps between surface color, optical color, and digital color. Once these and other forms of color creatively interact, perhaps Henri Alekan's dreams of a cinema able to "break through colour" will be fulfilled.

Notes

Introduction

1 Technological histories include Ryan (1977) and Haines (1993). Aesthetic histories include Johnson (1966) and Durgnat (1968). Anecdotal histories include Kalmus (1967) and Basten (1980). Histories that privilege ideology include Winston (1996). Period-specific and country-specific histories include Andrew (1980) and Gunning (1995). Process-specific histories include Kindem (1981), Belton (2000), and Higgins (2007). Most histories from the late 1970s onward have been written according to the belief that screen aesthetics are dependent on a combination of technological, industrial/economic, and ideological factors. Indeed, color proved a fertile testing ground for this approach to film history: prominent examples include Kindem (1979), Buscombe (1985), and Neale (1985).

2 Recent anthologies on color in film include Dalle Vacche and Price (2006), and Everett (2007). In my view, the standout anthology remains Jacques Aumont's *La Couleur en cinéma* (1995). Also notable is David Batchelor's *Colour* (2008), which anthologizes writings on color in twentieth-century art theory.

3 The only significant exception to the conceptual separation of cinematic black-and-white and color that I have found occurs in Aumont's anthology. In it, writers including Suzanne Liandrat-Guigues, Michel Chion, Alain Bergala, Philippe Dubois, and Aumont himself display a profound understanding of black-and-white's visual legacy.

4 My account of color mixture and reproduction is a synthesis of multiple sources including Holm et al. (1957) (which features a thorough yet comprehensible section on color reproduction), Neale (1985) (which features an elegantly concise history of color movie technology), and Kemp (1990) (which explores the relationship between color science and art history). The definitive account of photochemical color reproduction remains Hunt (1975), a book dense with technological detail.

5 The third additive primary is in fact violet (blue-green) not blue, but to refer to violet as an additive primary when almost everyone else refers to blue would confuse more than it would clarify.

6 Blue took the form of ultramarine made from ground lapis lazuli, red derived from insect blood, and yellow derived from saffron. For details of the provenance of artists' pigments, see Finlay (2002).

7 This explanation of aniline color and CMYK printing is taken primarily from Hunt (1975).

8 Aristotle's ordering of colors by tone has found a practical application in the color bars used in broadcast television. Arraying colors from "darkest" on the left to "lightest" on the right, color bars allow technicians to maintain color fidelity when moving footage between tapes and hard drives. They also provide a quick means of checking that a transmission includes a full range of tones: by turning down the color on a viewing monitor, a technician can turn color bars into a grayscale running from black to white.

9 A *reductio ad absurdum* of the tendency to discuss screen color in terms of surface characteristics can be seen in the attempt by a recent commentator to attach Pantone numbers to on-screen colors (Higgins 2007: 237). What such an endeavor could possibly achieve is frankly baffling. To classify screen color fully, one would require infinite Pantone numbers.

Chapter 1

1 I refer to the screen color that results from the reproduction of all frequencies of light as cinematographic color or "natural" color.

2 The addition of pigments to film prints is in fact, paradoxically, an example of subtractive color. Like fabric dyes or wall paints, the colors in the painted or dyed film-print selectively absorb light, subtracting wavelengths from white light.

3 Residual demand for hand-painted films continued into the 1910s. A *Motion Picture News* article entitled "Gaumont Hand Colouring" (August 31, 1912) noted that Gaumont, the next largest French production company behind Pathé, was still hand-coloring between four and six reels of film per month.

4 For details of the conditions at Pathé's stenciling workshop, see Jorge Dana's interview with veteran Pathé colorist Germaine Berger (Dana 1992). The reluctance of men to engage in detailed craft-based work also helps explain the fact that many early film editors were women. Following the closure of Pathé's stenciling workshop in the 1920s, Berger became a negative cutter.

5 For a more detailed account of the process of hand painting and the materials involved, see Usai (1996). For a more detailed account of film stenciling process, see Coe (1981: 113). For a more technically focused summary of the various

"unnatural" color processes used in early cinema, and a thorough account of the dyes used in these processes, see Read (2009).

6 A major project is currently underway to transfer up to 20,000 fragments of manually colored films, saved by film historian David Turconi in the 1960s, to digital formats (see Yumibe 2007). The result will form the most varied collection of early color film readily available for study. Unfortunately, the project remains incomplete at the time of writing, so I remain reliant in this section on the handful of early color film prints to have been transferred to video and DVD, and on the writing of film historians who work directly with early film prints.

7 See, for example, Anon. (1921).

8 For further details of de Chomón's work for Pathé, first as a hand colorist and subsequently as a production supervisor and director, see Minguet Batllori (2009).

9 The "80 to 90 percent" claim was first made by a contemporaneous commentator in *Transactions of the Society of Motion Picture Engineers*, and reasserted by James Limbacher and Roderick Ryan (Blair 1920: 45; Limbacher 1969: 5; Ryan 1977: 16). Limbacher's and Ryan's sources are not clear, but recent research suggests that this figure is accurate for many national cinemas of the 1910s and 1920s, and somewhat lower for the 1890s and 1900s (Yumibe 2005).

10 In Handschiegl coloring, film prints were selectively blacked out and turned into printing plates – one per color, as in stenciling. A colored dye was then applied to the plate and transferred to a black-and-white print of the film through a contact printing method referred to as "dye-imbibition" or "dye-transfer." Films with Handschiegl coloration in at least some of their prints included D. W. Griffith's *The Birth of a Nation* (1915), *Intolerance* (1916), and *Broken Blossoms* (1919). For more examples, see Nowotny (1983: 297). For further details of the process, see Kelley (1927).

11 Films of the 1920s that feature hand-painted additions include Henry King's *The White Sister* (1923), Buster Keaton's *The Navigator* (1924), and Raoul Walsh's *What Price Glory* (1926).

12 Until the advent of magnetic sound, recorded sound existed in the form of wavelengths printed on a narrow strip at the edge of the film print. When white light passed through this optical soundtrack, it activated a photoelectric cell which transformed light back into sound. Colored dyes absorbed light, and so inhibited the amount of sound-light making it through the film print to the cell, resulting in an increased need for amplification and a concomitant increase in ambient noise (Jones 1929: 199).

13 For an exhaustive list of the many early color processes, see Ryan (1977).

14 A notable aspect of Kalmus's business acumen was his ability to persuade producers to buy into early Technicolor processes, thus paying for the privilege

of testing his products. Another was his ability, when he could not persuade producers to take his risks for him, to raise capital to enable Technicolor to make its own test movies.

15 The following summary of Technicolor's early market fortunes is based on Herbert Kalmus's own, surprisingly candid, reminiscences (1967 [1938]).

16 The following summary of Technicolor's technologies is taken from Haines (1993).

17 Attempts to find equivalence between music and color unsurprisingly reached their apex in the para-scientific realm of sixteenth-century art theory. Both musical theorist Gioseffe Zarlino and Giuseppe Arcimboldo, court artist to the Habsburg emperors in Prague, attempted to reconcile musical harmony with Aristotle's tonal color scale. For a brief account of their theories, see Kemp (1990: 273). For a broad overview of historical connections between color and music, see Gage (2001: 227). In the twentieth century, attempts to identify a consonance between music and color reached a theoretical crescendo in the writings of Wassily Kandinsky and a cinematic crescendo in the "visual music" animations of Oskar Fischinger. Fischinger's silent film *Radio Dynamics* (1942) is labeled in its credits as a "color-music composition." Analogies between color and music continue to be made to the present day. Sound engineers, for example, often describe sound with reference to Newtonian color. Just as white light is the combination of all the colors of the spectrum, white noise is the combination of all sound frequencies; narrower frequencies of sound are typically given color labels (for example, pink noise).

18 Prominent musicals of the early 1930s to feature Technicolor sequences include John Murray Anderson's *The King of Jazz* (1930), Cecil B. DeMille's *Madam Satan* (1930), and William K. Howard's *The Cat and the Fiddle* (1934).

19 Bordwell also suggests a fourth category: artistic motivation, in which elements of a film are not motivated narratively. Examples of artistic motivation include virtuoso camera moves that draw attention to a film's artifice (1985: 21). Though I accept Bordwell's first three categories, I regard his fourth as a category too many, an attempt to find a unity in all the leftover elements of classical Hollywood films that resist classification according to his first three categories.

20 At the same time, black-and-white and color are also unnecessary signifiers. If we see Dorothy fall asleep in Kansas and wake up in Oz, we realize that she is dreaming. Though psychologically motivated, the move to color provides no narrative information. Again, even when it is made to mean, color still resists meaning.

21 There had been previous isolated examples of narratively motivated color in Hollywood – for example, color was used for two dream sequences in Geroge Fitzmaurice's *Cytherea* (1924). But none had been so overt. The color sequences in *Cytherea* were still perceived as unmotivated: a review in *Variety* (May 28,

1924, p. 27) drew attention not to their narrative signification but to the fact that they were "picturesque enough to cause a murmur of comment." Color had also occasionally been realistically motivated in early cinema. For example, Philippe Dubois observes that in Pathé's *Au Pays noir* (1905), set above and below ground at a mine, scenes taking place above ground in natural (white) light are black-and-white while scenes taking place underground in artificial light are tinted (1995: 76).

22 Lewin uses a similar trick in two other films: *The Moon and Sixpence* (1943) and *The Private Affairs of Bel Ami* (1947). For a comparative analysis of these three films, see Dubois (1995: 83).

23 The film's black-and-white was also technologically a subtraction. The scenes in Heaven were shot in three-strip Technicolor processed without the dyes; Michael Powell reminisces that cinematographer Jack Cardiff suggested this as the only means of achieving the rose's transition to color (1987: 498).

24 For statistical evidence, see Limbacher (1969), which offers an appendix listing all the films made between the 1910s and 1960s that used Technicolor processes.

25 For a full account of Cinecolor's brief economic life, see Belton (2000). A history of Magnacolor remains to be written.

26 For statistical evidence, again see Limbacher (1969).

27 For an early account of the difficulties of lighting for color, see Surtees (1949). In the article, cinematographer Robert Surtees discusses the "need" for low-key lighting when using color, and introduces colleagues to the new complication of color temperature.

Chapter 2

1 Kinemacolor was a two-color additive process. It was based on the idea that using only two of the three additive primaries (red and green) might suffice to create films which reproduced a wide enough range of colors to be commercially viable. The process involved using a modified camera fitted with a rotating wheel, within which were set red and green filters. The wheel was placed between the lens and the negative, and revolved in such a way that individual frames of the negative were exposed through the red filter and the green filter in alternation – one red, one green, and so on. The exposed negative was processed and printed as black-and-white. The final print was shown in a projector also fitted with a red/green filter wheel, so that frames exposed through red were projected through red and likewise with green. Red and green frames alternated multiple times per second, and so they perceptually merged, resulting in a two-thirds color film. The process was first demonstrated in 1908, and used over the next few years in a range of films, including that of the coronation procession of George V in 1911. See Coe (1981: 117).

2 For a history of Dufaycolor, see Brown (n.d.).
3 Agfacolor was released in Germany in 35mm in 1940, and used for a number of wartime films including Josef von Báky's *Münchausen* (1943) and Veit Harlan's *Kolberg* (1945). See Coe (1981: 137).
4 Prominent examples of British Technicolor films include *The Thief of Baghdad* (Ludwig Berger, Michael Powell, 1940), Laurence Olivier's *Henry V* (1944), David Lean's *Blithe Spirit* (1945), and a number of films by Michael Powell and Emeric Pressburger.
5 Kodachrome was released in 1935 and initially targeted at the amateur market. When projected on a cinema screen rather than a domestic screen, its 16mm format resulted in noticeably more grain than a 35mm print. Another perceived obstacle to its professional use was the fact that it was a reversal stock. When exposed and developed, the raw stock resulted not in a negative but a positive print – ideal for showing on a single domestic projector, but less than ideal for films aimed at general release that required multiple prints. These technological obstacles combined with the fact that, as a product usable by amateurs, Kodachrome was perceived as a threat by industry practitioners and so professionally snubbed.
6 Early expressions of enthusiasm for color can be found in Rohmer (1989 [1949]: 39–40), Godard (1998a [1956]: 98), and Antonioni (1996 [1960]: 136).
7 The connection between *La Collectionneuse* and New Hollywood is more than just stylistic. Rohmer's cinematographer, Nestor Almendros, went on to work on a number of high profile Hollywood films of the late 1970s and early 1980s including Terrence Malick's *Days of Heaven* (1978), Robert Benton's *Kramer vs. Kramer* (1979), and Alan J. Pakula's *Sophie's Choice* (1982).
8 As the content of Godard's films became more overtly political in the mid-1960s, his uses of color did eventually assume a narrative role. It became a declaration of his political intent. For example, in *La Chinoise*, the Red of revolution is folded into the red, white, and blue of the American flag with antithetical implications to Abel Gance's use of the *tricolore* in *Napoléon*. In this way, Godard used color to re-brand himself as a revolutionary.
9 Other words commonly used to describe the transformative effect of black-and-white include "reduction" (Arnheim 1958: 62) and "abstraction" (Lundemo 2006). Each word places slightly different emphasis on what is essentially the same cluster of effects.
10 It should be noted that Arnheim was not a neutral observer of monochrome and color aesthetics. In a trenchant analysis of Arnheim's film theory, Ara. H. Merjian points out that his assertion that film was art had much invested in the transformative effects of black-and-white. Merjian even suggests that *Film as Art* can be read as a defense of black-and-white in light of the impending threat of color (2003: 154).

11 Kubrick was technically not a European auteur: though he lived and worked in Britain, he operated within the Hollywood system on big budgets. At the same time, unlike a typical Hollywood director, he had full creative control of his films and a strongly "auteurist" sensibility. One way in which this sensibility expressed itself was in his vacillation between black-and-white and color throughout the 1960s.

12 Even Isaac Newton was not immune to the historical imaginary of painting. On a number of occasions in the *Opticks*, he slips into metaphor, suggesting that rays of light "paint" colors onto surfaces (1721: 32). As I discuss further in Chapter 4, this proved to be a dangerous analogy.

13 In another article, Antonioni provides a contradictory explanation for why he abandoned the white forest shot, claiming that rain washed the whitewash off the trees (1996: 204).

14 Following the definitions that I established in Chapter 1, I refer to the co-presence of black-and-white and color within individual shots as mixture, and the co-presence of black-and-white and color shots within a film as hybridity.

15 There is also a pragmatic explanation for the film's chromatic hybridity. Eisenstein could not get hold of more color stock. The only color stock that the Soviet authorities had in their possession during World War II was a small amount of rationed Agfa stock seized by the Soviet army as it advanced into Germany. For a concise summary of the circumstances surrounding Eisenstein's experiment with color, see Dubois (1995).

16 http://www.acs.ucalgary.ca/~tstronds/nostalghia.com/TheTopics/newsCriterion OnSolaris.html. Accessed 07.09.2007.

17 The only exceptions that I have found to this connotative inversion are a small number of late 1960s head films, in which the mental presence of sobriety is black-and-white and the drug-induced descent into delirium is color. Examples include John Donne's *Alice in Acidland* (1969) and José Mojica Marins's *Awakening of the Beast* (1970).

18 The first Bollywood Gevacolor film was Ezra Mir's *Pamposh* (1954). Mehboob Khan's *Mother India* (1957), one of the most successful of India's many 1950s independence allegories, was also made in Gevacolor. See Foster (1954).

19 Subsequent attempts by Gevaert to infiltrate other countries' markets through local production proved more successful. By 1972, the recently merged Agfa-Gevaert had factories in Belgium, Germany, France, Spain, the USA, Argentina, Brazil, and India (Anon. 1972: 812).

20 The key factors contributing to the continued use of black-and-white in Eastern Europe were essentially the same as those within the Soviet Union, but mitigated by the fact that Eastern European countries were slightly more open to the influence of the West, especially in the form of discreetly imported Kodak film stock. Though I do not here have the space to explore the transformations taking place in Poland, Czechoslovakia, Hungary, etc. individually, my

account of the Soviet Union provides a basic blueprint for the economic and cultural processes at work throughout Eastern Europe.

21 It is a typically Soviet irony that it should be left to one of the most uncompromising art film directors of his generation to voice such simple economic truths. At the same time, Tarkovsky's appeal to economics was also slightly naïve. *Mirror*'s stubbornly apolitical introspection had been condemned as reactionary from almost all directions – the Party hierarchy, film critics, regional distributors, even other artists (Tarkovsky 1986: 8). So the fact that Tarkovsky's international profile was a bankable asset was irrelevant. No apparatchik could afford to champion a work that had been so vilified.

22 There were five categories of Soviet film: highest, first, second, third, and fourth (Golovskoy 1986: 47).

23 http://www.acs.ucalgary.ca/~tstronds/nostalghia.com/TheTopics/Stalker/sjoman.html. Accessed 07.09.2007.

24 An equally delayed move to color occurred in Cuba, which – lacking the facilities to manufacture color film domestically and faced with a trade embargo imposed by the United States – had virtually no access to color film stock throughout the 1960s. Revolutionary Cuba's first color feature film was *Un Día en el Solar* (Eduardo Manet, 1965), a musical comedy. Its second color feature film was Manuel Octavio Gómez's *Los Días del Agua* (1971). Even though imported East German Orwocolor subsequently began to appear with greater regularity, black-and-white film production exceeded that of color for much of the 1970s.

25 Films were most often sourced officially from Goskino, and unofficially from the state film school (VGIK) and East European embassies (Golovskoy 1986: 134).

Chapter 3

1 Newsreels used 16mm rather than 35mm because the smaller format allowed for the use of lighter cameras, because it was cheaper, and because the higher definition achievable with 35mm was not necessary for the small screen. The use of reversal stock rather than negative stock made processing quicker and cheaper: in reversal stock, the photographed image is inscribed into the film emulsion in the form of a positive rather than a negative. The footage does not need to be transferred onto a print stock – the exposed film is itself the final print.

2 Local television took several years more to complete its transition to color (Kindem 1979: 35). The most delayed televisual transition to color, however, occurred within consumers' homes. Black-and-white television sets remained a common household feature until well into the 1980s.

3 Black-and-white imagery *can*, however, induce desire indirectly, through connotation. From the late 1980s onward, advertising has routinely used black-

and-white as a mark of quality. For case studies on the use of black-and-white in print advertising, see Grainge (2002).

4 By making the past visually distinct from the present, black-and-white also allowed the past to be segregated from it, as I discuss in the following section. It is possible that this segregation in turn influenced theories of the postmodern. Would post-modern theorists have seized so quickly on the late 1960s as a period of cultural transition had there not occurred a shift from black-and-white to color media?

5 Black-and-white photographs were initially sepia due to the chemicals used to develop them. By the end of the nineteenth century, advances in film developing technology allowed photographs to be printed in pure shades of gray. The presence of sepia in early cinema is thus not the necessary by-product of the developing process, but the result of a deliberate choice to tone a black-and-white print with a sepia dye. In this sense, sepia can be seen as an added color. At the same time, sepia-toned images are still monochrome, and so typically regarded as "black-and-white."

6 The earliest cinematic use of the word referenced in the *Oxford English Dictionary* is an October 1916 film review in *Variety*.

7 The *Oxford English Dictionary* defines a flashback as follows: "A scene which is a return to a previous action in the film, a CUT-BACK; hence, a revival of the memory of past events, as in a picture or written presentation."

8 These examples reinforce my hypothesis, as set out in Chapter 1, that the convention of chromatic opposition is far more deeply entrenched than any individual meaning attributable to black-and-white or color.

9 To allow multiple copies of a film to be made without wearing out its original camera negative, the negative has historically been printed onto "interpositive" film stock. The interpositive has then been printed onto "internegative" film stock, and the internegative in turn printed onto multiple final positives for screening in cinemas.

10 DVD audio commentary, *Ed Wood*, Burbank: Buena Vista Home Entertainment, 2003.

11 DVD audio interview, *Down By Law*, New York: Criterion Collection, 2002.

12 DVD interview with Suzuki Seijun, *Tokyo Drifter*, New York: Criterion Collection, 1999.

13 Each of the no-budget costs cited in this section exclude distribution costs incurred after the films were completed. For no-budget films picked up for commercial release, distribution costs routinely amount to several hundred thousand dollars.

14 One can trace the association between black-and-white and "realism" back even further, to the first black-and-white photographs by Nicéphore Niépce in the late 1820s. As Siegfried Kracauer suggests, from the time of their invention until the early twentieth century, photographs were generally perceived as "copies of nature" (1960: 7). Beaumont Newhall provides evidence for this

claim in his discussion of the public shock that greeted Henry Peach Robinson's *Fading Away* (1858), a photograph featuring a posed scene of a dying girl and her family: "[T]he very fact it was a photograph implied that it was a truthful representation, and so the scene was viewed literally" (1972: 76). As all photographs were black-and-white, their lack of color became intertwined with their perceived authenticity.

15 The six black-and-white art films in the United States' 1967 "Top 50" were Joseph Strick's *Ulysses*, Jirí Menzel's *Closely Watched Trains*, Ingmar Bergman's *Persona* and *The Hour of the Wolf*, Alain Resnais's *Le Guerre est finie*, and Orson Welles's *Chimes at Midnight*. The other black-and-white film was Richard Brooks's *In Cold Blood*.

16 Interview with Peter Bogdanovich, 2001. *The Last Picture Show* (DVD), London: Columbia TriStar Home Entertainment.

17 An interesting variant of this use of black-and-white occurs at the beginning of Clint Eastwood's *Mystic River* (2003), a color film which announces its lofty aspirations by beginning with a black-and-white Warner Brothers logo. In this way, the studio positions its product as a serious, Oscar-contending work.

18 It is telling that out of dozens of black-and-white period films made since the late 1960s, I have found only one – François Truffaut's *L'Enfant Sauvage* (1970) – set before the invention of monochrome photography.

19 Of course, this void is restricted to "first world" countries. For most of the people currently alive, pain, degradation, hunger, lack of livelihood, and premature death are not just cultural memories.

20 The references to past representations in *Manhattan* also key in with Paul Grainge's observation that black-and-white can be used to create a sense of timelessness (2002: 71). Black-and-white allows Davis's/Allen's life at least occasionally to transcend the postmodern banality of the late 1970s. New York becomes a simulacrum of itself, a classical timeless city that will always be black-and-white on the walls of student bedrooms. In the same way, television commercials use black-and-white to advertise luxury products, making diamond rings and Swiss watches appear as though they exist above the transitory gratification provided by contemporary consumerism. Though the intended impression is one of timelessness, the use of black-and-white is again premised on its obsolescence: monochrome commercials stand out from the visual noise of other contemporary advertising because black and white is now a rarity.

Chapter 4

1 Throughout this chapter, whenever I refer to the *Opticks*, it is to this revised fourth edition, not the more frequently referenced 1704 first edition. In the fourth edition, Newton indulges in a few more literary techniques – including

rhetoric, metaphor, and digression – than in previous editions. As a result, it provides a slightly richer source for my investigation of Newton's influence on the cultural imaginary.

2 Newton's optical theories were not immediately and universally accepted. Hermann von Helmholtz lists almost a dozen works written in opposition to Newton (Helmholtz 2000: 118). Opposition to Newton's *Opticks*, first published in 1704, continued into the early nineteenth century, most famously in the form of Goethe's *Fahrenlehre* (1810). The *Fahrenlehre* is a masterpiece of misplaced genius, and perhaps the most eccentric and baffling contribution to color theory ever written. In it, Goethe argues that Newton's theory is of little use to visual artists, and also questions a number of Newton's optical discoveries (Goethe 1971: 16, 72). Despite Goethe's faulty science, the book's influence on the popular imagination was immense.

3 It is notable also that Palmer chose violet (blue-green) rather than blue as his third additive primary. Like yellow, blue occupies a relatively narrow portion of the spectrum, and so "blue" is in fact slightly too specific a label for describing the third range of frequencies that cone cells are most responsive to.

4 Photographic emulsions of the time were sensitive only to the extreme blue end of the spectrum. For an explanation of the chemistry behind Maxwell's good fortune in being able to reproduce at least *some* red and green color, see Evans (1961).

5 For a more thorough technological account of the major early color processes, see Coe (1981).

6 Darkness is not quite the same as blackness. If I refer to a black room, the words probably inspire images of a room with black walls rather than a room without light. Black here is a surface phenomenon, the absorption of all light by a colored pigment. Darkness, by contrast, is the absence of light. Blackness involves color, darkness does not. In this chapter, I generally use the terms "blackness" and "darkness" interchangeably. This ambiguity is deliberate. Darkness photographs as black. In photographs and films, blackness and darkness are indistinct.

7 It should also be noted that Newton observed the refracted light in his study as it "falls upon" paper or board (1721: 8). Though Newton's optical colors required atmospheric darkness, they also required a white screen in order to be viewed.

8 The use of blue to signify night dates back to early cinema. In countless black-and-white films of the 1910s and 1920s, scenes shot during the day were tinted blue and transformed into night.

9 Imperfections in the printing process can cause cyan, magenta, and yellow to mix together as brown. As a result, printers also use black ink to ensure that the image has a full tonal range.

10 Interview with Vilmos Zsigmond in *Visions of Light* (Arnold Glassman, Toddy McCarthy, Stuart Samuels, 1992).

11 *Suspiria 25th Anniversary* featurette (Robert A. Ferretti, 2001), *Suspiria* collectors' edition DVD. Troy, MI: Anchor Bay Entertainment, 2001.

12 Realism, of course, is an exceptionally slippery concept. For the sake of clarity, I here use the term "realism" to describe the style of filmmaking that was perceived in the late 1950s as "realistic." Realism is grayness, handheld camera, and location filming. The more minimal understanding of realism as that which accurately reproduces visual reality, I refer to as verisimilitude.

13 A reviewer in *Films and Filming* wrote: "In his presentation Hitchcock has copied the camera styles of the Continental realists. He has tried to achieve the casual looking-in on reality" (Baker 1960).

14 DVD of *Psycho* (1998), Los Angeles: Universal Studios, 2002.

15 "Hitchcock's Presence," Accessed 10.12.2007. http://www.psychomovie.com/production/prodhitchcock.html.

Chapter 5

1 At the end of the eighteenth century, John Dalton carried out a similar process of discovery (1798). Having noticed recurrent anomalies whenever he discussed color with other people, he conducted an experiment to see whether the words that he used to describe variously colored objects correlated with those used by other people. Discovering that sometimes they did not, he concluded that he was unable to distinguish between certain colors, thereby discovering the phenomenon of color blindness.

2 Perhaps even this isolated praise of the *Moby Dick*'s desaturation owes more to the film's press release, which proudly advertised the details of Huston's chromatic experiment, than to the film itself.

3 The following summary of telecine technology's early history derives from Holben (1999).

4 In addition to making possible the transfer of film to video, telecine also enables other equally important transformations. For example, it allows material filmed at 24 frames per second (fps) to be transferred to television frame rates (25fps for PAL, 30fps for NTSC), allowing filmed material to be televised without appearing to flicker. Telecine also allows a film's aspect ratio to be changed to fit the shape of a television screen: the aspect ratio of a widescreen movie can be over 2:1, while the standard aspect ratio for television broadcast is currently 16:9.

5 Kodak set up Cinesite in 1992 as a testing ground for its proprietary Cineon digital film technology (Fisher 1993: 50). In contrast to Technicolor, Kodak anticipated future technological trends, and did not find itself overtaken by

start-up competitors when its core technology became obsolescent in the late 1990s.

6 Another common technique was bleach bypass, which involved bypassing the bleaching stage when a film negative was processed, resulting in an effect similar to silver retention, though not variable. For details, see Probst (1998b).

7 A key development in DI technology occurred in 1996, with the release of the Philips Spirit DataCine, which made possible the real-time transfer of film into high quality 2K (1920 × 1440 pixel) data files. Previously in feature films, film had been transferred to digital formats for special effects work using film scanners, which typically required 300 hours to scan a two-hour feature film (Holben 1999: 118). Real-time 2K telecine (or "datacine") helped make extensive use of DI economically feasible.

8 Folded into this irony is the fact that Chris Watts, the film's visual effects supervisor, began his career at Color Systems Technologies, the company that colorized Ted Turner's films in the 1980s (Fisher 1998: 61).

9 Over subsequent years, DI became an increasingly popular post-production route. By April 2003, almost 30 films had gone entirely through DI (Kaufman 2003: 81). It is now the industry norm.

10 For details of Scorsese's use of digital color in *The Aviator*, see Goldman (2005).

11 It is worth noting that the remediation of analogue film has been facilitated by recent developments in software design. Visual effects plug-ins for common post-production programs such as Final Cut Pro and After Effects routinely include "film-look" filters. "Film-look" options feature in The Foundry's Tinderbox series, Tiffen's DFx, and Magic Bullet's LooksSuite. Visual effects company Red Giant even provides a plug-in for creating a range of different "looks" based on specific films including *The Matrix* and *Saving Private Ryan*. Dust, scratches, mould, etc. can also be reproduced with commercially available filters.

12 This is hardly surprising, considering that the last new black-and-white film negative, Ilford Mark V, was released in 1965 (Jones 1965).

13 The appeal of black-and-white for visual punctuation also partially explains the proliferation of black-and-white television commercials and pop videos since the early 1990s. Black-and-white promos derive their visual distinction, and so augment their power to sell, from the fact that the media landscape surrounding them is predominantly color (Grainge 2002: 72).

14 This tendency also manifests itself in the assimilation into dominant visual culture of numerous other shooting methods and styles once the preserve of experimental cinema: for example, non-linear narratives, disjunctive editing, handheld camerawork, self-reflexivity, and so on. In fact, almost *every* sustained stylistic emergent in cinema history has eventually found itself incorporated into dominant culture.

15 Despite astonishing technological advances in digital colorization, media corporations have not begun again to colorize old Hollywood movies. One

might speculate that the tense relationship between studios and creatives (as demonstrated by the 2007–8 writers' strike) and the lingering memory of the virulence with which campaigners opposed colorization in the 1980s has discouraged renewed colorization.

16 Painting metaphors also abound in product names – for example, Quantel's Paintbox and da Vinci color correctors.

17 As this example from *Hero* demonstrates, digital tools can also be harnessed to limit color movement: though the yellows of the leaves cycle to red, the dying swordfighter's red clothes are masked so as to remain red. Similarly, digital color correction can also minimize the changes in color and light that occur when a camera moves around. For example, Aleksandr Sokurov's *Russian Ark* (2003), a single-shot steadicam tour of the Hermitage, involved hundreds of dynamic digital color corrections counteracting the often extreme changes in lighting conditions faced by the camera as it moved through the museum (Oppenheimer 2003: 95).

18 Deleuze highlighted "movement-colour" as the only intrinsically cinematic form of color, dismissing surface color and "atmospheric colour" (optical color) as belonging to painting. As my analysis of *Waking Life* suggests, movement-color and digital color are closely aligned.

19 "The Weight of the Line: Animation Tales." *A Scanner Darkly* DVD extra, Burbank: Warner Home Video, 2007.

20 This hierarchical production process interlaces with the film's distinctly classical visual style. *Waking Life*'s narrative meanders across a city, from conversation to conversation; analogously, as the film moves from the work of one artist to another, the basis of its movement-color changes. In *A Scanner Darkly*, by contrast, the rotoscoping is compositionally motivated: the shifting colors evoke the shifting perception of reality experienced by the main character. Though not tied down to objects within the diegesis, Sabiston's rotoscoped color is nonetheless forced to fulfil a function.

21 It should be noted that the movement-color in *Waking Life* is itself relatively tame compared to Sabiston's short film *Snack and Drink* (2000), the first work in which he used his interpolated rotoscoping. There is no artistic freedom like that of having no funding.

22 Note again the imaginative constraints at work in this range of options.

23 Absent color is structurally inherent in screen color, and has now been successfully incorporated into digital color, so it does not require championing. As for film color – this color may appear to be an obsolete mode of production, but it is notable that many of Stan Brakhage's experiments in applying pigment directly onto film continued until his death in 2003, and remain unsurpassed as expressions of abstract color – see, for example, *Black Ice* (1994) (Plate 5.16). Perhaps future experimental films may yet return to Brakhage's artisanal mode of production.

Bibliography

"À Montreal, des sujets hauts en couleur, dès 1897." 1896. *La Presse*, 29 June, p. 4.

Abel, Richard. 1994. *The Ciné Goes To Town: French Cinema 1896–1914*. Berkeley: University of California Press.

Alberti, Leon Battista. 1972. *On Painting and on Sculpture: The Latin Texts of De Pittura and De statua*. Translated by C. Grayson. New York: Phaidon.

Almendros, Nestor. 1979. "Photographing *Days of Heaven*." *American Cinematographer* 60 (6): 562–5, 592–4, 626–32.

Alonzo, John A. 1975. "Behind the Scenes of *Chinatown*." *American Cinematographer* 56 (5): 526–9, 564–5, 572–3, 585–91.

Anderson, Perry. 1998. *The Origins of Postmodernity*. London: Verso.

Andrew, Dudley. 1980. "The Post-War Struggle for Colour." In *The Cinematic Apparatus*, edited by S. Heath and T. de Lauretis, 61–75. London: Macmillan Press.

Anon. 1921. "A British Colour Film. 'The Glorious Adventure' for Covent Garden." *The Times*, December 14, 1921, p. 7.

Anon. 1935. "Report of the Color Committee." *Journal of the Society of Motion Picture Engineers* 24 (1): 29–30.

Anon. 1946. "German Color Secret on Way to U.S. and Britain." *Motion Picture Herald* 162: 23.

Anon. 1958. "*South Pacific*." *Variety*. March 26, p. 6.

Anon. 1962. "'South Pacific' Sets All-Time UK B.O. Record, Bigger Than 'Wind'." *Variety* 22: 25.

Anon. 1966. "Eastman Announces Two New Improved 16mm Color Film Stocks." *American Cinematographer* 47 (3): 198, 217.

Anon. 1972. "Education Industry News." *Journal of the Society of Motion Picture and Televison Engineers* 81 (10): 807–24.

Anon. 1986. "Colorised films 'selling well' on video." *Screen Digest*: 32.

Anon. 1995. "Wielding the Double-Edged Sword: Digital Post and Effects." *American Cinematographer* 76 (5): 26–32.

Anon. 1999a. "Major French Black-and-White Feature Shot on Colour Negative." *In Camera*: 14–15.

Anon. 1999b. "Behind The Scenes With … Cinematographer Jean-Marie Dreujou." *Screen International* (1219): 35.

Antonioni, Michaelangelo. 1996. *The Architecture of Vision*. New York: Marsilio Publishers.

Aristotle. 1906. *De sensu and De memoria*. Translated by G. R. T. Ross. Cambridge: Cambridge University Press.

Aristotle. 1935. *On the Soul, Parva Naturalia, On Breath*. Translated by W. S. Hett. London: William Heinemann.

Arnheim, Rudolf. 1958. *Film as Art*. London: Faber and Faber.

Aumont, Jacques. 1992. "La trace et sa couleur." Cinémathéque (2): 6–24.

Aumont, Jacques. 1994. *Introduction à la couleur: des discours aux images*. Paris: Armand Colin Éditeur.

Aumont, Jacques (ed.). 1995. *La Couleur en cinéma*. Milan and Paris: Mazzotta/Cinémathèque française.

Baker, Peter. 1960. "*Psycho.*" *Films and Filming* 6 (12): 21.

Bankston, Douglas. 2001. "Searching for Clues." *American Cinematographer* 82 (5): 58–65.

Barthes, Roland. 1981. *Camera Lucida: Reflections on Photography*. New York: Hill & Wang.

Bartov, Omer. 1997. "Spielberg's Oskar: Hollywood Tries Evil." In *Spielberg's Holocaust: Critical Perspectives on Schindler's List*, edited by Y. Loshitzky, 41–60. Bloomington: Indiana University Press.

Basten, Fred E. 1980. *Glorious Technicolor: The Movies' Magic Rainbow*. London: Thomas Yoseloff.

Batchelor, David. 2000. *Chromophobia*. London: Reaktion.

Batchelor, David. (ed.). 2008. *Colour*. Cambridge, MA: MIT Press.

Baudrillard, Jean. 1983. *Simulations*. Translated by P. Foss, P. Patton, and P. Beitchman. New York: Semiotext(e).

Baudrillard, Jean. 1994. *Simulacra and Simulation*. Translated by S. F. Glaser. Ann Arbor: University of Michigan Press.

Baylor, Denis. 1995. "Colour Mechanisms of the Eye." In *Colour: Art and Science*, edited by T. Lamb and J. Bourriau, 103–36. Cambridge: Cambridge University Press.

Bazin, André. 1997. *Bazin At Work: Major Essays and Reviews from the Forties And Fifties*, edited by B. Cardullo. Translated by B. Cardullo and A. Piette. New York: Routledge.

Bellour, Raymond. 2000. *The Analysis of Film*. Translated by E. B. C. Penley. Bloomington: Indiana University Press.

Belton, John. 1992. *Widescreen Cinema*. Cambridge, MA: Harvard University Press.

Belton, John. 2000. "Cinecolor." *Film History* 12 (4): 344–57.

Belton, John. 2008. "Painting by Numbers: The Digital Intermediate." *Film Quarterly* 61.3: 58–65.

Benjamin, Walter. 1999. *Selected Writings,* Vol. 2 *(1927–34)*, edited by M. Bullock and M. W. Jennings. Translated by R. Livingstone and others. Cambridge, MA: Harvard University Press.

Bergala, Alain. 1995. "La couleur, la Nouvelle Vague et ses maîtres." In *La Couleur en cinéma*, edited by J. Aumont. Milan: Mazzotta.

Bergery, Benjamin. 2004. "Cinematic Impressionism." *American Cinematographer* 85 (12): 58–69.

Björkman, Stig, Torsten Manns, and Jonas Sima. 1973. *Bergman on Bergman.* Translated by P. B. Austin. London: Secker and Warburg.

Blair, G. A. 1920. "The Tinting of Motion Picture Film." *Transactions of the Society of Motion Picture Engineers* (10): 45.

Bolter, Jay David, and Richard Grusin. 2000. *Remediation: Understanding New Media.* Cambridge, MA: MIT Press.

Bordwell, David, Janet Staiger, and Kristin Thompson. 1985. *The Classical Hollywood Cinema: Film Style and Mode of Production to 1960.* New York: Columbia University Press.

Branigan, Edward. 1976. "The Articulation of Color in a Filmic System." *Wide Angle* 1 (3): 20–31.

Branigan, Edward. 1984. *Point of View in the Cinema: A Theory of Narration and Subjectivity in Classical Film.* Berlin: Mouton Publishers.

Brewster, David. 1883. *Letters on Natural Magic.* London: Chatto and Windus.

Brown, Simon. n.d. "Dufaycolor – The Spectacle of Reality and British National Cinema." Accessed 10.12.2009. www.bftv.ac.uk/projects/dufaycolor.htm.

Browning, Robert. 1991. *Dramatic Monologues.* London: Folio Society.

Burch, Noël. 1990. *Life To Those Shadows.* Translated by B. Brewster. London: BFI Publishing.

Burnett, Ron. 2004. *How Images Think.* Cambridge, MA: MIT Press.

Buscombe, Edward. 1985. "Sound and Colour." In *Movies and Methods, Volume II*, edited by B. Nichols. Berkeley: University of California Press.

Calhoun, John. 2003. "Wrap Shot." *American Cinematographer* 84 (11): 120.

Carmichael, Jae. 1982. "Lighting and Production Design." *American Cinematographer* 63 (11): 1156–61.

Castleman, Harry, and Walter J. Podrazik. 1982. *Watching TV: Four Decades of American Television.* New York: McGraw-Hill Book Company.

Cavell, Stanley. 1979. *The World Viewed, Enlarged Edition.* Cambridge, MA: Harvard University Press.

Chanan, Michael. 1996. "New Cinemas in Latin America." In *The Oxford History of World Cinema*, edited by G. Nowell-Smith, 740–9. Oxford: Oxford University Press.

Chisholm, Brad. 1990. "Red, Blue, and Lots of Green: The Impact of Color Television on Feature Film Production." In *Hollywood in the Age of Television*, edited by T. Balio, 213–34. Boston, MA: Unwin Hyman.

Coe, Brian. 1976. *The Birth of Photography: The Story of the Formative Years, 1800–1900.* London: Ash and Grant.

Coe, Brian. 1981. *A History of Movie Photography.* London: Ash and Grant.

Crary, Jonathan. 1992. *Techniques of the Observer: On Vision and Modernity in the Nineteenth Century.* Cambridge, MA: MIT Press.

Crowther, Bosley. 1958. "*South Pacific.*" *The New York Times*, March 20, p. 33.

Cubitt, Sean. 2004. *The Cinema Effect.* Cambridge, MA: MIT Press.

Cubitt, Sean. 2009. "Line and Colour in *The Band Concert.*" *Animation: An Interdisciplinary Journal* 4 (1): 11–30.

Cushman, George W. 1958. "Testing the World's Fastest Color Film." *American Cinematographer* 39 (4): 236–7, 248–50.

Dalle Vacche, Angela, and Price, Brian (eds.). 2006. *Color: The Film Reader.* New York: Routledge.

Dalton, John. 1798. "Extraordinary Facts Relating to the Vision of Colours: With Observations." In *Memoirs of the Literary and Philosophical Society of Manchester*, 5 (1): 28–5. London: Cadell and Davies.

Dana, Jorge. 1992. "Couleurs au pochoir." *Positif* 375–6: 126–8.

Davidoff, Jules. 1991. *Cognition through Color.* Cambridge, MA: MIT Press.

Deleuze, Gilles. 1986. *Cinema 1: The Movement-Image.* Translated by B. Habberjam and H. Tomlinson. London: Athlone Press.

Dolce, Lodovico. 1970. *Aretin: A Dialogue on Painting.* Menston, Yorkshire: Scolar Press.

Douchet, Jean. 1963. "Rencontre avec Leon Shamroy." *Cahiers du Cinéma* 25 (147): 31–4.

Doyle, Chris. 2004. *R34G38B25.* Corte Madera, CA: Gingko Press.

Dubois, Philippe. 1995. "Hybridations et métissages: Les mélanges du noir-et-blanc et de la couleur." In *La Couleur en cinéma*, edited by J. Aumont, 74–92. Milan: Mazzotta.

Dundon, Merle L., and Dan M. Zwick. 1959. "A High-Speed Color Negative Film." *Journal of the Society of Motion Picture and Television Engineers* 68 (11): 735–8.

Durgnat, Raymond. 1968. "Colours and Contrasts." *Films and Filming* 15 (2): 58–62.

Durgnat, Raymond. 2002. *A Long Hard Look at Psycho.* London: BFI Publishing.

Dyer, Richard. 1997. *White.* London: Routledge.

Eagleton, Terry. 1996. *The Illusions of Postmodernism.* Oxford: Blackwell Publishers.

"Eastman Announces Two New Improved 16mm Color Film Stocks." 1966. *American Cinematographer* 47 (3): 198, 217.

Edgerton, Gary R. 2000. "The Germans Wore Gray, You Wore Blue." *Journal of Popular Film and Television* 27 (4): 24–32.

Eisenstein, Sergei. 1970. "One Path to Color: An Autobiographical Fragment." In *The Movies as Medium*, edited by L. Jacobs. Translated by J. Leyda. New York: Farrar, Straus and Giroux.

Eisenstein, Sergei. 1977. "First Letter About Colour." *Film Reader* 2: 181–4.

Eisenstein, Sergei. 1983. *Immoral Memories: An Autobiography*. Translated by H. Marshall. Boston, MA: Houghton Mifflin.

Eliasson, Olafur. 2006. *Your Engagement Has Consequences: On the Relativity of Your Reality*. Baden, Switzerland: Lars Müller Publishers.

Eliot, T. S. 1969. *The Complete Poems and Plays of T. S. Eliot*. London: Faber and Faber.

Elsaesser, Thomas. 1998. "Digital Cinema: Delivery, Event, Time." In *Cinema Futures: Cain, Abel or Cable*, edited by T. Elsaesser and K. Hoffmann, 201–22. Amsterdam: Amsterdam University Press.

Elsaesser, Thomas. 2005. *Cinema Europe: Face to Face with Hollywood*. Amsterdam: Amsterdam University Press.

Elsaesser, Thomas. 2009. "The Mind-Game Film." In *Puzzle Films: Complex Storytelling in Contemporary Cinema*, edited by W. Buckland, 14–41. Chichester: Wiley-Blackwell.

Elstob, Kevin. 1997. "*Hate (La Haine)*." *Film Quarterly* 51 (2): 44–9.

Evans, Ralph M. 1961. "Maxwell's Color Photograph." *Scientific American* 25 (5): 118–28.

Everett, Wendy (ed.). 2007. *Questions of Colour in Cinema: From Paintbrush to Pixel*. Bern: Peter Lang Publishing.

Fassbinder, Rainer Werner. 2004. *Fassbinder über Fassbinder*, edited by R. Fischer. Frankfurt am Main: Verlag der Autoren.

Fell, John. 2000. "Rudolf Arnheim in Discussion with Film Students and Faculty, San Francisco State College, 7 May 1965." *Film History* 12 (1): 11–16.

Finlay, Victoria. 2002. *Colour: Travels through the Paintbox*. London: Hodder and Stoughton.

Fisher, Bob. 1993. "Off to Work We Go: The Digital Restoration of Snow White." *American Cinematographer* 74 (9): 48–54.

Fisher, Bob. 1996. "Enhancing the Palette." *American Cinematographer* 78 (5): 65–9.

Fisher, Bob. 1998. "Black and White in Color." *American Cinematographer* 79 (11): 60–7.

Fisher, Bob. 2000. "Escaping from Chains." *American Cinematographer* 81 (10): 36–49.

Foster, Frederick. 1954. "India's First Feature in Gevacolor." *American Cinematographer* 35 (8): 390, 414–16.

Foster, Frederick. 1959. "A Faster Color Negative." *American Cinematographer* 40 (6): 364–5, 368, 370.

Foucault, Michel. 2002. *The Order of Things*. Abingdon and New York: Routledge.

Gage, John. 2001. *Colour and Culture: Practice and Meaning from Antiquity to Abstraction*. London: Thames and Hudson.

"Gaumont Hand Coloring." 1912. *Motion Picture News*, August 31, p. 18.

Gavin, Arthur E. 1958. "*South Pacific* New Concept in Color Photography." *American Cinematographer* 39 (5): 294–6, 318–19.

Gavin, Arthur E. 1959. "*Porgy and Bess* A Photographic Masterpiece." *American Cinematographer* 40 (8): 476–7, 496, 498–9.

Gavin, Arthur. 1963. "Filming *The Great Escape*." *American Cinematographer* 44 (7): 336–8, 354, 356–8.

Gelmis, Joseph. 1971. *The Film Director As Superstar*. London: Secker and Warburg.

Gili, Jean A. 1992. "Cyrano de Bergerac." *Positif* 375–376: 125.

Godard, Jean-Luc. 1972. *Godard on Godard*. Translated by T. Milne. Edited by J. Narboni and T. Milne. London: Secker and Warburg.

Godard, Jean-Luc. 1998a. *Jean-Luc Godard par Jean-Luc Godard* (Vol. 1). Paris: Cahiers du Cinéma.

Godard, Jean-Luc. 1998b. *Jean-Luc Godard: Interviews*. Jackson: University Press of Mississippi.

Goethe, Johann Wolfgang von. 1971. *Goethe's Colour Theory*, edited by R. Matthaei Translated by H. Aach. London: Studio Vista Limited.

Goldman, Michael. 2005. "Scorsese's Color Homage." *Millimeter* (January): 14–26.

Goldstein, Carl. 1991. "Rhetoric and Art History in the Italian Renaissance and Baroque." *The Art Bulletin* 73 (4): 641–52.

Golovskoy, Val S. 1986. *Behind the Soviet Screen: The Motion-Picture Industry in the USSR 1972–1982*. Translated by S. Hill. Ann Arbor: Ardis.

Gomery, Douglas. 1992. *Shared Pleasures: A History of Movie Presentation in the United States*. Madison, WI: University of Wisconsin Press.

Goodhill, Dean. 1982. "Black and White Cinematography for Dead Men Don't Wear Plaid." *American Cinematographer* 63 (11): 1181–6.

Gottlieb, Sidney. 1995. *Hitchcock on Hitchcock: Selected Writings and Interviews*. London: Faber and Faber.

Grainge, Paul. 2002. *Monochrome Memories*. Westport, CN: Praeger.

Gray, Beverly. 2000. *Roger Corman: An Unauthorized Biography of the Godfather of Indie Filmmaking*. Los Angeles: Renaissance Books.

Greene, Graham. 1980. *The Pleasure Dome, The Collected Film Criticism 1940–50*. Oxford: Oxford University Press.

Greene, Walter R. 1947. "30 Years of Technicolor." *American Cinematographer* 28 (11): 392–3, 410–11.

Gross, Edward. 2005. "The CFQ Interview." *Cinefantastique* 37 (2): 24–31.

Gschwind, Rudolf, and Peter Fornano. 2009. "Fading and Reconstruction of Colour Films." *Colour and the Moving Image: History, Theory, Aesthetics, Archive* Conference, Arnolfini Gallery, Bristol, Great Britain.

Gunning, Tom. 1995. "Colorful Metaphors: The Attraction of Color in Early Silent Cinema." *Fotogenia* 1. Accessed Jan 15, 2005. www.muspe.unibo.it/period/ fotogen/num01/numero1d.htm.

Haines, Richard W. 1993. *Technicolor Movies*. Jefferson, NC: McFarland and Company.

Handley, C. W. 1935. "Lighting for Technicolor Motion Pictures." *Journal of the Society of Motion Picture Engineers* 25 (5): 423–31.

Hansen, Miriam. 1997. "*Schindler's List* Is Not *Shoah*: Second Commandment, Popular Modernism, and Public Memory." In *Spielberg's Holocaust: Critical Perspectives on Schindler's List*, edited by Y. Loshitzky, 77–103. Bloomington: Indiana University Press.

Hanson, W. T., Jr., and W. I. Kisner. 1953. "Improved Color Films for Color Motion-Picture Production." *Journal of the Society of Motion Picture and Television Engineers* 61 (6): 667–701.

Hanssen, Eirik Frisvold. 2006. *Early Discourses on Colour and Cinema: Origins, Functions, Meanings*. Stockholm University. Accessed Aug 27, 2007. www.geocities.com/frisvoldhanssen/.

Haralovich, Mary Beth. 2006. "All That Heaven Allows: Color, Narrative Space, and Melodrama." In *Color: The Film Reader*, edited by A. Dalle Vacche and B. Price. New York: Routledge.

Harrell, Alfred D. 1993. "Telecine: The Tools and How to Use Them." *American Cinematographer* 74 (3): 61–7.

Harvey, David. 1989. *The Condition of Postmodernity*. Oxford: Basil Blackwell.

Helmholtz, Hermann von. 2000. *Helmholtz's Treatise on Psychological Optics*, Vol. 2, edited by J. P. C. Southall. Bristol: Thoemmes Press.

Hertogs, Dan, and Nico de Klerk. 1995. *Disorderly Order: Colours in Silent Film*. Amsterdam: Stichting Nederlands Filmmuseum.

Higgins, Scott. 2003. "A New Colour Consciousness: Colour in the Digital Age." *Convergence* 9 (4): 60–76.

Higgins, Scott. 2007. *Harnessing the Technicolor Rainbow: Color Design in the 1930s*. Austin: University of Texas Press.

Higham, Charles. 1970. *Hollywood Cameramen: Sources of Light*. London: Thames and Hudson.

Hilton, Kevin. 2004. "You Can Colour my World." *Broadcast*, August 20, 24–5.

Hirshfeld, Gerald. 1978. "An American Film Institute Seminar With Gerald Hirshfeld, ASC. Part 1." *American Cinematographer* 59 (6): 574–5, 584–5, 588, 602–5.

Holben, Jay. 1999. "From Film to Tape." *American Cinematographer* 80 (5): 108–22.

Holben, Jay. 2001. "The Root(s) of All Evil." *American Cinematographer* 82 (10): 48–57.

Hollander, Anne. 1991. *Moving Pictures*. Cambridge, MA: Harvard University Press.

Holm, William R. et al. 1957. *Elements of Color in Professional Motion Pictures*. New York: Society of Motion Picture and Television Engineers.

Holmlund, Chris, and Justin Wyatt (eds.). 2005. *Contemporary American Independent Film: From the Margins to the Mainstream*. London: Routledge.

Homer. 2004. *The Odyssey*. Translated by E. McCrorie. Baltimore: Johns Hopkins University Press.

Horowitz, Sara R. 1997. "But Is It Good for the Jews? Speilberg's Schindler and the Aesthetics of Atrocity." In *Spielberg's Holocaust: Critical Perspectives on Schindler's List*, edited by Y. Loshitzky, 119–39. Bloomington: Indiana University Press.

Howe, James Wong. 1937. "Reaction on Making his First Colour Production." *American Cinematographer* (October): 408–12.

Hunt, R. W. G. 1975. *The Reproduction of Colour*. Kings Langley, Hertfordshire: Fountain Press.

Huse, Emery. 1954. "Tri-X - New Eastman High-Speed Negative Motion Picture Film." *American Cinematographer* 35 (7): 335, 364.

Huxley, Aldous. 2004. *Brave New World and Brave New World Revisited*. New York: Harper Collins Publishers.

Huysmans, J. K. 1968. *Against Nature (À Rebours)*. Translated by R. Baldick. Harmondsworth: Penguin.

Huyssen, Andreas. 1995. *Twilight Memories: Marking Time in a Culture of Amnesia*. New York: Routledge.

Huyssen, Andreas. 2000. "Present Pasts: Media, Politics, Amnesia." *Public Culture* 12 (1): 21–38.

Inglis, Andrew F. 1990. *Behind the Tube: A History of Broadcasting Technology and Business*. Boston, MA: The Focal Press.

Iosifyan, Sergei. 1976. "Faktory uspekha filma." *Kinomekhanik* 6.

Iyer, Shilpa Bharatan. 2005. "Bollywood Gets Dose of Color." *Variety* 398 (9): 11.

Jameson, Fredric. 1984. "Postmodernism, or The Cultural Logic of Late Capitalism." *New Left Review*: 53–92.

Jameson, Fredric. 1989. "Nostalgia for the Present." *The South Atlantic Quarterly* 88.2 (2): 517–37.

Jameson, Fredric. 1992. *The Geopolitical Aesthetic*. Bloomington, IN: Indiana University Press.

Jarman, Derek. 1995. *Chroma*. London: Vintage.

Johnson, William. 1966. "Coming to Terms with Color." *Film Quarterly* 20.1 (1): 2–22.

Jones, Christopher. 1965. "From England Comes High Speed, Fine Grain B&W Film." *American Cinematographer* 46 (8): 504–5.

Jones, Loyd A. 1929. "Tinted Films for Sound Positives." *Transactions of the Society of Motion Picture Engineers* 13 (37): 199–226.

Kaes, Anton. 1989. *From Hitler to Heimat: The Return of History as Film*. Cambridge, MA: Harvard University Press.

Kalmus, Herbert T. 1967. "Technicolor Adventures in Cinemaland." In *A Technological History of Motion Pictures and Television: An Anthology from the Pages of*

the *Journal of The Society of Motion Picture and Television Engineers*, edited by R. Fielding. Berkeley: University of California Press.

Kalmus, Natalie. 1935. "Color Consciousness." *Journal of the Society of Motion Picture Engineers* 25 (2): 139–47.

Katz, David. 1935. *The World of Colour*. Trans. R. B. MacLeod and C. W. Fox. Edinburgh: Edinburgh Press.

Kaufman, Debra. 1996a. "A New Telecine Debuts from Philips." *American Cinematographer* 77 (9): 14–16.

Kaufman, Debra. 1996b. "Tape Transfer: Advice and Options from Top Colourists." *American Cinematographer* 78 (2): 12–14.

Kaufman, Debra. 1999. "Creating a Digital Film Lab." *American Cinematographer* 80 (9): 129–9.

Kaufman, Debra. 2003. "A Flexible Finish." *American Cinematographer* 84 (4): 80–9.

Kaufman, Debra, and Ray Zone. 2002. "A Legacy of Invention." *American Cinematographer* 83 (5): 64–77.

Kaufmann, Anthony. 1998. "The Whiz Kid – Darren Aronofsky, Writer/Director of *Pi*". *indieWIRE*. Accessed December 10, 2006. www.indiewire.com/people/int_Aronofsky_Darrn_980710.html.

Kelley, William V. D. 1927. "Imbibition Coloring of Motion Picture Films." *Transactions of the Society of Motion Picture Engineers* 10 (28): 238–41.

Kemp, Martin. 1990. *The Science of Art*. New Haven: Yale University Press.

Kindem, Gorham. 1979. "Hollywood's Conversion to Colour: The Technological, Economic, and Aesthetic Factors." *Journal of the University Film and Video Association* 31: 29–36.

Kindem, Gorham. 1981. "The Demise Of Cinemacolor – Technological, Legal, Economic, and Aesthetic Problems in Early Color Cinema History." *Cinema Journal* 20 (2): 3–14.

Koszarski, Richard. 1999. "Reconstructing Greed. How Long, and What Color?" *Film Comment* 35 (6): 10–15.

Koszarski, Richard. 2000. "Foolish Wives: The Colour Restoration That Never Happened." *Film History* 12 (4): 341–3.

Kracauer, Siegfried. 1960. *Theory of Film, The Redemption of Physical Reality*. New York: Oxford University Press.

Lee, Spike. 1987. *Spike Lee's Gotta Have It: Inside Guerilla Filmmaking*. New York: Simon and Schuster.

Lejeune, C. A. 1956. "At The Films: Tar and Blubber." *The Observer*, November 1, p. 9.

Lejeune, C. A. 1958. "At The Films: Sound and Fury." *The Observer*, 27 April, 8.

Levin, Thomas Y. 2003. "Iconology at the Movies: Panofsky's Film Theory." In *The Visual Turn: Classical Film Theory and Art History*, edited by A. Dalle Vacche, 85–114. New Brunswick: Rutgers University Press.

Levy, Emanuel. 1999. *Cinema of Outsiders: The Rise of American Independent Film*. New York: New York University Press.

Leyda, Jay. 1960. *Kino: A History of the Russian and Soviet Film*. Princeton, NJ: Princeton University Press.

Lightman, Herb A. 1947. "Painting with Technicolor Light." *American Cinematographer* 28 (6): 200–1.

Lightman, Herb A. 1968. "Filming *Planet of the Apes*." *American Cinematographer* 49 (4): 256–9, 278.

Lightman, Herb A. 1970. "Best Achievement in Cinematography, *Butch Cassidy and the Sundance Kid*." *American Cinematographer* 51 (5): 436–8, 472–5.

Lightman, Herb A., and Richard Patterson. 1982. "*Blade Runner*: Production Design and Photography." *American Cinematographer* 63 (7): 684–7, 715–24.

Limbacher, James L. 1969. *Four Aspects of the Film*. New York: Brussel and Brussel.

Loring, Charles. 1950. "Lighting for Color Movies." *American Cinematographer* 31 (1): 16, 23.

Lundemo, Trond. 2006. "The Colors of Haptic Space: Black, Blue and White in Moving Images." In *Color: The Film Reader*, edited by A. Dalle Vacche and B. Price, 88–101. New York: Routledge.

Lyon, Richard. 1989. *The 1990 Survival Guide to Film*. Los Angeles: LyonHeart Publishers.

MacAdam, David L. (ed.). 1970. *Sources of Colour Science*. Cambridge, MA: MIT Press.

Macdonald, K. 1994. *Emeric Pressburger: The Life and Death of a Screenwriter*. London: Faber and Faber.

Mahajan, K. K. 1996. "The History and Practice of Cinematography in India: Interview with K. K. Mahajan." Accessed September 28, 2005. www.sarai.net/cinematography/pdf/interviews/kk_mahajan.PDF.

Mahajan, K. K. 2005. *The History and Practice of Cinematography in India: Interview with K. K. Mahajan*. Accessed September 28, 2005. www.sarai.net/cinematography/pdf/interviews/kk_mahajan.PDF.

Mailer, Norman. 1949. *The Naked and the Dead*. London: Allan Wingate.

"Major French Black-and-White Feature Shot on Colour Negative." 1999. *In Camera*, July, 14–15.

Mamoulian, Rouben. 1960. "Color and Light in Films." *Film Culture* 21: 68–79.

Manovich, Lev. 2001. *The Language of New Media*. Cambridge, MA: MIT Press.

Margolis, Jason. 1999. "'Following' Britain's Neo-Noirist, Christopher Nolan." *indieWIRE*. Accessed November 24, 2007. www.indiewire.com/article/following_britains_neo-noirist_christopher_nolan/.

Maxwell, James Clerk. 1861. "On The Theory of Three Primary Colours." *The British Journal of Photography* 8 (147): 270–1.

Mazzanti, Nicola. 2009. "Colours, Audiences, and (Dis)continuity in the 'Cinema of the Second Period'." *Film History* 21.1: 67–93.

McBride, Joseph. 1997. *Steven Spielberg: A Biography*. New York: Simon and Schuster.

McCabe, Bob. 1995. "Global Village: Mathieu Kassovitz." *Empire* 78: 54.

Merjian, Ara H. 2002. "Middlebrow Modernism: Rudolf Arnheim at the Crossroads of Film Theory and the Psychology of Art." In *The Visual Turn: Classical Film Theory and Art History*, edited by A. Dalle Vacche. New Brunswick, NJ: Rutgers University Press: 154–92.

Metz, Christian. 1974. *Film Language: A Semiotics of the Cinema*. Translated by M. Taylor. New York: Oxford University Press.

Minguet Batllori, Joan M. 2009. "Segundo de Chomón and the Fascination for Colour." *Film History* 21.1: 94–101.

Mott, Roy. 1919. "White Light for Motion Picture Photography." *Transactions of the Society of Motion Picture Engineers* 8: 7–41.

Mottram, James. 2002. *The Making of Memento*. London: Faber and Faber.

Mulheren, David R. 1965. "Colour Filming for Outside Processing." *American Cinematographer* 46 (12): 785–7.

Musser, Charles. 1990. *The Emergence of Cinema*. New York: Charles Scribner's Sons.

Musser, Charles. 2002. Screen Notes on *The Movies Begin: A Treasury of Early Cinema, 1894–1913*. Vol. 1: *The Great Train Robbery and Other Primary Works* (DVD). New York: Kino Video.

Naremore, James. 1973. *Filmguide to Psycho*. Bloomington, IN: Indiana University Press.

Nash, Paul. 1937. "The Colour Film." In *Footnotes to the Film*, edited by C. Davy. London: Lovat Dickson.

Neale, Stephen. 1985. *Cinema and Technology: Image, Sound, Colour*. London: Macmillan.

Nelson, Skip. 1965. "Color Filming for In-Station Processing." *American Cinematographer* 46 (12): 782–4.

Neupert, Richard. 1990. "Technicolor and Hollywood: Exercising Color Restraint." *Post Script* 10 (1): 21–9.

Newhall, Beaumont. 1972. *The History of Photography: From 1839 to the Present Day*. London: Secker and Warburg.

Newton, Isaac. 1721. *Opticks: or, a Treatise of the Reflections, Refractions, Inflections and Colours of Light*. 3rd edn. London: William and John Innys.

"Night vision." 2003. *Televisual*, October 1, p. 63.

Nowotny, Robert A. 1983. *The Way of All Flesh Tones: A History of Colour Motion Picture Processes 1895–1929*. New York: Garland Publishing.

Oppenheimer, Jean. 2003. "Tour De Force." *American Cinematographer* 84 (1): 84–5.

Oshima, Nagisa. 2006. "Banishing Green." In *Color: The Film Reader*, edited by A. Dalle Vacche and B. Price. New York: Routledge.

Parker, David L. 1972. "Blazing Technicolor," "Stunning Trucolor," and "Shocking Eastmancolor." In *The American Film Heritage: Impressions from the American Film Institute Archives*, edited by The American Film Institute. Washington, DC: Acropolis Books.

Pennington, Adrian. 2006. "Pop Art and Paranoia." *Imagine* (7): 36–9.

Pierson, John. 1995. *Spike, Mike, Slackers and Dykes: A Guided Tour Across a Decade of American Independent Cinema*. New York: Hyperion.

Pino, Paolo. 2000. *Dialogo Di Pittura*. Rome: Lithos.

Plath, Sylvia. 1996. *The Bell Jar*. London: Faber and Faber.

Poirier, Maurice George. 1976. "Studies on the Concepts of 'Disegno,' 'Invenzione,' and 'Colore' in Sixteenth- and Seventeenth-Century Italian Art and Theory, Fine Arts." PhD diss. New York University, New York.

Powell, Michael. 1987. *A Life in Movies*. London: Methuen.

Powell, Michael, and Hein Heckroth. 1950. "Making Colour Talk." *Kinematograph Weekly*, October 5, p. 5.

Poynton, Charles. 2005. "Color in Digital Cinema." In *Understanding Digital Cinema: A Profesisonal Handbook*, edited by S. Swartz, 57–82. Burlington, MA: Focal Press.

Predal, René. 1975. "Souvenirs de L. H. Burel." *Revue Internationale d'Histoire du Cinéma* 3.

Probst, Christopher. 1997a. "Color Conundrum." *American Cinematographer* 78 (5): 79–85.

Probst, Christopher. 1997b. "Picture Perfect." *American Cinematographer* 79 (4): 30–4.

Probst, Christopher. 1998a. "The Last Great War." *American Cinematographer* 79 (8): 20–34.

Probst, Christopher. 1998b. "Soup du Jour." *American Cinematographer* 79 (11): 82–93.

Probst, Christophcr. 1999. "Welcome to the Machine." *American Cinematographer* 80 (4): 32–44.

Probst, Christopher. 2000. "A Digital R*evolution*." *American Cinematographer* 81 (9): 151–4.

Probst, Christopher. 2004. "A Retro Future." *American Cinematographer* 85 (10): 32–43.

Rajadhyaksha, Ashish, and Paul Willemen. 1994. *Encyclopaedia of Indian Cinema*. London: BFI Publishing.

Raskin, Richard. 1999. "'It's Images You Can Trust Less and Less.' An Interview with Wim Wenders on *Wings of Desire*." *P.O.V.* (8): 5–20.

Read, Paul. 2009. "'Unnatural Colours': An Introduction to Colouring Techniques in Silent Era Movies." *Film History* 21.1: 9–46.

Rebello, Stephen. 1990. *Alfred Hitchcock and the Making of Psycho*. New York: Dembner Books.

"Report of the Color Committee." 1935. *Journal of the Society of Motion Picture Engineers* 24 (1): 29–30.

Riley, Bridget. 1995. "Colour for the Painter." In *Colour: Art and Science*, edited by T. Lamb and J. Bourriau, 31–64. Cambridge: Cambridge University Press.

Rodowick, D. N. 2007. *The Virtual Life of Film.* Cambridge, MA: Harvard University Press.

Rohmer, Eric. 1989. *The Taste for Beauty.* Translated by C. Volk. Cambridge: Cambridge University Press.

Rosenbaum, Jonathan. 1995. *Placing Movies.* Berkeley: University of California Press.

Ross, Chuck. 1986. "Colorized Movies Doing Well in Syndication." *The Hollywood Reporter* 294 (6): 4.

Rushdie, Salman. 1992. *The Wizard of Oz.* London: BFI Publishing.

Ryan, Roderick T. 1977. *A History of Motion Picture Color Technology.* London: Focal Press.

Sacks, Oliver. 1995. *An Anthropologist on Mars.* London: Picador.

Salt, Barry. 1992. *Film Style and Technology: History and Analysis.* London: Starword.

Schleier, Curt. 1994. "Steven Spielberg's New Direction." *Jewish Monthly* 108 (4): 12.

Scorscse, Martin. 2003. *Scorsese on Scorsese*, edited by D. Thompson and I. Christie. London: Faber and Faber.

Shafer, Bob, and Dexter Alley. 1966. "Overcoming the Problems of Color TV Newsfilming." *American Cinematographer* 47 (2): 113–15.

Shapiro, Alan E. 1994. "Artists' Colors and Newton's Colors." *Isis* 85 (4): 600–20.

Sharits, Paul. 1966. "Red, Blue, Godard." *Film Quarterly* 19 (4): 24–9.

Shay, Estelle. 2006. "Sterling Allen on *A Scanner Darkly.*" *Cinefex* (107): 33–7.

Shearman, John. 1962. "Leonardo's Colour and Chiaroscuro." *Zeitschrift für Kunstgeschichte* 25 (1): 13–47.

Sherman, Paul D. 1981. *Colour Vision in the Nineteenth Century.* Bristol: Adam Hilger.

Shulman, Milton. 1958. "At the Cinema: Brando Loses Faith in his Fuehrer." *Sunday Express*, April 27, p. 17.

Simmons, Norwood L. 1962. "The New Eastman Color Negative and Color Print Films." *American Cinematographer* 43 (6): 362–3, 385.

Skoller, Donald (ed.). 1973. *Dreyer in Double Reflection.* New York: E.P. Dutton and Co.

Sloane, Judy, and Nikki Baughan. 2005. "City Limits." *Film Review* (657): 56–62.

Steen, Russell. 1996. "Top of the Charts." *American Cinematographer* 78 (3): 85–90.

Stensvold, Alan. 1966. "Filming the *Bob Hope Vietnam Christmas Show* in 35mm Color." *American Cinematographer* 47 (2): 110–12.

Surtees, Robert. 1949. "Color is Different." *American Cinematographer* 29 (1): 10–11; 31.

Swift, Jonathan. 1983. *The Complete Poems*, edited by P. Rogers. Harmondsworth: Penguin.

Tarkovsky, Andrei. 1986. *Sculpting in Time*. Translated by K. Hunter-Blair. London: Bodley Head.

Tarkovsky, Andrei. 1994. *Time within Time, The Diaries 1970–1986*. Translated by K. Hunter-Blair. London: Faber and Faber.

Taylor, John Russell. 1972. "The Last Picture Show." *The Times*, March 8, p. 13.

Telotte, J. P. 2008. *The Mouse Machine*. Urbana and Chicago: University of Illinois Press.

Trainor, Richard. 1993. "Henri Alekan: Black and White Light. An Interview." *Sight and Sound* 3 (6): 114–17.

Trosko, V. L., and V. G. Komar. 1974. "The Soviet Motion Picture Industry." *American Cinematographer* 55 (8): 922–4.

Truffaut, François. 1984. *Hitchcock*. New York: Simon and Schuster.

Turim, Maureen. 1989. *Flashbacks in Film*. New York: Routledge.

Turovskaya, Lyudmila. "Lyudmila Feiginova talks to Maya Turovskaya." Accessed 10.12.2009. www.acs.ucalgary.ca/~tstronds/nostalghia.com/TheTopics/Stalker/chugunova.html.

Usai, Paolo Cherchi. 1996. "The Colour of Nitrate: Some Factual Observations on Tinting and Toning Manuals for Silent Films." In *Silent Film*, edited by R. Abel, 21–30. New Brunswick, NJ: Rutgers University Press.

Vasari, Giorgio. 1996. *Lives of the Painters, Sculptors and Architects*. Translated by G. du C. de Vere. 2 vols. Vol. 2. London: David Campbell Publishers.

Walker, Alexander. 1999. *Stanley Kubrick, Director*. New York: W.W. Norton & Company.

Wenders, Wim. 1991. *The Logic of Images*. London: Faber and Faber.

Weyand, Armin. 1984. "Heimat: eine Entfernung. Ein Gespräch mit Edgar Reitz." *Frankfurter Rundschau*, October 20, p. 3.

"Wielding the Double-Edged Sword: Digital Post and Effects." 1995. *American Cinematographer* 76 (5): 26–32.

Wilde, Oscar. 1908. *Complete Works of Oscar Wilde*. Translated by E. R. Ross. London: Methuen and Co.

Williams, David E. 2007. "Few Against Many." *American Cinematographer* 88 (4): 52–65.

Williams, F. 1977. "Filming in 16mm: Sepia Tones for that 'Period' Look." *Movie Maker* (11): 750–1.

Williams, Raymond. 1977. *Marxism and Literature*. Oxford: Oxford University Press.

Williamson, Samuel J., and Herman Z. Cummins. 1983. *Light and Colour in Nature and Art*. New York: John Wiley and Sons.

Winston, Brian. 1996. *Technologies of Seeing*. London: BFI Publishing.

Wittgenstein, Ludwig. 1977. *Remarks on Colour*, edited by G. E. M. Anscombe. Translated by L. McAlister and M. Schättle. Oxford: Basil Blackwell.

Wölfflin, Heinrich. 1950. *Principles of Art History: The Problem of the Development of Style in Later Art*. New York: Dover Publications.

Wollen, Peter. 1980. Cinema and Technology: A Historical Overview. In *The Cinematic Apparatus*, edited by S. Heath and T. de Lauretis, 14–22. London: Macmillan Press.

Young, Thomas. 1802. *A Syllabus of Lectures on Natural and Experimental Philosophy*. London: The Press of the Royal Institution.

Young, Thomas. 1807. *A Course of Lectures on Natural Philosophy and the Mechanical Arts*. London: Joseph Johnson.

Yumibe, Joshua. 2005. "Silent Cinema Colour Aesthetics." Paper read at "The Sense of Colour", May 28, at Herstmonceux Castle, England.

Yumibe, Joshua. 2007. "Fragments of the Past: Exploring Clues to Early Color Film." *CLIR Issues* 60, November/December. Accessed May 22, 2008. www.clir.org/pubs/issues/issues60.html.

Žižek, Slavoj. 1992. *Everything You Always Wanted to Know about Lacan (But Were Afraid to Ask Hitchcock)*. London: Verso.

Žižek, Slavoj. n.d. *Is There A Proper Way To Remake a Hitchcock Film?* Accessed January 27, 2007. www.lacan.com/hitch.html.

Zsigmond, Vilmos. 1980. "Behind the Cameras on "Heaven's Gate"." *American Cinematographer* 61 (11): 1110–13, 1164–5, 1172–81.

Index

Titles in *italics* relate to films unless otherwise stated.